CW01022189

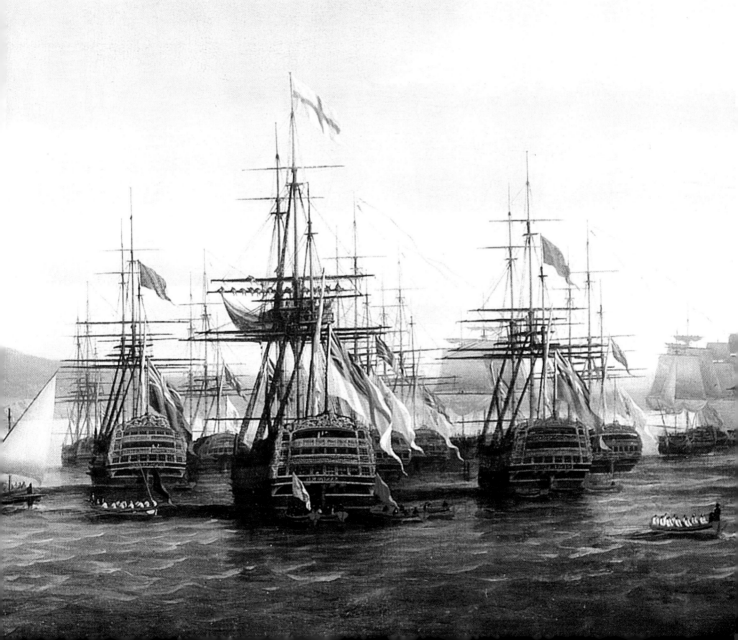

DOMINIC SERRES R.A.

1719–1793

WAR ARTIST TO THE NAVY

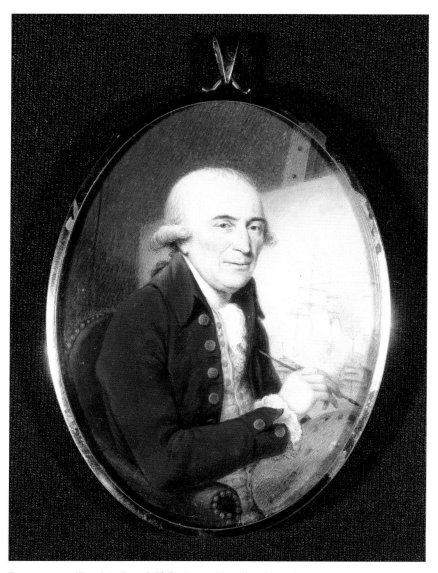

FRONTISPIECE: 'Dominic Serres', Philip Jean, 1788, 4¼ x 3¼ ins. (10 x 8 cm).
By courtesy of the National Portrait Gallery, London

DOMINIC SERRES R.A.

—— 1719–1793 ——

WAR ARTIST TO THE NAVY

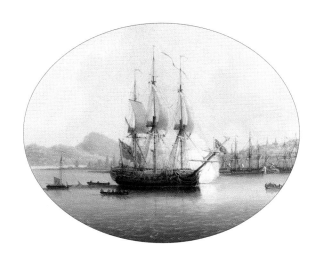

ALAN RUSSETT

ANTIQUE COLLECTORS' CLUB

© Alan Russett 2001

World copyright reserved

ISBN 1 85149 360 3

The right of Alan Russett to be identified as author of this work has been asserted by
him in accordance with the Copyright, Designs and Patents Act 1988

All rights reserved. No part of this publication may be reproduced, stored in a retrieval
system, or transmitted in any form or by any means electronic, mechanical, photocopying,
recording or otherwise, without the prior permission of the publishers.

British Library Cataloguing-in-Publication Data
A catalogue record for this book is available from the British Library

Printed in England by the Antique Collectors' Club Ltd., Woodbridge, Suffolk
on Consort Royal Satin paper supplied by the Donside Paper Company, Aberdeen, Scotland

ANTIQUE COLLECTORS' CLUB

The Antique Collectors' Club was formed in 1966 and quickly grew to a five figure membership spread throughout the world. It publishes the only independently run monthly antiques magazine, *Antique Collecting*, which caters for those collectors who are interested in widening their knowledge of antiques, both by greater awareness of quality and by discussion of the factors which influence the price that is likely to be asked. The Antique Collectors' Club pioneered the provision of information on prices for collectors and the magazine still leads in the provision of detailed articles on a variety of subjects.

It was in response to the enormous demand for information on 'what to pay' that the price guide series was introduced in 1968 with the first edition of *The Price Guide to Antique Furniture* (completely revised 1978 and 1989), a book which broke new ground by illustrating the more common types of antique furniture, the sort that collectors could buy in shops and at auctions rather than the rare museum pieces which had previously been used (and still to a large extent are used) to make up the limited amount of illustrations in books published by commercial publishers. Many other price guides have followed, all copiously illustrated, and greatly appreciated by collectors for the valuable information they contain, quite apart from prices. The Price Guide Series heralded the publication of many standard works of reference on art and antiques. *The Dictionary of British Art* (now in six volumes), *The Pictorial Dictionary of British 19th Century Furniture Design, Oak Furniture* and *Early English Clocks* were followed by many deeply researched reference works such as *The Directory of Gold and Silversmiths,* providing new information. Many of these books are now accepted as the standard work of reference on their subject.

The Antique Collectors' Club has widened its list to include books on gardens and architecture. All the Club's publications are available through bookshops world wide and a full catalogue of all these titles is available free of charge from the addresses below.

Club membership, open to all collectors, costs little. Members receive free of charge *Antique Collecting*, the Club's magazine (published ten times a year), which contains well-illustrated articles dealing with the practical aspects of collecting not normally dealt with by magazines. Prices, features of value, investment potential, fakes and forgeries are all given prominence in the magazine.

Among other facilities available to members are private buying and selling facilities and the opportunity to meet other collectors at their local antique collectors' clubs. There are over eighty in Britain and more than a dozen overseas. Members may also buy the Club's publications at special pre-publication prices.

As its motto implies, the Club is an organisation designed to help collectors get the most out of their hobby: it is informal and friendly and gives enormous enjoyment to all concerned.

For Collectors — By Collectors — About Collecting

ANTIQUE COLLECTORS' CLUB
5 Church Street, Woodbridge Suffolk IP12 1DS, UK
Tel: 01394 385501 Fax: 01394 384434
——— or ———
Market Street Industrial Park, Wappingers' Falls, NY 12590, USA
Tel: 845 297 0003 Fax: 845 297 0068

For Isabella and Edward

CONTENTS

ACKNOWLEDGEMENTS 8

INTRODUCTION 10

CHAPTER I: A Roving Youth and a Place in Artists' London 1719-1756 12

CHAPTER II: The Opportunity: The Seven Years' War
 and the Vogue for Naval Pictures 1756–1763 21

CHAPTER III: The Capture of Havana 1762; Prints and Paintings 46

CHAPTER IV: The Sandbys as Friends and the Patronage
 of 'Gentlemen of Rank in the Naval Department' 1763-1768 64

CHAPTER V: Commemorative Paintings; Royal Patronage and
 Royal Academy Life 1768–1776 82

CHAPTER VI: The War of American Independence 1776–1783 103

CHAPTER VII: The Summit Reached; Marine Painter to the King;
 The Artist as Collector 1780 128

CHAPTER VIII: Battle Commissions in Spate 1781 142

CHAPTER IX: Rodney in the West Indies; A Legacy; Hughes in the East Indies 154
 1782-1784

CHAPTER X: Serres in Paris with Vernet 1785–1786 171

CHAPTER XI: Travels; a Marriage and Bath Spa for the Cure 1785–1788 177

CHAPTER XII: Senior Academician; Drawings and Prints;
 John Thomas's Tour and Marriage 1789–1791 190

CHAPTER XIII: A Painting Exhibited; Librarian of the Royal Academy;
 Last Months 1791–1793 204

CHAPTER XIV Epilogue 216

INDEX 220

ACKNOWLEDGEMENTS

The gracious permission of Her Majesty The Queen to reproduce Dominic Serres's paintings and drawings of the Royal review of the fleet in 1773 (Plates 47–54) and the group portrait by Johann Zoffany of the Royal Academicians (Colour Plate 37) is gratefully acknowledged, together with the generous assistance of Christopher Lloyd, Surveyor of the Queen's Pictures, the Hon. Mrs. Jane Roberts, Curator of the Print Room in the Royal Collection, and the staff of Royal Collection Enterprises.

I have also greatly appreciated the help and support of David Adshead, Delphine Allannic, William Bishop, James W. Cheevers, Barbara Clarkson, Ronald Cohen, John Dickinson, Dr. C. and Dr. K. Draper, Dr. Kate Fielden, William Forrester, E. McSherry Fowble, Peter Gibson, the Hon. Mrs. Lucy Keppel, Vivienne Knight, Dr. Joan Lane, Arthur S. Lefkowitz, Charles Leggatt, Eckart Lingenauber, Marcus Lynch, Michael MacCabe, Olivier Meslay, Charles Nugent, Mora Dianne O'Neill, Sir Richard Hyde Parker, Bt., Tom Pocock, Susanna Quash, Lord de Saumarez, Dom Geoffrey Scott, Dr. Kim Sloan, Dr. David Syrett, Lord Thomas of Swynnerton, The Reverend F.J. Turner, Clive Wilkinson, Viscount Windsor, Samantha Wyndham.

The volume owes an immeasurable debt to the National Maritime Museum, Greenwich, which houses the largest collection of works by Dominic Serres. I am most grateful to members of the staff there who have been so helpful in many aspects of the research for and the production of the work, in particular to Roger Quarm and Dr. Pieter van der Merwe for much helpful advice during preparation and constructive comment after reading the typescript, Caroline Hampton for professional help on Serres's painting techniques, and Christopher Gray, Lucy Pringle, Lindsey Macfarlane and Eleanor Heron of the Picture Library for picture research and the provision of transparencies and photographs for reproduction as illustrations. The staff of the Caird Library at the Museum have been unfailingly helpful.

Members of the staff of the following libraries used and other institutions consulted have all given ready service and willing help, for which I am grateful. Auch: Société Archéologique du Gers, Direction des Archives Départementales du Gers; Cambridge: Fitzwilliam Museum; Chantilly: Bibliothèque des Fontaines; Lille: Archives Départementales du Nord; London: British Library, Christie's Archives, Family Records Centre, Genealogical Society, Greater London Record Office, Guildhall Library, Library of the Royal Academy of Arts, London Library, National Art Library (Victoria and Albert Museum), National Register of Archives, Public Record Office (Kew), Royal Society of Arts, Westminster City Archives; Paris: Archives de France (C.A.R.A.N.), Bibliothèque d'Art et d'Archéologie; West Lothian: Dalmeny House.

In the search for works by Serres and, where appropriate, reproductions of them,

many art galleries, museums and collections have been approached. I wish to thank curators, curatorial and picture library staff at the following for their generous help. Adelaide: Art Gallery of South Australia; Birmingham Art Gallery; Halifax: Art Gallery of Nova Scotia; Hamilton: Art Gallery of Hamilton; Ipswich Museums and Galleries; Jersey Heritage Trust; London: British Museum Department of Prints and Drawings, Courtauld Institute of Art Photographic Survey, Government Art Collection, Guildhall Art Gallery, The Iveagh Bequest (Kenwood House), National Portrait Gallery, National Trust Photographic Library and houses, Paul Mellon Centre for Studies in British Art, Royal Academy of Arts, Tate Britain, Victoria and Albert Museum, Witt Library (Courtauld Institute of Art, University of London); Manchester: Whitworth Art Gallery; Ottawa: National Archives of Canada; Paris: Musée de la Marine; Sydney: Australian National Maritime Museum; Toronto: Art Gallery of Ontario, Royal Ontario Museum; Warwick Castle; Yale Center for British Art.

I am also most grateful to auction houses and fine art dealers for their helpful support in searching for paintings, drawings and reproductions of them, and arranging for me to use them as illustrations: Bonham's, Christie's Images, Daniel Hunt Fine Art, Lane Fine Art, Mallett, Sotheby's, and Spink Leger.

I wish to express my warm appreciation of the support of my publisher and last, but by no means least, I thank my wife for her unstinting help in so many ways to carry through the enterprise.

INTRODUCTION

In the second half of the eighteenth century a small band of marine painters in England was recording the naval battles and combined operations of the wars which Britain waged in Europe, America and around the world. Dominic Serres has traditionally been considered as no more than another member of this group of specialist painters. His French origins, his prolific output, his election as a founder member of the Royal Academy, its only marine painter, and his appointment as Marine Painter to George III, have conferred upon him a certain distinction, but no attempt has previously been made to assess in greater depth the nature of the man and his *oeuvre*, his standing as an artist and in the artistic community and his relationship with the leading naval commanders of his day. It is the purpose of this biography to make good that omission.

Although Claude Joseph Vernet persisted in addressing him as 'mon cher compatriote', Serres had abandoned his French birth and upbringing in early youth to become a mariner and world traveller and, after being brought to England as a prisoner of war in about 1745, remained after the peace treaty and became thoroughly assimilated in his country of adoption. His only return to France, in 1785, was at the instigation of Vernet. In his beginnings as a painter Serres also adopted the typically British and currently fashionable genre of painting, that of landscape. Throughout his life he was to remain at heart a landscapist, deploying his considerable talents by including landscape features whenever he could. His role in collaborating with printmakers in the early 1760s, when he established his reputation, was as a painter of coastal scenes where local topography often predominated. Ships and the sea invariably also appeared and, as these had been Serres's elements, he executed them with accuracy and telling effect. The prints were produced to meet the growing public demand for images of the seaborne military operations which took place during the Seven Years' War between 1756 and 1763.

Having made a name for himself as a painter of pictures from which the engravers could work, Serres quickly came to attract the patronage of senior naval commanders who wished to perpetuate their prestigious engagements in a more permanent medium and larger, more distinctive format by commissioning oil paintings. Among these commanders were Hawke, Keppel, Hervey (Earl of Bristol), Hyde Parker, Barrington, Rodney, Jervis (Earl St. Vincent), Locker and Hughes. With wars, threats and rumours of wars, and memories of wars continuing in unbroken succession for the remainder of the century, Serres's work in response to these commissions became more exclusively devoted to the depiction of naval actions of all kinds, whether fleet battles or single ship engagements. Yet he never lost his feeling for the pastoral and this expressed itself not only in the inclusion of landscape whenever possible in his canvases but also in his preference for the calmer scene after the action rather than the noise and devastation of

battle. His painterly effect was frequently achieved by careful use of chiaroscuro, a sense of space and the accurately observed play of light.

Never apparently having received formal training as a painter, Serres conformed to the prevailing conventions of the period without displaying the influence of any one particular master or school. But his enormous collection of paintings, drawings and prints shows that he was an avid collector and open to the style and techniques of other artists. His amendment and reworking of drawings by the Willem van de Veldes demonstrate that he was prepared to experiment and learn from the most distinguished examples available to him. It was at the bidding of a nobleman, an amateur of marine painting, that Serres produced a series of drawings for instruction in the appropriate techniques. These were later incorporated in the *Liber Nauticus*, published by his elder son, John Thomas, in 1805–6.

Dominic Serres's friendship with Paul Sandby was clearly a central feature of his life and a contributory factor to his preferment and wide circle of friends. Serres was a notable figure in the artistic, naval and French expatriate communities which reflected his congenial personality and gregarious nature. Yet he was hard-working and achieved a prolific output. He had been married for over forty years at the time of his death and his family of six surviving children were all artists, John Thomas being the best known to posterity.

Serres emerges from this study as the leading marine painter of his time and a significant figure in the art history of the period. Many of his paintings are readily accessible in both public galleries and in the country houses of the families which originally commissioned them.

Pronunciation of the name can prove an initial obstacle. In French the pronunciation of the ending of Serres would resemble that of 'hair', while the English would be closer to that of '(b)erries'. The choice between the two still seems to be left to personal preference. The spelling of Dominic has varied over time. In Serres's lifetime it was usually spelt in the anglicised form of Dominick. Over the years, those anxious to preserve the French flavour have used Dominique, and there have been other variants. The intermediate spelling, Dominic, has become generally accepted and it is this that is used in this biography. In the case of Dominic's second son, however, the spelling Dominique has been preferred as this was that written in the register at the time of his marriage.

Serres's date of birth has traditionally been taken as 1722, but, on the evidence examined in the text, it is more likely to have been 1719, and that is the date here assumed.

All the illustrations are reproductions of works by Dominic Serres unless otherwise stated. Dimensions are given height by width.

All publications in the footnote references are London, unless otherwise stated.

CHAPTER I

A ROVING YOUTH AND
A PLACE IN ARTISTS' LONDON
1719-1756

Horace Walpole's building project for his 'Gothick' villa at Strawberry Hill, Twickenham, 'the prettiest bauble you ever did see', continued from 1747 onwards, as he extended the original house by adding one elaborate feature after another. His *Description of the Villa* was first published in 1774 but, as the work progressed, he determined to issue an enlarged edition, with illustrations, in order to give a more complete impression of the building, its decoration and contents. As early as June 1770, Walpole had written to Paul Sandby trying to make contact with his elder brother, Thomas, the first Professor of Architecture at the Royal Academy, who 'was so obliging as to promise to come and draw the perspective of my Gallery'. Thomas was not only difficult to locate but evidently also dilatory in completing the assignment, for eleven years later, in June 1781, Walpole referred to 'Thomas Sandby's fine view of the Gallery, to which I could never get him to put the last hand'.

After a few weeks, on 16 August 1781, Walpole wrote: 'I have a painter making drawings for the description of the house and collection'. The painter was Edward Edwards (1738–1806), elected Associate of the Royal Academy in 1773, and he was 'much employed at Strawberry Hill until 1783'.[1] It was he who finished Thomas Sandby's 'fine view of the Gallery' and provided some of the drawings which were engraved for the enlarged, illustrated *Description of the Villa* published in 1784.

At the same time as Horace Walpole was creating his esoteric show-piece residence on the banks of the Thames and publishing its *Description*, he was also engaged in another publishing venture, his *Anecdotes of Painting in England*. This encyclopaedic review of the greatest painters from earliest times up to his own day, was a collation of the extensive but ill-organised notes left by George Vertue (1684–1756), the engraver and antiquary now known as the founder of English art history. It also contained much of Walpole's own input. The first three volumes were published in 1762. The fourth volume was printed (on Walpole's own press at Strawberry Hill) in 1771 but not published until 1780, having been 'delayed through motives of tenderness' for contemporaries censured in the text and their surviving relatives.

Edwards had studied at the Royal Academy schools and in Italy and was of some repute as a portraitist, but was unable to achieve the highest rank of his profession and was never elected a Royal Academician. He was, however, well known in artistic circles, being appointed Teacher of Perspective (only full Academicians were entitled Professor) at the Academy in 1788, and determined to emulate Walpole by compiling a sequel to *Anecdotes of Painting*. This continuation would take the biographical sketches on from the reign of George II, where Walpole had left off, and bring them right up to date and include his own contemporaries. Edwards's *Anecdotes of Painters who have resided or been born in England, intended as a continuation to the Anecdotes of Painting by the late Horace, Earl of Orford* was published in 1808, shortly after his death.

Edwards wrote from Newcastle on 28 October 1787 to his friend Dominic Serres, R.A., primarily to promote his case for election to the chair of Perspective at the Academy, but

1. W.S. Lewis et al. ed., *The Correspondence of Horace Walpole*, 48 vols., New Haven and London, 1937-83, Vol. 41, p.189; Vol. 2, p.274 and footnote.

also to describe his travels in the north. He concluded: 'My very best compliments to Mrs. Serres . . . when you see Ill. Signor Neapolitano Horace tell him I think of him . . . Mr. Sandby is a bad correspondent but I forgive him'.[2]

This friendship between Edwards, Serres and the Sandbys is central to the story of Dominic Serres and his success in the world of art in the second half of the eighteenth century.

Edwards acknowledged that he drew upon Serres's friendships and recollections for some of his *Anecdotes*, notably those of Charles Brooking, and it is upon Edwards, in turn, that we principally rely for knowledge of Dominic Serres's early years. The entries in his *Anecdotes* are usually brief and that devoted to Serres is no exception, the information included about his birth, upbringing and education being skeletal in the extreme. It was, however, based upon personal acquaintance and Serres's own memories, although these may well have been subject to omissions and additions, as is often the case with personal reminiscences as the years pass. As such, it is the best record available of Serres's early life and that upon which all later accounts, most of them equally perfunctory, have ultimately been based. Edwards opens as follows: 'Born at Auch in Gascony and educated in the college of that city. When he was a young man, he left his friends rather abruptly and went to the West Indies, which voyage was occasioned, as he said himself, by a disappointment in a tender connection'.

A family by the name of Serres was known in Auch in the eighteenth century, Antoine Serres being a watchmaker and Jean Serres, a turner. The death certificate of a Jean Serres shows a date of death which can be read as May 1761, at the age of eighty-five years. He had received the last sacrament on the ninth of May and was buried on the tenth in the chapel of Notre Dame.[3] This could have been Dominic's father, although nothing further is known about him or his family.

A clear and perhaps surprising omission from Edwards's *Anecdotes* is the customary starting point for such dictionary entries, namely the date of birth. This could have reflected a lack of certainty on the subject. Joseph Farington, R.A. (1747–1821), the artist and socialite whose diaries are the source for much of the history and anecdote of art and artists of this period, was another who not only gave Edwards information and encouragement for his *Anecdotes,* but also read and criticised the lives as they were written. Farington's diary entry for 4 November 1793 recorded the death of Dominic Serres and noted that he 'was about seventy-three or four years of age'. This would place the date of birth in 1720 or 1719. More significantly, family records among Serres's descendants consistently give October 1719 as the date. Taken together, these indicators suggest that it would be reasonable to accept late 1719 as a more accurate date of birth for Dominic than the previously generally stated year of 1722.

The name 'de Serres' figures several times in biographies of the French nobility, the earliest reference being in the fifteenth century. Most bearers of the name were eminent in academic and scientific spheres and one, suffering for his religion at the end of the seventeenth century, fled to England and is buried in Winchester Cathedral. Although direct descent has not been established, family tradition has accorded the artist the title 'Count Jean Dominic de Serres'. One account records that George III later offered Serres a knighthood, but that he declined it, saying that he was entitled to a higher rank in France, that of Marquis. He was reputedly a nephew of the Archbishop of Rheims, born at the family mansion, Beauperre, at Auch, and educated at the Jesuit college at Douai. Tradition has affirmed that he was intended by his parents for the Church, but that he rebelled – perhaps the 'tender connection' was somehow related to this, ran away from home and went on foot to Spain. Even though these details of lineage and early life have

2. Christie's Autograph Letters Sale, 12 November 1968, Lot 238.
3. O. Meslay, 'Dominique Serres', *Bulletin de la Société Archéologique du Gers,* Auch, 3e trimestre, 1997, p.289.

not yet been substantiated by further genealogical research, such family background would help to explain the artist's evident social ease and charm.[4]

Auch being in the south-west of France it would not have been surprising that Serres, having decided to run away to sea or to go abroad, would have crossed the Pyrenees to a Spanish port. From there he would have shipped in a vessel probably trading around the Iberian coast and into the Mediterranean. He was later described as speaking 'perfect Italian', and from an early date he was producing pictures of Mediterranean ports and types of vessel, so he may have served in an Italian ship or lived for a while in Italy. Then, probably after many adventures, he crossed the Atlantic and finally arrived in Havana, Cuba, the flourishing capital city of the Spanish dominions in the western hemisphere where, Edwards says 'he stayed a few years He afterwards entered on board a Spanish ship, in which he was taken prisoner, brought to England, and confined in the Marshalsea prison in the Borough. There he married, and, when released, settled in a shop upon London-bridge'.

Another account, clearly based on this, but derived from James Gandon (1742–1822), another friend of Serres and Sandby, adds that Serres 'entered on board of a Spanish man-of-war, in which he was taken prisoner, being, as he represented himself, lieutenant in the ship'. A further account records that he was captured, exchanged with other prisoners and then captured a second time.[5]

The Marshalsea prison, on the south side of the Thames in Southwark, was used as a naval prison at this period, but rather more for felons such as pirates, than prisoners of war. If, however, Serres was taken as a naval officer prisoner of war, he might, unusually, have been lodged there on being brought to this country. Nevertheless, the tradition that he was interned in Northamptonshire may be nearer reality. The Marshalsea was also a debtors' prison and it is possible that Serres was released or, as some accounts have it, 'paroled by George II', came to live in London and subsequently fell into debt for which he was imprisoned. Most of the records of the Marshalsea were destroyed by the mob at the time of the Gordon Riots in 1780 and it has not proved possible to establish the facts surrounding his stay in the prison.

Details of his marriage have, however, been uncovered. On 16 July 1749 he was married at the new Chapel in St. Bride's parish to Mary Colldycutt (Caldecott) by the Reverend John Tarrant, one of those clergymen who performed the so-called Fleet marriages outside the proper formalities of the parish church, and known as such because of the location of the Fleet prison in St. Bride's. They were frequently contracted by men on the margins of the law such as prisoners, deserters or other renegades, or simply sailors paid off from their ship. Certificates of marriage were issued and the details entered in the pocket book register kept by the officiating clergyman, rather than in the formal marriage register of the parish church. The full entry in Tarrant's register under 16 July 1749 reads: 'Dominick Serres of St. George's Southwark Bat.[chelor] & Painter & Mary Colldycutt of Do.[Ditto] Spr.[Spinster] J.[ohn] T.[arrant] s.2"6 [2 shillings and sixpence – Tarrant's fee]'.[6]

The fact that it was a Fleet marriage seems to endorse Edwards's statement that Serres married while still in the Marshalsea. In July 1749 Serres would have been almost thirty years of age, but Mary, born on 8 April 1731, only just over eighteen. Dominic would almost certainly have been a Roman Catholic by birth and upbringing and Mary probably a Protestant. The hurried elopement across the river from Southwark to St. Bride's for a clandestine marriage is, however, most readily explained by Mary's discovery that she was pregnant. These romantic circumstances also lend credence to the belief that Mary was the daughter of Serres's gaoler. The maiden name of Mary's mother, Mrs.

4. Information provided by Barbara Clarkson is gratefully acknowledged.
5. *Memoir of John Thomas Serres by a Friend*, 1826, p.8.
6. Public Record Office, Kew, St. Bride's New Chapel (Tarrant), 243.

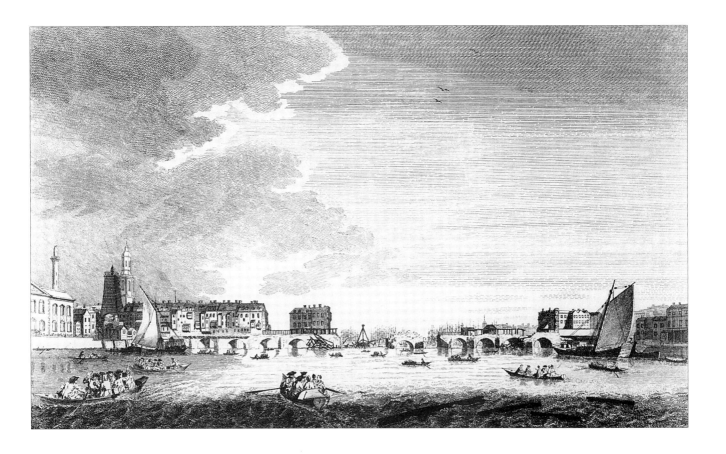

PLATE 1. 'London Bridge and the Ruins of the Temporary Bridge destroyed by fire, April 11, 1758', engraving on paper, drawn and engraved by A. Walker (1726–65), published by R. Wilkinson, 28 June 1758, 15 x 9 ins. (38 x 22 cm). Serres and his wife lived on London Bridge and may well have witnessed the fire.

©The British Museum

Caldecott, was Browne. She was the daughter of a Mrs. Browne who owned extensive wharves on the Thames near old London Bridge and lived to the age of 104 years.

It is also significant that Serres was described as a 'Painter' at the time of his marriage. This would imply that he had achieved a sufficient proficiency in the art to be so considered, or was at least an ambitious aspirant to greater heights. That he was not described as a mariner would suggest that he had been resident in England long enough to have lost any such appellation and taken on that of painter. If this were a period of several years, it would mean that he was captured during the war of Austrian Succession with Spain, which lasted from late 1739 until April 1748, and saw almost constant naval activity in the West Indies, and that he probably arrived in England not later than about 1745. He would then have had time to establish himself as a citizen and practising painter, with the often customary financial vagaries of that calling accounting for his sojourn in the Marshalsea in 1749.

The baby was born on 10 December 1749 and named Jane. She was to live until the age of twenty-nine, dying on 23 April 1779.

Living on London Bridge

The houses on the old London Bridge were progressively demolished during the 1750s, so it would have been entirely understandable for Serres and his new wife, coming from Southwark, to set up house and shop there in which to paint and sell his works of art (Plate 1). The old and decrepit wooden buildings remaining on the bridge would have offered economical accommodation to an indigent artist. Their name has not been found in the rent books of the Bridge House Estates, but this is no surprise as they would almost certainly have occupied rooms sub-let by the long-standing tenants who paid rent to the Corporation of London.

Mary gave birth to a second daughter, who was given the name of Catherine, on 6 August 1751.

But in 1752, either because he found his painting unremunerative or perhaps because he again felt the wanderlust of his early manhood, Serres undertook a voyage to Havana as the master of a trading ship. The log of this voyage, illustrated with miniature portraits of the family, was contained in an album sold in London in about 1936, but its present whereabouts are unknown.[7] This would confirm that Dominic had indeed been a mariner and risen to the level of ship's master even though further details are, frustratingly, denied us. The return to Havana would have been logical, a route and waters he probably knew well, and an opportunity to revisit old friends and places. There is no evidence that Serres made further voyages in the 1750s and it seems likely that he remained in London, applying himself to the exercise of his skills as a painter. For, by the beginning of the next decade, he had developed the sophisticated artistic talent which was revealed as soon as public exhibitions and the market for prints gave him the opportunity to bring his paintings to the attention of a wider public.

Mary and Dominic's family continued to grow. Mary was born on 28 October 1753, but was sadly to die in 1762. Sarah arrived on 18 January 1756 and Joanna (or Johanna) on 2 February 1758. Both lived into the next century and will appear later in the narrative. Mary gave birth to her first son, John Thomas, on 12 December 1759.

During these years Dominic was also forming friendships with other artists. Edwards, in writing his entry on Charles Brooking (1723–59), the leading marine painter of the middle years of the century, acknowledges Serres's contribution to the biography based on his friendship with Brooking before the latter's death in 1759. The friendship may have started as early as 1754 when Brooking was living in Token House Yard, Lothbury, in the City, not far from London Bridge. His first son was baptised in the local parish church on 6 February 1751. Sawrey Gilpin (1733–1807), who was apprenticed to Samuel Scott (c.1702–72) from 1749 until 1758 and knew Brooking, said of him '. . . a sickly man. He had been much at sea. Scott greatly admired his works'.[8] The shared experience of sea-going would have been an added link between Serres and Brooking, two like-minded marine painters living in the City, some way from the more usual haunts of artists. Brooking moved soon afterwards to Castle Street, Leicester Square, in the West End, and his second son was baptised in St. Martin-in-the-Fields, the church in which Brooking was buried after his untimely death less than six months later. Visiting Brooking at his new address would undoubtedly have encouraged Serres himself to think about the advantages to be gained from making a similar move nearer to the centre of the London art world and the wealthy inhabitants of the new streets being built around Bond Street.

Stylistic similarities between the work of the two artists have led to suggestions that Serres was a pupil of Brooking, but they could equally reflect a mutual influence and interaction between the two artists in the course of their friendship. Sawrey Gilpin made pertinent observations about their painting techniques:

> Scott prepared his ground of Brown Oker and White, and made water part darker than rest, finished at once. Monamy and Serres used the same technique of superimposing the details of their pictures on a previously laid down layer of dark underpainting. Brooking on the other hand preferred to work on a light toned ground to which he applied the series of thin glazes that give his pictures their peculiar translucence.[9]

7. M.L. Pendered and J.Mallett, *Princess or Pretender?*, 1939, p.81 fn.
8. *Joseph Farington's Diary*, J. Greig ed., 8 vols., 1922–28; K.Garlick, A. Macintyre and K.Cave ed., 12 vols., 1979–83, 8 February 1797.
9. Quoted in C. Sorensen, *Charles Brooking 1723–1759*, exhibition catalogue, Aldeburgh and Bristol, 1966, p.13.

These comparisons give every impression of placing the four painters on a basis of equality. The clear inference is that, during the last years of Brooking's life, Serres had achieved sufficient standing to be accepted as an equal by the younger but more accomplished artist.

Academies and the Foundling Hospital

The decades 1740 and 1750 were a period of burgeoning evolution in the development of British painting, accompanied by the inevitable differences of opinion on the direction this development should take and the means by which it should be achieved. At this time, many contemporary artists in England were of continental origin and most patrons still preferred to collect Old Masters or purchase works while on the grand tour abroad. The main thrust of much initiative was therefore to improve the quality of indigenous art. In pursuing this, controversy centred largely on the role of formal artistic teaching and the value of a national academy. Although academies for the training and encouragement of artists had been in existence for many years in Italy and France, there was no comparable national institution in England. Private and informal schools had been opened in the previous century and the early decades of the eighteenth, but most had failed after a few years. William Hogarth (1697–1764) had attended one of these academies directed by Sir James Thornhill (1675/6–1734) and in 1729 married Thornhill's daughter. Hogarth was convinced of the need for academic training and, on his father-in-law's death, opened another academy in St. Martin's Lane. This flourished for over thirty years, until the foundation of the Royal Academy, and may be regarded as its direct forerunner as a teaching establishment. Hogarth's name became well established during the next twenty years through his 'modern moral' series of paintings of contemporary life, such as 'Marriage a la Mode', and the engraved prints which popularised them.

But Hogarth was also a serious portrait painter and in 1740 painted Captain Thomas Coram, who had recently received a Royal Charter for the establishment of the Foundling Hospital in London. While the new buildings in Bloomsbury Fields were under construction from 1742 to 1745, Hogarth persuaded fifteen other artists to join him in presenting works of art to the orphanage as a means of helping to raise funds for it. The artists were made Governors of the Hospital and met annually for a commemorative feast, thus creating another of the more formal associations of artists which were growing up. It was, however, as a public exhibition space for works of art that this initiative was ground-breaking. The paintings on display drew large crowds and a visit to the Foundling Hospital became a popular outing for fashionable people about town. It was, thus, the first public art gallery in London.

Charles Brooking was rescued from anonymity in 1754 by Taylor White, the Treasurer of the Foundling Hospital, who commissioned a marine painting from him for the Hospital. Painted as a pendant to another large marine by Peter Monamy (1681–1749) and completed in eighteen days, it is usually known as 'A Vice-Admiral of the Red and his squadron at sea'. A panoramic marine view, it measures 70 x 123 ins. (178 x 312 cm). As a result, Brooking was elected a Governor of the Hospital on 26 June 1754. The painting, like most of the others donated at that time, still embellishes the walls of the old Hospital building.

Although in the ensuing years artists continued to support the Hospital by presenting works, including Joshua Reynolds and George Lambert in 1757 and John Shackleton and Francis Cotes in 1758, Dominic Serres was not among them. Nor is there any other reference to him in connection with Hogarth, the St. Martin's Lane Academy or the Foundling Hospital.

Canaletto, Warwick and the Sandbys

Antonio Canale, known as Canaletto (1697–1768) had, with the support and co-operation of the collector and agent, Consul Joseph Smith (1682–1770), built up a successful practice in Venice, largely for English patrons and the English market. In 1746, finding that his touring clientele was diminishing owing to the restrictions of the war, he moved to London, where he stayed, with some short intervals in Venice, until 1755. He lodged initially at 16 Silver Street, just north of Golden Square (near today's Piccadilly Circus), and in 1753 moved to 41 Beak Street, nearby. He there had a studio in the garden, to which he invited clients to view his works, and which still exists today. Although it took him some time to establish himself, he soon exercised a considerable influence on British painting, particularly in the realm of topographical landscapes to which he brought his own southern interpretation of light and perspective. Samuel Scott, an established painter of marine subjects, was one who was stimulated to adapt and successfully emulated Canaletto's wide views of the Thames and other London landmarks.

During his time in England, Canaletto stayed on several occasions at Warwick Castle, the seat of Lord Brooke, who in 1759 became the Earl of Warwick, and there painted a series of landscape views of the castle and surroundings. The early visits were in 1748 and 1749 and a later one in 1752. Lord Brooke was a noted patron of the arts and provided hospitality and commissions for artists at Warwick. His second son, the Hon. Charles Greville, was also a keen patron of artists, although he is more popularly remembered for packing his mistress, Emma Hart, off to his uncle, Sir William Hamilton in Naples, where, as Lady Hamilton, she met and entranced Admiral Horatio Nelson.

Charles Greville enjoyed moving in artistic circles in London and Warwick, and it may have been he who gave his friend Paul Sandby a pair of Canaletto's watercolour drawings of Warwick Castle, preliminary sketches for two oil paintings. Paul Sandby is recorded as a visitor to Warwick in the 1770s and his acquaintance with the Greville family may have originated in the earlier period of Canaletto's visits.

The Sandby brothers, Thomas (1721/3–98) and Paul (1730–1809) enjoyed considerable royal favour. This dated from the time when Thomas had joined the household of William Augustus, Duke of Cumberland, in Scotland, as Draughtsman, in the aftermath of the 1745 rebellion, the last attempt to restore the Stuart dynasty to the throne of England. This post carried a salary of about £100 p.a. and in 1764 Thomas was appointed Steward to the Duke, at a salary of £400 p.a., which made him effectively Deputy Ranger of Windsor Great Park. He continued in this appointment when the new Duke of Cumberland, Henry Frederick (1745–90), became Ranger on the death of his uncle in October 1765, and retained it for the rest of his life. Paul Sandby had also worked as a draughtsman in Scotland, and in 1768 obtained the post of Chief Drawing Master at the Royal Military Academy, Woolwich, at a salary of £150 p.a., for attendance one day a week. These connections not only brought the brothers a measure of financial security but also introduced them to important patrons, enhancing their standing among other artists. This gave them added influence in the groupings and initiatives concerned with the development of English art, although they were not among the most vocal protagonists. Nevertheless, Paul was closely involved in 1753 with a group of artists, particularly engravers, at the St. Martin's Lane Academy in efforts to set up an official academy. However, there was an animosity between Paul Sandby and Hogarth who, for all his efforts to promote artistic education, was against the establishment of an official national

academy. Sandby published an 'Analysis of Deformity' as a satire on and counter to Hogarth's 'Analysis of Beauty' which delineated the tenets of ideal artistic beauty.

In February 1753 the brothers Sandby set up their own sketching classes in Poultney Street, where Thomas lived, with printed invitations in rhyming couplets. Two years later, Thomas was one of sixteen members of the St. Martin's Lane Academy who issued a 16-page pamphlet which proposed *The Plan of an Academy* ... in a form very similar to that later adopted by the Royal Academy.

It would have been unlikely that Canaletto, as a visiting foreign artist, would have been much involved in these efforts to promote an academy, but he was living and working very close to the Sandbys, in the artists' quarter around Golden Square, and it is most probable that they met and discussed the issues of the day. In a similar vein, a friend recorded a little later that Paul Sandby lived 'in habits of great intimacy' with Richard Wilson (1713/4–82), the influential landscape painter, who had returned from Italy in 1757 and settled in the neighbourhood.

That the Sandbys, and Paul in particular, came to be the hub around which so much activity revolved in the artistic community was undoubtedly due to his congenial and sociable nature. A friend who wrote a memoir on his death, said:

> He left this world affectionately remembered and beloved by all who knew him. There was a politeness and affability in his address, a sprightliness and vivacity in his conversation, together with a constant equanimity of temper, which, joined with his having been the friend of such men as Foote, Churchill, Garrick, Goldsmith, Macklin, and others of the same class, rendered his society and conversation singularly animating and interesting.[10]

The Serres move to Piccadilly

This was the exhilarating environment and stimulating community of artists which Dominic Serres entered when, on leaving London Bridge, as Edwards continues, 'he removed to Piccadilly, nearly opposite the Black Bear inn, where, in a small shop, he exposed his pictures at the window for sale, which were mostly Sea Views, and sometimes Landscapes'. The Black Bear was located on the north side of Piccadilly, almost in the middle of the present Circus, and the Serres shop and lodging would thus have been on the south side, the site of today's Criterion Restaurant. The family is shown living at this address until 1763, when Thomas Mortimer's *Director* carried the entry: 'Serres, Dominick, Painter of Landscapes and Sea Pieces . . .' In 1764 the address was 'Mr. Serres in Piccadilly' and in 1765 'Near the White Bear, Piccadilly'.

Since the White Bear, a coaching inn for Bath, was on the south side, almost opposite the Black Bear, now the location of the Criterion Theatre, it seems that they may, in fact, have remained in the same house or perhaps moved next door.[11] Later in 1765 the family moved to Warwick Street, Golden Square.

Augusta Charlotte Seeres (sic) was baptised on 11 October 1761 in St. James's, Piccadilly, having been born on 16 September, the daughter of Dominick and Mary. St. James's, only a few steps from the Serres home, was their parish church and therefore the logical place for the christening. It was also, by coincidence, the burial place of the two great Dutch marine painters, Willem van de Velde, father and son. Dominic here displayed the loyalty and patriotism for his adopted country which was to characterise him for the rest of his life. He had just returned from Harwich where he had made a preliminary

10. *The Monthly Magazine*, December 1809, quoted in W. T. Whitley, *Art in England, 1800–20*, 1928, p.151.
11. H. Phillips, *Mid-Georgian London*, 1964, pp.53–54.

sketch of the arrival of Princess Charlotte for her marriage to the young George III, who had succeeded to the throne the previous year. The resoundingly royalist names given to his daughter were in celebration of the event. Dominic and Mary were evidently equally anxious to conform to the customary conventions of an Anglican baptism in spite of his presumed Catholic upbringing and their runaway marriage.

This inevitably raises the question why no formal records of the births of the previous children have yet been found. A reasonable assumption may be that they were all born while their parents lived on London Bridge, or elsewhere in that vicinity, and the records have not survived. After the baptism of Augusta Charlotte, it is, again, enigmatic that no record has been found of the birth of Dominique Michael, the eighth child and second son, on 29 September 1763, other than in his mother's book.

Dominic would already have had some acquaintance with the artists living in the neighbourhood, not least from his friendship with Brooking, whose lodgings had been nearby. But it is probable that Paul Sandby was among those who gave him the warmest welcome and continuing encouragement. J.T. Smith, an artist who later became Keeper of Prints at the British Museum, wrote:

> The liberality of the brothers Sandby, Royal Academicians, will be remembered by every person who had the pleasure of being acquainted with them; but more particularly by those who benefited by their disinterested communication and cheering encouragement in their art. For my own part, I shall ever consider myself indebted to them for a knowledge of lineal perspective...[12]

Artists' first public exhibition

The many efforts to give artists the opportunity to display and sell their works to a wider public finally came to fruition in 1760. The artists meeting at the annual Foundling Hospital feast on 5 November 1759 resolved to hold a meeting at the Turk's Head Tavern, Gerrard Street, Soho, in order to promote an exhibition of contemporary work to take place the following April. The problem of finding a suitable room was met by the agreement of the Society for the encouragement of Arts, Manufactures and Commerce, founded in 1754 (now the Royal Society of Arts), to the use of their premises in the Strand. The Society would not permit an entrance fee to be charged, but 6,582 catalogues were sold at sixpence each during the two weeks the exhibition was open, and the enterprise was judged a financial success. The Society also offered premiums, or prizes, for the best history and landscape paintings. The 130 exhibits by 69 artists included works by Joshua Reynolds, Louis François Roubiliac, Francis Hayman, Paul Sandby and Richard Wilson, but there was none from Dominic Serres and only two marine paintings.[13]

There had, however, been differences between the organising artists and the Society apart from the question of an entrance fee. The award of premiums had given rise to discontent, as well as attracting Hogarth's disapproval, and the Society also demanded a voice in the selection of works and their hanging. Many of the leading artists therefore decided to go elsewhere and took a room in Spring Gardens, Charing Cross, for their 1761 show, styling themselves the Society of Artists of Great Britain. The prime movers, Reynolds, James Paine, an architect, William Chambers (1723–96), the architect and tutor to the new king, and Joseph Wilton (1722-1803), the sculptor, were joined by other artists, including Paul Sandby, who had exhibited the previous year, and also attracted to their number others such as Thomas Gainsborough (1727–88) and Hogarth.

12. J.T. Smith, *A Book for a Rainy Day*, 1905, p.303.
13. Society of Arts Exhibition Catalogue, 1760.

CHAPTER II

THE OPPORTUNITY: THE SEVEN YEARS' WAR AND THE VOGUE FOR NAVAL PICTURES 1756–1763

In spite of the fact that there are very few securely attributed works by Serres dated before the early 1760s, it is apparent that he was, at the time of his move to Piccadilly, adapting his artistic output to the changing environment. Previously, when he was working from London Bridge, it seems likely that he was producing paintings, probably seapieces for the nautical clientele centred on the Pool of London, and landscapes, which were largely anonymous, either by reason of their quality and subject matter, or owing to the fact that they were not signed, or perhaps a combination of both. Since he sold his works from his own premises, it seems unlikely that he suffered in the same way as Brooking, whose anonymity was the result of an unscrupulous dealer obliterating his signature on paintings. Indeed, since, according to Edwards, Serres was the source of this information about Brooking, it may be reliably assumed that he would avoid the same pitfall himself. It is probable that Serres was producing unspectacular pictures, painted for an undemanding market which was content with unremarkable and traditional subjects and treatments. Selling from his own shop to a local market may, in fact, have been a reason why his works were unsigned.

But this was to change rapidly. The Seven Years' War, which had broken out between England and France in 1756, brought many stirring naval and combined operations around the world in which British arms were victorious. The year 1759 came to be known as the Year of Victories, many of them naval or achieved as a result of naval enterprise and success. Public interest in these actions grew rapidly and artists made great efforts to meet the demand for images which would convey and commemorate the drama and significance of the conflicts. The images were not only paintings, which would inevitably have a limited and more affluent range of viewers, but also prints from engravings, which could be produced in relatively large numbers and sold at a modest price to a much wider public.

By this time the commerce of print production and marketing in London was already well established. Prints produced in Europe had been imported into England for well over a century and the business continued to be substantially international, with a prosperous two-way trade between artists, engravers, publishers and sellers in London and all the leading European centres. Initially foreign engravers had brought their skills to London and they remained an important nucleus in English print production. But London had expanded rapidly as a centre for the production and marketing of prints, not only in terms of numbers and variety of subject matter, but also of quality. A new Copyright Act in 1767 further strengthened the producers by vesting the rights of production clearly in the owner of the plate. Artists came to use the print market as a means of increasing public awareness of their paintings and generating additional income; aristocrats permitted their collections of Old Masters to be engraved and published; images of country houses and estates appeared as tourist guides; and catalogues of notable collections of prints were

issued. Contemporary British works included in this new vogue for print-collecting were principally history paintings, portraits, genre subjects, topographical views, maps and depictions of military and naval operations. The last category became particularly popular in time of war.[1]

This flourishing market also offered publishing opportunities to others who were not members of the professional trades involved. The originator could well be, as in the cases to be examined shortly, an artist, sometimes amateur, with an entrepreneurial flair or simply a desire to try and earn some money from his drawings, who undertook to publish a set of prints. He would usually retain an artist to work up his drawings into oil paintings from which the engravers could more readily reproduce the images on their plates, mainly, at this date, by engraving or etching on copper. The paintings would also provide the model for any later colouring of the prints. For elaborate dedications a calligrapher was employed to engrave the lettering on the plate when the image was finished. A printer would then be found to print from the plates and prepare the impressions for sale to the public, usually by way of booksellers. From the commercial point of view, the publisher would, at an early stage, advertise the project in order to attract subscribers, two hundred of whom were usually considered necessary to turn a profit. Subscribers would put down a deposit to help finance the various stages of production, which could be lengthy, and pay the balance on delivery of the finished work.

Although roles in the process were frequently combined, each stage had its distinctive requirement and respective technical and artistic skill: the maker of the original drawing, the painter in oils, the engraver, the calligrapher, the printer, the colourist, the publisher and the bookseller. It was, therefore, very much a co-operative effort, with each depending on the other for prompt and effective performance of his or her part in the whole. It equally relied on the ability of the publisher to obtain the co-operation and continuing adherence of capable collaborators. Networks of friendship and collaboration between artists and craftsmen of different skills were thus vitally important in setting these projects in train and seeing them through to completion. These networks must also, to some extent, have determined who was invited to participate in a project. The consistency with which the same engravers worked on successive series of prints suggests that they may have had an important catalytic and cohesive role in putting the groups together. An added bonus for the oil painter, which was to bring Serres great benefit, was that high quality prints circulating among the public could attract wealthy patrons and encourage them to place commissions for their own, larger, versions in oils and perhaps also order further paintings of other subjects.

The breakthrough: Richard Short and the Capture of Quebec

Dominic Serres, as an established painter of landscapes and marine scenes, was well placed to take advantage of the new demand for war pictures, and keenly grasped the opportunities it offered. This he did both by producing and displaying his own paintings of the events and also, more importantly, by becoming associated with publishers of sets of prints. It seems to have been principally the latter which enabled him, at about the age of forty, to make the breakthrough from nonentity to public recognition which would take him to the highest echelons of art in his adopted country.

Although one cannot know the precise sequence of events or where the original initiative lay, Richard Short was the first artist-publisher with whom Serres worked. The

1. T. Claydon, *The English Print 1688–1802*, New Haven and London, 1997.

association, which was to extend to two further series of prints, was crucially important in launching the painter on his high-profile career.

Richard Short was a purser in the Navy but also a skilled topographical and naval draughtsman and engraver. In 1747/8 he drew and engraved representations of ships and naval engagements for publication by John Boydell, and further engravings dated 1751 are known. As purser, he was one of the first to go on board the *Prince of Orange* (70 guns) at Chatham on 8 April 1757 while she was commissioning, joining from the *Leopard*. He was to remain on the *Prince of Orange* throughout her commission until May 1763 when she was paid off. The *Prince of Orange* was on constant service until her return to Plymouth when the Admiralty granted Short shore leave on 18 June 1762. During these five years the *Prince of Orange* participated in some of the most historic operations of the war and Short was able to employ his artistic talents to record the principal places and actions he witnessed.

In February 1758 the warship sailed for North America carrying a regiment of soldiers, and in May was in Halifax, Nova Scotia, going on to Louisbourg with Boscawen's victorious fleet. The months from December 1758 were spent in Halifax harbour until April 1759, when she left on the voyage up the St. Lawrence river for the assault on Quebec. Back in Halifax for the winter, the *Prince of Orange* was again in the St. Lawrence and off Quebec for the summer of 1760, returning to Spithead by the end of the year. Preparations were then put in hand for the attack on Belleisle and at the end of March 1761 Short was at sea in his ship *en route* to the south Brittany coast. The *Prince of Orange* played a central role in the capture of the island and remained on station in the area until her return to Plymouth in June 1762, when Short went on leave until November 1762.

The capture of Quebec was a daring and skilful operation which immediately caught the public imagination, particularly as the army commander, the young Brigadier James Wolfe, died in the hour of victory. The public mood was later to be caught and immortalised by Benjamin West (1728–1820) in his strikingly innovative painting 'The Death of General Wolfe'. Vice-Admiral Charles Saunders (1720–75) was in command of the combined force which took the city, and its arrival there had been the climax of a superb feat of navigation, taking the fleet up the St. Lawrence river. Part of the survey of the route had been conducted by the youthful James Cook, later the explorer of the Pacific Ocean. The entire episode had a wide popular appeal but was the source of particular pride to the naval fraternity.

Short decided to publish a set of twelve prints from the drawings he made on the spot at Quebec at the time of the attack and capture. All are views, none of warlike activities, and most illustrate the devastated condition of many buildings in the city after the bombardment and assault. Short's shipboard functions would have precluded his taking part in combat and his drawings were therefore made principally on going ashore when the fighting was over. The *Prince of Orange*'s return to the city in the summer of 1760 would have given him ample time to go ashore again to sketch. Copies of the prints are rare but have survived in more complete and accessible form than the oil paintings which Short commissioned from his drawings. Four paintings by Dominic Serres, signed and dated 1760, have been traced which seem to be the originals for four, out of the set of twelve, engravings. Two are in the National Archives of Canada, 'A view of the Treasury and Jesuits' College, Quebec' (Colour Plate 1) and 'A view of the Church of Notre Dame de la Victoire built in commemoration of the raising of the siege in 1695 and destroyed in 1759' (Colour Plate 2). Two more were in a private collection and

PLATE 2. 'A view of the Intendant's Palace, Quebec', oil on canvas, signed and dated 1760, 13 x 20 ins. (34 x 52 cm). Serres must have received Short's drawings by mail from North America for the *Prince of Orange* did not return to England until the end of 1760.

Photograph: Photographic Survey, Courtauld Institute of Art

PLATE 3. 'A view of the Bishop's house with the ruins as they appear in going down the hill, from the upper to the lower town', oil on canvas, signed and dated 1760, 13 x 20 ins. (34 x 52 cm). Short probably arranged the engraving, printing and publishing of the prints from Serres's paintings while his ship was at Spithead in the early months of 1761. In September he was at sea off Belleisle.

Photograph: Photographic Survey, Courtauld Institute of Art

subsequently sold at auction: 'A view of the Intendant's Palace, Quebec' (Plate 2) and 'A view of the Bishop's house with the ruins as they appear in going down the hill, from the upper to the lower town' (Plate 3). These four paintings are almost all the same size as the prints, 12¾ x 19¾ ins. (33.6 x 52 cm), supporting the presumption that they were made as originals for the engravers. This being so, it seems reasonable to assume that Serres also painted others, and perhaps all twelve. As the prints were published by Short in September 1761, while he was still on board *Prince of Orange*, there must have been some arrangement between him and Serres before he sailed, perhaps sending his drawings back by mail. Although he was not formally granted leave, he could have made arrangements with the engravers and printers during the three months his ship was at Spithead at the beginning of the year. Indeed, Serres himself may have played a more active part in the process of production than is apparent.

Short was anxious to have the prints ready quickly, while public recollection of the event

COLOUR PLATE 1. 'A view of the Treasury and Jesuits' College, Quebec', oil on canvas, signed and dated 1760, 13 x 19 ins. (34 x 49 cm). The first paintings Serres produced after Richard Short's on-the-spot drawings were of Quebec in 1759 and 1760. Eight engravers worked from the oil paintings and their plates made up a set of twelve prints published by Short in September 1761. D. Serres National Archives of Canada C25663

Colour Plate 2. 'A view of the Church of Notre Dame de la Victoire built in commemoration of the raising of the siege in 1695 and destroyed in 1759', oil on canvas, signed and dated 1760, 13 x 19 ins. (34 x 49 cm). Short, who was purser on board the *Prince of Orange*, went ashore when the siege was over and drew the scenes of devastation in the captured city. D. Serres National Archives of Canada C25662

was fresh, and, bearing in mind the time-consuming nature of the work, used no fewer than eight engravers to produce the twelve plates. The engravers employed were Pierre Charles Canot (1710–77), Charles Grignion (1717–65), Peter Paul Benazech (1728–98), James Mason (1710–c.85), William Elliott (1727–66), Anthony Walker (1726–65), Antoine Benoist (1721–70) and John Fougeron (fl.1750–69). Most of these were well-established engravers, Canot, for example, having been working in London as early as 1735 and later engraving for Thomas Sandby and Charles Brooking. Mason had also been active for nearly twenty years, while Elliott worked with Richard Wilson, and Benazech with Francis Swaine. Together they formed a loose grouping which was to produce plates after many of Serres's paintings. When published, the set of prints of Quebec was dedicated to Vice-Admiral Sir Charles Saunders, in honour of his leadership of the operation.

But Serres was not working solely for Richard Short. By 1759 he had already started to appeal directly to the market for commemorative images of topical events with 'The Great Storm of 1759', signed and dated that year. He also painted other pictures of the capture of Quebec. One pair, 'A View of Quebec' and 'The Attack by General Wolfe', both signed and dated 1760, may have been based on Short's topographical drawings but did not form part of the same set, being more concerned with the attack itself. It is possible that they were commissioned by Captain Hugh Palliser (1723–96), an early mentor of James Cook, who was in command of the *Shrewsbury* (74 guns), one of the twenty-two ships-of-the-line which, together with thirteen other warships and the army transports, made their passage up the St. Lawrence to invest the town. He also led the attack by seamen to capture the lower town of Quebec. Palliser was eventually appointed Governor of Greenwich Hospital, the home for naval pensioners, and in 1796 presented to the Hospital a pair of fiercely dramatic night views by Serres, one showing French fireships attacking the English fleet as it lay at anchor off Quebec on the night of 28 June 1759 (Colour Plate 3), and the other of a similar attempt by about one hundred fire-rafts a month later. The lurid night scenes immediately capture the highly-charged atmosphere of the engagement as ships' boats tow away the burning vessels and beach them. The paintings are still in the Greenwich Hospital Collection at the National Maritime Museum.

The Society of Arts Exhibitions 1761 and 1762
Although Serres had not participated in the 1760 exhibition, he saw the opportunity offered by the Society of Arts, perhaps attracted by the premiums, and it was there that he exhibited for the first time in May 1761. Four of his paintings were accepted, two sea views (nos. 32 and 46), 'The *Océan*, man-of-war, on fire' (no. 85) and 'A View of Warwick Castle' (no. 81).

The painting of the *Océan* on fire is of particular interest as it shows Serres, at this first public exhibition, again responding to the national interest in the naval victories of the Seven Years' War by submitting a topical commemorative picture. While the North American campaign was progressing on the St. Lawrence, Admiral Edward Hawke (1705–81) was on the Atlantic coast of Europe blockading Brest in order to keep the French Channel fleet bottled up. At the same time, Admiral the Hon. Edward Boscawen (1711–61), having returned from the capture of Louisbourg, was similarly detailed to contain the enemy Mediterranean fleet in Toulon, to prevent its escape and a junction of the two fleets for an invasion of England. The Minorca base was no longer available to the British, having been lost as a result of Admiral Hon. John Byng's indecisive naval action in 1756, for which he had ultimately suffered the supreme penalty. Boscawen was

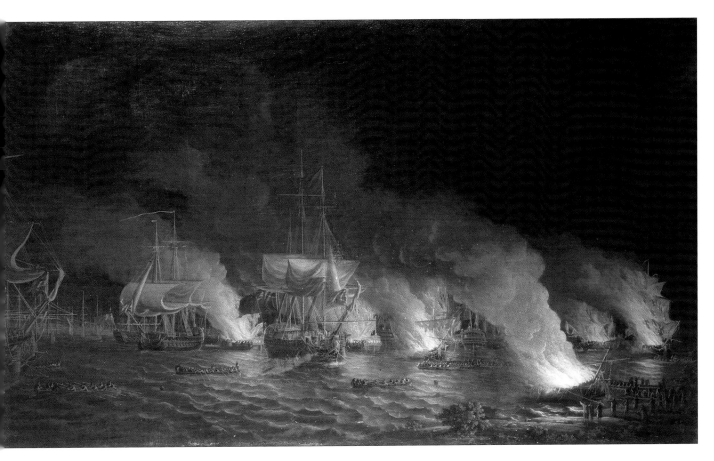

therefore obliged to withdraw his fleet to Gibraltar for repairs and revictualling. The French escaped from Toulon and had passed through the Straits of Gibraltar before Boscawen could prepare his ships and put to sea. His chase of the French fleet ended off the town of Lagos, in southern Portugal, when he brought it to battle on 18 August 1759. The next morning, the *Océan* (80 guns), the flagship of the French Admiral de la Clue, was forced into the shallows and ran aground, de la Clue being wounded and taken ashore to Lagos, where he died. Captain Kirke in the *America* (60 guns) finally disabled the *Océan* and took possession of her. Unable to salvage the vessel, he set fire to her. The outcome of the battle was a total British victory, one other ship-of-the-line being burnt and three captured. Five French ships-of-the-line succeeded in escaping to Cadiz, but Boscawen lost no ships and British casualties were much lighter than the French. Serres evidently decided to celebrate the victory, which came shortly before the capture of Quebec, with a vivid scene of the warship on fire rather than a more conventional, but probably less arresting, battle composition of the ships at sea.

The Landscape premiums at the Society of Arts

'A View of Warwick Castle' hung at the 1761 exhibition was submitted, with four other entrants, for the Landscape premiums offered by the Society, a first prize of £50 and a second of £25. Serres won neither, but as 174 guineas were left in the fund for the Polite Arts, as this sector of the Society's work was known, and 'as the three candidates who have not gained the first and second premiums in Landscape Painting appear to this Committee to have a great deal of merit, they [the Committee] recommended to the Society to give them a reward of ten guineas each'. But, sadly, Serres was to be denied, by a whisker, even this modest bonus at his first public show. When the Committee recommendation was put to the full Society on 15 April 1761, 'A Doubt arising concerning the Number of Hands held up, the Society divided: and whereas the Rules and Orders require that a Majority

COLOUR PLATE 3. 'French fireships attacking the English fleet off Quebec, 28 June 1759', oil on canvas, 36 x 60 ins. (91.5 x 152.5 cm). Serres always enjoyed painting a night scene and this attack gave him the opportunity to make a vivid portrayal.

National Maritime Museum, London

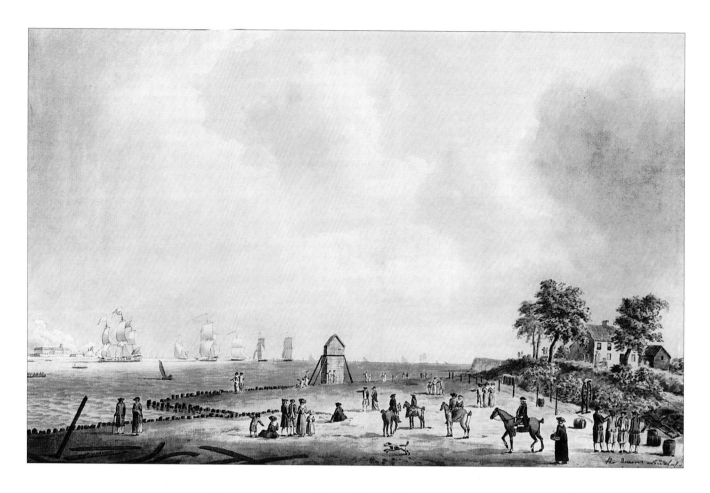

PLATE 4. 'The arrival of Princess Charlotte at Harwich, September 1761', watercolour with pen and black ink on laid paper, signed with initials, inscribed 'The Queen's Arrival at Harwich' and dated 1761, 14 x 21 ins. (35 x 54 cm). A drawing, made on-the-spot or worked up later from sketches, which already shows the broad land- and skyscape and deep foreground interest of the finished oil.

National Maritime Museum, London

2. Society of Arts Minute Books.
3. *Memoir of John Thomas Serres by a Friend*, 1826, p.10.

to bestow an Extraordinary Sum of Money shall consist of two thirds at least of the Members present, the Question passed in the Negative, the Noes being 48, the Ayes 89'.[2]

The paintings submitted for the Landscape premiums had to be 54 ins. high and 72 ins. long (137 x 193 cm), unsigned and unframed. The Serres painting of Warwick Castle was therefore a substantial work which must have taken time and effort to produce. It must also have been painted at Warwick, or at least preparatory sketches made there. A later account states that Serres was a 'frequent visitor' at Warwick Castle[3] and it is probable, therefore, that Serres, like Canaletto, Sandby and other artists, was a guest there at the invitation and under the patronage of Lord Brooke. The assumption that Serres was familiar with the Greville family and knew Warwick well is supported by later events in his family. His son, John Thomas, became infatuated with Olivia Wilmot, and married her in 1791. She was the daughter of Robert Wilmot, a decorative painter at the Castle, and niece of the Reverend Dr. James Wilmot, Rector of Barton-on-the-Heath, Warwickshire, who was also closely associated with the Grevilles. Olivia's later pretensions to royal blood and the title of Princess of Cumberland were, she stated, based on papers provided to her in 1816 by the then Earl of Warwick. With regard to the painting itself, its present whereabouts are unknown, if, indeed, it still exists. It is possible that it remained unsigned after the exhibition at the Society of Arts, and this could be a reason why, in spite of its significant dimensions and popular subject, it has not been traced. The Society of Arts subsequently abandoned the requirement for these generous proportions as the canvases were too big to be readily saleable.

The inauguration of public exhibitions thus clearly achieved one of its principal objectives, at least as far as Dominic Serres was concerned, by giving him the opportunity to show his work in a way not previously possible. That he submitted four paintings, including one of a topical naval victory, and entered for the Landscape premium confirms that he was not only determined to take advantage of it, but also that he had the ability and self-confidence to do so.

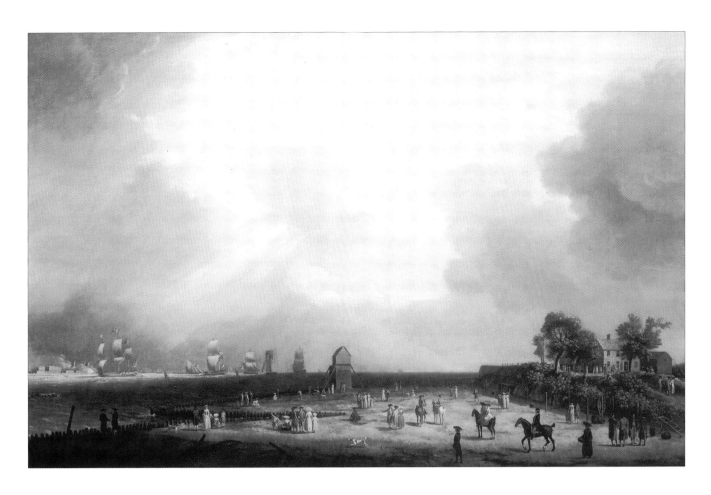

Princess Charlotte's arrival at Harwich

Serres's visit to Harwich in September 1761 to record the arrival of Princess Charlotte was clearly another step to record important current events which would prove popular with the public. The result was a watercolour drawing which tells us much about his abilities at this time (Plate 4). The drawing is immediately engaging because of its broad vista of the foreshore with parties of people promenading to enjoy the weather as well as to witness the arrival of the colourful squadron after its four-day crossing of the North Sea, during which it was blown almost to Norway by a severe gale. The carefully contrived light and shade effects from the clouds in the still stormy sky convey an underlying tension to heighten the historic event. The accurate topographical details, such as the windmill on the shore and the rope-walk on the right-hand side, add familiarity and interest to the scene. The ships are relegated to the background but their towering sails are balanced by the mill in the centre and the house and trees on the right. The whole becomes a fascinatingly complex coastal land- and skyscape rather than simply a plain sea-piece. The handling of the wide foreground spaces as well as that of the cloudy sky shows a developed skill and confidence as a watercolourist. The drawing is signed with initials, as was to become normal on Serres's watercolours, and dated 1761, suggesting that it was worked up from his on-the-spot sketches. The oil painting followed in 1763 and displayed the same qualities, with the greater emphasis on light and shade possible in that medium (Colour Plate 4).

The royal yacht *Augusta*, renamed *Royal Charlotte* in honour of her passenger, and her consorts figured in other, later extracts from the painting. A detail from it was probably the basis for one of the illustrations to appear in the *Liber Nauticus, and Instructor in the Art of Marine Drawing*. This volume, to which repeated reference will be made, was published in two parts, in 1805 and 1806, by John Thomas Serres, employing reproductions of many of his father's paintings and drawings, as well as his own, to illustrate the techniques of marine

COLOUR PLATE 4. 'The arrival of Princess Charlotte at Harwich, Sept. 1761', oil on canvas, signed and dated 1763, 32 x 51 ins. (81.5 x 129.5 cm). The finished painting to celebrate the new Queen's arrival in England was hung at the 1763 exhibition of the Free Society of Artists.

National Maritime Museum, London

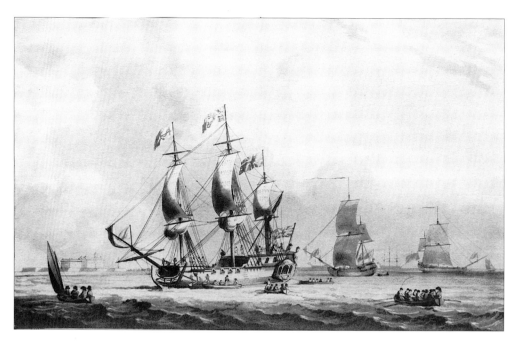

PLATE 5. 'A Yacht in a Light Breeze with a View of Harwich. The Queen Charlotte with her Present Gracious Majesty on Board. In the background is the Landguard Fort on the north shore', after Serres, *Liber Nauticus* Plate XXII, published by Edward Orme, London, 1805/6, 10½ x 16 ins. (27 x 41.5 cm). Many years after this event Serres was requested to produce a set of marine drawings for the instruction of a nobleman and incorporated in it elements from many of his more successful paintings. These were later included by John Thomas in a publication for the same purpose, the *Liber Nauticus*.

drawing. Plate XXII in the second part shows 'A Yacht in a Light Breeze with a View of Harwich', and carries the surtitle 'The Queen Charlotte with Her Present Gracious Majesty on Board. In the background is the Landguard Fort on the north shore' (Plate 5).

Paintings by Dominic Serres commemorating this royal arrival were hung at the Free Society's show in 1763. 'The Storm that preceded her Majesty's arrival, with a view of the Royal Yacht etc.' (no. 192) has not been traced, but probably exists as a gale scene, its true identity having been lost. 'A View of Landguard Fort' (no. 195) may have been similar to that just discussed. 'The Arrival of the Fleet, which brought Her Majesty, off Harwich' (no. 293) would have been the principal painting of those hung. Although competition was keen, even at the Free Society, the quality of this last painting must have made a powerful and favourable impression on the crowds who visited the exhibition.

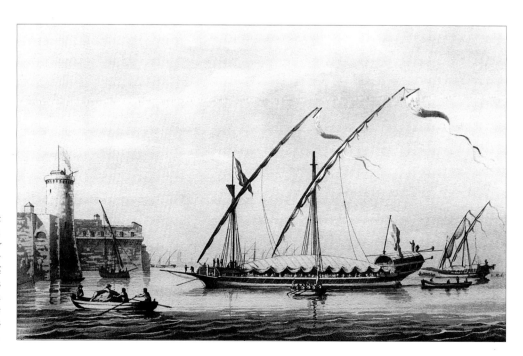

PLATE 6. 'A Neapolitan Galley at anchor off the Castel Vecchio, Leghorn', after Serres, *Liber Nauticus* Plate XL, published by Edward Orme London, 1806, 10½ x 16 ins. (27 x 41.5 cm). Serres drew on his long experience as a mariner to include a wide range of vessels and background views in his drawings for the nobleman.

COLOUR PLATE 5. 'Cattle passing a cottage in a wooded landscape', oil on panel, signed and dated 1762, 12 x 14 ins. (31 x 36 cm). An example of the landscapes Serres was producing in the early years of the decade.

©Christie's Images Ltd. 2001

But in 1761 and 1762 Serres was also still producing paintings of a generic and local nature, as demonstrated by his entries for the 1762 show at the Society of Arts, when the artists exhibiting there formed themselves into the Free Society of Artists. Although remaining loyal to this grouping, rather than transferring his allegiance to the Society of Artists at Spring Gardens, Serres was not an office-holder nor, apparently one of the prime movers in the foundation. A distinguishing feature of the Free Society of Artists was that all surplus proceeds from their annual shows were to be accumulated and distributed as needed for the benefit of distressed artists, their widows and orphans. Serres's works entered in 1762 were entitled: 'A view of a water-mill' (no. 3), 'A sea-piece by moonlight' (no. 21), 'A sea-piece; a fresh gale' (no. 22) and 'A Calm' (no. 189). Colour Plate 5, showing a typical rustic scene, is an example of his landscape work at this time. However, his move into more specific and maritime subjects in exotic locations was confirmed by 'A view of Leghorn Lighthouse and Mole, with row-galleys' (no. 24). An image of similar title was to appear in *Liber Nauticus*, Plate XL, and may have been a later, simplified version of the painting (Plate 6). This subject seems to confirm that, in his calling as a mariner, the artist had visited Leghorn (now Livorno) and knew the Mediterranean types of vessel, probably sketching them and the ports as he went.

COLOUR PLATE 6. 'Commodore Augustus Keppel', Joshua Reynolds, oil on canvas, 94 x 58 ins. (239 x 147.5 cm). Back in London, several years after Keppel had taken the artist as a passenger in *Centurion* to the Mediterranean, Reynolds painted his famous, trend-setting portrait of his friend. National Maritime Museum, London

Augustus Keppel: Naval commander and patron

The Hon. Augustus Keppel (1725–86) was the second son of the 2nd Earl of Albemarle and entered the navy in 1735 at the age of ten. In 1749, he was given command of the *Centurion* (50 guns), the ship in which he had served under Anson on his memorable cruise around the world, and appointed Commodore to parley with the Dey of Algiers for the release of Christian prisoners. The *Centurion* took its departure from Plymouth and, while there, Keppel, through his friend Lord Mount Edgcumbe, met the young Joshua Reynolds. They had probably been friends since boyhood as Reynolds's father had been Mount Edgcumbe's schoolmaster. As a result of the meeting, Keppel took the artist as a passenger on his ship to the Mediterranean, where Reynolds finally left Keppel at Minorca in January 1750 to pursue his artist's tour in Italy. Reynolds painted several portraits of his naval host while on board the *Centurion*. It was, however, four years later, back in London, that Reynolds painted his most famous, trend-setting portrait of Keppel (Colour Plate 6). They remained lifelong friends and Reynolds painted many more portraits of the naval commander over the ensuing years.

By 1758, Keppel, as a senior captain in command of the *Torbay* (74 guns), a unit of Lord Anson's fleet, was again appointed Commodore to lead a squadron for the capture of Goree. Earlier in the year the French settlements on the river Senegal in West Africa had been captured by the British and it was necessary also to secure Goree, the offshore island base commanding the coast. The island was, at the same time, an important staging post on the route to the Cape of Good Hope and the east. Keppel's squadron consisted of four ships-of-the-line in addition to the *Torbay*, three frigates and three auxiliary vessels, accompanied by six transports carrying seven hundred troops for the attack. After losing several of the smaller ships in a severe gale, Keppel captured the island, consisting 'principally of a mass of black basalt, which rises abruptly to the height of 300 feet',[4] after a fierce bombardment on 29 December 1758, and the British flag was hoisted over Fort St. Michael. Serres was later to paint four large canvases of the attack and capture of the island, some or all of them probably on commission for Augustus Keppel (see page 70 and Colour Plates 20 and 21 and Plate 33).

COLOUR PLATE 7. 'The battle of Quiberon Bay, 20 November 1759', oil on canvas, signed and dated 1779, 45 x 72 ins. (114.5 x 183 cm). Keppel was present at Admiral Edward Hawke's daring victory over Admiral Marquis de Conflans. The painting was later to be reproduced as a white marble 'bas relief' for Hawke's tomb (see Colour Plate 54).

National Maritime Museum, London

4. Hon. Reverend T. Keppel, *The Life of Augustus, Viscount Keppel*, 2 vols., 1842, Vol. 1, p.273.

PLATE 7. 'Port Andro, Belleisle', line engraving, P.C. Canot after R. Short and D. Serres, published by John Boydell, 1777, 14 x 20½ ins. (36 x 52 cm). The second series, of seven paintings, made by Serres for the engravers, from Short's on-the-spot drawings from His Majesty's Ship the *Prince of Orange*, was of the capture of Belleisle in 1761 by a combined force under the command of Augustus Keppel.

National Maritime Museum, London

After the capture of Goree, Keppel returned to European waters and, still in command of his squadron, was despatched on 18 May 1759 to intercept four French ships-of-the-line at Port Louis (now Lorient) on the south Brittany coast. During the summer the squadron joined Admiral Edward Hawke's fleet which, on 20 November 1759, convincingly routed Admiral le Marquis de Conflans's fleet, at Quiberon Bay by a combination of daring tactics and fine seamanship on a lee shore. Serres painted a dynamic portrayal of the action as the two fleets engaged each other racing before the gale into the shoal waters of Quiberon Bay (Colour Plate 7). The victory was of such significance, completing the achievement of Boscawen at Lagos three months before, and removing the naval threat to English shores and shipping, that Serres probably painted it for its intrinsic interest and value. The credit for the victory lay with Hawke, whose flagship, the *Royal George* (100 guns), is at the centre of the action depicted, and it is equally possible that he commissioned the painting. A marble bas-relief after the painting is the centre-piece of Hawke's funerary monument (see pages 125–126 and Colour Plate 55). The *Torbay*, under Keppel's command, distinguished herself during the encounter, worsting the French *Thésée* (74 guns) which sank.

The capture of Belleisle

In March 1761 Augustus Keppel, who was rapidly establishing himself as one of the able younger commanders in the fleet, was given charge of a powerful squadron sent to capture the island of Belleisle. Such attacks on islands off the south Brittany coast of France were a recurring

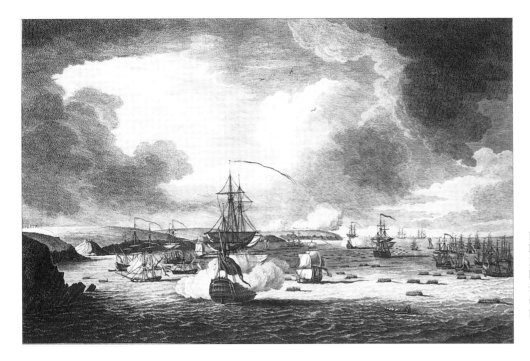

PLATE 8. 'Fort d'Arfic, Belleisle', line engraving, P.C. Canot after R. Short and D. Serres, published by John Boydell, 1777, 14 x 20½ ins. (36 x 52 cm). The landing at this point was successful and a bridgehead established.
National Maritime Museum, London

aggressive tactic of British policy throughout these wars, designed to compromise the French while limiting the naval and military risks. The young George III was already playing a determining role in policy and appointments, a part traditionally played by the monarch, which he was to continue, and issued secret instructions for the expedition direct to Keppel.

Richard Short, still Purser of the *Prince of Orange*, was present at the operation and again made drawings on the spot. He was probably not present in person at each separate phase of the assault, but clearly had the opportunity to sketch the coastal topography at the time, adding the vessels and landing craft later. On his return to England, probably during his spell of leave in the second half of 1762, Short embarked on his next publishing venture, the production of a set of seven prints of the capture of the island, again using Serres to work up his drawings into oil paintings.

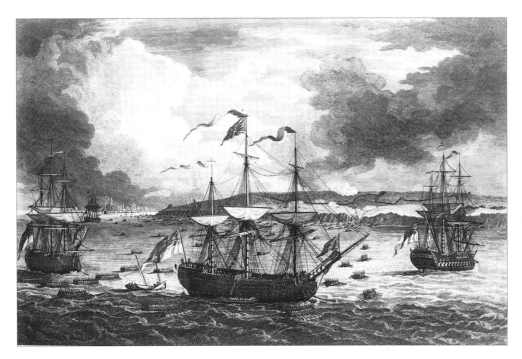

PLATE 9. 'St. Foy, near Locmaria Point, Belleisle', line engraving, P.C. Canot after R. Short and D. Serres, published by John Boydell, 1777, 14 x 20½ ins. (36 x 52 cm). Intended as a diversionary attack, this was also successful and a landing achieved.
National Maritime Museum, London

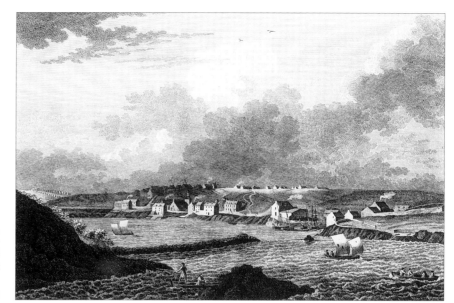

PLATE 10. 'Sauzon, Belleisle', line engraving, Wm. Elliott after R. Short and D. Serres, published by John Boydell, 1777, 14 x 20½ ins. (36 x 52 cm). Another feint attack was made at Sauzon on the north coast of the island.

National Maritime Museum, London

PLATE 11. 'Fortification and inland basin, Belleisle', line engraving, J. Mason after R. Short and D. Serres, published by R. Short, 1763, 14 x 20½ ins. (36 x 52 cm). This print was published by Short in 1763 and it is assumed that the entire series was issued at the same time, although most prints still available were published in 1777 by John Boydell.

National Maritime Museum, London

PLATE 12. 'Citadel & Town of Palais on Belleisle, which shows the Inner Fortifications and the Breach made in the Walls as appeared from the nearest Batteries of the English', line engraving, A. Benoist after R. Short and D. Serres, published by John Boydell, 1777, 14 x 20½ ins. (36 x 52 cm). Another view showing the breach by which the citadel was taken.

National Maritime Museum, London

The first attack was made at Port Andro, on the north-east corner of Belleisle, to the east of the capital, Le Palais, on 8 April 1761 (Plate 7). The naval bombardment has silenced the fort and the *Achilles* (60 guns), centre, has hoisted the Dutch flag at her mainmast head as a signal for the troop-carrying boats to make the assault. The *Prince of Orange*, on the right, wears Keppel's broad pennant of Commodore as he was temporarily on board to supervise the action. The *Dragon* (74 guns), Captain the Hon. Augustus John Hervey, is shown on the left. The defence proved too strong for the troops and they were forced to return to the ships. Another attack, launched further west at Fort d'Arfic on 22 April, was successful and a bridgehead established. The same three ships were in support and Plate 8 shows them neutralising the land batteries as the boats row the troops ashore, with the transports lying off.

A diversionary attack was made by Brigadier-General Lambert to the west at St. Foy, near Locmaria Point, to draw off the French from the main landing. Lambert was given discretion to pursue the assault if the landing was successful, and this he did. Plate 9 illustrates the scene and topography, with the *Swiftsure* (70 guns), flying Commodore Sir Thomas Stanhope's broad pennant, the *Essex* (64 guns) and the *Hampton Court* (64 guns) covering the operation. Another feint attack was made at Sauzon, on the north coast of the island to the west of Le Palais (Plate 10).

The troops advanced on Le Palais and, after a brief siege operation, captured the town on 8 June 1761. The three remaining pictures are more peaceful views of the town. Plate 11 shows the citadel as it appeared from the landward side, while in Plate 12 the breach in the fortifications is clearly visible from a more easterly viewpoint. Finally, Colour Plate 8 is a satisfying panorama with the Union flag flying over the castle, the fleet at anchor and a naval officer proudly surveying the splendid scene from the Raminet battery in the foreground.

COLOUR PLATE 8. 'The Breach in the Walls of the Citadel at Palais and the Land to Point Trelafar on Belleisle', line engraving, P.C. Canot after D. Serres published by R. Short, 8 October 1763, 14 x 20 ins. (36 x 52 cm). One of a set of seven prints, after paintings by Serres from Short's on-the-spot drawings, commemorating the capture of Belleisle in 1761 by a force under Keppel's command. It shows the victorious scene after the capital and citadel have been captured.

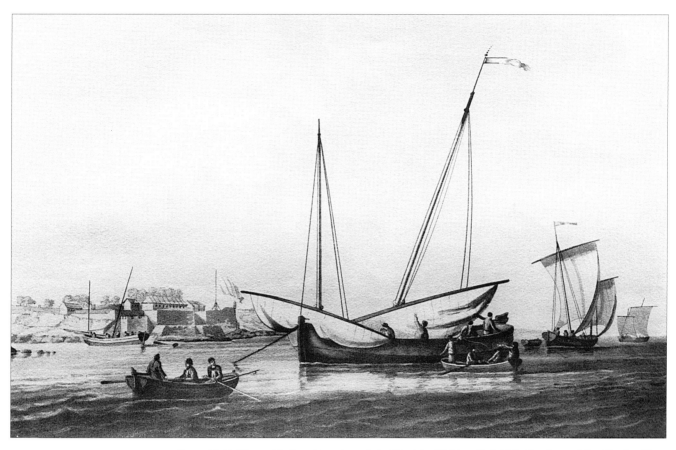

PLATE 13. 'A Chasse-Marée, with a view of the Citadel of Palais at Belleisle', after Serres, *Liber Nauticus*, Plate XXXII, published by Edward Orme, London, 1806, 10½ x 16 ins. (27 x 41.5 cm).

These illustrations are from the prints of the Belleisle series, two of which have been traced which bear the inscription 'Drawn on ye Spot, Designed and Published as ye Act directs by R. Short, Oct. 8, 1763'. Although most of the impressions now in circulation among galleries and collectors were published by John Boydell in 1777, it is probable that Short completed the full set of seven and published them in 1763. Boydell would very probably have later acquired the plates and used them, after necessary re-working and amendment, to reissue the prints as part of his comprehensive portfolio, fourteen years after their first appearance.

All the prints bear the lettering 'Serres pinxit', or 'painted', referring to his oil paintings from which the engravers worked. It is only the later impressions of the prints which carry the lettering 'R. Short delin.', like 'del.' the abbreviation for 'delineavit', referring to the original drawing in pencil or ink with, perhaps, watercolour wash or detail. As the inscription on the 1763 impressions, cited above, made clear that Short was the original artist and promoter, he did not at that time need to repeat the fact. When, however, Boydell later became the publisher, it was appropriate to do so.

For the engravers, whose names were given beneath the lower right-hand corner of the plate with 'sculp.', for 'sculpsit', Short turned to four of his trusted and tried collaborators: Canot, Benoist, Elliott and Mason. Again, clearly anxious to have the work carried out promptly, he employed the four to scrape seven plates.

Short dedicated all the prints to Augustus Keppel, with the exception of Plate 9 which was dedicated to Captain Sir Thomas Stanhope, the naval commander at St. Foy, and Plate 10 to Colonel John Crawford who led the landing at Sauzon. These inscribed dedications to the central and senior figures whose exploits were commemorated usually included the full rank, title and honours of the subject (at the date of the print rather than that of the

PLATE 14. 'Halifax 1759', Richard Short, pencil and grey wash on paper, 13 x 21 ins. (33 x 53 cm). A very rare example of Short's meticulous on-the-spot drawings. This one, with perhaps others, was Serres's source for his painting, reproduced at Colour Plate 9, and Mason's engraving from it, Plate 15. Short has concentrated on the topographical features, sketching in ideas for the shipping. Serres gave the shipping greater prominence while at the same time enhancing the elegance of the topography with a patch of sunlight beneath the heaped clouds. Art Gallery of Hamilton, The Bert and Barbara Stitt Family Collection

action itself) and some details of the action. It was usual to obtain prior approval for the dedication and 'with permission' specifically indicates that this was so, particularly when the patron was a member of the royal family. Such dedications, therefore, immediately raised the status of the production. The language of the inscription was appropriately flamboyant and enhanced by the flourishes of the copperplate lettering in which it was engraved, with the purpose not only of embellishing the plate, but also of highlighting the importance of the operation and the qualities of the intrepid commander. This was intended to make the print a more desirable object for the patron, his friends and the collecting public at large.

Three of Serres's oil paintings, based on Short's drawings, from which the engravers worked, are dated 1763 and it seems reasonable to assume that he painted the entire set of seven in time for them to be engraved and published by the later part of that year. It will be remarked that all the pictures, being coastal, have a strong landscape element which is handled by Serres with great competence, reflecting his established skill as a landscapist. The composition, incorporating foreground small boats and figures, carefully constructed recession of the shipping and light effects from the cloudy skies, is well-balanced, giving clear evidence of a painter who was already mature and versatile.

One of the paintings, entitled 'A view of the English squadron off Belleisle', was hung at the exhibition of the Free Society of Artists in April 1763 (no. 194). This could have been any of the paintings of the landings but was very probably Colour Plate 8, the most elegant and generally appealing of them, showing the wide and victorious view of Le

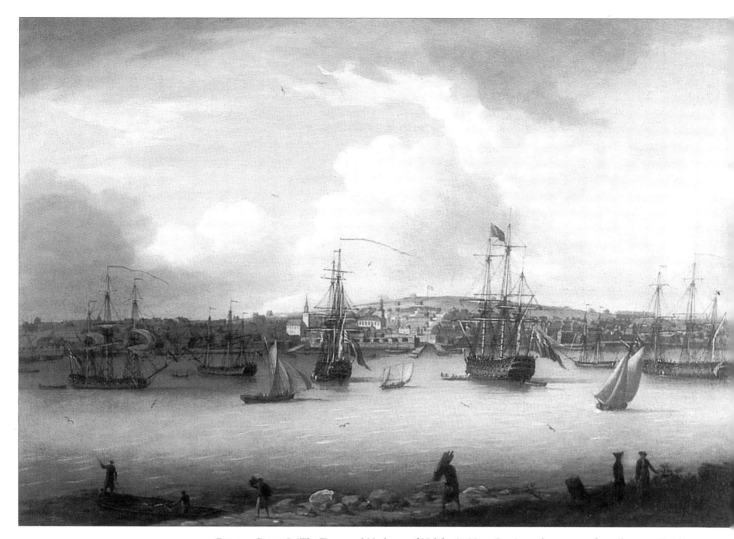

COLOUR PLATE 9. 'The Town and Harbour of Halifax in Nova Scotia, as they appear from the opposite shore, called Dartmouth', oil on canvas, 15 x 22 ins. (38 x 56 cm). Serres worked up Short's small but detailed topographical drawing (Plate 14) into this masterful painting of the scene, bursting with life, interest and colour. It provided James Mason, the engraver, with the model for his own accurate and equally complex rendering (Plate 15).

Collection of the Art Gallery of Nova Scotia. Purchased with funds provided by the Gallery's Art Trust Fund (Mrs. Stewart L. Gibson Bequest), the Cultural Foundation of Nova Scotia, and private and corporate donations, 1982

Palais. A detail of this view was to reappear later in *Liber Nauticus* as Plate XXXII, 'A Chasse-Marée, with a view of the Citadel of Palais at Belleisle' (Plate 13).

Prints by other engravers after this series of images, unattributed, but evidently either made directly from Short's original drawings or from Serres's paintings, appeared in nineteenth century history books as illustrations accompanying accounts of the 1761 capture of Belleisle.

Working again with Short: Views of Halifax, Nova Scotia

Presumably encouraged by the success of his Quebec series, but before he could have been assured of the outcome of the Belleisle enterprise, Short again put his entrepreneurial skills to work and initiated the production of yet another set of coastal topographical prints. This was a series of six views of Halifax, Nova Scotia, which he had visited, and had had plenty of time to draw, in 1758 and 1759. He relied on virtually the same team which had served him well and was continuing to do so. Dominic Serres painted the pictures, basing himself

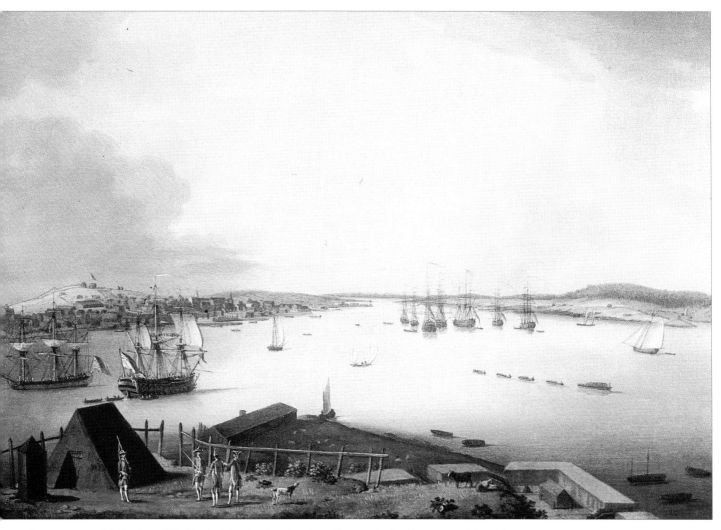

COLOUR PLATE 10. 'A view of Halifax, in Nova Scotia, taken from George Island', oil on canvas, 14 x 22 ins. (36 x 56 cm). A more panoramic view, similarly developed for the engraver from Short's drawing, particular care being taken with the encampment to provide foreground interest. A painting with this title was hung at the Free Society of Artists' exhibition in 1763.

Collection of the Art Gallery of Nova Scotia. Purchased with funds provided by the Gallery's Art Trust Fund (Mrs. Stewart L. Gibson Bequest), the Cultural Foundation of Nova Scotia, and private and corporate donations, 1982

on Short's drawings, from which James Mason etched and engraved four of the plates, John Fougeron one, and François Antoine Aveline (1718–80), a newcomer to the group, one.

By good fortune one of Short's original drawings in this series has survived (Plate 14), and this provides the opportunity to obtain a clearer idea of how the image evolved from drawing to print. Short's drawing of a view of the town and harbour of Halifax is small but topographically extremely detailed. In the harbour, however, ships and their placement are merely suggested. Short was a very competent draughtsman of ships and could well have drawn them in more detail himself, but preferred to leave them to the more skilled oil painting of Serres, whose working up of this very limited drawing, 'The Town and Harbour of Halifax in Nova Scotia, as they appear from the opposite shore, called Dartmouth', is masterful (Colour Plate 9). He creates an image which is well-balanced, uses light cleverly and includes detail of ship and shore which not only portrays the elegance of the new town but also the bustling activity in the harbour. As always with

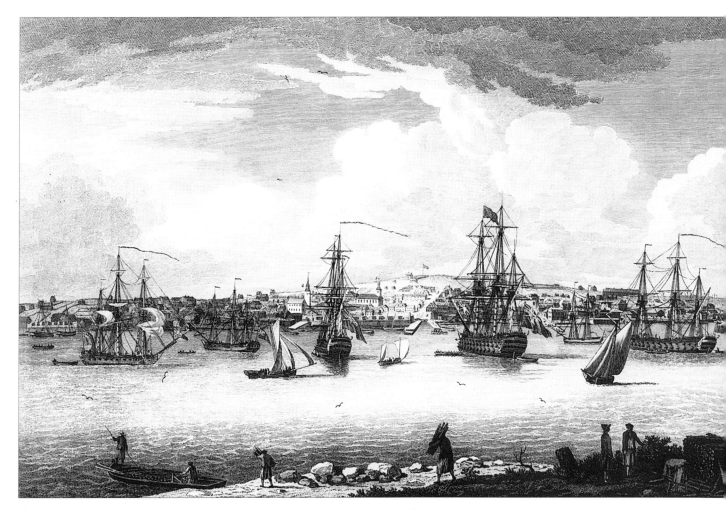

PLATE 15. 'The Town and Harbour of Halifax as they appear from the opposite shore, Dartmouth', line engraving, J. Mason after R. Short and D. Serres, 13 x 20 ins. (33 x 51 cm). The engraver faithfully reproduced the composition and fulsome effects of Serres's painting (Colour Plate 9) for the print.

©The British Museum

Serres, whenever there is an opportunity, foreground figures, appropriately occupied, add warmth and intimacy to the scene. The painting is of small size, only slightly larger than that of the engraved plate for the prints. This was not only an achievement for the painter but also a valuable aid to the engraver. In this case it was James Mason, who was equally skilful in reproducing the clarity and complexity of the composition (Plate 15).

Serres was evidently painting the oils at the same time as those of the Belleisle expedition, for he also exhibited three of them at the Free Society in 1763 (nos. 196–198: 'A view of Halifax, in Nova Scotia, taken from George Island', 'A view of Halifax, in Nova Scotia, taken from the Citadel-hill' and 'A view of the Governor's House and St. Mather's Meeting House at Halifax' (Colour Plates 10, 11 and 12). All these paintings have the same characteristics as the one discussed and make up a distinguished topographical record. The two remaining paintings have not been traced, but reproductions of their respective prints are illustrated at Plates 16 and 17.[5]

Mason, Fougeron and Aveline must also have been working on their plates at the same time as, or soon after, the Belleisle series, for Short was able to issue the set of six, all

5. See *At the Great Harbour: 250 Years on the Halifax Waterfront*, exhibition catalogue, Art Gallery of Nova Scotia, Halifax, 1999. Information provided by M.D. O'Neill, Guest Curator, is gratefully acknowledged.

PLATE 16. 'The Church of St. Paul and the Parade at Halifax', line engraving, J. Fougeron after R. Short and D. Serres, 13 x 20 ins. (33 x 50 cm). Serres's original oil paintings for the last two prints of the set have not been traced. ©The British Museum

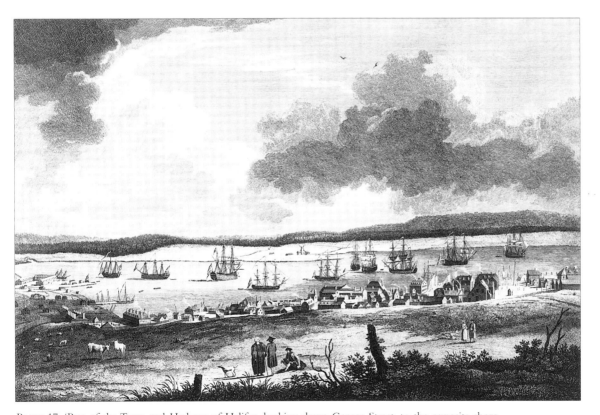

PLATE 17. 'Part of the Town and Harbour of Halifax, looking down George Street, to the opposite shore, Dartmouth', line engraving, J. Mason after R. Short and D. Serres, 13 x 20 ins. (33 x 51 cm). The set of six views shows the proud development of Halifax in the ten years since its foundation. ©The British Museum

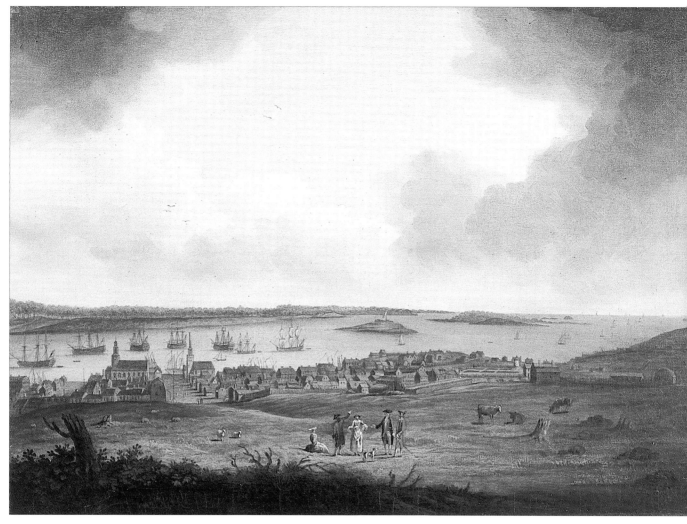

Colour Plate 11. 'A view of Halifax, in Nova Scotia, taken from the Citadel-hill, looking down Prince Street', oil on canvas, 14 x 22 ins. (36 x 56 cm). This alternative view of the city, with foreground figures again animating the scene, was also hung at the Free Society of Artists' exhibition in 1763 and reproduced as a print. Collection of the Art Gallery of Nova Scotia. Purchased with funds provided by the Gallery's Art Trust Fund (Mrs. Stewart L. Gibson Bequest), the Cultural Foundation of Nova Scotia, and private and corporate donations, 1982

inscribed: 'Drawn on the spot designed & publish'd as the Act directs by R. Short, March 1, 1764.' James Mason had three of his engravings of Halifax hung shortly afterwards at the 1764 exhibition of the Free Society (nos. 111–113) together with one of the capture of Havana (no. 114) (see page 47). These plates were also later acquired by Boydell and prints from them reissued by him.

All the prints were dedicated by Short to 'George Dunk, Earl of Halifax, His Majesty's Principal Secretary of State etc.' and a description of the scene given in English and French. The two languages indicate that Short had expectations of sales on the Continent and perhaps in North America, presumably as it was at peace at the time and the subject matter not too inflammatory. George Montagu, 2nd Earl of Halifax (1716–71), married a wealthy heiress who inherited the property of Sir Thomas Dunk and thereupon changed his name. He succeeded his father in 1739 and in 1748 became head of the Board of Trade: 'The commerce of America was so much extended under his direction that he was sometimes styled the "Father of the Colonies" and the town of Halifax in Nova Scotia

COLOUR PLATE 12. 'A view of the Governor's House and St. Mather's Meeting House at Halifax', oil on canvas, 15 x 22 ins. (38 x 56 cm). The third view of the city to be hung at the same exhibition and part of the same set of paintings produced for the engravers.

Collection of the Art Gallery of Nova Scotia. Purchased with funds provided by the Gallery's Art Trust Fund (Mrs. Stewart L .Gibson Bequest), the Cultural Foundation of Nova Scotia, and private and corporate donations, 1982.

was called after him in 1749, in commemoration of his energy in aiding the foundation of the colony'.[6]

In 1761 Halifax was appointed First Lord of the Admiralty and a year later Secretary of State for the Navy. Short was thus again able to obtain the most elevated patronage for the endorsement of his prints. Moreover, the strategic importance of the ice-free port in Nova Scotia to British ambitions in North America had been clearly demonstrated by the capture in 1758 of the French fortress of Louisburg, on the adjacent Cape Breton Island, which opened the way to the St. Lawrence river and the capture of Quebec the following year.

The importance of the publication of such sets of prints in promoting the work of Dominic Serres and attracting further commissions will be examined shortly in greater depth in the context of the Keppel family, but evidence of it may already be found in the present instance. The Earl of Halifax may well have been encouraged by this series to purchase other works by Serres, for several were included in the Earl's collection of paintings when it was posthumously dispersed at auction in 1789.

6. Dictionary of National Biography.

CHAPTER III

THE CAPTURE OF HAVANA 1762; PRINTS AND PAINTINGS

After his invasion of Belleisle, Augustus Keppel returned to England and soon became involved in the preparations for an attack on Havana, Cuba, usually known at the time as 'the Havannah' in strict translation of the Spanish. Capital of the Spanish possessions in the western hemisphere, the city was the base of its naval forces and the hub of its mercantile supremacy in the region. As a result of the 1761 'Family Compact', Spain had been giving France increasing support in the colonial war against England and George III finally gave his agreement to a declaration of war on Spain at the beginning of 1762. The government of William Pitt the Elder, much encouraged by the the King's uncle, the Duke of Cumberland, immediately resolved, amid great secrecy, to deal a major blow to Spanish power in the West Indies by an attack on Havana. The command of the operation was almost a Keppel family affair, and was later to become the target of envious criticism when the lucrative spoils became known. General George, 3rd Earl of Albemarle, was given overall command with Admiral Sir George Pocock in command of the naval force. Augustus Keppel, Albemarle's younger brother, was second-in-command to Pocock, and his younger brother, Colonel the Hon. William Keppel was a divisional commander in the army.

Ships, troops and transports were despatched from England to join the forces already in the Caribbean and instructions sent to North America for further reinforcements to proceed southwards. The gigantic expeditionary force made a rendezvous with the Leeward Islands squadron under Admiral George Brydges Rodney (1718–92) at Cas des Navires bay in Martinique, where the fleets watered, the water on the ex-French island being known to be better than on the British bases. Rodney's capture of the island earlier in the year, supported by Captain the Hon. Augustus Hervey (1724–79), was subsequently to be the subject of several paintings by Serres for these patrons.

In order to achieve the greatest element of surprise, the convoy of twenty-two ships-of-the-line, thirty-one other warships and about 130 transports carrying troops and supplies, took the Old Bahama Channel between the north coast of Cuba and the Bahamas. This route was little frequented by shipping owing to the difficulties of its navigation, and its use by such an extensive fleet, including large men-of-war, would be totally unexpected by the Spanish garrison at Havana.

Lieutenant Orsbridge's drawings and prints

Among the men-of-war was the *Orford* (66 guns) under the command of Captain Marriot Arbuthnot. One of his lieutenants was Philip Orsbridge, who had been commissioned on 13 January 1758. From this seaward vantage point, Orsbridge recorded in drawings all the stages of the approach, siege and capture which occupied the coming weeks.

After his return to England, and probably being paid off at the end of the war, Orsbridge decided to turn his sketches to advantage by publishing them as a series of twelve commemorative prints. In this he was very probably guided by the example of Richard

Short, whose topical series of prints were at the time freshly circulating and currently being published, for he resorted to the same production team with whom Short was so successful. Orsbridge's notices in the *Public Advertiser* of 11 and 12 April 1764 announced the sale of the first three of these prints together with a Frontispiece (Plate 18), adding that: 'To every Three Views, will be delivered proper Explanations, etc. of the different situations of the Fleet. Note. The first and second views may be joined together, and then Van and Rear of all His Majesty's Ships and Transports will be seen at One View' (Plates 19 and 20).

After the eighth plate, Orsbridge, probably having entered upon a venture with which he was not entirely familiar, appended the following dignified but anxious note to his Explanations:

> The Author returns his most grateful Thanks to the Subscribers, by whose Generosity he has been enabled to finish eight of the Plates in an elegant Manner; but finding the Expence greatly to exceed his Expectations, he humbly hopes that those Gentlemen who have been so kind as to encourage the Undertaking, will make Use of their Interest among their Friends, to procure him an additional Number of Subscribers, to repair the Loss he must sustain without such Assistance. He likewise begs Leave to assure them, that, at all Events, he is determin'd to finish the remaining Four Plates in a Manner, that he does not doubt will meet with general Approbation. Their Favours will ever be gratefully acknowledg'd by their Obedient Servant, P. ORSBRIDGE
> Please to direct to Lieut. Philip Orsbridge of the Navy, in a Court opposite the Blue Posts, Maiden Lane, Covent-Garden.

His Explanations accompanying the tenth print end with the statement: 'The Author, Lieutenant Philip Orsbridge, of His Majesty's Navy, returns his grateful Thanks to the Nobility and Gentry who have honour'd him with their Subscriptions, and assures them that Plates XI and XII which finishes the whole Work, is in great Forwardness, and will be carefully deliver'd, with proper Explanations'. A further notice in the *Public Advertiser* of 21 May 1765 suggests that the full set was by then finished and ready for sale as a whole, at a price of two guineas.

Orsbridge had used two of the established engravers for his prints, Pierre Charles Canot for seven and James Mason for five. One of the earlier plates in the series engraved by Mason, Plate V, 'Landing and Marching of His Majesty's Land Forces…' (Plate 23), was probably the print he submitted to the Free Society exhibition in 1764 under the title 'A View of the landing of his Majesty's troops at the Havanna'. This would confirm the forwardness of Orsbridge's production schedule at this time.

It was no mean achievement for Orsbridge to have published the entire set of twelve prints, each 17¾ x 25½ ins. (45 x 65 cm), in the space of just over twelve months, even if the speed of production resulted in some curious errors, such as the spelling of his surname as 'P.O.R. Sbridge' on the first eight plates.

Whatever reward, either financial or in terms of reputation, Orsbridge may have derived from the publication was, sadly, short-lived. A sale catalogue of Mr. Christie for Thursday 9 April 1767 included the effects of 'The late ingenious Captain Orsbridge, of Milbank-street, Westminster. Author of the Twelve Capital Prints on the Expedition and taking of the Havanna, among which effects are Twelve setts of the said Views'. The prints were, however, republished later, for they appear in the Sayer & Bennett catalogue of 1775. These printsellers may have purchased the plates from Orsbridge or, perhaps, his executors, but at least his enterprise was preserved for a few years.[1]

1. File notes National Maritime Museum.

PLATE 18. Title page of 'The capture of Havana, 1762', a set of twelve engravings after Lieutenant Philip Orsbridge and Dominic Serres, published by Orsbridge, 1764–65, 17¾ x 25½ ins. (45 x 65 cm). Serres worked up Orsbridge's on-the-spot drawings into small oil paintings for the engravers P.C. Canot and James Mason to copy. They worked with despatch to produce the plates so quickly. The subscription cost was two guineas for the set.

Plates 18–30 National Maritime Museum, London

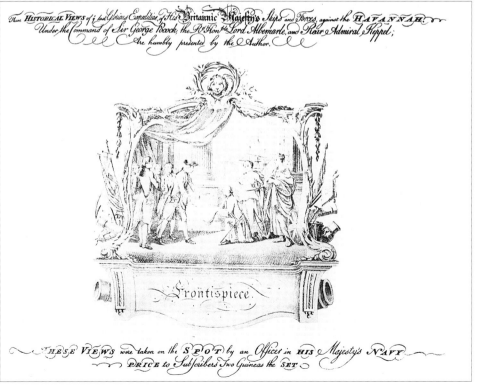

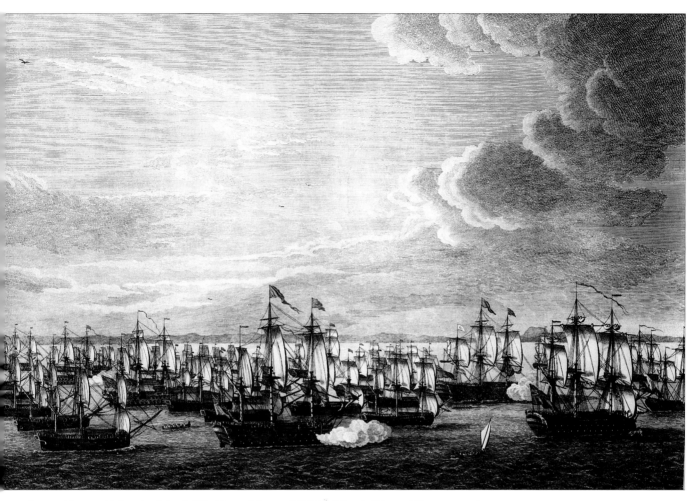

PLATES 19 AND 20 (I and II, joined). 'The Van and Rear of all His Majesty's Ships and Transports . . .'

Title page (Plate 18) carries at the top the wording 'The HISTORICAL VIEWS of y' last Glorious Expedition of His Britannic Majesty's Ships and Forces, against the HAVANNAH. Under the Command of Sir George Pocock, the Rt Honble Lord Albemarle, and Rear Admiral Keppel; Are humbly presented by the Author', and underneath the image: 'THESE VIEWS were taken on the SPOT by an Officer in HIS Majesty's NAVY. PRICE to subscribers Two Guineas the SET'.

Plates I and II (Plates 19 and 20) show 'The Van and Rear of all His Majesty's Ships and Transports, and are contrived to join, that the whole may be seen at one View. The Van of this great fleet was led by three Frigates, the Richmond, Capt. Elphinstone, the Mercury by Capt. Goodall, and Alarm by Capt. Alms, and many small Vessels and Long-boats placed at several Stations.

'The Admiral Sir George Pocock, in the Van of the Center Division, a Blue Flag striped at the Fore-top-mast-head, the Signal for the Fleet to alter the course . . . [The Earl of Albemarle was on board Pocock's flagship, Namur (90 guns)]. The second Division . . . was commanded by the Hon. Augustus Keppel, Commodore, and Second-in-Command, in H.M.S. Valiant, wearing a Broad Red Pendant at the Main-top-mast-head . . . The Third Division, commanded by Capt. John Barker, Senior Captain, in the Culloden, wearing large White Pendant . . . The Names of all the Commanders of His Majesty's Ships, are inserted at each End of the Plates; the Land as represented is the Island of Cuba; as also the Pan or Cape Land of the Matanzes, at a large Distance, being a high Table-Land'.

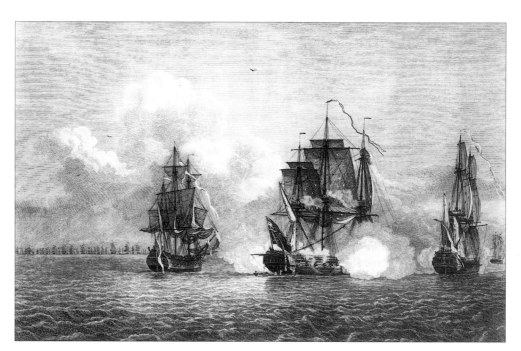

PLATE 21 (III). 'His Majesty's Frigate Alarm . . . taking Two Spanish Frigates of War . . .'

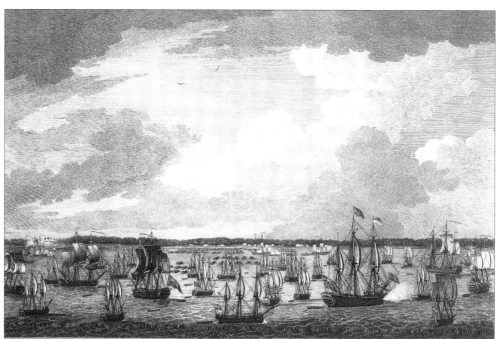

PLATE 22 (IV). 'H.M.S. Namur . . . bore away, to go to the Westward of the Havannah . . .'

Omitted from these extracts from the 'Explanations', and those following, are Orsbridge's detailed listing of the signals being flown and the identifying flags of the ships in the fleet, which was presumably included for the professional naval interest. As their colours are all precisely denoted it may mean that the prints were also intended to be coloured, but no example of this has been found.

Plate III (Plate 21) is 'A Perspective View of His Majesty's Frigate Alarm (32 guns), Capt. Alms, on Thursday June the 3d, 1762, engaging and taking Two Spanish Frigates of War, in Sight of the whole Fleet, as sailing down the old Straits of Bahama; viz. the Phoenix (22 guns; 175 men), the Thetis (18 guns; 65 men), which, with one Spanish Brig, after a smart engagement, was the next Morning brought into the Fleet'.

The need to surprise Havana would make it imperative that these patrolling enemy

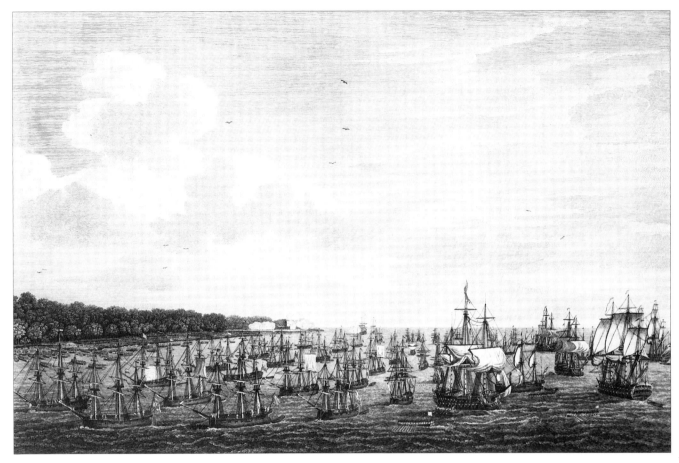

PLATE 23 (V). 'Landing and Marching of His Majesty's Land Forces . . . and taking the fort of Cojimer . . .'

warships were captured in order to prevent them escaping before the fleet and alerting the city. As a matter of passing interest, the *Alarm* was the first vessel in the navy to be sheathed underwater with copper as protection against the devastating effects of tropical boring worms such the Teredo. Captain Alms was to appear again twenty years later in command of another warship, depicted by Serres, distinguishing itself at the centre of a fiercely contested battle (see pages 166 and 167 and Plate 81).

Plate IV (Plate 22) shows 'Sir George in H.M.S. Namur, with such Ships of his Fleet as he thought proper, and Transports, bore away, to go to the Westward of the Havannah, in order to make another Landing, supposed to be Two Armies; at 4 a.m. in the morning of 7th… the Commodore hoisted a signal for all His Majesty's Land Forces to embark in the Flat-Boats; as also a Signal for His Majesty's Ships of War Mercury, Bonetta Sloop, and Granado Bomb to go in Shore to attack the Fort of Baccuranao, which is represented in the said View, and was silenced and taken Possession of by them, after some smart Firing: At, or about Nine o'Clock, the Commodore made the Signal for the Boats to advance towards the shore, as represented in the View; at Half past Ten o'Clock the Troops was landed'.

The next day another landing was made to the east of the entrance to Havana harbour, on which side stood the formidable fortress of El Morro.

Plate V (Plate 23) is 'A Perspective View of the Landing and Marching of His Majesty's Land Forces . . . and H.M.S. Dragon the Hon. Augustus John Hervey, and Granado Bomb engaging and taking the Castle of Cojimer; shewing at the same Time how the Transports anchor'd a-long the Shore; . . . the Flat-Boats rowing down a-long Shore in order, as soon as the Castle was silenced, to make a Bridge for the Army to march over the River between them and the Castle'.

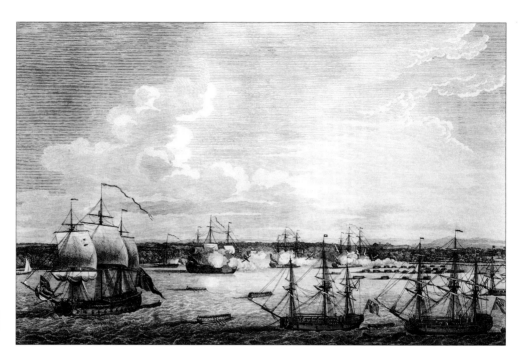

PLATE 24 (VI). 'His Majesty's Ships
. . . engaging the Castle and
Batteries of Choera . . .'

The following plate returns to the western landing and the attack on the fort of Choera.

Plate VI (Plate 24) is 'A Perspective View, on Friday the 11th of June, 1762, of His Majesty's ships Bellisle, Captain Joseph Knight, Echo Frigate, Captain John Lendrick, Mercury, Captain Samuel Granston Goodall, and Lurcher Cutter, engaging the Castle and Batteries of Choera; also the Nottingham, Captain Thomas Collingwood, standing off and on, ready to assist them when ordered; this Attack begun at Four or Five o'Clock in the Afternoon, when all the Marines was embark'd in the Flat-Boats under the Command of the Hon. Colonel William Howe; at One or Two next Morning the Castle surrendered, and then the Marines was landed safe, and march'd and took possession of it: In the River lay one Brig, one Sloop, and one Schooner. N.B. From this River our Army was supplied with Water all the Siege'.

Attention then switches to the landings east of the city nearly three weeks later.

Plate VII (Plate 25) is 'A Perspective View, between Six and Seven o'Clock in the Evening on the 30th of June, 1762, of the Artillery, Tents, Landing Cannon, Bombs, Shells, Shot, Powder, Provisions, Stores, Facines, and all other Necessaries for the Use of the Army; also the Soldiers, Seamen, and Negroes drawing Cannon, and carrying Stores to the Batteries; Boats landing Water from the Transports for the Army, with H.M.S. Orford, Marriot Arbuthnot, Esq. making Signals to the Commodore of such Shells as fell into the Moro, with His Majesty's Ships Dragon, the Hon. Aug. Hervey; Cambridge, William Goostrey, Esq.; Marlborough, Thomas Burnett, Esq. Lying-to with their Heads to the Northward, in order for H.M.S. Sterling Castle to get to the Westward of them, to be ready the next Morning to lead the Squadron to the Attacks'.

The eighth plate shows the view the following morning, 1 July.

Plate VIII (Plate 26) shows 'Grand Attacks by Land and Sea, by His Majesty's three Ships, Dragon, Cambridge in the Van, William Goostrey, Esq; who was kill'd, with the Master of his Ship; Marlborough in the Rear; shewing at the same time where the Sterling Castle, Capt. James Campbell, was, and her Distance, as she was to have lead the Squadron; with one of His Majesty's Bomb-Vessels throwing Shells into the Moro and Punto Castles, with His Majesty's Frigate Mercury making Signals to the Admiral; also His Majesty's Frigate Echo standing under his Top-sails, with Flat-Boats mann'd and arm'd, in order to tow any of the three Ships off, if occasion requir'd; with a View of many others lying under the Rocks for the same Purpose. The Boat near the Cambridge shews John Lindsay, Esq;

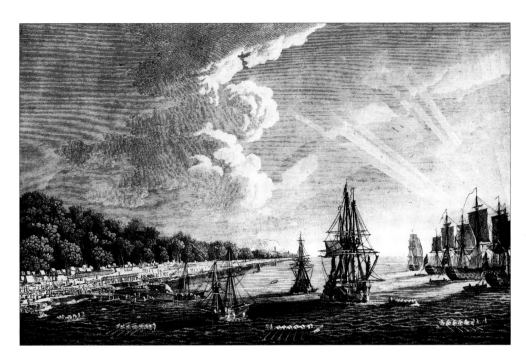

PLATE 25 (VII). 'Landing Cannon, Bombs . . . Provisions, Stores . . . and all other Necessaries . . .'

Captain of His Majesty's Frigate Trent, now Sir John Lindsay, going on board the Cambridge, to take on him the Command, after the Death of her late Captain. Also a View of His Majesty's Fleet at Anchor off the Punta Brava'.

This operation was not a great success. The *Dragon* indeed went aground but was got off. The warships were unable to elevate their guns sufficiently to make any real impression on the fort above them, while the defenders did great damage to the sails and rigging of the ships by their gunfire. Captain James Campbell was court-martialled for his failure to lead the squadron by bringing the *Stirling Castle* close to the fortress, and on 16 August was dismissed the Service.

Whereas a more dynamic commander, such as James Wolfe, would probably have opted for an immediate surprise assault, the Earl of Albemarle pursued the traditional siege by investment, surrounding the El Morro fortress, which was the key to the harbour and city, and

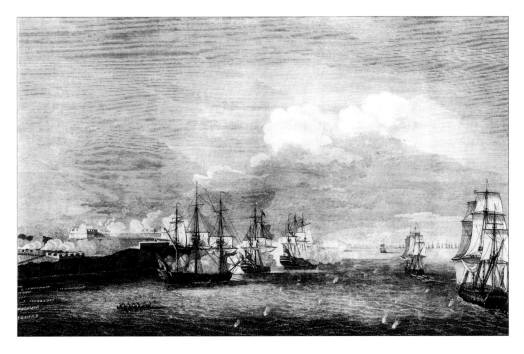

PLATE 26 (VIII) 'Attacks...by His Majesty's three Ships, Dragon, Cambridge...and Marlborough in the rear...'

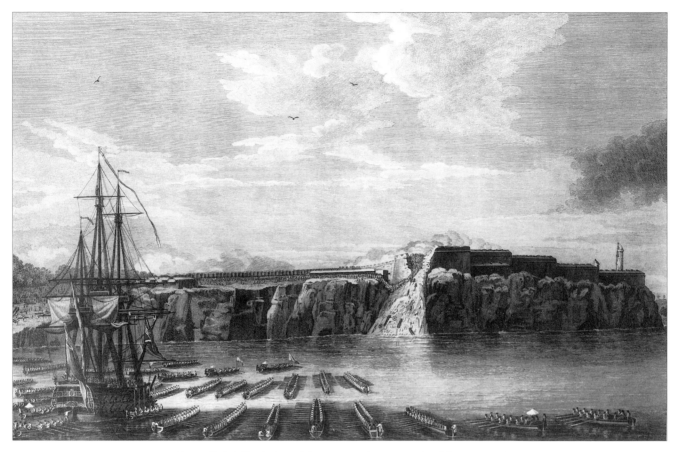

PLATE 27 (IX). 'Springing of the Mines at the N.E. Angle of the Moro . . .'

bombarding it from gun emplacements on the landward sides as well as from the sea. This took weeks to accomplish and at an enormous cost to his troops as they died of thirst, sunstroke and tropical disease. A wide and deep ditch at the foot of the walls of El Morro was only discovered after the landing and provided a formidable barrier to the assault. It was hidden from view at its seaward end by a high narrow wall of rock. This was negotiated at night by a party of Cornish tin miners from the fleet, experienced in mining with explosives, who succeeded in breaching the outer wall of the fortifications. The next of Orsbridge's prints shows the assault along this narrow path which culminated in the capture of the fortress.

Plate IX (Plate 27) is 'A Perspective View, between the Hours of One and Two o'Clock in the Afternoon of the 30th of July, 1762, of the Springing of the Mines at the N.E. Angle of the Moro; His Majesty's Forces entering the Breach; the amazing Difficulties the Troops surmounted in passing the Narrow Breach, where but one Man could go abreast, is properly described; with a View of H.M.S. Alcide of 64 Guns, Capt. Thomas Hankerson, with a Number of Flat Boats man'd and arm'd'.

With the capture of El Morro, the bombardment of the city of Havana could begin, but was not to last long as the town was in no position to defend itself from its own protecting fortress across the harbour. The tenth view is from within the harbour looking seawards.

Plate X (Plate 28) is 'A Perspective View of the grand Attacks of the City and Punto Castle, between the Hours of Five and Ten in the Morning of the 13th of August, 1762; the terrible Fire from His Majesty's Batteries on those of the Enemy is shewn; and a View of the Spanish Ships when sunk, some Part of their Masts appearing above Water; with the White Flags from the Spanish Admirals, and on the Towers displayed, as Signals of Submission'.

The capitulation was signed and on the next day the British forces moved to occupy the town and dismantle the defensive boom.

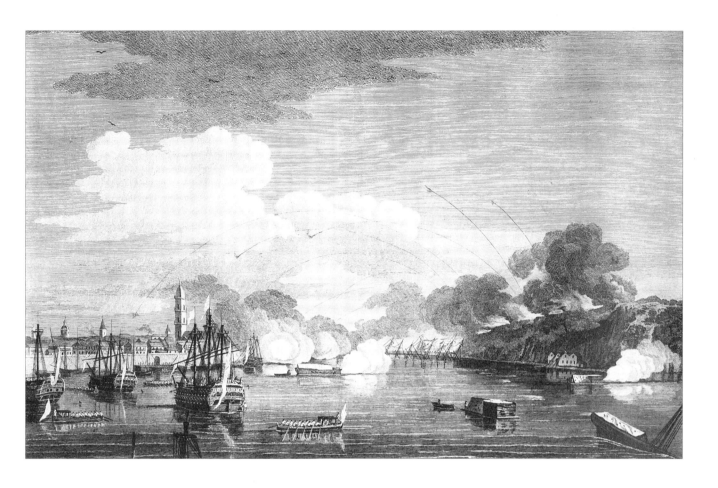

Plate XI (Plate 29) is 'A Perspective View, taken the 14th of August, 1762, of the N.W. Angle of the Moro Castle, Towers, City, Punto Castle, and Harbour; shewing the Situation of the Batteries on the adjacent Hills, His Majesty's Sloops of War, Bonetta, and Cygnet, assisting to open the Booms. His Majesty's Land Forces are seen going in Flat Boats to take Possession of the Punto Castle and the North Gate of the City'.

PLATE 28 (X). 'Attacks of the City and Punto Castle . . .'

PLATE 29 (XI). 'His Majesty's Sloops of War . . . assisting to open the Booms . . .'

PLATE 30 (XII). 'The Fleet . . . entering the Harbour to take Possession of the Spanish Ships . . .'

Plate XII (Plate 30) is 'A Perspective View, taken at some Distance at Sea by the Author, on the 16th of August, 1762, of the Harbour, the Land to the Westward, and Moro Castle to the Eastward; the Fleet is seen entering the Harbour to take Possession of the Spanish Ships, etc. The Hon. Augustus Keppel in H.M.S. Valiant, leading the Red Squadron from the Eastward; Sir George Pocock, Admiral of the Blue and Commander in Chief, in H.M.S. the Namur, and his Squadron, turning to Windward in order to sail in'.

Pocock accorded Keppel the privilege of leading the fleet in as a recognition of his distinguished leadership during the operations.

Serres's paintings of the Havana expedition

Probably prompted by the quality of Serres's paintings from Short's drawings for the engravers to reproduce, Orsbridge retained him for his own series, for all twelve prints are inscribed 'Serres pinxit'. Busy though he would have been with his work for Short, Serres evidently completed the painting of the full set of pictures for Orsbridge by about the end of 1764, although individual paintings may have been executed in 1762 or 1763. Indeed, Serres himself may have offered to collaborate with Orsbridge in the venture in order to give prominence to some of his own depictions of the siege and capture.

Seven oil paintings of these subjects by Serres, dated in these years, have been traced which correspond in all detail to the prints and were therefore probably the originals for them. All are of a smaller size, approximately 15½ x 24½ ins. (39.5 x 62 cm). Although this may appear small for such broad and active scenes, it was not unusual for Serres, particularly in view of the likely speed of production and the need for them to correspond closely to the dimensions of the plates to be engraved. The Orsbridge prints after these

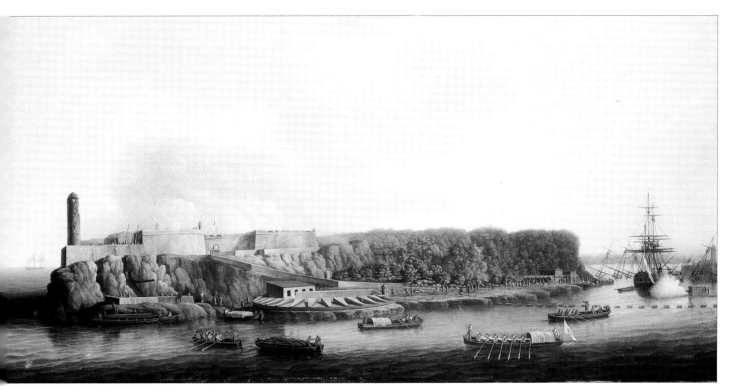

COLOUR PLATE 13. 'The capture of Havana, 1762: Morro Castle and the boom defence before the attack', oil on canvas, signed and dated 1770, 33 x 69 ins. (84 x 175.5 cm). An outstanding marine landscape which demonstrates Serres's skill in balancing sweeping topographical features with the human detail of military activity. National Maritime Museum, London

seven paintings, which are now mainly in private collections, are Plates III, V, VI, VII, IX, XI, and XII. The remaining five paintings have not yet been traced.

Two other early paintings of Havana, signed and dated 1762, are not related to any of the prints and give the impression of having been produced soon after the events, putting Serres's local knowledge to rapid use in order to meet public interest and demand. These works may also have been instrumental in prompting Orsbridge to engage Serres to work up his drawings for the series of prints.

There are many other paintings by Serres of the operation, those that are dated being later than 1764. Some are alternative versions to those used for the prints, probably painted to meet a general or particular demand, while others are quite different from the engravings. The most comprehensive collection of these further paintings is from the Albemarle family, now housed in the National Maritime Museum. Among these are some of Serres's best and most evocative works, most of them with the strong landscape element in which he excelled.

'The capture of Havana, 1762: Morro Castle and the boom defence before the attack' (Colour Plate 13), signed and dated 1770, is a fine piece of marine landscape painting, worthy of comparison with the panoramic views of Bernardo Bellotto (1721–80), Canaletto's nephew and pupil until 1746, when Canaletto came to London. It is a masterly handling of the wide view and the intensity of the action, striking a careful balance between the mass of the fortified promontory, the figures at its foot and the small boat activity in the foreground. Behind, a curtain of smoke rises from the encampment as troops prepare to attack the castle.

'The capture of Havana, 1762: the English battery before Morro Castle' (Colour Plate 14)

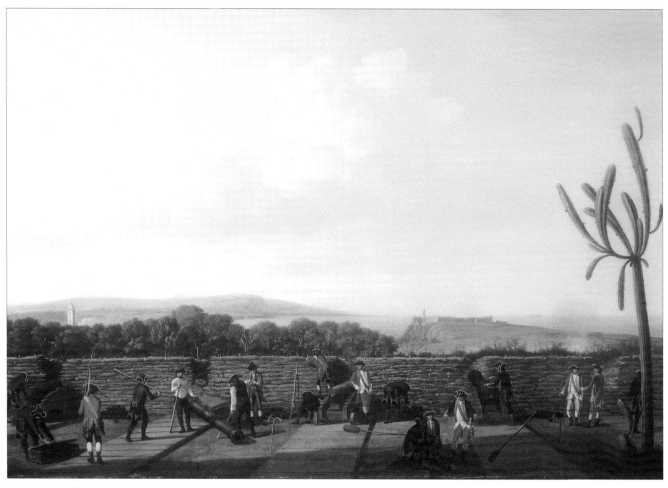

COLOUR PLATE 14. 'The capture of Havana, 1762: the English battery before Morro Castle', oil on canvas, 33 x 48 ins. (84 x 122 cm). The overturned gun and smoking fuses as the artillery bombards the fortress, lend immediacy to this otherwise apparently peaceful scene. National Maritime Museum, London

is a deceptively calm depiction of one of the emplacements, constructed by the attackers on the rocky heights inland, from which the Morro could be bombarded. There is no suggestion in the orderly scene of the toll in lives taken by the transportation from the shore of all the building materials as well as the military equipment shown in the picture. Serres not only paints a broad landscape view but also captures the immediacy of the moment with the overturned gun on the left and the smoking slowmatches ready to fire the artillery. All the figures and equipment in the foreground space are painted with assurance.

'The captured Spanish fleet at Havana, August-September 1762' (Colour Plate 15), is a complex but satisfying panorama from the southern end of the harbour, showing the captured Spanish warships at anchor, ships on the stocks being burnt at left and the sunlit El Morro seen down an open sightline at centre right. The tropical cloudscape is an important element of the composition and execution.

One of the best-known images of the series, where the oil painting is an exact replica of the print, and its painted precursor, is 'The British Fleet entering Havana, 21 August 1762' (Colour Plate 16). Signed and dated 1775, this is a splendid exhibition version measuring 47 x 71 ins. (119.5 x 180.5 cm), almost certainly painted for Augustus Keppel.

Finally, two of Serres's paintings are of scenes in Havana after the occupation, showing the calm and remarkably unpopulated atmosphere in the city centre. 'The Cathedral at

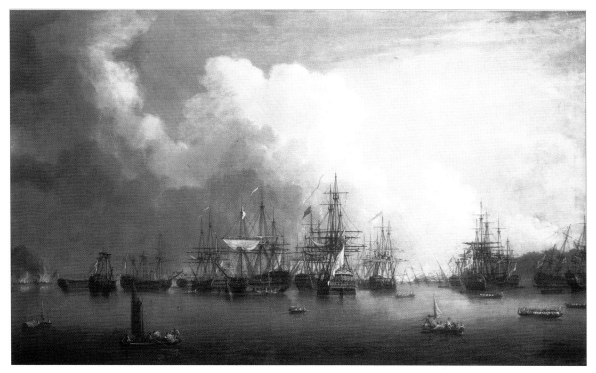

COLOUR PLATE 15. 'The captured Spanish fleet at Havana, August–September 1762', oil on canvas, 42 x 71 ins. (108 x 180.5 cm). The view from the southern end of the harbour includes a characteristic Serres open sightline, centre right, to the sunlit El Morro in the distance. National Maritime Museum, London

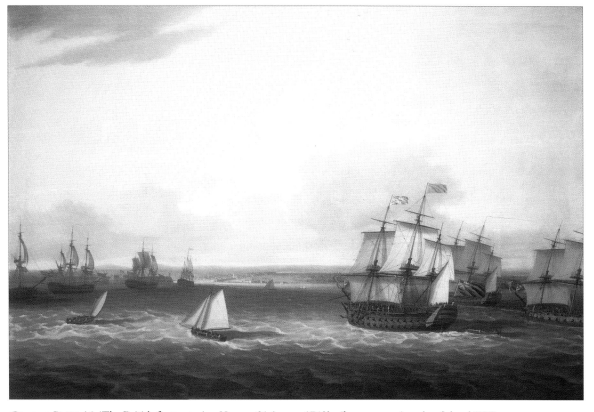

COLOUR PLATE 16. 'The British fleet entering Havana, 21 August 1762', oil on canvas, signed and dated 1775, 47 x 71 ins. (119.5 x 180.5 cm). Augustus Keppel is shown leading the fleet in, an honour accorded him by his commander, Admiral Sir George Pocock, in recognition of his distinguished leadership during the siege. Like most of these large oils, this was commissioned by the Keppel family, long after the publication of the prints, to commemorate their part in the operation. National Maritime Museum, London

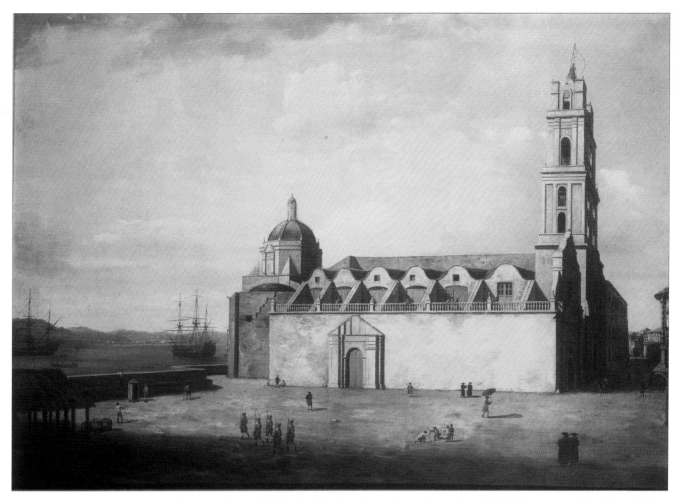

COLOUR PLATE 17. 'The Cathedral at Havana, August-September 1762', oil on canvas, 32 x 47 ins. (81.5 x 119.5 cm). This remarkably peaceful scene of the centre of the city after its capture owes its origin to another on-the-spot draughtsman, Elias Durnford, an engineer. In this case, however, Durnford seems to have produced his set of six prints directly from his drawings, Serres later copying two of them for views in the city centre.

National Maritime Museum, London

Havana, August-September 1762' (Colour Plate 17) and 'The Piazza at Havana' (Colour Plate 18) both use quiet tones to depict the space and buildings in the bright tropical sunlight and achieve a cool effect, avoiding the strident pigments and harsh contrasts which might have been employed by a lesser artist.

Elias Durnford's engravings

The paintings by Serres of the occupied city of Havana clearly owe their origin to the publishing venture of another on-the-spot draughtsman. Elias Durnford, an engineer, probably from North America, was a member of the occupying forces in Havana after its capture, and published a set of six engravings in England after the war. One is dated August 1764 and it may be assumed that the others in the set appeared at about the same time. These are quite different from Orsbridge's military and naval prints, recording mainly pastoral and landscape scenes taken after the fall of the city. They are delicately drawn and may be regarded as somewhat surprising from the pencil of an engineer, who might have been expected to interest himself more in fortifications and military works. All are stated as having been drawn by Durnford and contain keys to places of interest, but no painter is mentioned. Familiar names appear among the engravers employed: Pierre Charles

COLOUR PLATE 18. 'The Piazza at Havana', oil on canvas, 32 x 47 ins. (81.5 x 119.5 cm). A pair to the previous illustration, this also uses quiet tones to depict the space and buildings in the bright tropical sunlight, achieving a cool effect. The presence of occupying troops and sailors, probably included as the painting was commissioned by one of the military Keppel brothers, is similarly understated.

National Maritime Museum, London

Canot, Edward Rooker, assisted with etching on one plate by Paul Sandby, T. Morris and William Elliott. The persistence of this nucleus of engravers through all these series of prints, and the repeated presence of Serres as the artist, is a strong indication that the group and its publishers were friendly and probably closely associated in the business of producing works of this type.

One of Durnford's series was entitled 'View of the Franciscan Church and Convent in the City of Havana, taken from the Alcalde's house in Granby Square' (Plate 31). Serres's painting of the Cathedral (Colour Plate 17) is virtually the same as this print, with the addition of a group of five soldiers, centre left in the foreground. This minor amendment may be attributed to the assumed military commission for the painting, which is discussed on pages 62-63. It contrasts with the more peaceful appeal of the print, epitomised by the inscription in English, French and Spanish, considered appropriate after the Treaty of Paris in 1763 and the return of the city to Spanish rule. Two more of Serres's paintings may owe their origin directly or indirectly to Durnford's engravings, but the relationship is not as close as that just shown. It must also be remembered that Serres was very familiar with Havana, having lived there for several years, and would have had a detailed knowledge of the topography of the city and surroundings.

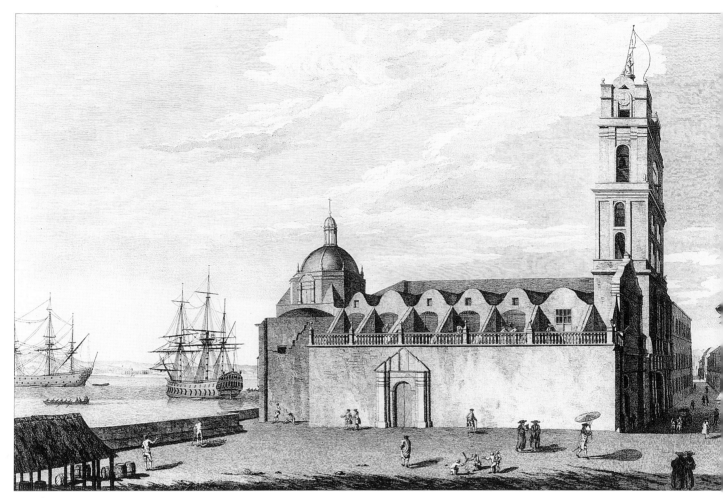

Plate 31. 'View of the Franciscan Church and Convent in the City of Havana, taken from the Alcalde's house in Granby Square', engraving by Edward Rooker after Elias Durnford, Engineer, 1764. Durnford published a series of prints of the city after its occupation. Serres clearly used at least two of them as the basis for his oil paintings for the Keppel family as, for example, that shown in Colour Plate 17.

National Maritime Museum, London

The Albemarle Collection of Serres paintings

All eleven of the Serres paintings of Havana, at present in the National Maritime Museum, were previously in the possession of the Earl of Albemarle, the lineal descendant of the commander in 1762. It is assumed, therefore, that they were originally all commissioned by the then Earl or his brothers. Other members of the family may have ordered other versions which are known in private collections. The dating of the paintings, where known, and their relationship to the prints, discussed above, suggest that few, if any, were commissioned before 1764. It seems more probable that Philip Orsbridge published his prints, using his drawings and Serres's paintings from them, and that the Keppel family, liking the prints and the idea of a higher-quality commemoration, commissioned further paintings from Serres.

A noticeable difference is apparent in the nature of the subject matter between two groups of the paintings, which is echoed in the respective sizes of the canvases in each group. Five, Colour Plates 13, 14, 17, 18, and a version of the scene represented in Plate 27, are concerned more with the military side of the operation and the occupation after its successful conclusion. They are also smaller in size, being, with one exception, of similar

dimensions. These may have been commissioned by the Earl of Albemarle himself or possibly his brother William. The other six paintings, Colour Plates 15 and 16 and others derived from Plates 22, 23, 25 and 28, are of similar, larger size and depict the naval aspect, with ships of the fleet, transports, auxiliaries and ships' boats occupying much of the picture plane. These may have been commissioned by Augustus Keppel, the naval second-in-command, whose flagship *Valiant* (74 guns) is often given a position of prominence. The painting of the fleet entering Havana (Colour Plate 16), which gives Keppel pride of place, is signed and dated 1775, three years after the death of the Earl and, it will be recalled, the year in which Orsbridge's engravings were republished. Augustus Keppel died, unmarried, in 1786 and his paintings may have been amalgamated on his death with those of his brother, thus forming the full group of eleven.[2]

Serres exhibited 'A View of the Spanish men-of-war, frigates and galleons, in the harbour of the Havannah at the reduction of that place, with a view of the Moro-Castle at the mouth of the harbour' (Colour Plate 15), at the Society of Artists in 1768 (no. 153). From 30 September to 3 October that year the Society arranged a special exhibition in honour of the King of Denmark, who had married one of George III's younger sisters in 1766 and was on a state visit. Serres's painting 'The storming of the Moro-Castle at the Havannah' (no. 104) was hung at the show. This was probably a version of Orsbridge's Plate IX (Plate 27), a well-balanced naval and military view of the final assault on the breached north-eastern corner of the fortress which would have had a dramatic appeal to the public.

These commissions from the Keppel family for the Havana paintings illustrate how the contemporary popularity of prints worked to Serres's advantage as a means of publicising the artist's name and promoting his work. As a result, he attracted commissions in increasing numbers from patrons who wished to possess more permanent and expensive oil paintings to commemorate their exploits. By the middle of the 1760s, Dominic Serres was thus becoming established as one of the principal marine landscape painters in London. The standing, influence and wide circle of friends of aristocrats and senior commanders such as the Keppels undoubtedly encouraged others, particularly naval commanders, to patronise Serres and thus provide him with the solid continuing workload he was to enjoy for the rest of his life.

2. Erica Davis file note National Maritime Museum.

THE SANDBYS AS FRIENDS AND THE PATRONAGE OF 'GENTLEMEN OF RANK IN THE NAVAL DEPARTMENT' 1763–1768

Although Serres evidently brought himself to the attention of the public by his intense activity with the printmakers in the early years of the decade, he was, at the same time, taking advantage of the new public art exhibitions to display his work directly to potential buyers. His growing prominence, as well as his warm personality, would have strengthened the ties of friendship which he was already forming when he moved from London Bridge to the West End, and enabled him to widen his circle of acquaintances in the artistic community. It seems that the Sandby brothers were Serres's close and supportive friends and played an important part in helping him to establish himself not only in the company of artists but also in engaging the favour of patrons.

Thomas Sandby, partly because of his position of responsibility in the household of the Duke of Cumberland and occupation at Windsor, but also in part owing to his agreeable personality, made the acquaintance of many of the leading families. He and his wife had ten children and the list of sponsors at their baptisms gives an idea of Thomas's range of distinguished patrons: George Keppel, Viscount Bury, sponsor of their third child, William Keppel, born on 10 December 1761; Hon. Colonel William Keppel; Augustus Hervey of the family of the Earl of Bristol; Lord Amherst and his wife; the Duke of Cumberland and his wife, Anne Horton. A cousin, the Reverend George Sandby, had connections with Lord Anson and Admiral Boscawen and had been at Winchester College with Francis Greville, Lord Brooke, whose sister-in-law had sponsored Thomas Sandby's first child.[1] Many of these names, or members of their families, occur as patrons of Serres in these formative years of the 1760s or bear other relationships to him and his family, and it seems likely that the Sandbys were instrumental in effecting at least some of the introductions.

For the field was by no means uncontested. There were other established marine artists working at this time, some of whom were active and successful in the spheres Serres was now entering. Samuel Scott had been patronised by George, Lord Anson (1697–1762), was a friend of Hogarth and, now living at Twickenham, friendly with his neighbour Horace Walpole, who owned eight of his paintings and several drawings, and who accorded him a place in his *Anecdotes of Painting*. Joseph Farington recorded that Scott 'had much business and gained by his profession about 700 or 800 l [£] per year', being able to charge '60–70 guineas for a 6-foot by 4-foot canvas; 40 guineas for a half-length and 25 guineas for a Kitcat'.[2]

Other marine artists were John Clevely (c.1712–77), whose twin sons, John (1747–86) and Robert (1747–1806), followed in his footsteps, and Richard Paton (1717–91), taken to sea as an artist by Admiral Sir Charles Knowles, who was always busy with work for the engravers. Francis Holman (1729–84), Francis Swaine (c.1720–83), Thomas Mitchell (1735–90) and Richard Wright of Liverpool (1735–75), winner of premiums at the Society of Arts, were all painters with experience of ships and the sea who were meeting the strong demand for

1. J. Ball, *Paul and Thomas Sandby R.A.*, Cheddar, 1985, pp.149–217.
2. *Joseph Farington's Diary*, J. Greig ed., 8 vols., 1922–28; K.Garlick, A. Macintyre and K.Cave ed., 12 vols., 1979–83, 31 July 1796.

COLOUR PLATE 19. 'Elizabeth Castle, St. Helier, Jersey', oil on canvas, signed and dated 1764, 25 x 32 ins. (64 x 82 cm). Serres travelled in search of subjects and this is a true landscapist's handling of the imposing coastal scene.
Jersey Heritage Trust

marine and naval pictures. But, as late as 1764, *The Gentleman's Magazine* could state that Scott, Wright and Paton 'must stand foremost in painting shipping'. A younger generation of talented marine painters was also soon to emerge, in particular Nicholas Pocock (1740–1821) in Bristol and Robert Dodd (1748–1815). It was the unique capability of Dominic Serres as a landscape painter, perhaps even being regarded primarily as such, that set him apart from the common run of marine painters and opened privileged doors to him.

This attribute is well illustrated by a painting from 1764, which also shows that Serres travelled widely in search of material. 'Elizabeth Castle, St. Helier, Jersey' (Colour Plate 19) is a landscapist's handling of the imposing coastal scene, based on observation and sketches from that actual viewpoint, rather than from the sea in, perhaps, a hired boat. The balance of the composition, both landward and seaward, is already characteristic of Serres's developed technique.

Serres undoubtedly had a pleasant and engaging personality. Already over the age of forty and mature in 1760, a gallic flair, combined with his travels and varied experiences of life, would have made him an unusual figure in London artistic circles and enabled him to establish a rapport with others in society, and particularly the navy, of similarly wide experience. Edwards described him as 'a very honest and inoffensive man, though in his manners, "un peu

Gascon" '. The last word, clearly referring to his birthplace and perhaps a somewhat rustic bearing, is defined in the *Oxford English Dictionary*, as being 'a braggart'. The few anecdotes and letters which survive, and the several portraits, do not, however, seem to portray him in this light. He was once described as 'a fine boisterous fellow' and seems to have been cheerful, hail-fellow-well-met and, in the sense of 'Gasconade', evidently a good self-promoter. But he was at the same time loyal, rigorously disciplined and conscientious about his work and expected the same high standards of his family. His qualities were recognised by a position of influence and respect in the French expatriate community in London. The portraits, especially Philip Jean's miniature (Frontispiece), depict him with sensitive, finely-chiselled features and a lively, slightly amused expression. Although not lacking in self-confidence, he may not have been an overly assertive personality and this, together with his French origins and the need to establish himself in his profession, may account for the absence of his name from those taking the initiatives to establish academies and exhibitions.

These attributes would have appealed to the Sandby brothers and helped persuade them to support Serres in his struggle for recognition. Both Thomas and Paul Sandby played leading roles in improving the standing and perception of artists, and Paul, particularly, possessed a warm personality and propensity for friendship. Dominic evidently became a good friend, and later neighbour, of Paul, and there is a case for suggesting that, as a result, Paul and his brother positively promoted Serres's positioning in the artistic hierarchy. Serres followed Paul Sandby's move from membership of one artists' society to another during the 1760s and finally became, with him, a founder member of the Royal Academy. While Serres had other supporters and sponsors during these years, the Sandby brothers probably played a decisive role in his achievement of a place in the front rank of marine landscape painters by the end of the decade.

Once Serres had made the breakthrough by the publication of the print series and the resultant substantial direct commissions, an ever-expanding circle of influential naval commanders was happy to patronise him. His paintings received wider exposure and appreciation at the public exhibitions, particularly at the Royal Academy after 1768, where he exhibited every year during the rest of his life, a total of 105 paintings in all. Personal recommendation among naval commanders was another important factor in the growth of demand for his work – a network of interrelationships of family, friendship, comradeship in the service and political association can be traced between most of his patrons. Having established himself as a successful marine painter in a secure social situation, Serres does not appear to have lacked a steady flow of commissions, especially as wars, threats of wars and memories of wars persisted throughout his life-time. He seems, therefore, to have been able to maintain a comfortable life-style, even if not the most affluent. The very large collection of paintings and drawings he amassed, including many van de Velde drawings, does not suggest a state of penury.

There could, of course, be disadvantages attached to such naval commissions, as a contemporary French visitor to England pointed out:

> It is become almost the fashion for a sea-officer, to employ a painter to draw the picture of the ship which he commanded in an engagement, and where he came off with glory; this is a flattering monument, for which he pays with pleasure. The hero scrupulously directs the artist in every thing that relates to the situation of his vessel, as well in regard to those with whom, as to those against whom he fought. His politeness will not permit him to put anyone out of his place; and this is a new point, of which the painter must take particular care. And indeed an error in arrangement, upon this occasion, might be taken as a very great incivility.[3]

3. A. Rouquet, *The Present State of the Arts in England*, 1755, pp.60–66.

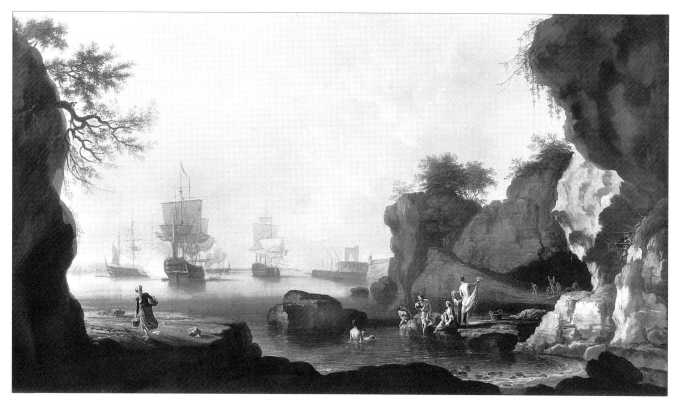

PLATE 32. 'Shore scene with shipping and bathers', oil on canvas, signed and dated 1765, 29 x 52 ins. (73 x 130 cm). Claude Joseph Vernet, the leading French marine landscape painter of the time, was an early influence on Serres, who had a great respect for the French artist and later struck up a friendship with him, going to Paris at his suggestion in 1785. Photograph courtesy Antique Collectors' Club

Or, as the Reverend William Gilpin (1724–1804), Sawrey's elder brother, rather more succinctly described Samuel Scott's work: 'The Hall [Shugborough] is adorned with the naval achievements of Lord Anson by Scott, in which the genius of the painter has been regulated by the articles of war'.[4]

1765: The move to Warwick Street, Golden Square

After his profuse submission to the 1763 exhibition, Serres's contribution to the 1764 show of the Free Society of Artists was limited to two paintings 'A large sea-piece, painted by desire, in the stile of Vernet' (no. 159) and 'A brisk gale' (no. 160). The painting in the style of Vernet is of interest from a number of points of view. Claude Joseph Vernet (1714–89) was one of the leading painters of the mid-century in France and by far the most distinguished marine landscape artist. If it was a patron who wished Serres to imitate Vernet it is an indication of the continuing preference of some English patrons for established continental rather than emerging indigenous practitioners. If it was an initiative of Serres himself, it reflected the importance of Vernet in England and Serres's response to his work. There were several Vernet pictures in England by this time; the Duke of Bedford acquired two this same year, and there would have been no shortage of prints, particularly of Vernet's major series of large paintings of the Ports of France, commissioned by the French King. Vernet's style was to have some influence on Serres, although more in the composition and handling of subject matter than in painterly technique, where he opted for less elaborate methods and effects than the Frenchman. 'Shore scene with shipping and bathers' (Plate 32), signed and dated 1765, is an illustration of Serres responding to the Vernet style at this time. He continued to retain a great respect for Vernet and was later to strike up a friendship with him (see Chapters VI and X).

The year 1765 saw two significant changes in Serres's life and career. At the spring

4. Reverend W. Gilpin, *Observations relative chiefly to Picturesque Beauty*, 2 vols., 1772, Vol. I, p.65.

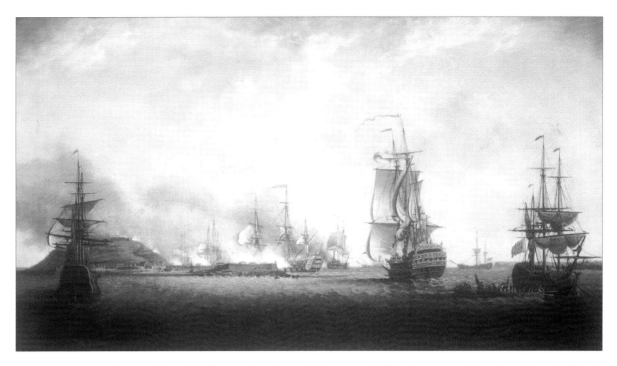

COLOUR PLATE 20. 'The attack on Goree, 29 December 1758', oil on canvas, 24 x 42 ins. (61 x 106.5 cm). Serres's first commission from Augustus Keppel was probably for a set of paintings to commemorate the capture of Goree, off the West African coast, by a squadron under his command. This scene shows the ships approaching and the bombardment beginning. M.o.D. Art Collection, National Maritime Museum, London

exhibitions he changed his allegiance from the Free Society to the Society of Artists, which that year received its charter and became known henceforth as the Incorporated Society of Artists. It continued to hold its shows at the room in Spring Gardens, between what is now Trafalgar Square and Admiralty Arch. The Society of Artists had been growing in stature as a result of the quality and eminence of its artists, while the Free Society had been less successful. The exhibitions of the latter removed from the Society of Arts in 1765 to Maiden Lane, Covent Garden, and later to other locations, finally ceasing in 1783. Having made the change, Serres did not again support the Free Society.

The encouragement of Paul Sandby's friendship may have been a reason why Serres decided to join the Incorporated Society and also, later in the year, to move house closer to Sandby's home in Du Four's Court, Broad Street, Carnaby Street. Edwards says of the move from Piccadilly: 'In this situation, it should seem, that he acquired notice, as from this place he removed to Warwick-Street, Golden Square, where he obtained much respectable employment, and acquired the patronage of some gentlemen of rank in the naval department'. The inference is that Serres no longer needed to display his pictures in the window, and that the house to which he and his wife moved was probably larger in order to accommodate their growing family.

Many of the naval commanders who now increasingly patronised Serres had returned from the war after the signature of the Treaty of Paris early in 1763. Usually wealthy with prize money, they were anxious to have their exploits commemorated in pictorial and tangible form and Serres was to be kept busy carrying out their commissions. Perhaps these were not ready when he submitted his opening contribution to the Incorporated Society in 1765, for it consisted of only two works, 'A seaport' and 'A large sea-piece' (nos. 114 and 115), which have uninformative titles and may again have owed something to Vernet.

Early the following year Serres was commissioned by another discriminating patron, who preferred Old Master paintings, to copy a work by van de Velde. The connoisseur was Edward Knight (1734–1812) of Wolverley, Worcestershire, a wealthy and cultured collector, cousin of

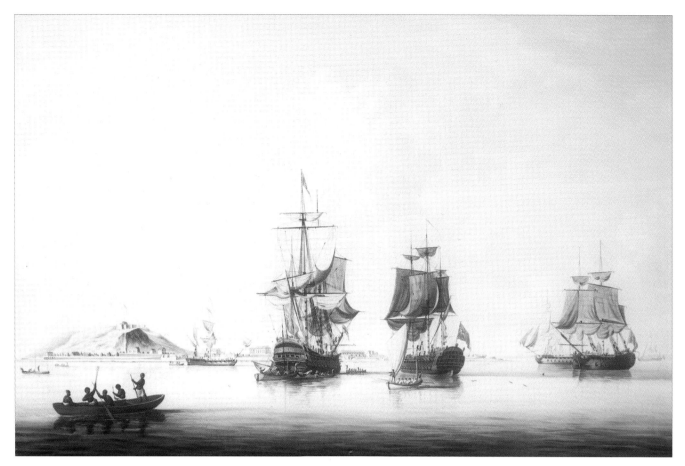

COLOUR PLATE 21. 'The attack on Goree, 29 December 1758; ships at anchor after the action', oil on canvas, 20½ x 31½ ins. (52 x 80 cm). Demonstrating Serres's preference for a more peaceful scene, this painting exemplifies his atmospheric handling of light and space. Its excellence suggests this was probably the painting exhibited under a similar title at the Society of Artists in 1768.

Art Collection, National Maritime Museum, London

Richard Payne Knight and brother-in-law of Coplestone Warre Bampfylde (1720–91) of Hestercombe (see page 187). His circle of friends included the poet William Shenstone, Sir George Beaumont and Nathaniel Marchant, the gem engraver. Edward Knight's cash book has an entry for 22 February 1766: 'Ordered of Serres a copy after Vandevelde 23 in. by 17 at 6 gns.'. How Serres came to know this member of the Worcestershire landed gentry, and perhaps, through him, other friends and patrons, is not clear. The acquaintance could have originated during his visits to the area some years previously when he painted Warwick Castle. Knight's cash books, which continue until 1792, are very detailed, meticulously noting every item of expenditure down to a few shillings, but there is no reference to Serres having been paid for the picture. Twenty years later Serres exhibited two paintings at the Royal Academy in 1786, both entitled 'Sea piece, in the style of Vandervelde, by the particular desire of a gentleman' (nos.197 and 213). One is left to speculate whether perhaps Serres made at least two efforts at copying the van de Velde painting, but that neither had come up to Knight's expectations and he had declined to accept either of them.

Nonetheless, he was willing to employ Serres again for, six years later, a further cash book entry for 3 June 1772 reads: 'Serres painting ships in Mr. B's picture £1. 01. 0.'. 'Mr. B'. is assumed to be Coplestone Warre Bampfylde who was an amateur artist, principally of landscapes. Later again, in 1785, Edward Knight was to buy a miniature by Olivia Wilmot (to become Serres) for '£3. 3. 0.'. As Olivia would then have been only thirteen, this may have been more in the nature of an encouragement to the young artist.[5]

5. J. Lane, 'The Dark Knight: Edward Knight of Wolverley and his collections', *Apollo,* June, 1999, pp.25–31. Information provided by Dr. Lane is gratefully acknowledged. The Knight archive is held at Worcestershire Record Office BA 10470/2; 899.310.

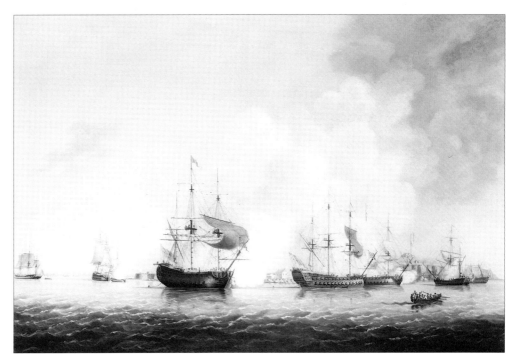

PLATE 33. 'The attack on Goree, 29 December 1758', oil on canvas, 20 x 32 ins. (51 x 81.5 cm). This, like Colour Plate 20, shows the bombardment in progress and expresses the intimidating effect the sudden arrival of warships must have had on the garrison of the island outpost.

National Maritime Museum, London

Recording the 1758 capture of Goree for Augustus Keppel

The first commission Serres received from Augustus Keppel for large retrospective paintings of his naval achievements was probably to commemorate the capture of Goree in December 1758 (see page 33). Four paintings of the operation are known, two showing the squadron approaching and attacking the island (Colour Plate 20 and Plate 33) and two of the ships at anchor after the action, one of which is illustrated at Colour Plate 21. The largest is signed and dated 1766. Two of the views, Colour Plate 21 and Plate 33, are a similar, smaller size, and thus probably a pair painted as an alternative version. All four expansive views demonstrate the essential qualities of Serres's style, the skilful blending of space and light and the contrast of the bulk and strong verticals of the ships against the carefully drawn forms of the background island. Detail is accurately rendered with due regard to sightlines and perspective. The peaceful scenes after the capture typically contrast with the vigour of the attack and the implicit thunder of the gunfire. One of the paintings was hung at the Special 1768 Incorporated Society of Artists' exhibition under the title 'A view of Goree, with Admiral Keppel's Squadron lying before it' (no. 106).

Paintings for Augustus Hervey

By the same year, 1766, Serres was executing commemorative pieces for another important patron, Captain the Hon. Augustus John Hervey (1724-79), who was later to become the 3rd. Earl of Bristol. Hervey had pursued a naval career since 1736 which took him to the Mediterranean and West Indies as well as western European waters. In the early part of the Seven Years' War he was in the Mediterranean in command of the *Phoenix* (20 guns) and took part in Byng's action off Minorca in May 1756, remaining, thereafter, one of the Admiral's staunchest supporters and defenders. The actions he wished to have perpetuated in oils were, understandably, of a more individual nature. Hervey was nothing if not an individualist and his amorous activities, revealed in his journal, earned him the appellation 'the English Casanova'. Being well-connected and the dashing commander, at this time, of a small frigate, he was often detailed, or allowed, by his admiral to go 'cruising'. This meant a detached assignment, usually for scouting, which provided the opportunity to cruise in populous waters and, with luck, to capture enemy merchant vessels and warships. Ransomed or bought in by the Admiralty, these would furnish generous prize money for the admiral as well as allocations for the captain,

officers and crew of the *Phoenix*. Hervey was also adept at securing another type of assignment, profitable in this case only for the captain, that of carrying specie on behalf of the government.

The term 'cruising' passed into colloquial use, at least among naval families. Fanny, the wife of Admiral Edward Boscawen, writing from London to her husband in March 1747, says: '[Allan] Ramsay [the Scottish portrait painter, a great friend of the Boscawens] dined and is now sent out on a cruise to Mrs. Clayton's etc. to see if he can bring in any prizes by way of addition to the fireside . . .' Later in the same letter: 'Ramsay returned from his cruise without bringing in one prize . . .'[6]

Relations between England and France had been deteriorating rapidly since 1755 with a state of undeclared war prevailing. It was only on receipt in London of the news of the French invasion of Minorca that, on 18 May 1756, war was formally declared. Hervey, on his cruises in the *Phoenix*, eagerly joined in these hostile preliminaries. Ranging around the eastern Mediterranean and under instruction to 'distress' French shipping, his journal entry for the 8 November 1755 reads:

> The wind being very hard westerly I bore away for the island of Argenteira [now Kimolos, one of the Greek Cyclades, three miles north-east of Milos] which is a better road than Milo, as you can get out at all weathers and there are three passages, whereas Milo is a very fine bay but you cannot get out with any wind. I arrived at two in the afternoon and between the main of the island, where the town of Argenteira is, which is a walled one on the summit of it, and a little low island on the larboard side, there were several sail of French ships whom I soon fired at and sent my boats to take possession of, there being no fort here nor any kind of government.

Gales twice forced him back to the anchorage but at the third attempt, on 25 November, he was able to get away with his prizes and 'took two more prizes in my way down to Malta'.[7]

Serres's painting of this action is, in chronological order of the events portrayed, the first of a set of three painted for Augustus Hervey. It carries the subtitle across its foot 'H.M. Ship Phoenix, Capt. Hervey taking 14 French ships at Argenteira, Nov. the 9th. 1756' (Colour Plate 22). The addition of a year to the date was probably in order to give the action legality, placing it after the declaration of war. On 9 November 1756 Hervey was in fact on his way back to England to appear as a witness at Byng's court martial. After many months of litigation the capture and ransom of the ships was shown to have been a mistake, as the vessels were deemed to have been under neutral Turkish protection. Hervey was ultimately obliged to pay £6,000 in compensation for the prizes, from which his personal finances were to suffer for many years.

In June 1756 he was promoted into the *Hampton Court* (64 guns) and continued in the Mediterranean fleet. The subtitle on the second painting in the set is: 'Capn. Hervey in the Hampton Court burning the Nimph French Frigate of 36 guns on the coast of Majorca, June ye 21st. 1758'. His journal entry reads:

> The 20th I chaced a ship in the evening off Majorca, which, with little wind, I could not get up to, but made her a French frigate of 32 guns. The Revenge could not get up at all, it was so little wind. The French ship rowed and towed endeavouring to get into Alcudia Bay . . . It was now almost night . . . At daylight I . . . towed my own ship in . . . hailed the French man-of-war to strike and give up…but he set fire to his ship. As his guns were all pointed into me, and I feared his blowing up so near me, I immediately fired a broadside into him, and she sank on one side immediately.

6. C. Aspinall-Oglander, *The Admiral's Wife*, 1940.
7. All references are to Augustus Hervey's Journal, ed. D. Erskine, 1954, pp.185–287.

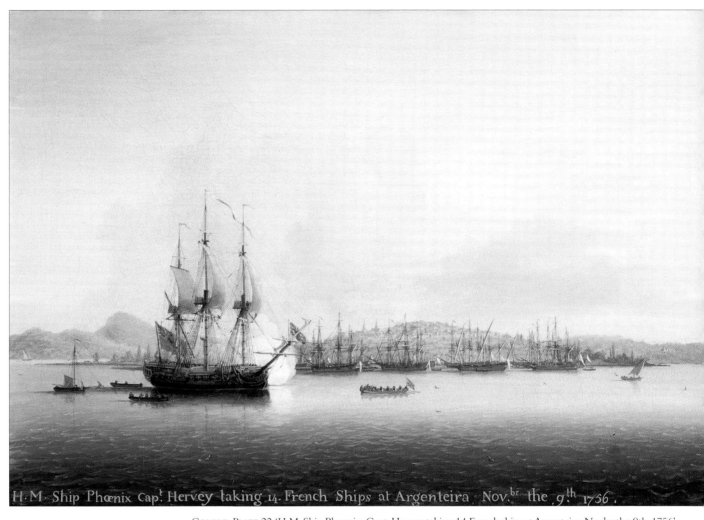

H.M. Ship Phœnix Cap.^t Hervey taking 14 French Ships at Argenteira Nov.^{br} the 9.th 1756.

COLOUR PLATE 22. 'H.M. Ship Phoenix, Capt. Hervey taking 14 French ships at Argenteira, Novbr. the 9th. 1756', oil on canvas, signed and dated 1769, 20 x 29 ins. (53 x 75 cm). Serres was commissioned to paint a retrospective series commemorating the naval engagements of Augustus Hervey, when he was a young frigate commander. Meanwhile, his amorous exploits prompted him to become known as 'the English Casanova'.

Ickworth. National Trust Photographic Library/Angelo Hornak

These two paintings are at Ickworth, the seat of the Bristol family in Suffolk, while the third of the set is in the National Maritime Museum, Greenwich, its subtitle is: 'Capn. Hervey in ye Monmouth burning the Rose F. Fte. [French Frigate] of 36 guns under ye Walls of Malta, July ye 1st. 1758, the Lime and Ambuscade Frigates in Company' (Plate 34). Hervey's journal recounts the incident:

> The 1st July in the evening we saw a sail off the West end of Malta that appeared a frigate. We chased her with little wind all night, and at daybreak we saw her about four miles off and scarce a breath of wind . . . I had very little regard to the neutrality of the island of Malta [controlled by the Knights of Malta] . . . as I looked upon it as little less than an arsenal for the French ships of war . . . About 8 in the morning the French frigate was rowing and towing with a very light air of wind close in with the shore, endeavouring to fetch into Malta . . . She fired at me, and luckily gave me that handle to begin . . . The instant that I fired at her the batteries on shore, which were crowded with people, began to fire at me, being then about a musket shot from the shore . . . The French frigate began to run on shore . . . I sent my Lieutenant with orders to destroy her . . . but before this could be executed she took fire, and was instantly in a blaze, and about 10 blew up.

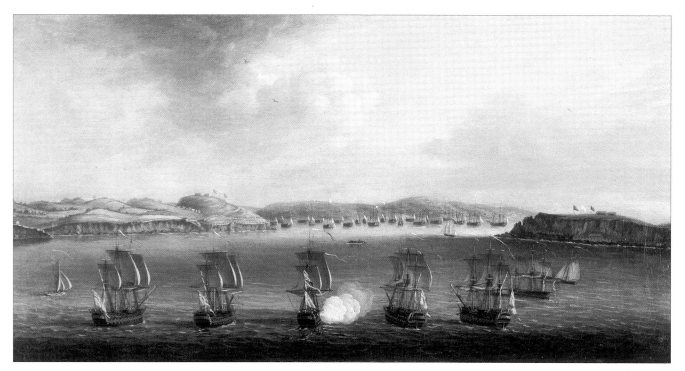

COLOUR PLATE 23. 'Naval Action', probably the blockade of Brest in 1759, oil on canvas, signed and dated 1763, 13 x 26 ins. (33 x 66 cm). Although apparently a pair to Colour Plate 24 of Martinique, this view seems to be European and could be off Brest in 1759. Hervey was then in command of the inshore squadron maintaining a close blockade of the port, while Admiral Hawke and the main fleet cruised off Ushant.

Ickworth. National Trust Photographic Library/Angelo Hornak

The Grand Master of the Knights sent off a deputation, accompanied by the British Consul, to protest at this action, to which Hervey replied 'Qu'ayant eu l'honneur de voir son eminence le Grand Maitre sur son balcon, je ne pouvoit faire autrement que lui donner un feu de joie'. There was no further riposte from either the Knights or the French.

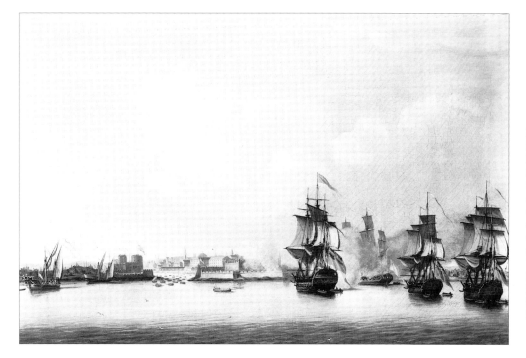

PLATE 34. 'Capn. Hervey in ye Monmouth burning the Rose F. Ft. [French frigate] of 36 guns under ye Walls of Malta, July ye 1st. 1758, the Lime and Ambuscade Frigates in Company', oil on canvas, signed and dated 1769, 21 x 30 ins. (53.5 x 76 cm). The third of the set, commemorating another skirmish ten years earlier. This one ended before the walls of Malta, with the inhabitants looking on, and Hervey sending an impertinent message to the Grand Master.

National Maritime Museum, London

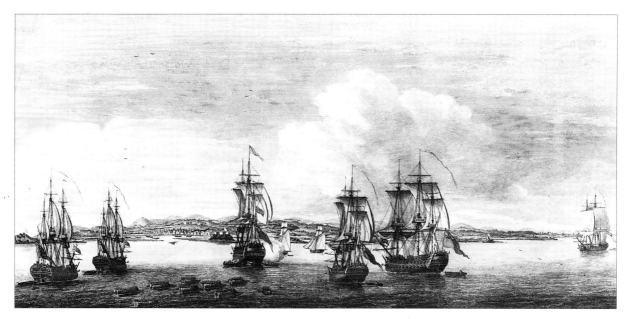

PLATE 35. 'The taking of the port of La Trinité and all the north side of the island of Martinique by the Hon. Comdre. Hervey Febry. 11th. 1762', engraving by P.C. Canot after D. Serres, published by Canot in February 1775. Canot's decision to publish this print nine years after Serres's original oil painting (Colour Plate 24), points to the continuing public interest in the events of the Seven Years' War. National Maritime Museum, London

Hervey in the West Indies

Serres had previously made a pair of paintings for Hervey, one of them dated as early as 1763. This, also at Ickworth, is known as a 'Naval Action' (Colour Plate 23), although the situation appears to be closer to that prior to the capture of the vessels at Argenteira. The precise nature and location of the incident, as the English squadron lies off a high shoreline which shelters a fleet of French ships in the land-locked bay, has not been determined with certainty, but seems likely to have been off Brest in 1759. While Hawke with his main fleet cruised off Ushant to maintain a loose blockade, he sent Hervey and a light squadron to keep a close watch inshore. At one point four ships-of-the-line emerged from Brest to attack the inshore squadron, but Hervey, instead of retiring, went to meet them and, with the support of the fleet, drove them back into the port.

The painting which seems to be its pendant, being of similar size and distinct framing, but dated 1766, is a West Indies view, inscribed 'The taking of ye Port of La Trinité & all ye North Side of ye Island of Martinique by ye Hon. Comdre. Hervey Febry. 11th. 1762' (Colour Plate 24). Hervey, promoted in January 1760 to the *Dragon*, a new 74-gun ship, had left his happy hunting ground in the Mediterranean and joined Keppel's squadron for the capture of Belleisle in 1761 (see pages 34-40). He was then posted to the Caribbean and came under Admiral Rodney's command on the Leeward Islands station. In January 1759, an unsuccessful attack had been made on Martinique, the heart of the French presence in the area, but the force had gone on to occupy the nearby island of Guadeloupe. With the conquest of the French empire in North America after the capture of Quebec, ships and troops were available for an attack on Martinique, the last major French island stronghold in the Caribbean. Rodney set out from Barbados in January 1762 with a strong naval force, and transports carrying almost 14,000 troops under Major-General the Hon. Robert Monckton, to carry out the assault. While Rodney and Monckton concentrated their main attack on the south-western coasts of the island and the heavily defended Fort Royal area, Hervey was despatched with part of the force on a diversionary operation to capture La Trinité on the north-east coast. He and the 500 troops with him were successful in taking the town, whereupon the

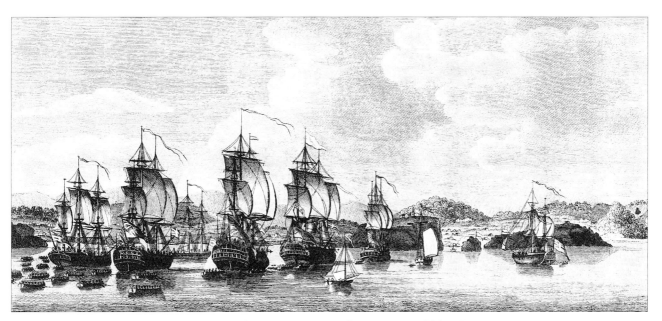

PLATE 36. 'A view of the island of St. Lucie', etching by P.C. Canot after D. Serres, published by Torre. Although Serres's original oil painting was clearly of Hervey's attack on St. Lucia in 1762 (Colour Plate 25), and Canot died in 1777, this print was published years later over the inscription, in English and French, 'Taken Dec. 31, 1778 by the Honble. Admiral Barrington'. Engraved plates were durable enough, with some reworking, to be put to repeated use! National Maritime Museum, London

northern part of the mountainous island capitulated. This was the action Serres was called upon to celebrate in his painting. By the end of February the entire island was occupied, providing, a few months later, a convenient watering place for Pocock's fleet on its way to Havana. Hervey's success was popularised and perpetuated by P.C. Canot publishing his engraving of Serres's painting in February 1775 (Plate 35).

Following this success, Hervey was very soon afterwards, on 24 February, again detached, with four ships, to take St. Lucia. Arriving off the narrow harbour entrance of the Carenage, now Castries, shown in Serres's painting of this operation (Colour Plate 25; see also map Plate 62), Hervey was unable to determine the strength of the defences. By way of subterfuge he sent one of his officers in with a flag of truce to demand capitulation of the garrison, but also went himself disguised as a midshipman interpreter. This reconnaissance confirmed that the place could be taken, and when preparations were made the next morning to do so, the Governor surrendered.

A print very closely resembling Colour Plate 25 seems to have had an interesting history (Plate 36). The principal difference with the painting is the removal of a small man-of-war from the (viewer's) right-hand side of the harbour entrance to the left-hand side. The print appeared as an etching with the inscription, in English and French, 'A view of the Island of St. Lucie, taken Dec. 31, 1778 by the Honble. Admiral Barrington' and the details 'D. Serres pinx.; P.C. Canot sculp.', published by Torre. No imprint has been traced with lettering referring to Hervey's action in 1762. Canot died in 1777 so the plate must have been engraved before 1778 and may at that time have been correctly finished and, perhaps, published. An enterprising publisher then probably decided to put the plate to good use, almost twenty years later, by reissuing it, after reworking, with a fresh caption. The public's appetite for these commemorative prints, especially in time of war, was such that the publisher could practice deceptions of this nature with impunity. The image was clearly durable, for the print was reissued years later, with the same caption, in a French edition by Antoine Suntach (1776–1842), an engraver working abroad, who made a practice of copying English prints.

The last painting by Serres, still on display at Ickworth, is of a famous victory, also in the

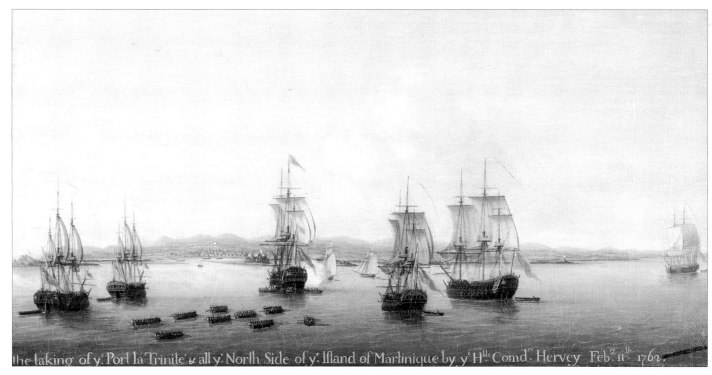

the taking of y^e Port la Trinité & all y^e North Side of y^e Island of Martinique by y^e H^{ble} Comd^{re} Hervey Feb^{ry} 11th 1762.

COLOUR PLATE 24. 'The taking of ye Port of La Trinité & all ye North Side of ye Island of Martinique by ye Hon. Comdre. Hervey Febry. 11th. 1762', oil on canvas, signed and dated 1766, 13 x 26 ins. (33 x 66 cm). Hervey was despatched by Admiral Rodney and General Monckton, who were attacking the south-west coast, to carry out a diversionary attack on the north side of the mountainous island.

Ickworth. National Trust Photographic Library/Angelo Hornak

West Indies, but twenty years later, after Hervey's death in 1779. It is a smaller panel inscribed: 'Lord Rodney conveying the Ville de Paris into Port Royal, Jamaica. D. Serres Pinxit Bath 1788' (Colour Plate 26). This commemorated Rodney's historic engagement with Vice-Admiral Comte de Grasse at the Battle of the Saintes on 12 April 1782, towards the end of the next major war, the War of American Independence, when the French flagship of 104 guns was captured. The origins of the painting are unknown. A picture of similar title was exhibited at the Royal Academy in 1790 (no. 169), where it was described as being ' a frieze for a chimney piece'. Although the Ickworth painting is on panel, it seems to be too small for such a purpose. Rodney was among Serres's patrons (see pages 154–156) and another, larger version of this picture is one of a pair, the other being a depiction of an incident during the battle, both also signed and dated 1788, which may have been painted for the Admiral. Although Rodney was frequently at Bath for the sake of his health, he was not there in 1788 at the same time as Serres was taking the waters at the spa, and this may have been a copy the artist made for another client while he was in Bath, possibly for a member of the Hervey (Bristol) family.

Opposite above: COLOUR PLATE 25. 'The Taking of the Island of St. Lucie by the Honble. Comdre. Hervey, Febr. 26th. 1762', oil on canvas, 35 x 60 ins. (89 x 152.5 cm). After Martinique, Hervey was promptly sent to capture the neighbouring island of St. Lucia. Serres's painting shows the squadron off the Carenage, now Castries, and the inscription painted across the foot identifies it. Nevertheless, a print very closely resembling this image later enjoyed several reincarnations to commemorate Admiral Barrington's actions at the same location during the War of American Independence, in 1778 (Plate 36). National Maritime Museum, London

Opposite below: COLOUR PLATE 26. 'Lord Rodney conveying the Ville de Paris into Port Royal, Jamaica', oil on panel, signed and dated Bath 1788, 12 x 18 ins. (30 x 46 cm). This small panel, painted twenty years later than Serres's pictures for Hervey, commemorates the battle of Les Saintes, 1782, during the War of American Independence, when the French flagship was captured. Serres typically opts for the more peaceful scene of the prizes being proudly brought into the British base rather than depicting the heat of the battle itself.

Ickworth National Trust Photographic Library/Angelo Hornak

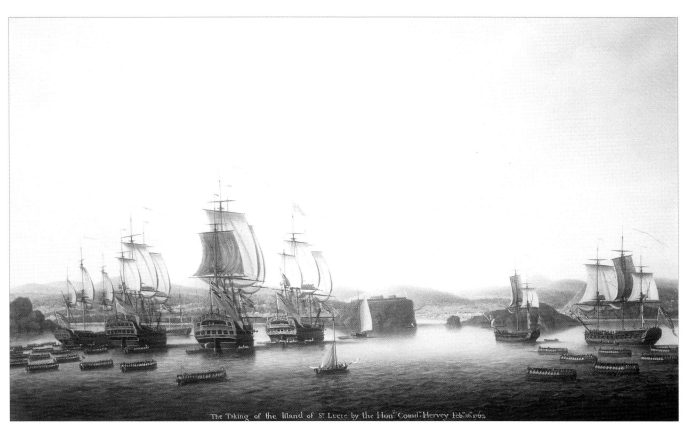

The Taking of the Island of St Lucie by the Hon.ᵇˡᵉ Comd.ʳ Hervey Feb.ʳˡᵏ 1762.

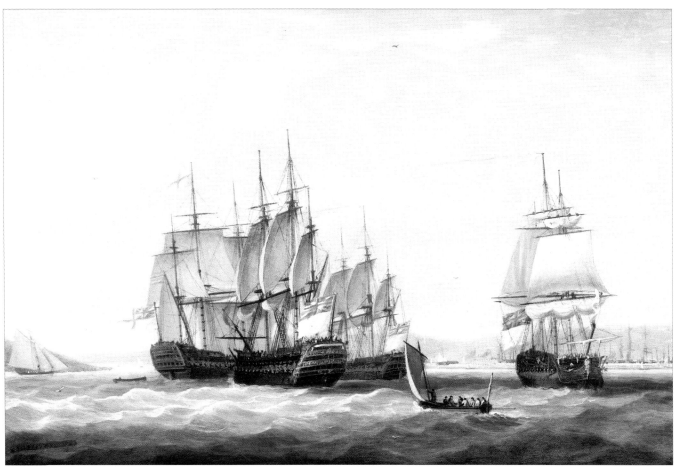

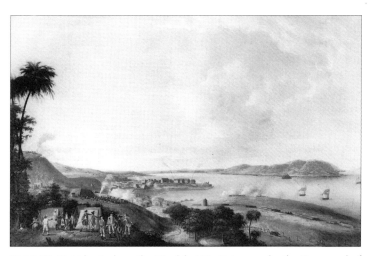

PLATE 37. 'British attack on the Citadel at Martinique under the Command of Sir Robert Monckton, January 1762', oil on canvas, signed and dated 1767, 24 x 39 ins. (61 x 99 cm). General Monckton was the military commander with Rodney when they attacked the south-west side of the island. He commissioned this fine landscape and is presumably one of the group of officers depicted in the foreground.
Anglesey Abbey. The Fairhaven Collection (The National Trust). Photograph: Photographic Survey, Courtauld Institute of Art

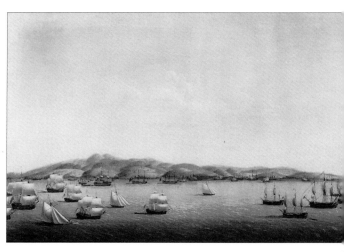

PLATE 38. 'Rodney's fleet Bombarding Martinique and British Troops land under Sir Robert Monckton, February 16 1762', oil on canvas, 24 x 39 ins. x 99 cm). The second of the pair commissioned by Monckton. requirements of a broad maritime view of the coast and distant bombardm result in a lack of foreground interest and a less satisfactory composition.
Anglesey Abbey. The Fairhaven Collection (The National Trust). Photogra Photographic Survey, Courtauld Institute of

The Capture of Martinique

Serres painted two other larger pictures of the attack on Martinique at about the same time. These were for General Monckton, the military commander. The more military, 'British attack on the Citadel at Martinique under the Command of Sir Robert Monckton, January 1762' (Plate 37), is signed and dated 1767, and shows Serres at his best in portrayal of landscape, figures and military activities as well ships and the sea. The other, a naval subject, entitled 'Rodney's Fleet bombarding Martinique and British Troops landing under Sir Robert Monckton, February 16 1762' (Plate 38), is less effective. The search for a panoramic format to demonstrate the topography and imposing array of sea power has resulted in a rather formal and lifeless depiction, with the action of bombardment and landing lost in the distance against the shoreline. The transports and cutters are shown correctly sailing by the wind, giving variety left and right in the middle distance and leaving a clear sightline to the shore, but there is a lack of foreground interest. Both paintings passed by descent in the Monckton family and are now in Anglesey Abbey, near Cambridge.

Paintings at Plymouth

As time permitted between the commissions, Serres was active in England, travelling to obtain topographical and interesting material for use in this paintings. Drawings survive and derivations from them were to appear in *Liber Nauticus*, illustrating types of vessel in English and continental coastal situations. At the Incorporated Society of Artists in 1766 Serres exhibited 'A sloop, with a view of Calshot Castle, the Isle of Wight at a distance' (no. 154) which may have been the original for Plate XVIII in *Liber Nauticus* (Plate 39), and in 1767 'The return of a fleet into Plymouth Harbour, with a prize' (no. 139). The latter was probably one of a fine pair of paintings of this subject, now at Greenwich, both signed and dated 1766 (Colour Plates 27 and 28). The two views, apparently taken a few minutes apart, show the vessels moving into Plymouth with a favourable top-sail breeze. The ships are not identified, but in one picture, the central man-of-war flies an admiral's flag at the main top-mast head, which suggests that the pair may have been commissioned by that personage, especially as the prize would have been valuable. Probably of similar genesis, but somewhat

PLATE 39. 'A sloop, with a view of Calshot Castle, the Isle of Wight at a distance', after D. Serres, *Liber Nauticus*, Plate XVIII, published by Edward Orme, London, 1805. Serres travelled constantly to popular places in search of subjects for future paintings. This drawing is probably derived from his painting with the same title exhibited at the Incorporated Society of Artists in 1766. It was a favourite subject for he gave a simliar drawing to Mary Hartley in Bath in 1788.

PLATE 40. 'Drake's Island, Plymouth', oil on canvas, 34 x 48 ins. (86.5 x 122 cm). Painted from the same viewpoint at a less momentous time than that in Colour Plates 27 and 28, this gentle scene suggests that Serres was at heart of a peaceable disposition and preferred to surround his ships with everyday activities.

National Maritime Museum, London

smaller in size, is another view from the same spot, 'Drake's Island, Plymouth' (Plate 40) which provided the foreground interest of shoreside figures. Although Serres was soon to be called upon to produce more belligerent depictions of naval actions at sea, these gentle views over Plymouth Sound give the impression that he was at heart of a peaceable disposition and enjoyed surrounding his ships with the warm comfort of landscape.

Founder member of the Royal Academy

The Incorporated Society of Artists was particularly active in 1768, arranging its special exhibition in honour of the King of Denmark, in addition to its annual show in the spring. Some artists submitted the same works on each occasion, but not so Serres, who had a total of six paintings, three of them from his major series for the Keppels of the capture of Goree and of Havana.

But discord was rife in the Incorporated Society and moves were afoot to promote the establishment of a national academy under royal patronage. These were undertaken by leading members of the Society, principally Benjamin West, William Chambers, Joseph Wilton, Edward Penny, Richard Wilson, G.R. Moser, F.M. Newton and Paul Sandby, and were conducted in great secrecy from the President and office holders of the Incorporated Society. The King was favourably inclined and things moved very fast. On 28 November 1768, twenty-two artists signed a Memorial to the King requesting the establishment of an academy. The King assented and on 10 December signed the 'Instrument of Foundation of the Royal Academy'. The first General Assembly was held on 14 December when the Council of eight members, including Paul Sandby, was elected.

The Council met on 20 December and made various appointments, including that of Mr. William Randall as Stationer to the Society. This was hardly a notable position but it seems to have offered the opportunity to supply the Academy with stationery. Its interest lies in a minute of a Council Meeting of the Academy held over thirty years later, on 3 February 1800, which reads: 'Randall Stationer, some time deceased, and his widow lately deceased, had served the Royal Academy from its Institution. The two Misses. S. and A.C. Serres, Daughters of the late Dominic Serres, Esq. R.A. and Librarian applied to succeed them. And

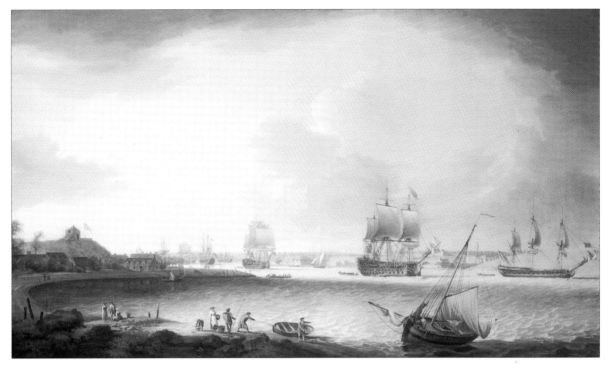

COLOUR PLATE 27. 'The return of a fleet into Plymouth Harbour, with a prize', oil on canvas, signed and dated 1766, 36 x 62 ins. (91.5 x 157.5 cm). A good example of Serres's best coastal landscape technique: foreground interest in Firestone Bay, Drake's Island in the left background with Mount Edgecumbe on the right, powerful cloud and cast light effects and truthful perspective depiction of the ships.

National Maritime Museum, London

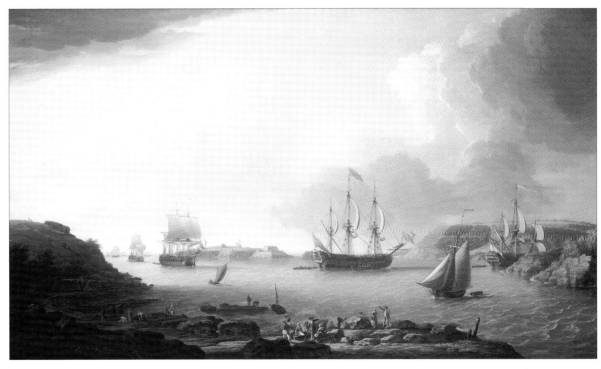

COLOUR PLATE 28. 'The return of a fleet into Plymouth Harbour', oil on canvas, signed and dated 1766, 36 x 62 ins. (91.5 x 157.5 cm). The pair to the previous illustration shows the scene a few minutes later as the men-of-war have sailed slowly further into the harbour, a time-lapse depiction which Serres favoured. The ships are unidentified, but, as the central vessel flies an admiral's flag at the main top-mast head, it is possible that the pair was commissioned by him to commemorate the proud moment of his return home with a prize.

National Maritime Museum, London

they were unanimously assented to'. Augusta Charlotte and Sarah were therefore presumably at that time in business as stationers, but a year later they were again applying to the Academy for charitable support and were granted the sum of 'Twenty Pounds'.

Returning to the events of December 1768, Joshua Reynolds had not been among the twenty-two signatories of the Memorial but was persuaded to join the Academy and became its first President. He declared the Royal Academy formally established and open with his First Discourse on 2 January 1769 and was knighted by the King on the opening of the first exhibition on 22 April 1769.

The Academy was constituted to consist of forty members, although only thirty-six were appointed at the outset. Dominic Serres was one of them. Considered dispassionately, this could occasion some surprise. It has been seen that he was not involved in any of the 'political' activities towards the formation of the Academy, he had not been an office holder in either the Free Society or the Incorporated Society, and he was not one of the signatories of the Memorial to the King. He had obviously been building up a good reputation and a distinguished list of patrons, but these were for landscape and marine paintings. Joshua Reynolds placed history painting at the head of his heirarchy of quality in the arts set out in his inaugural Discourses, delivered at the Academy in the early months of 1769. Marine painting did not figure at all in that ranking and even landscape was accorded a very low place. Furthermore, there were 220 members of the Incorporated Society and the limited membership of the Royal Academy, which included two women, was carefully divided between disciplines.

Why was Serres among the chosen few? His French origin would not necessarily have been a barrier, seven others being of foreign birth, but it would hardly have been considered an advantage. He was classified as a 'painter' and was the only marine painter in the group, a uniqueness which may have helped his selection. The proposition here is that it was Paul Sandby, one of the prime movers in the foundation of the Academy and an inaugural Council member, who advocated and secured Serres's selection, on the basis of their friendship as well as of Dominic's professional talents. This could well have been endorsed by favourable comment from such as the Keppels to the Duke of Cumberland and the King. The appointment as founder Academician was a notable accolade for Serres and immediately gave him an enhanced status from which he was able to continue to develop his successful career. He had moved up in the artistic rankings and henceforth ceased to be a member of the Incorporated Society, not exhibiting again at its shows. His network of patrons expanded and he was kept busy executing naval commissions. Within eight years the War of American Independence would open new theatres of conflict whose images would supercede those of the Seven Years' War.

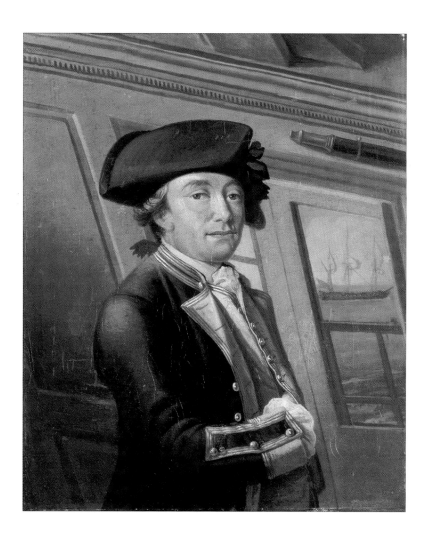

COMMEMORATIVE PAINTINGS; ROYAL PATRONAGE AND ROYAL ACADEMY LIFE 1768-1776

COLOUR PLATE 29. 'Captain William Locker', oil on canvas, signed and dated 1769, 14 x12 ins. (57 x 30.5 cm). The only known portrait painted by the artist. It is a true likeness, in carefully-drawn uniform, appropriately set in a ship's cabin, with a view of Locker's ship seen outside. It is a tantalising hint of what Serres might have achieved if he had pursued this branch of painting.
Yale Center for British Art, Paul Mellon Collection, U.S.A./Bridgeman Art Library

In 1769 Serres was commissioned to recall on canvas a naval action which had taken place twelve years earlier, in July 1757. It was of a single-ship action, only one vessel of each warring nationality participating. These engagements were typically between frigates, light and fast vessels mounting about 28 guns, referred to as 'the eyes of the fleet', which were despatched on lone shadowing, scouting, cruising or similar missions where their sailing and fighting qualities were required. They were often commanded by young, dashing and ambitious captains anxious to achieve fame and, with luck, fortune. Many of the engagements, being between equally-matched ships, showed great courage and skill by both sides, whether victor or vanquished. Any commemorative painting of this nature also had the added advantage of being cheaper, as the canvas, or sometimes panel, was smaller than that required for a major fleet engagement.

In 1756 Admiral Hawke appointed William Locker (1731–1800) Lieutenant in the *Experiment* (20 guns) under Captain Strachan. Strachan was taken ill and for two months was

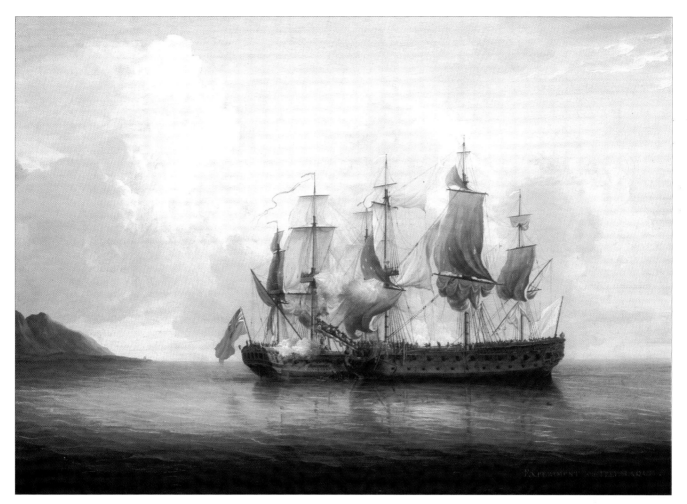

COLOUR PLATE 30. 'H.M.S. Experiment taking the Télémaque, 19 July 1757', oil on canvas, signed and dated 1769, 26 x 37 ins. (66 x 94 cm). William Locker, as a Lieutenant, led the boarding party which captured the *Télémaque* off Alicante. He was wounded in the operation and, to commemorate what was probably his finest hour in action, later commissioned a pair of paintings from Serres. This one shows the opening of the engagement, the other the taking. National Maritime Museum, London

replaced by John Jervis, then Lieutenant in the *Culloden*. Forty years later Jervis was to achieve undying fame as the victor of the battle of Cape St. Vincent, from which he took the title of the earldom conferred on him. Over the intervening years he remained a friend of Locker and also became a patron of Serres. After Strachan's return, the *Experiment* captured the *Télémaque*, a privateer of 20 guns and 400 men, off Alicante on 19 July 1757. The *Télémaque*, relying upon her superiority in numbers, grappled the *Experiment* and tried to board, but was beaten off. Seeing that the enemy were wavering, Strachan, as Locker described it in a letter to his father, 'ordered me to take the men and enter her, which they no sooner saw than they all, or best part of them, got off the deck as fast as they could. We had only two or three men wounded in boarding', one of them being Locker himself.[1] Forty-eight, however, were killed or wounded in the entire action, but this compared with 235 from the *Télémaque*'s crew. Looking back in peacetime, Locker, not unreasonably, felt that this was one of his finest hours and commissioned Serres to capture it in a pair of oil paintings. The first, showing the beginning of the action is now at Greenwich (Colour Plate 30), while the second, depicting the taking of the privateer, was sold from the family collection in 1928.

At the same time Locker persuaded Serres to paint his portrait, the artist's only known foray into this genre (Colour Plate 29). Comparison with other portraits of Locker show

1. Dictionary of National Biography.

it to be a most competent likeness, appropriately dressed in uniform and set in a ship's cabin, with telescope above the open stern-light and anchored frigate beyond. The attention given to the painting of the uniform was a precursor to the series of prints of naval uniforms Serres was to draw and publish some years later. Locker also prevailed upon Serres to paint his country house, Saint Vincents, West Malling, Kent (Colour Plate 31). This has an attributed date of about 1779, probably the year when Locker bought the house.

Locker moved with Strachan to *Sapphire*, in which they took part in the battle of Quiberon Bay, and was in 1760 taken back by Hawke into his flagship the *Royal George*, becoming First Lieutenant. In 1777, after the outbreak of the War of American Independence, Locker was given command of the *Lowestoffe* (32 guns), in which, for the next fifteen months, the young Horatio Nelson was a Lieutenant. Locker's health gave way in 1779 as a result of his wound sustained in taking the *Télémaque* and he was given shore appointments. It was probably at this time that he bought his house in Kent. He was always a well-known figure in the navy and would undoubtedly have helped promote Serres's abilities among his many naval colleagues. In 1793 Locker was appointed Lieutenant-Governor of Greenwich Hospital and while there presented one of Serres's paintings of the 1757 engagement to the Hospital. His son, Edward Hawke Locker, followed his father's wishes and was instrumental in building up the collection of paintings for public exhibition in the Painted Hall of the Hospital. This collection, on loan, in turn formed the nucleus of the works of art in the National Maritime Museum on its formation.

For the opening exhibition of the Royal Academy in April 1769, Serres presented a virtuoso selection of paintings, demonstrating his full range of talents from a landscape night scene, through peaceful coastal maritime views to fully-fledged marine compositions. One was directly commemorative, 'The siege of Fort Royal at Martinique' (no. 107), probably Plate 37, but others were less specific in time: 'An English man-of-war chasing a French chebeck into a neutral port' (no. 108); 'A ship-of-the-line and a frigate going upon a cruise in the Mediterranean, with a view of Gibraltar in the distance' (no. 109) and 'A view of a ruined abbey by moonlight' (no. 110). 'A view from the gun-wharf at Portsmouth' (no. 106) (Colour Plate 32), ranks as one of Serres's masterpieces of its kind. While lacking the grand scale and complex structure of the paintings of the ports of France by Vernet, it is, like the paintings of Plymouth, an atmospheric and balanced portrayal of an everyday scene at Portsmouth dockyard: foreground figures at work with equipment, quayside material, men-of-war lying off, with Spithead and the Gosport shore in the background.

Paintings for Samuel Barrington

The year 1770 found Serres painting for another leading officer who was also to be an important patron after his distinguished actions in the forthcoming war. This was Captain the Hon. Samuel Barrington (1729–1800) who was at this time serving in *Venus* (36 guns) as flag captain to Henry Frederick, Duke of Cumberland, the King's brother. The Duke had joined the navy in 1768 in order to maintain the connection of the royal family with the fleet after the death of his elder brother, Edward Augustus, Duke of York. He had served for a year as a midshipman in *Venus* under Barrington, before being promoted Captain, then Rear-Admiral and hoisting his flag in the same ship. But the engagements Barrington wished to commemorate were, again, single-ship actions in his younger days during previous wars. The *Bellone*, a 36-gun French frigate, was captured in 1747, immediately renamed *Bellona* and sent out with Barrington in command. While cruising off Ushant she

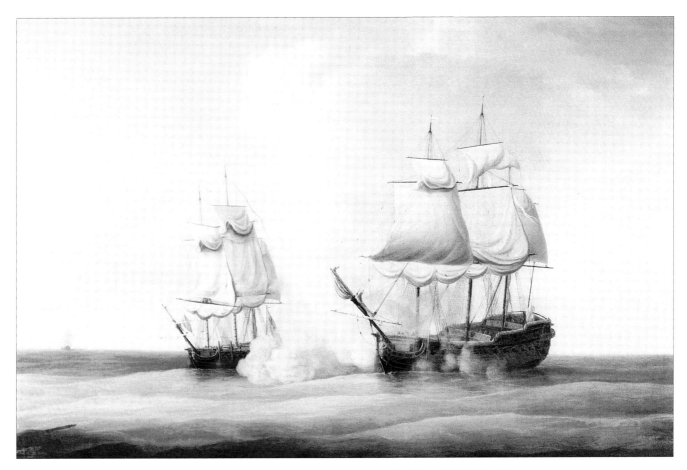

PLATE 41. 'The capture of the Duc de Chartres, 18 April 1747', oil on canvas, signed and dated 1770, 25 x 40 ins. (63.5 x 101.5 cm). Young commanders of frigates relished single ship engagements, with an enemy of similar or superior strength, as a chance to prove their courage and skill. Samuel Barrington had been appointed to command the *Bellona* at the age of eighteen and was naturally proud of his capture of the large French East Indiaman soon afterwards. Twenty-three years later he asked Serres to record the action.

National Maritime Museum, London

found and captured the French East Indiaman, *Duc de Chartres*, on 18 August 1747 after a two-hour engagement. Serres's painting (Plate 41), clearly emphasised the disparate size of the frigate and the much larger Indiaman, which mounted 30 guns as defensive armament. The companion painting (Colour Plate 33) is of a similar action twelve years later, when Barrington was in command of *Achilles* (60 guns), a unit of Hawke's fleet keeping watch on the western approaches. On 4 April 1759 he took the very large privateer *Comte de St. Florentine*, also carrying 60 guns, to the west of Finisterre. In the summer of that year Rodney, as Rear-Admiral, was on board *Achilles* for the bombardment of Le Havre, where flat-bottomed boats were assembled for the invasion of England. Barrington was not at the battle of Quiberon Bay, but in 1761, still in *Achilles*, was in Keppel's squadron at Belleisle.

These paintings passed from Samuel Barrington, who was unmarried, to his younger brother, the Hon. Shute Barrington. The latter became Lord Bishop of Durham and in 1824 presented them to Greenwich Hospital, together with two other, later, pictures of an action in St. Lucia (Colour Plate 56 and pages 133-136).

At the same time Shute Barrington gave a picture to the Hospital which represented an unusual excursion for Serres. The full title of the work in nineteenth century catalogues of the collection is 'King Henry VIII, in the "Harry-Grace-a-Dieu", of 100 guns, sailing to Calais for the Celebrated Conference with Francis I of France 1520' and the subtitle 'By Dominic Serres RA from the ancient Picture at Windsor Castle . . . Size 3 ft.11 ins. by 5

COLOUR PLATE 31. 'Saint Vincent's, near West Malling, Kent', oil on canvas, 12 x 18 ins. (32 x 46 cm). Locker also asked Serres to paint his country house, probably when he bought it in 1779. This allowed the artist to return to the style of his early pastoral landscapes.

Yale Center for British Art, Paul Mellon Collection, U.S.A./Bridgeman Art Library

ft.11 ins.'. This painting, temporarily hung in the Lieutenant-Governor's house at Greenwich, was destroyed in a fire on 8 December 1935. The original is not known in the Royal Collection, but similar inscriptions appear on engravings by W. le Roch and W.A. le Petit after the painting, which were published as prints (Plate 42).[2] Judging by these reproductions, it was a fine painting and is the only known such retrospective work by Serres of a sixteenth-century subject. The prints date to the 1830s and one is left to speculate on the reasons for Serres being called upon to copy the original in oils. It may have been commissioned by the King or, less likely, by Barrington, or, since the original was referred to as 'ancient', and probably in poor condition, he may have been asked to make a copy in order to preserve the image.

2. Information provided by Dr. P van der Merwe is gratefully acknowledged.

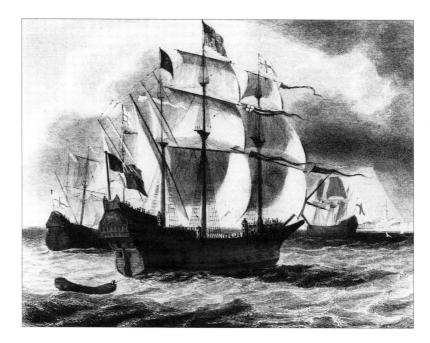

PLATE 42. 'The Harry Grace a Dieu 1522', coloured engraving by W.A. le Petit after D. Serres. R.A., published by Harding and Lepard, 1 October 1831. Serres made a copy of an 'ancient picture at Windsor Castle' of the warship carrying Henry VIII to his meeting with Francis I of France at the Cloth of Gold in 1520, but it was destroyed by fire in 1935. The original is no longer in the Royal Collection. This print, and other similar versions, are now probably the only secure record of the paintings.

National Maritime Museum, London

COLOUR PLATE 32. 'Ships off the Gun Wharf at Portsmouth, 1770', oil on canvas, 36 x 59 ins. (91.5 x 150 cm). Although not as broad and complex as Vernet's 'Ports of France', this is one of Serres's most successful of its kind: an atmospheric and balanced portrayal of an everyday scene at the naval dockyard.

National Maritime Museum, London

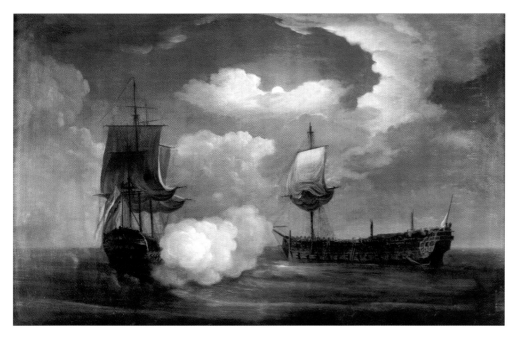

Colour Plate 33. 'The capture of the Comte de St. Florentine by H.M.S. Achilles, 4 April 1759', oil on canvas, 25 x 40 ins. (63.5 x 101,5 cm). At the same time as he commissioned Plate 41, Barrington ordered this companion painting of a similar action twelve years later. He was to commission further paintings from Serres to commemorate his successes in the next war.

National Maritime Museum, London

Other paintings 1770

For the Royal Academy exhibition in 1770, Serres submitted six paintings, again showing a versatility of subject matter designed to appeal to a wide public. This was a pattern he was to repeat at the Academy exhibitions in subsequent years. The only directly commemorative work was 'The burning of Basseterre in the island of Guadeloupe' (no. 167), referring to an incident in the Seven Years' War. 'A view of the Cape of Good Hope, with a British squadron returning from the East Indies' (no. 168) may be related to the paintings of the naval activity in India upon which he was working at this time. 'A view of Gibraltar' (no. 169) was always an attractive subject, and 'A seaport' (no. 171) still in the Vernet tradition. The customary English coastal scene was included with 'A view of Hurst Castle in Hampshire' (no. 172) and Serres's favoured night scene 'An engagement by moonlight' (no. 170).

From the same year dates a small oil which, over a period of a century, has graced all London's national galleries. It was for many years attributed to Ludolf Backhuysen (1631–1708), the influential Dutch marine painter, in spite of being signed with initials and dated 1770 (Colour Plate 34). It is a simple composition vividly executed in a style that lends more truth to the stormy scene than the more flamboyant Backhuysen would have imparted. The painting was bequeathed to the Victoria & Albert Museum in 1870, subsequently lent to the National Gallery and later passed to the Tate Gallery. It is now back at the Victoria & Albert Museum.

Actions in India

The year 1771 introduced a pair of large paintings of actions from the Seven Years' War which took place in a theatre of operations previously unrecorded by Serres: India or, in terms of the naval command, the East Indies station. 'The capture of Geriah, February 1756' (Colour Plate 35) and 'The capture of Chandernagore, March 1757' (Colour Plate 36) are both signed and dated 1771.

Pirates under Tulagee Angria had long ravaged shipping of all nationalities on the Malabar coast of western India, south of Bombay. Angria had extended his control along the coast and had become increasingly presumptuous in his attacks on East India Company ships and even British ships-of-the-line. In 1755 Commodore William James (1721–83), commander of the East India Company fleet, had attacked and captured Angria's northerly bases, but Geriah, 'at least as strong as Gibraltar and, like that, situated on a mountain inaccessible from the sea',[3] remained as the pirates' principal stronghold. Rear-Admiral Charles Watson (1714–57) reached Bombay at the end of 1755 with four ships-of-the-line and ten other vessels. The 800 European and 1,000 Indian troops in the force were commanded by Lieutenant-Colonel Robert Clive (1725–74), freshly returned from England. The combined assault was launched on 12 February 1756 and within forty-eight hours the citadel and town were in British hands, yielding much military equipment and booty. Serres's depiction shows the naval bombardment in full force against the fortifications.

After the reduction of Geriah, Watson's squadron, with Clive on board, returned to Fort St. David, near Madras, on India's east coast. It was there that they learnt of the fall of Calcutta to Suraj-ud-Dowlah and the arrival of six large troop-carrying French Indiamen, to be fitted out as men-of-war, as a reinforcement of the French presence in India. Watson and Clive immediately set out to retake the town on the Hooghly river which was the centre of British trade and settlement in Bengal, and discovered, on arrival, the incarceration and death of Europeans in the infamous Black Hole. The French supported Suraj-ud-Dowlah and when Calcutta had been recaptured in January 1757, the joint commanders decided to proceed

3. G. Dunbar, *Clive*, 1936, p.74.

PLATE 43. 'The taking of Severndroog by Sir William James', line engraving after Dominic Serres. The original painting for this print was probably one of a pair commissioned by James, after his return to England, to commemorate his victories over Angria and his pirate fleets. National Maritime Museum, London

further up-river to reduce Chandernagore, the French base and centre of activity. Watson was able to muster only three ships from his small squadron before the town, *Kent* (70 guns), his flagship *Tiger* (60 guns) and *Salisbury* (50 guns), and these are depicted in Serres's painting (Colour Plate 36). After three hours' bombardment on 23 March the town capitulated. Three months later Clive ousted Suraj-ud-Dowlah and re-established British control at the battle of Plassey, when sailors from the fleet fought alongside the troops. Serres's painting of the capture of Chandernagore was hung at the Royal Academy exhibition in 1773 (no. 271).

Watson, sadly, did not live to enjoy or pursue these victories as he died on 16 August 1757. The other senior commander present at both these actions, as Watson's second-in-command, was Rear-Admiral George Pocock (1706–92), who succeeded to the command on his death. As Pocock's flagship, *Cumberland* (66 guns), was too deep to reach Chandernagore, he had gone up-river by boat and hoisted his flag in the *Tiger*, seen at the mizzen top-mast head of the ship on the right in Colour Plate 36. As these were very much Watson's actions, and Pocock went on to greater things, such as the capture of Havana, it seems most likely that Serres received the commission for these paintings from

COLOUR PLATE 34. 'Ships in a gale', oil on panel, signed with initials and dated 1770, 17 x 27 ins. (43 x 68 cm). In spite of the signature this small seascape was for many years attributed to Ludolf Backhuysen, the influential Dutch marine painter, as it is much in his style.

Courtesy of the Board of Trustees of the Victoria & Albert Museum

Watson's widow or his son, Charles, upon whom a baronetcy had been conferred in 1760 in recognition of his father's distinguished service. They might even have been a coming-of-age present for Charles who reached his twenty-first birthday in 1772.

Serres produced three further pictures of these operations at about the same time. Two of them were painted for Commodore William James to celebrate his successes against Angria before Watson's force arrived on the scene. James returned to England in 1759, having made his fortune in India, and purchased an estate near Eltham, Kent. He became a Director of the East India Company and later its Chairman, M.P. for West Looe, an Elder Brother of Trinity House, and in 1778 was created a Baronet. One painting, 'The Departure of the Fleet. Commodore James, Honourable East India Company, on his way to attack Severndroog', signed and dated 1773, is in a Canadian museum. Severndroog, an island fortress, was one of the northerly bases used by Angria's marauders. Plate 43 reproduces an engraving after Serres of the taking of the stronghold. The third painting is also known through a print engraved by Robert Pollard (1755–1838) after Serres's oil and inscribed 'The capture of Victoria, Angria's most northerly possession, by Sir William James, 9 April 1755, from a painting by Dominic Serres in the possession of Lady James'. Fort Victoria, or Bencote, was to the north of Severndroog. After her husband's death, in 1784 Lady James erected the Severndroog Tower to his memory on Shooters Hill, near their estate. His monument in the north transept of Westminster Abbey is close to Admiral Watson's and nearby is that of Edward Dunk, Earl of Halifax.

COLOUR PLATE 35. 'The capture of Geriah, February 1756', oil on canvas, signed and dated 1771, 45 x 72 ins. (114.5 x 183 cm). Serres's first retrospective painting of naval actions in India was of a joint operation between Rear-Admiral Charles Watson and Colonel Robert Clive to dislodge the pirate Tulagee Angria from his fortress at Geriah, on the Malabar coast. National Maritime Museum, London

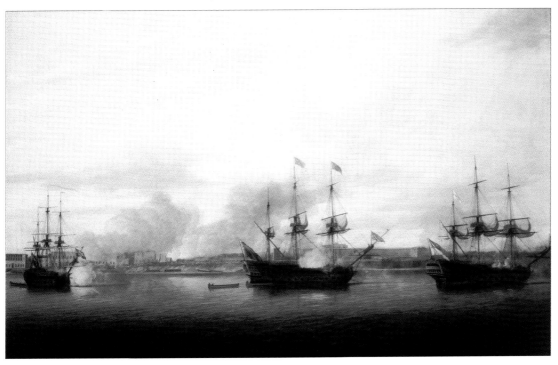

COLOUR PLATE 36. 'The capture of Chandernagore, March 1757', oil on canvas, signed and dated 1771, 45 x 72 ins. (114.5 x 183 cm). From the west coast the force moved on to Bengal, where, after retaking Calcutta, it captured Chandernagore, the centre of French activity further up the Hooghly river. Serres's companion painting clearly demonstrates the intimidating effect towering men-of-war, with their thundering broadsides, had on isolated colonial settlements. National Maritime Museum, London

The 1771 Academy Exhibition and Black-ey'd Susan

Reference must be made to the Academy exhibition of 1771. Once again Serres submitted five paintings revealing an intriguing variety of subject matter. The first, 'A fleet sailing out of the Downs, with the story of black-ey'd Susan' (no. 181) seems as if it was an effort to recapture a rhyme and image which had been popular thirty years earlier. Peter Monamy, the marine painter, had joined other artists, such as Hogarth and Hayman, in painting pictures to decorate the supper boxes, similar to the boxes still found in some theatres, at Vauxhall Gardens, on the south bank of the Thames. This was the most popular rendezvous for pleasure-seeking Londoners in the middle years of the century. 'A painting representing Black-eyed Susan returning to shore having been taking leave of her Sweet William who is on board one of the fleet in the Downs' was one of Monamy's contributions. A print after the painting was published by Thomas Bowles in October 1743 (Plate 44) and included in the inscription two verses of 'Sweet William's farewell to Black Eyed Susan', a popular lyric of the period, attributed to Lockman. Heavily sentimental, they read:

> O Susan, Susan Lovely Dear,
> My Vows shall ever true remain;
> Let me Kiss off that falling tear,
> We only part to meet again;
> Change as ye list ye Winds, my Heart shall be
> The faithful Compass that still points to thee.
>
> The Boatswain gave the dreadful Word,
> The Sails their Swelling Bosom spread.
> No longer must she stay aboard:
> They kissed, She Sigh'd, he hung his head:
> Her less'ning Boat unwilling rows to Land,
> Adieu, She cries, and wav'd her Lilly Hand.

What Serres made of it pictorially, and how he reproduced the verses, remains a matter for speculation since his painting has not been traced. If handled in anything like the same manner as Monamy and Bowles, it must have brought a light-hearted and populist touch to the august surroundings of the Academy, which the crowding public probably much enjoyed.

Serres's commemorative work for the 1771 show was 'The Royal George returning from the Bay' (no. 182). The *Royal George* (100 guns) was Hawke's flagship at the battle of Quiberon Bay in 1759 and it is to be assumed that this painting was executed in celebration of the victorious admiral's arrival at Spithead. Serres returned to the subject eight years later with another exhibit at the Academy and it will be examined in more detail at that stage (see pages 122 and 124 and Colour Plate 53). To his almost regular 'Sea engagement by moonlight' (no. 183) he added, on this occasion, two views on the river Exe, near Powderham Castle in Devonshire (nos. 184 and 185).

Zoffany's painting of the Royal Academicians

Johan Zoffany (1733/4–1810), came to England in 1760 and quickly found favour with the new king, painting many portraits of the royal family. He was commissioned in 1771, presumably by the King, to paint the first group portrait of all the Royal Academicians. It was hung at the Academy exhibition in 1772 (no. 290), when Horace Walpole noted in his catalogue 'This excellent picture was done by candlelight; he made no design for it,

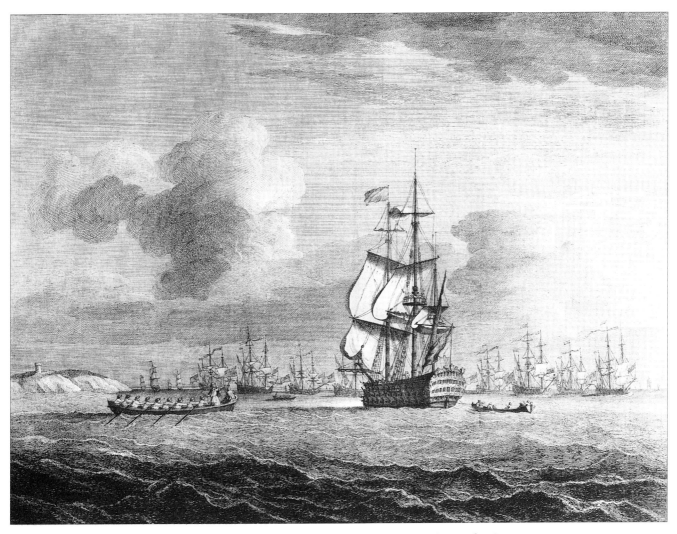

PLATE 44. 'Sweet William's Farewel [sic] to Black-Eyed Susan', line engraving by P. Fourdrinier after P. Monamy, published by Thomas Bowles, 28 October 1743, 10 x 14 ins. (25 x 36 cm). Serres exhibited his version of this scene, together with the heavily sentimental verses which accompanied it, at the Academy in 1771. It has not been traced, but the light-hearted and populist touch must have raised some eyebrows in those august surroundings. ©The British Museum

but clapped in the artists as they came to him, and yet all the attitudes are easy and natural, most of the likenesses strong'[4] (Colour Plate 37). The painting was engraved by Richard Earlom (1743–1822) and published as a print in August 1773. Dominic Serres appears as one of the lesser lights, fifth from the left in the back row, but, significantly, close behind the right shoulder of Paul Sandby who seems to be in conversation with his brother, Thomas, in the grouping close to the President, Sir Joshua Reynolds (Colour Plate 38). It was to be almost ten years before Serres was the subject of an individual portrait, but then, reflecting his enhanced standing in the artistic community, he sat to several artists, including probably Joshua Reynolds himself, within the space of a few years.

A Serres painting which was long attributed to Backhuysen has been discussed on page 88 (Colour Plate 34), and it is of interest to consider briefly another, made in 1771, which was a copy of a van de Velde oil painting. Serres built up a very large collection of van de Velde drawings during his lifetime and quite often worked over, or strengthened, the outlines and washes of the Dutch masters as studies to help develop his own compositions.[5] Like all marine painters during the century since the pre-eminence of the Willem van de Veldes, father and

4. O. Millar, *The Later Georgian Pictures in the Collection of H.M. the Queen*, 1969, no. 1210.
5. M.S. Robinson, *The Drawings of the Willem van de Veldes*, 2 vols., 1958 and 1974.

COLOUR PLATE 37. 'The Royal Academicians', Johan Zoffany, oil on canvas, 1772, 40 x 58 ins. (101 x 147 cm). This group portrait of the Academicians, probably commissioned by the King, shows Dominic Serres fifth from the left of the back row, at the shoulder of his good friend Paul Sandby. Zoffany is seen, with his palette and brushes, in the lower left hand corner. The Royal Collection © 2001 Her Majesty Queen Elizabeth II

COLOUR PLATE 38. 'The Royal Academicians', Johan Zoffany, detail including Dominic Serres and Paul Sandby. Horace Walpole noted in his catalogue of the 1772 Academy exhibition that this painting was '… done by candlelight; he [Zoffany] made no design for it, but clapped in the artists as they came to him…' It was to be almost ten years before Serres was the subject of an individual portrait.

The Royal Collection © 2001 Her Majesty Queen Elizabeth II

1. Benjamin West (1738-1820), artist
2. Tan-che-qua, a Chinese artist visiting England
3. Jeremiah Mayer (1735–89), miniaturist
4. Dominic Serres (1719–93), artist
5. Paul Sandby (1730–1809), artist
6. Thomas Sandby (1721/3–98), artist
7. William Tyler (d.1801), sculptor and architect
8. John Inigo Richards (d.1810), artist
9. Francis Milner Newton (1720–94), artist
10. Sir William Chambers (1726–96), architect
11. Sir Joshua Reynolds (1723–92), artist
12. George Barret (?1732–84)
13. Joseph Wilton (1722–1803), sculptor
14. Francis Hayman (1708–76), artist
15. Mason Chamberlain (d.1787), portrait painter

(The key is based on Oliver Millar's in *The Later Georgian Pictures in the Collection of H.M. The Queen*, 1969)

COLOUR PLATE 39. 'Dutch coastal craft on a fresh day off a jetty', oil on canvas, signed with initials and dated 1771, 37½ x 55 ins. (95 x 139.5 cm). Serres amassed a large collection of drawings by the van de Veldes and at times made copies of their finished works. Why he painted this copy of 'A kaag in a fresh breeze off a groyne', 1672, is not known, but it is a remarkably faithful reproduction. Reproduced courtesy Ronald Cohen

son (1611–93 and 1633–1707), Serres had clearly been influenced by their work. But the painting he chose to copy, 'A kaag in a fresh breeze off a groyne', of 1672 (Colour Plate 39), dated from a period when the Dutch artist was much influenced by Backhuysen's dramatic, rough sea pictures.[6] Backhuysen may indeed have been working in the van de Velde studio at the time. The original painting was in an English collection in the 1770s and is now in the National Gallery of South Africa in Cape Town. Serres's version is in private ownership.

In the wider world beyond Serres, his patrons and their commissions, this was a time when several events of related interest occurred. In 1771 the Duke of Cumberland married Anne Horton, a commoner, without the permission of his brother, the King. As a result, in the following year the King enacted the Royal Marriages Act, which forbade any marriage by a member of his family without his permission. Reasonable though this may have appeared from the King's point of view, it led to a succession of illicit liaisons, marriages to which the King did not give his approval and at least one bigamous marriage, by his brothers and sons. These were to plague the royal family until George III's death in 1820 and to jeopardise the succession to the throne. Olivia Wilmot was born on 3 April 1772, married John Thomas Serres on 1 September 1791 and, after he had divorced her, came to claim that she was the legitimate daughter of the Duke of Cumberland. Her legal suit, widely regarded as fanciful, continued well into the nineteenth century.

6. D. Cordingly, *The Art of the van de Veldes*, exhibition catalogue, National Maritime Museum, 1982, no. 151.

PLATE 45. 'A view of Stone-henge', watercolour over ink, inscribed 'Drawn on the Spot, 8 Oct. 1770 by D.Serres', 9 x 16 ins. (21.5 x 36.3 cm). This was probably a preliminary drawing for a painting of the same title Serres submitted to the Academy in 1773. The curious method of delineating the stones is found elsewhere in Serres's sketches and may have been an idiosyncratic shorthand he employed for rough and irregular rock surfaces.

©Crown Copyright: UK Government Art Collection

Within artistic circles, 1772 saw the death of Samuel Scott at Bath and the sale of his effects. Scott had been, like Serres, a friend of the Sandbys. Paul Sandby had moved in 1766 to a house in Poland Street, which he took over from his friend Sir William Chambers, the architect, who moved to one of his newly-designed and built houses in Berners Street. Sandby did not stay much longer in Soho and in 1772 removed to a more healthy and pastoral location, 4 St. George's Row, overlooking Hyde Park (now 23 Hyde Park Place).

Council member of the Royal Academy

At the General Assembly of the Royal Academy on 10 December 1772, Dominic Serres was elected a member of the Council for the year 1773, his first office in the Academy or any of the societies of which he had previously been a member. In this capacity he was mentioned in the letter to the King, sent later in the same month, presenting the Laws and Regulations of the Royal Academy for royal approbation. This mention may have brought the marine painter to the King's attention and encouraged the commission for paintings of the royal review of the fleet a few months later, in June 1773, discussed on pages 97–102. But before that Serres had to join his colleagues on the Arranging Committee for the hanging of the annual exhibition, an exercise always open to criticism from those whose pictures were not hung in as prominent and accessible positions as they thought they should have been. Serres remained on the Council for 1774 and was thus involved in the organisation of the annual banquet that year, as described on page 102. He again served on the Council in 1780 and 1781 and the Arranging Committee in the latter year, and the Council in 1790 and 1791, being a member of the Arranging Committee in 1790. Until his appointment as Librarian, this was the extent of his participation as an office holder in the administration of the Academy.

The Royal Academy Exhibition 1773

At the Royal Academy exhibition in 1773 Serres presented his customary range of subject matter, this year adding to the retrospective painting of the capture of Chandernagore (no. 271) one of more immediate and popular human interest. This was an exploit of great seamanship: 'The India ship, Duke of Cumberland, being wrecked on the coast of Guinea; fourteen of the men went to Gambia in the long boat; and, having raised and decked her, arrived safe home in her' (no. 273). The title of his Gibraltar painting was still non-specific, but was probably the view of the Rock, signed and dated 1771, showing the *Pembroke* in the centre with an Algerian xebec in the right foreground (no. 272) (Colour Plate 40). Built in 1757, the *Pembroke* was brought back into commission in 1769, after being laid

up for five years. She was then Commodore Charles Proby's flagship on his posting to the Mediterranean and it may be his arrival at Gibraltar which is here commemorated. Proby, who had been a midshipman in the *Centurion* on Anson's voyage round the world, became Controller of Victualling Accounts in 1771 where he would have worked with Philip Stephens, the Admiralty Secretary, who may have recommended Serres to him.

The English topographical subject this year was 'A view of Stonehenge' (no. 274). A watercolour of the ancient site, Plate 45, may have been a preparatory study for this painting. The delineation of the stones is somewhat curious, but is similar to Serres's drawings of other rocky pinnacles, such as the Needles, off the south-west point of the Isle of Wight, and may have been an idiosyncratic shorthand he employed in his sketches.

A Royal Commission: The Review of the Fleet

Shortly after the exhibition, between 22 and 26 June 1773, Serres was at Portsmouth to record, for the King, his Majesty's review of the fleet. With characteristic care he plotted the plan and elevation of the ships moored in Spithead for the occasion (Plate 46). Among the ships' captains, also noted on the plan, are several of his patrons, for example Barrington in the *Albion* (74 guns), and it may have been one of these who proposed that the Academician should be chosen by the King to commemorate the events. As the various ceremonies and less formal activities unfolded over the following days, Serres made a series of drawings as a pictorial record to be used in the studio for the oil paintings which would recall the high points of the visit. Four of the drawings have survived and are in the Royal Collection. They are inscribed 'Painted for his Majesty Geo. 3d' and lettered as part of a sequence.

The finished set of oil paintings, also in the Royal Collection, would not only celebrate the disciplined naval etiquette and enthusiasm attending the King among the moored warships, but also show him enjoying a brisk sail in his yacht in the eastern Solent. It also enabled the artist to demonstrate his versatile talents in recording with meticulous care, on the one hand, the colourful and crowded scenes of boats among the towering men-of-war and, on the other, the monarch relishing the surging thrill of being under sail in a fresh breeze.

'His Majesty saluted by the Fleet at his arrival on board the Barfleur at Spithead' (Plate 47) pictures the scene after the King has gone on board the *Barfleur*. The Royal Standard and other flags have been broken out at the mastheads, and the ships of the fleet are firing a royal salute, their yards manned overall, while the barges of the Board of Admiralty, the three Flag Officers and all the Captains remain in attendance. The ships' names are legible

PLATE 46. 'The Plan, Elevation and Perspective views of the Fleet at Spithead, as it was when his Majesty reviewed it, in June 1773', ink and wash, signed and dated 1773. Serres's meticulous preparation for the series of paintings of the review for the King began with this drawing of the dispostion of the fleet at anchor. Several of the captains annotated, such as Barrington, were already patrons of Serres and may have recommended him to George III.

National Maritime Museum, London

PLATE 47. 'The Royal visit to the Fleet, 1773: 'His Majesty saluted by the Fleet at his arrival on board the Barfleur at Spithead', oil on canvas, signed and dated 1774, 61 x 96 ins. (154 x 244 cm). George III's formal arrival in the fleet makes a splendid scene which Serres handles with all his skill and enthusiasm. The *Barfleur* is at the centre of attention with the barges, having delivered their admirals and captains, awaiting their return, and spectator craft thronging the waters. Distance, detail and perspective are carefully balanced, with the adjacent line of warships in proper recession, their names legible on their sterns in accordance with the artist's plan.

The Royal Collection ©2001
Her Majesty Queen Elizabeth II

PLATE 48. 'The Royal review of the fleet, June 1773. His Majesty on board Barfleur while the fleet fires a salute', wash and pencil on paper, 16 x 23 ins. (39 x 58 cm). This drawing was the preliminary for the oil painting reproduced below, which follows the composition closely.

The Royal Collection ©2001
Her Majesty Queen Elizabeth II

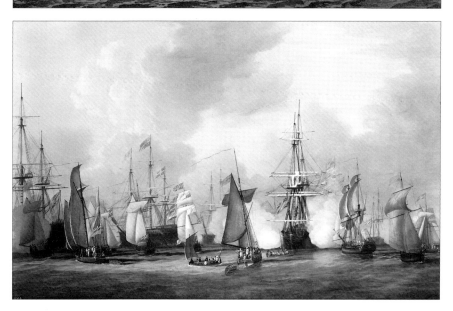

PLATE 49. 'The Royal visit to the Fleet, 1773: 'A salute is fired', oil on canvas, signed and dated 177?5, 61 x 97 ins. (154 x 245 cm). The finished oil painting, from the drawing shown in Plate 48, demonstrates Serres's concern with foreground figures and small vessels, as local people come out to join in the festivities.

The Royal Collection ©2001
Her Majesty Queen Elizabeth II

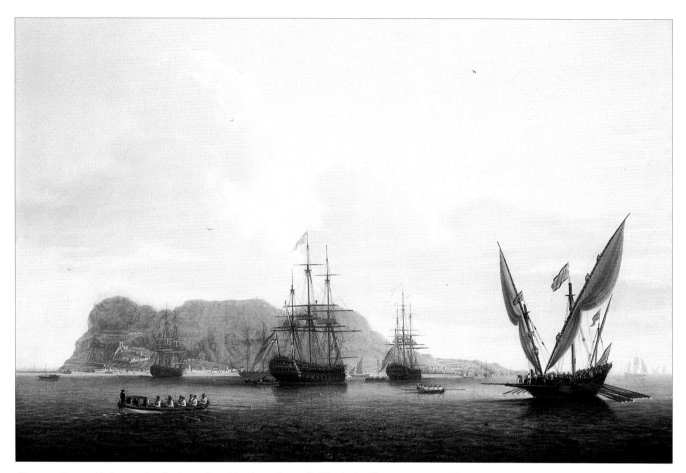

COLOUR PLATE 40. 'H.M.S. Pembroke and an Algerian xebec off Gibraltar', oil on canvas, signed and dated
1771, 24 x 36½ ins. (61 x 92 cm). Probably Serres's painting with a similar title exhibited at the Royal Academy
in 1773, it may have been commissioned by Commodore Charles Proby, another veteran of Anson's round-
the-world voyage, who flew his flag in *Pembroke* on posting to the Mediterranean in 1769.

Photograph courtesy of Spink-Leger Pictures

and conform correctly to Serres's plan: from the right, *Royal Oak*, with the flag of Thomas
Pye, Vice-Admiral of the Red, at its fore top-mast head, *Lennox*, *Torbay*, *Dublin*, with the
flag of Lord Edgcumbe, Vice-Admiral of the Blue, at its fore, and *Albion*; on the left, behind
Barfleur, is *Worcester*. This painting was exhibited at the Royal Academy in 1774 (no. 269).
A smaller version, also signed and dated 1774 and of equal quality, is in a private collection.
A popular print after the painting was published by Pattisall on 19 December 1774.

Plate 48 reproduces Serres's drawing which became the oil painting (Plate 49) of
another occasion during the royal visit, when the King was again on board *Barfleur* and
the fleet was firing another ceremonial salute. Although not quite as full of activity as the
previous, it again demonstrates Serres's concern and skill with foreground figures and
small vessels, achieving a sense of spontaneity as local people come out to join in the
festivities. Another drawing, Plate 50, contains elements which were incorporated in both
the previous finished paintings (Plates 47 and 49). It similarly emphasises the dense
geometrical pattern of the ships' rigging, reminiscent of van de Velde, and the fine
perspective recession lines of the composition which characterise the two final works.

On 25 June 1773 the King sailed in the royal yacht *Augusta* from Spithead to Sandown Bay,
accompanied by the Plymouth Squadron led by Lord Edgcumbe in *Dublin*, now proudly
identified by the cross of St. George at the fore, as he had been promoted Vice-Admiral of the
White by the King that same morning. This episode is commemorated in Plate 51 and the
return in the evening of the same day, sketched in Plate 52, in Plate 53. Serres was very probably,

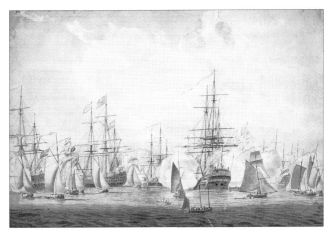

PLATE 50. 'The Royal review of the fleet, June 1773', wash and pencil on paper, 14½ x 22 ins. (37 x 55.5 cm). Some ideas later incorporated in both the oils illustrated at Plates 47 and 49 are included in this drawing. The strong geometrical pattern of ships' rigging and fine perspective recession lines are characteristic.

The Royal Collection ©2001 Her Majesty Queen Elizabeth II

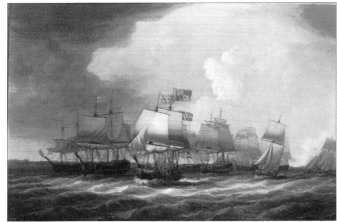

PLATE 51. 'The Royal visit to the Fleet, 1773: George III on board the Augusta, yacht, sailing from Spithead towards St. Helens with the Plymouth Squadron', oil on canvas, signed and dated 1775, 60 x 96 ins. (152 x 244 cm). The third painting in the set of four for the King is more individual and portrays the lively scene as the yacht, with its escort, heads out towards the open sea in a fresh breeze.

The Royal Collection ©2001 Her Majesty Queen Elizabeth II

like his predecessor Willem van de Velde, out in a small boat to record the different points of sailing on the outward and return trips and to emphasise them by the wave patterns, the motion of the vessels and the fall of light on the sails. Even so, it may be remarked that Serres adhered to the contemporary conventions of aerial perspective, as if from a higher, more distant viewpoint. It was later, Romantic artists, such as de Loutherbourg and Turner, who were to employ viewer's perspective in marine painting, bringing the point of view much lower and closer, heightening the sense of personal involvement in the human drama of the scene. 'In all the processions before-mentioned, both to Spithead and back again, a very great number of yachts, and other sailing vessels and boats, many of them full of nobility and gentry, accompanied the barges, as well as the Augusta, while the King was on board'.[7] These other yachts are depicted in Plate 53, the larger and less manoeuvrable warships having returned earlier, while the King enjoys it all from his vantage-point high on the poop of his yacht. Serres there skilfully highlights the King in a patch of sunlight at the centre of the picture while adding immediacy

7. Annual Register 1773, pp.202–7, quoted in O. Millar, *The Later Georgian Pictures in the Collection of H.M. the Queen*, 1969, no. 1072.

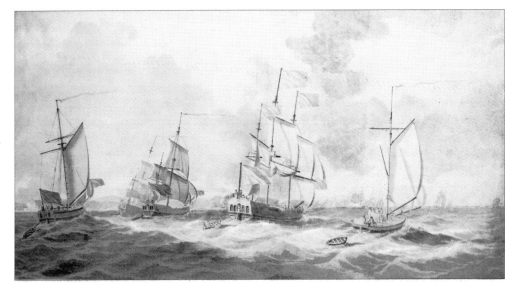

PLATE 52. 'The Royal review of the fleet, June 1773', wash and pencil on paper, 12 x 23 ins. (31 x 57.5 cm). The sketch for the painting of the King's return from Sandown Bay on 25 June, illustrated at Plate 53. Serres was probably in a small boat to make the sketch from this viewpoint.

The Royal Collection ©2001 Her Majesty Queen Elizabeth II

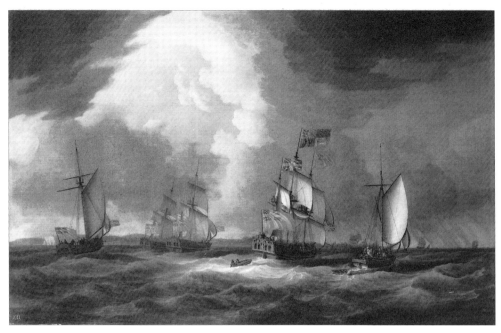

PLATE 53. 'The Royal visit to the Fleet, 1773: George III, on board the Augusta, yacht, returning to Spithead', oil on canvas, signed and dated 1775, 60 x 97 ins. (122 x 245 cm). The characteristic use of light by Serres illuminates the King standing on the poop of his yacht enjoying the return sail in the evening. From a similar viewpoint to Plate 51, with Culver Cliff, Isle of Wight, in the left background, the picture clearly shows the changed wind direction and sea-state from the outward journey.

The Royal Collection ©2001 Her Majesty Queen Elizabeth II

to the rest of the composition by dramatic cloud patterns and their light and shade effects on the water. Plates 51 and 53 were both hung at the Royal Academy in 1775 (nos. 288 and 289).

The fourth drawing of the King's visit to the fleet is of a less spectacular episode: the royal yacht sailing through the attendant merchant ships and transports, on the fringe of the fleet, to acknowledge the part they played in naval operations (Plate 54). The drawing exemplifies Serres's arresting compositional technique of placing the object of prime

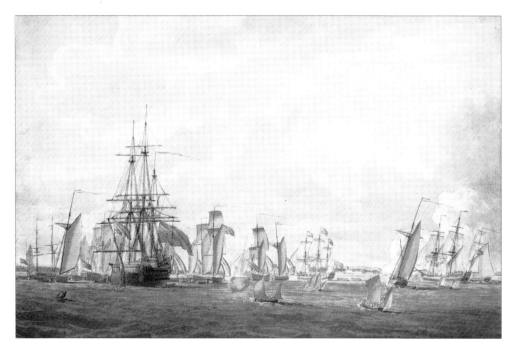

PLATE 54. 'The Royal review of the fleet, June 1773', wash and pencil on paper, 14 x 21½ ins. (36 x 54.5 cm). The scene shows the King sailing through the attendant merchant ships at the review. Serres's compositional technique places the point of interest, the royal yacht, in the middle distance, revealed by an open sightline between receding vessels on either side.

The Royal Collection ©2001 Her Majesty Queen Elizabeth II

interest in the middle distance, revealed by an open sightline between receding vessels on either side, and an element of repoussoir from the small foreground boats.

In addition to the first of these paintings of the royal review, in 1774 Serres exhibited at the Royal Academy 'A view in the Menagerie at Castle Ashby, the seat of the Earl of Northampton' (no. 271) as well as four other paintings. Menageries were one of the fashionable attributes of aristocratic estates in mid-eighteenth century England, when exotic animals and birds were being brought home by travellers returning from far-off and previously undiscovered parts of the globe. That at Castle Ashby was a folly built in the 1750s by Thomas Wright of Durham which contained outstanding Rococo plasterwork in the main room. It soon became a popular tourist attraction, as it remains to this day, and it may have been for this reason that Serres decided to paint and display it. Admiral Rodney, who was later to be an important patron of Serres, was also a frequent visitor to Castle Ashby and it may have been he who encouraged the artist to undertake the assignment.

Dinner at the Royal Academy: The Academician–Admiral

As a member of the Academy Council, Serres's nautical experience was called upon in the arrangements for the annual dinner. The banquet was customarily held on the King's birthday, 4 June, and took place in 1774 in one of the stately apartments of Somerset House, the Academy's home since 1771, but soon to be demolished and replaced by Sir William Chambers's imposing new buildings. All the artists exhibiting works at that year's exhibition were invited and among distinguished guests was Captain the Hon. Samuel Barrington. There was, as usual, a search for an innovation with which to enliven the occasion. A press report described the proceedings:

> The two stewards, Signor Bartolozzi and Mr. Serres, exerted themselves greatly on this occasion: tho' their Care was united in providing the Company an excellent Dinner and good Wine, the separate Care of the Marine Department was very properly allotted to Mr. Serres, who anchored a Yacht opposite the Academy, well appointed with Pateraros, which on a Signal given when the King's Health was drunk, and while the Band of Music was playing 'God Save the King', gave a royal Salute with 21 Guns. The same was repeated when the Queen's Health was drunk, and likewise at the Health of the Prince of Wales, and the rest of the Royal Family. It must be acknowledged, notwithstanding the great Care and Anxiety which Mr. Serres had about the Success of the Artillery, they did not perform with that Regularity and Exactness which he too fondly expected from inexperienced Gunners. Every Bounce out of Time was observed to give him great Uneasiness, greater indeed than such a Cause seemed to deserve; however, he comforted himself with the Impossibility of Perfection and assured the Company that it was just so at Portsmouth. But full Amends was made for the Irregularity of the Firing by the Excellence of the Music. Mr. Bartolozzi had the Care of this Department and by his Interest with Mr. Giordani procured a most magnificent Band, who, after Dinner, placed themselves in the Middle of the Room, surrounded by the Company at Table.... Upon the whole, all the Company acknowledged this Entertainment to be the most splendid, and the best conducted, of any they have had on the like Occasion since the Establishment of the Royal Academy'.[8]

Another account attributed part of the irregularity of the later salutes 'to the nervousness of the Academician–Admiral who signalled from a window at Somerset House to the "gentlemen artillery" on board the ship'.[9]

8. *Public Advertiser*, 7 June 1774.
9. W.T. Whitley, *Artists and their Friends 1700–99*, 2 vols., 1928, Vol. I, p.304.

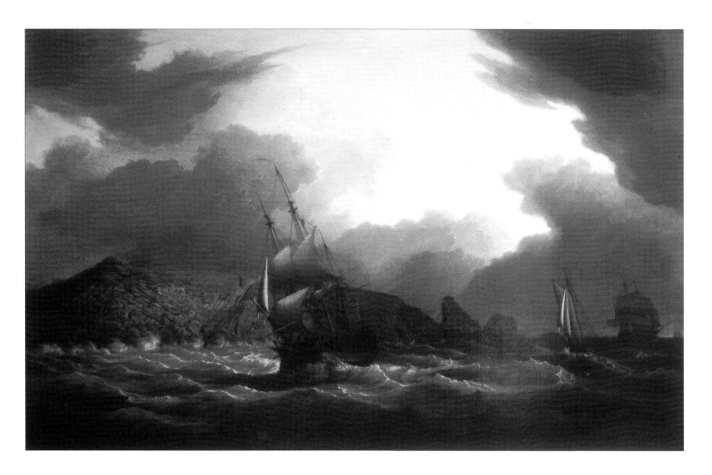

CHAPTER VI

THE WAR OF AMERICAN INDEPENDENCE
1776–1783

The year in which England drifted irrevocably into war with its North American colonists gave Dominic the satisfaction of seeing his elder son, John Thomas, exhibit for the first time at the Academy's annual show. John Thomas, aged seventeen and admitted, undoubtedly with the help of his father's influence, as an Honorary Exhibitor, selected 'A view of the Queen's Palace' (no. 333) as his work. This was probably a view of Buckingham House which the King had bought in 1762 and transferred to the Queen for life in 1775 in exchange for Somerset House, then to become the home of the Royal Academy. Evidently, therefore, a landscape painting, John Thomas was following in his father's footsteps by specialising early in this genre of painting. Dominic may well have considered landscape a good discipline in which to learn and one more likely to be remunerative. Indeed, although John Thomas henceforth exhibited one or more paintings each year at the Academy, it was not until after his visit to Germany and the Netherlands, over ten years later, that he began to depart from landscape and exhibit coastal scenes with a greater marine element.

Meanwhile, Dominic continued to produce his almost traditional mix of subject matter in response to diversified commissions: at least one pair of retrospective commemoratives of the Seven Years' War, two landscape commissions and a generalised shipping and coastal view.

The *Melampe*, a French privateer of 36 guns, was captured on 2 November 1757 and taken into service in the British navy. Posted to her soon afterwards was Wilbraham Tollemache

COLOUR PLATE 41. 'Storm near Lundy Island', oil on canvas, signed and dated 1776, 29 x 45 ins. (75 x 115 cm). Sir John Borlase Warren bought Lundy Island, in the Bristol Channel, and a yacht in 1775, and very soon afterwards commissioned Serres to paint this pair of pictures of his new property. This wild view of the south-west side of the island was hung at the Royal Academy exhibition in 1776.

Leggatt Brothers

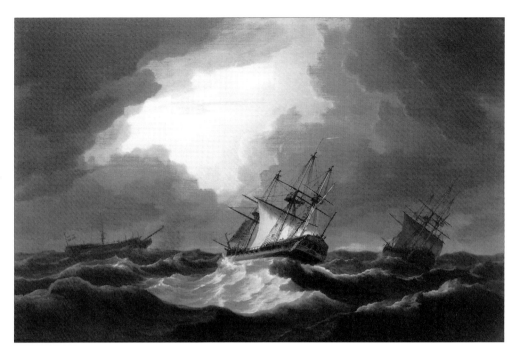

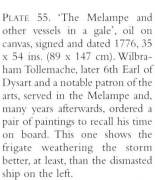

PLATE 55. 'The Melampe and other vessels in a gale', oil on canvas, signed and dated 1776, 35 x 54 ins. (89 x 147 cm). Wilbraham Tollemache, later 6th Earl of Dysart and a notable patron of the arts, served in the Melampe and, many years afterwards, ordered a pair of paintings to recall his time on board. This one shows the frigate weathering the storm better, at least, than the dismasted ship on the left.

The Lord Tollemache, Helmingham Hall. Photograph: Photographic Survey, Courtauld Institute of Art

(1739–1821). He later became 6th Earl of Dysart and a noted patron of the arts, commissioning portraits from Reynolds and Gainsborough and landscapes from, among others, Wilson. It was probably thus that he ordered a pair of paintings, which Serres executed in 1776, as a souvenir of his time as a young man in *Melampe*. The first was of his ship and other vessels in a gale (Plate 55) and the second of the capture of the *Danae* (38 guns) on 27 March 1759 (Plate 56). The *Melampe*, Captain William Hotham, and *Southampton* (32 guns) engaged two French frigates in the North Sea and, after a fierce action in which the *Melampe* suffered much damage, took the *Danae*, the other having made good its escape. It is not recorded whether Tollemache personally distinguished himself in the action but it would in any event have remained a vivid memory. Serres's painting shows the three vessels closely engaged, with the fourth in the distance disappearing towards the horizon.

A mezzotint by John Jones (c.1745–97) of the *Melampe* in a gale was subsequently published. Demonstrating, again, the commercially expedient reincarnation such plates could sometimes undergo, the same image was later reissued with the inscription amended to 'Admiral Christian's convoy in a gale in the Channel, December 1795'.

The two landscape commissions demonstrate that Serres was still in demand as a landscape painter, albeit of coastal views. Two of the works comprised his submission to the Royal Academy exhibition in 1776: 'A view of Brown Sea Island and Castle, near Poole, belonging to Humphry Sturt Esq'. (no. 278) and 'The south-west view of the island of Lundy in the Bristol channel, belonging to Sir John Borlase Warren, Bart', (no. 279).

The commission for a pair of views of Lundy Island from Sir John Borlase Warren (1753–1822) would undoubtedly have owed much to Serres's naval connections, for Warren was at the beginning of a long and distinguished career in the navy. His education was unusual. He was intended for the Church and entered Emmanuel College, Cambridge, but, on the death of his elder brothers, joined the navy as an Able Seaman in 1771. Dividing his time between ship and college, he graduated in 1773 and, the following year, was elected M.P. for Marlow. On the death of his father, in June 1775, he succeeded to the baronetcy of Borlase and soon afterwards bought Lundy Island and a yacht in which 'he amused himself in the Bristol Channel'. He sold the yacht on the outbreak of war, rejoined the navy and went to North America in the frigate *Venus*.[1] The painting hung at the Academy is inscribed 'Storm near Lundy Island' (Colour Plate 41) but shows the south-west side of the island, that exposed to the Atlantic weather. The other is inscribed 'View of Lundy Island' and probably represents

1. Dictionary of National Biography.

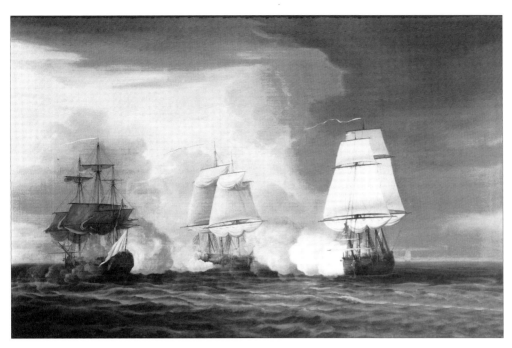

PLATE 56. 'The Danae taken by the Melampe and the Southampton', oil on canvas, signed and dated 1776, 35 x 54 ins. (89 x 147 cm). The two British ships encountered two French frigates and captured one, while the other, shown in the right background, made her escape. Tollemache may have distinguished himself in the affray and the excitement of the action undoubtedly remained a vivid memory.
The Lord Tollemache, Helmingham Hall. Photograph: Photographic Survey, Courtauld Institute of Art

Sir John leaving for the landing place on the eastern side while a salute is fired from the yacht (Colour Plate 42). Although the commission was primarily for landscapes to record the island, the storm scene shows Serres, perhaps in response to the inhospitable nature of the terrain, opting for a very marine representation in the tradition of the old Dutch masters and the style of Backhuysen. The paintings remained in Sir John's family until 1912 when they were purchased and presented to the Cardiff Exchange, presumably because of the proximity of the island to that city. They graced the Exchange for fifty five years until their disposal in 1967.

PLATE 57. 'A frigate with a view of the Needles', after D.Serres, *Liber Nauticus* Plate XXV, published by Edward Orme, London, 1805. Serres's drawing made for the nobleman, which was reproduced in *Liber Nauticus*, was based on his oil painting of the scene now at Waddesdon Manor, having previously adorned Baron Ferdinand de Rothschild's yacht *Rona*.

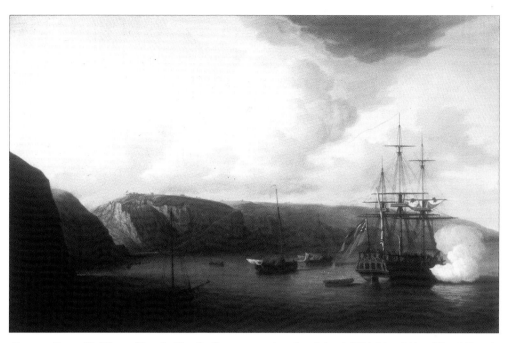

COLOUR PLATE 42. 'View of Lundy Island', oil on canvas, signed and dated 1776, 29 x 45 ins. (75 x 115 cm). A calmer scene than that in Colour Plate 41 shows Borlase Warren leaving his yacht for the landing on the eastern side of the island, while a salute is fired. It is the type of marine landscape, combining rugged coastline and temporarily calm sea, which Serres handled with mastery. Leggatt Brothers

A final, but probably unrelated, echo of Lundy Island appeared in the last year of Serres's life, 1793, when he exhibited 'Bristol man letter of marque, with a view of the island of Lundy' (no. 25) at the Royal Academy. Nothing more is known of the picture or its origins, but the artist may have been returning to previous themes at a time of failing health.

The last dated work from 1776 is one of Serres's regular illustrative portrayals of types of vessel against familiar English coastal backgrounds, which later provided John Thomas with the originals for many of the plates in the second part of *Liber Nauticus*. It is of a frigate sailing out past the Needles at the western tip of the Isle of Wight. The painting is now at Waddesdon Manor, and provided the basis for Plate XXV of the *Liber Nauticus* (Plate 57).

'Serres is the best painter I know . . . ': The Hyde Parker commissions

It was a letter from Captain Hyde Parker (1714–83), on board *Invincible* in the Channel fleet in 1777, to his elder son Harry, which launched Serres on recording actions of the War of American Independence and also saw the beginning of fruitful patronage by another famous naval family. Hyde Parker wrote proposing to commemorate 'the good conduct and gallantry' of his younger son, Hyde, by commissioning 'four pieces to be done in the best manner'. He continued:

> I know the dimensions of those Wallace has ordered, but desire you will consult with Mr. Stephens who in my opinion neither wants taste or judgement in these matters, and fix with him the most suitable size and embellishments. Serres is the best painter I know for this purpose, but if there is anyone more excellent in the art I would wish him to be employed coute que coute.

Hyde Parker goes on to suggest that there should also be a full-length portrait of his son.

Hyde Parker junior (1739–1807) was at the time in command of the frigate *Phoenix* (44 guns) in North America, part of the force commanded by the brothers Howe, General William (1729–1814), who had been at both Quebec and Havana, and Vice-Admiral Richard (1726–99), which had arrived at New York in June and July 1776. The Howes arrived with instructions from England to negotiate with the rebel colonists or, if unsuccessful, to put down

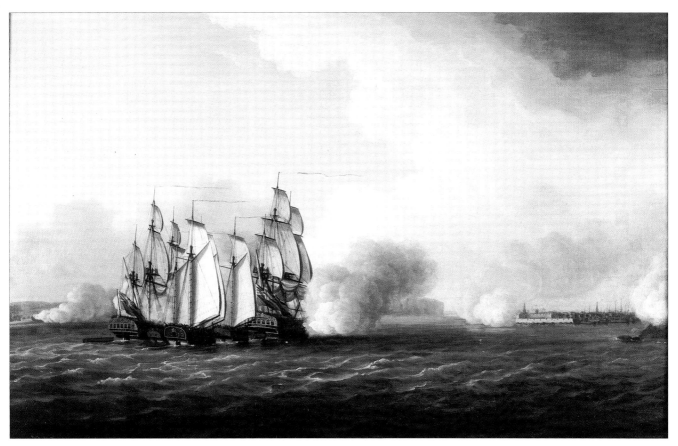

COLOUR PLATE 43. 'The passage of the Hudson River', oil on canvas, signed and dated 1777, 25 x 39 ins. (63 x 99 cm). Captain Hyde Parker wrote proposing to commemorate 'the good conduct and gallantry' of his younger son, Hyde, in North America, with 'four pieces to be done in the best manner', and continued: 'Serres is the best painter I know for this purpose'. This painting shows Hyde Parker's small squadron, in July 1776, approaching one of the forts at the mouth of the Hudson, or North, river, probably the Battery on the southern tip of Manhattan island. Melford Hall. National Trust Photographic Library/John Hammond

the insurrection by force. Negotiations proved fruitless, the Americans having issued their Declaration of Independence on 4 July, and the attacks to capture New York began. The navy played a crucial role in the fighting, not only by ferrying and protecting the troops, but also by operating in the rivers around Manhattan island, bombarding shore batteries and interfering with General Washington's communications and movements of troops and material. This was the role in which Hyde Parker had distinguished himself.

Immediately on his arrival, Admiral Howe despatched Hyde Parker, in company with the *Rose* (20 guns), the schooner *Tryal* and two tenders, to penetrate the Hudson river, then also known as North river. The small squadron broke through the American batteries at the entrance of the river on 12 July and advanced to the Tappan Zee, the long stretch above Haarlem and the northern end of Manhattan Island as far as Tarrytown. The ships operated with impunity in that area for a month, harassing Washington's east-west communications across the river, while the Americans did their best to dislodge them with the limited means at their disposal. The most effective attack, and that most dangerous to the British ships, was launched on the night of 16 August when fireships set the tender *Charlotte* afire and threatened the *Phoenix* and other vessels in the squadron. The first pair of paintings by Serres in response to the commission from Harry Parker was of this foray up the Hudson River the previous summer.

'The passage of the Hudson River' (Colour Plate 43) shows the squadron, tightly bunched for defensive solidity, approaching one of the forts on the shore, possibly the Battery on the

southern tip of Manhattan, and responding to the defending cannonade. Five years later, General Washington was to confirm to de Grasse, the French admiral, his opinion, formed at this time, that shore batteries alone could not stop ships having a fair wind.[2] The painting demonstrates this situation, with the warships advancing briskly, all plain sail set, before a following breeze, at a comfortable distance from the batteries. Serres handles the scene with customary restrained impact, the sunlight catching the wave crests, the sails, distant wall and gun smoke which, with the clouds, unifies the action at the centre and balances the composition across its width. The second painting, also signed and dated 1777, was hung at the Royal Academy in the spring of that year with the caption 'An attack by the Provincials, with fire ships and gallies, upon H.M.S. Phoenix, Captain Parker, and the Rose, Captain Sir James Wallis, in the North River, New York; from a sketch by Sir James Wallis' (no. 320) (Colour Plate 44). The work is an effective and skilful depiction of the events, in the best tradition of Serres's favourite night scenes. The heart of the fire in the vessel alongside the *Phoenix* is painted in clear vivid colour, while the flames rising through the tarred rigging, the most vulnerable part of the ship's exterior, are enhanced by the billowing smoke, and the *Rose* and *Tryal*, with the Heights of the New Jersey shore on the right-hand side, reflect the macabre light. The fireship was alongside *Phoenix* for forty-five minutes before the frigate's hoses, clearly visible in the painting, reduced the flames and enabled the burning hulk to be towed away. Two days later the squadron returned to the fleet, running the gauntlet of the Hudson river defences without damage.

It is clear from the senior Hyde Parker's letter that Captain Sir James Wallace had already ordered paintings of the action. These, or one of them, may have been commissioned from Serres by Wallace, for another version of the fireship painting, with the same dimensions and date, is in the collection of the Mystic Seaport Museum, Connecticut. Serres's painting was subsequently published as a hand-coloured aquatint and etching by J.F.W. DesBarres on 12 April 1778, being part of his renowned series 'The Atlantic Neptune'. The Mr. Stephens referred to in the letter would have been Philip Stephens (1725–1809) who was patronised by Anson, became his secretary and, in 1763, was appointed Secretary of the Admiralty, a post he held for the next thirty-two years. He became M.P. for Sandwich in 1768 and was created Baronet and appointed a Lord of the Admiralty on his resignation from the Secretaryship in 1795. As Secretary he occupied a pivotal and influential position in the administration of the navy and its officers throughout these historic decades. The Admiralty correspondence reveals that he was frequently the intermediary on behalf of senior officers in more personal affairs and this occasion seems to have been no exception, when even his artistic judgement was to be called upon.

The *Phoenix* and other units of the fleet continued in support of the land forces as they launched a conventional assault on New York from Long Island and Brooklyn Heights. The southern part of Manhattan island was consolidated during September and it was then finally decided to send warships again into the Hudson river in a co-ordinated move with the army to outflank the Americans, who continued to hold the northern part of the island. It was thus that, on 9 October, Hyde Parker in *Phoenix* found himself leading another squadron, this time somewhat stronger, northwards towards the narrows between Forts Washington and Lee at the northern end of Manhattan island, near the location of the present George Washington Bridge.

In the intervening months the defenders had thrown a boom, or *chevaux-de-frise*, across the waterway at this point, where it was dominated by the powerful guns of the two forts on the high ground on each bank, in order to protect the strategically vital east-west crossing of the river further up-stream. Parker led the approach to this obstruction in *Phoenix*, with a light following wind and the ships of his squadron in close support, making maximum impact in

2. W.L. Clowes, *The Royal Navy, A History*, 7 vols., Vol. III, 1898, reprinted 1996, p.385.

PLATE 58. 'A Plan of the Operations of the King's Army . . . in New York and East New Jersey . . . From the 12th. of October to the 28th. of November 1776', engraved by William Faden, 1777, after C.J. Sauthier, published in Stedman's *American War*, London, 1794. A section of a contemporary plan of the North, or Hudson, river showing Hyde Parker's small squadron anchored off Terry Town (top right hand corner). The *chevaux-de-frize* between Forts Lee and Washington is shown towards the bottom of the map. The attack by fireships in August 1776 took place north of the obstruction, between the high cliffs.

National Maritime Museum, London

deep water at its weakest point, the mooring to the New York shore at Jeffereys Hook beneath Fort Washington. The ships successfully broke through and were able once more to control movement on this stretch of the river which, thanks to the success of the land forces, the army was now able to exploit. A contemporary map reproduced for a 1793 history of the war shows the squadron anchored off Tarrytown or Terry Town (Plate 58). But it is the critical moment, or minutes, of crunching impact with the sunken timbers, under heavy gunfire, which Serres was to record for the Parker family. His painting was the first of the second pair under the commission, both dated 1779, and was hung at the Academy exhibition that year, entitled: 'H.M.S. the Phoenix, Captain Parker, the Roebuck, Captain Hammond, and the Tartar, Captain Ommaney, forcing their way through the chevaux de frize, the Forts Washington and Lee and several batteries up the North River, New York, October 9th. 1776' (no. 295). The painting (Colour Plate 45) is another of Serres's admirable executions, bearing his highly competent characteristics in the handling of landscape as well as marine elements and the unifying effects of gun smoke and clouds. The portrayal of gun smoke was recognised at the time as a determining criterion of the quality of brushwork in such paintings and it remains a demanding test. Even Benjamin West, second President of the Royal Academy, was taken to Spithead by an admiral in order to receive a lesson on the effect of smoke in a naval battle and 'several ships were ordered to manoeuvre as in action and fire broadsides, while the painter made notes'.[3] Serres's mastery of the technique was matched by

3. H.von Erffa and W. Staley, *The Paintings of Benjamin West*, New Haven and London, 1986.

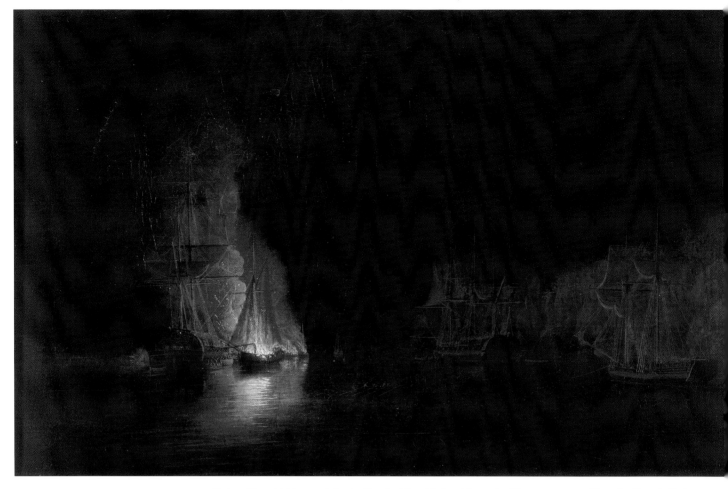

Colour Plate 44. 'An attack by the Provincials, with fire ships and gallies, upon H.M.S. Phoenix, Captain Parker, and Rose, Captain Sir James Wallis, in the North River, New York; from a sketch by Sir James Wallis', oil on canvas, signed and dated 1777, 25 x 39 ins. (63 x 99 cm). Serres enjoyed painting night scenes illuminated by fire or moonlight and this attack gave him ample scope. After lying alongside the *Phoenix* for forty-five minutes, the fire was extinguished by the ship's pumps, the hoses clearly visible, and the vessel towed away.

Melford Hall. National Trust Photographic Library/John Hammond

his ability to paint equally imposing cloud formations within his skyscapes.

A watercolour drawing by Serres relating to this oil is in the British Museum, inscribed, signed and dated (Colour Plate 46). Several versions of the finished work are known, most varying considerably in detail, and it seems probable that each of the captains, and some of the officers, proud of their part in the operation, ordered copies from Serres after they had seen and liked the original. Three of these are in American collections and another privately owned. Thomas Mitchell (1735–90) copied the painting in 1780 and this version is in the National Maritime Museum. William Joy (1803–57) also made a copy which is now in the United States.[4]

While it was principally for his leadership in these operations that Hyde Parker received a knighthood on 21 April 1779, he had, in the meantime, been engaged upon another assignment where he distinguished himself. This was the landing at Savannah, Georgia, which took place in February 1779 and was to furnish the subject for the second painting that year under Serres's commission from the Parkers. A small detachment of troops under Lieutenant-Colonel Archibald Campbell sailed from Sandy Hook, New York, at the end of November 1778, convoyed by a division of frigates commanded by Hyde Parker, still in the *Phoenix*.

Four weeks later the force entered the Savannah river and soon afterwards occupied the city. Frigates were frequently employed during the American war because their size and

4. Information provided by J.W. Cheevers, Senior Curator, U.S. Naval Academy Museum, Annapolis, is gratefully acknowledged.

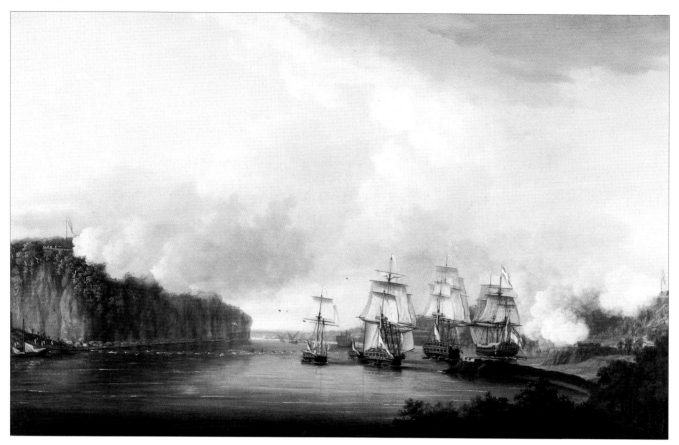

COLOUR PLATE 45. 'H.M.S. Phoenix, Captain Parker, the Roebuck, Captain Hammond, and the Tartar, Captain Ommaney, forcing their way through the chevaux de frize, the Forts Washington and Lee and several batteries up the North River, New York, October 9th. 1776', oil on canvas, signed and dated 1779, 27 x 45 ins. (69 x 114 cm). On a second expedition to cut Washington's lines of communication across the river, Hyde Parker found that an obstruction had been built to prevent him going further. He succeeded in breaching it by forcing its junction with the shore. Melford Hall. National Trust Photographic Library/John Hammond

Colour Plate 46. 'Captain Hyde Parker in the Phoenix going up the North River, New York', watercolour and ink, signed and dated (illegible), 12 x 20 ins. (30 x 51 cm). Presumably Serres's preliminary drawing for Colour Plate 45. He painted several versions of the oil in which the detailed arrangement of the ships varied slightly.

©The British Museum

shallow draught enabled them to navigate with much greater flexibility, in combined operations with the land forces, on the coastline indented with many estuaries and creeks. Hyde Parker's ships were thus able to go close inshore and cover the landing troops by a short-range bombardment. Serres's painting shows the view from the transports, lying further off, as the well-regimented boatloads of soldiers and marines are rowed towards the shore (Colour Plate 47). The masthead pennants of the warships streaming in the wind make it clear why the gun smoke is blowing back over the ships and the advancing boats.

Hyde Parker was subsequently transferred to the West Indies where, on the coast of Cuba, the *Phoenix* was caught in the disastrous great hurricane of 6 October 1780. Thirteen naval ships were lost, many with all hands, and nine of their captains, while the islands of Barbados, St. Lucia and Jamaica were also devastated. The *Phoenix* was among the ships lost, but fortunately she was wrecked near the shore and her complement was saved, together with most of the armament and provisions. Hyde Parker had spent five exciting and successful years in the *Phoenix* and it is therefore no surprise that Serres was called upon to commemorate her final demise, particularly as it must have been a singular achievement to save her entire crew. The painting shows the battered frigate wallowing in the enormous breakers and sailors escaping with lifelines. On the left other figures have collected on the beach beneath high cliffs and a red and stormy sky. The painting, signed and dated 1781, is so darkly dramatic that the details are difficult to discern in reproduction (Colour Plate 48). Like all the Serres canvases discussed here, it is in the library of Melford Hall, Long Melford, Suffolk, which was purchased by Sir Harry Parker Bart. in 1786 as the family seat, after his father's death.

The Actions of Hyde Parker senior

While Hyde Parker junior was heavily occupied in North America, his father, promoted Rear-Admiral of the Blue early in 1778, had crossed the Atlantic in the same year, with his flag in the *Royal Oak* (74 guns). He was part of Vice-Admiral the Hon. John Byron's fleet of thirteen ships-of-the-line sent to reinforce the American station since France had, in February, joined the Americans in their conflict with the British. On Byron's return to England after his undistinguished major fleet action against Vice-Admiral Comte d'Estaing off Grenada on 6 July 1779, Hyde Parker took over command of the fleet until the arrival of Admiral Sir George Rodney the following March. As a divisional commander he took part in the latter's fleet action against Rear-Admiral Comte de Guichen near Martinique on 17 April 1780. This, too, was a failure by the English fleet as Rodney's signals and intentions were not understood by his junior flag-officers and some captains, leading to recriminations and Rodney's censure of Parker and Rear-Admiral Rowley. Parker, whose nickname in the service was 'Vinegar', was infuriated and went home shortly afterwards. This failure was indeed of far-reaching effect since, had the British won a decisive victory on that day, the inconclusive engagement off Chesapeake Bay and, therefore, the surrender at Yorktown the following year could well not have happened. It was probably for this reason that, when the time came for commemorative paintings, Hyde Parker chose a less contentious and bellicose incident for another painting by Serres.

There is no record of the commission for this picture, dated 1781, and its pendant, but it seems likely that the Admiral's sons, Harry and Hyde junior, decided to honour their father in the same way that he had some years earlier proposed to mark the exploits of Hyde junior. The event is described in the entry of the 1782 Academy catalogue, where it was hung: 'The

British fleet under the command of Rear-Admiral Sir Hyde Parker, consisting of sixteen sail-of-the-line and a 50-gun ship, going to sea from Gros Islet Bay, St. Lucia, on the 25th. March 1780, in the face of twenty-five sail of French ships-of-the-line, for the protection of an English convoy of troops and merchant ships from Antigua' (no. 59) (Colour Plate 49). The memorable aspects of the situation would have been the speed with which Hyde Parker's ships put to sea on the appearance of de Guichen's fleet and their success in deterring such a superior force from pressing its attack on the convoy. The painting shows the English ships sailing out past Pigeon Island at 11 o'clock on 25 March to cover the convoy from the French fleet, visible on the horizon in the right background. Serres's viewpoint, which sees the high sterns, sails and flags of the warships leaving the shadowed foreground and sailing into the sunshine beyond, adds the element of urgency to an otherwise routine fleet manoeuvre.

The Dutch entry into the war on the side of the Americans, joining the French and, latterly, the Spaniards, who had also declared against Britain in June 1779, added a further dimension to the world-wide spread of operations the navy was called upon to undertake. After his irate return to England, Hyde Parker, promoted Vice-Admiral in September 1780, was given command of the North Sea squadron which, because the resources of the navy were stretched to the limit, consisted largely of older, smaller ships, many in poor condition. His force was convoying a large merchant fleet home from the Baltic when, on 5 August 1781 near the Dogger Bank, it encountered a Dutch squadron under Rear-Admiral Johan Arnold Zoutman, also escorting a convoy. Both sides put seven ships into the line, although each included a large frigate which would not normally have been so employed. Hyde Parker, in the *Fortitude* (74 guns), probably still smarting from Rodney's criticism after the engagement in the West Indies, ordered his convoy away to the English coast and attacked the enemy, who shielded their own convoy. The engagement was largely indecisive as neither fleet was in good shape for battle, and was later described as 'a most satisfactory exhibition of valour, and a most unsatisfactory battle; magnificent, but not war'.[5] The purpose of protecting the convoy was achieved and one Dutch ship was sunk, but casualties on both sides were very heavy. Hyde Parker could, however, regard it as a success, or perhaps, a vindication, and he commissioned Serres to paint it, as a pair to the one of St. Lucia (Colour Plate 50). Serres uses his customary chiaroscuro and towering clouds to great effect, catching an episode during the battle when the English ships were redeploying to bear down again on the enemy line.

Another, smaller, version of the painting of the Dogger Bank action is known. An engraving after it by Robert Pollard was published by him and Robert Wilkinson in May 1782, at the same time as the original was being shown at the Academy exhibition. This coincidence of timing may indicate that Serres, like many of the artists of his day, was now himself actively initiating the making and selling of prints in order to promote his paintings.

Hyde Parker junior was also present at the battle, captain of the frigate *Latona* (38 guns). James Saumarez (1757–1836), later Admiral Lord de Saumarez, then Lieutenant in the flagship, recalled that:

> When the action had ceased, Hyde Parker bore down on the *Fortitude* and affectionately inquired for his brave parent, of whose gallantry he had been an anxious eye-witness. The admiral, with equal warmth, assured his son of his personal safety, and spoke of his mortification at being unable, from the state of his own ship, and from the reports he had received of the other ships, to pursue the advantage he had gained, in the manner he most ardently desired.[6]

5. W.L. Clowes, *The Royal Navy, A History*, 7 vols., Vol. III, 1898, re-printed 1996, p.508.
6. John Ross, *James, Lord de Saumarez*, 2 vols., 1838, Vol. I, p.50.

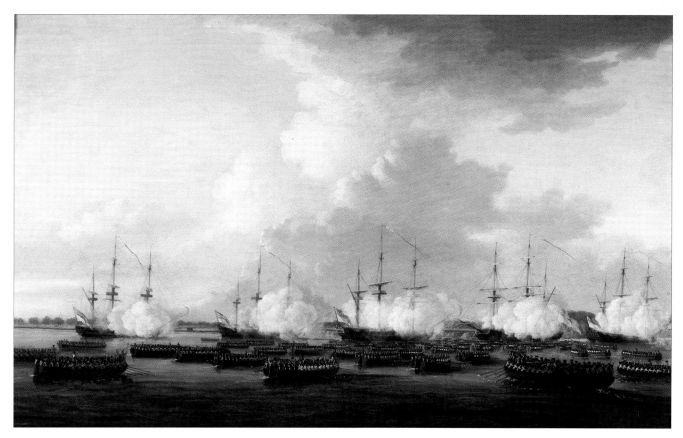

COLOUR PLATE 47. 'The landing at Savannah', oil on canvas, signed and dated 1779, 27 x 45 ins. (69 x 114 cm). The last of the four paintings originally commissioned, this shows the landing at Savannah, Georgia, in December 1778. Serres was paid £29. 5s. for the second, larger pair.

Melford Hall. National Trust Photographic Library/John Hammond

On their return to the Nore after the action, the King paid Hyde Parker and his squadron the singular tribute of visiting the ships. The Admiral, however, remained fiercely critical of the Admiralty for having provided him with such poor ships and attributed the absence of a more decisive outcome of the battle to that cause. Living up to his nickname, and indifferent to the royal honour accorded him, he said to the King 'I wish your Majesty better ships and younger officers. For myself, I am now too old for service'. It was, therefore, hardly surprising that no further honours or awards were conferred on Parker at that time and he averred that he would not, in any event, have accepted them. He was nonetheless appointed Knight of the Bath in 1782 and posted as Commander-in-Chief of the East Indies station. He sailed for India at the end of the year in *Cato* (80 guns), taking with him his fourteen year old grandson as a midshipman. The ship never reached its destination, being wrecked on the Malabar coast with the loss of all hands. Sir Hyde Parker junior went on to achieve high rank and is now memorable in history chiefly as Nelson's commander at the Battle of Copenhagen in 1801 whose signal Nelson ignored by putting his telescope to his blind eye.

For this last, larger pair of paintings, completed in 1782, Serres was paid £34. 5s. For the two previous pairs of the North American actions he received £34. 4s. 6d. and £29. 5s. For the wreck of the *Phoenix* he was paid only £2, the reason for which must be left to conjecture. The level of remuneration enjoyed by Samuel Scott for his marines and landscapes has already been mentioned (see page 64). By way of further comparison, George Stubbs (1724–1806), the renowned equestrian painter, was in 1776 paid 80

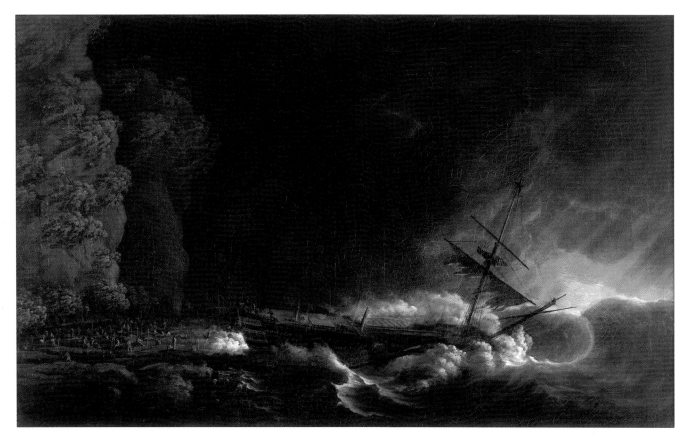

COLOUR PLATE 48. 'The shipwreck of the Phoenix at night', oil on canvas, signed and dated 1781, 27 x 45 ins. (69 x 114 cm). The frigate Phoenix, Hyde Parker junior's command since 1775, was wrecked on the coast of Cuba in the great hurricane of 6 October 1780. The painting shows men escaping with lifelines under a towering cliff and red, stormy sky. The entire ship's company and most of the armaments and stores were saved. This, and the Captain's distinguished service in the ship, were undoubtedly why the picture was commissioned.
Melford Hall. National Trust Photographic Library/John Hammond

guineas for his portrait of the Reverend Robert Carter Thelwell and family, considerably larger than the Serres paintings, which comprised figures, two ponies and a chaise (Holburne Museum, Bath).

To conclude the discussion of the relationship between Serres and the Parkers, it is of interest to note that the portrait of his son, which Hyde Parker senior had suggested in his original letter in 1777, was commissioned from George Romney (1734–1802), who also painted portraits of the father. Romney was working on these portrayals at the same time as Serres was producing his depictions of the naval actions. It was then that the two artists very probably met and came to collaborate, Serres painting the marine backgrounds to some of Romney's naval portraits, such as that of Admiral Sir Francis Geary (National Maritime Museum, London).

Commodore Sir George Collier in Penobscot Bay 1779

A minor operation of the early years of the American war was commemorated by Serres for another senior naval officer. The British, endeavouring to hold key points on the extensive coastline and deny them to the colonists, set up a small military post at the entrance to Penobscot Bay, Maine, in June 1779. The Commonwealth of Massachusetts was provoked into responding with the despatch of a powerful flotilla under Commodore Dudley Saltonstall comprising a frigate and sixteen sloops to convoy twenty-four transports carrying 1,000 troops. The American force prepared to invest the British fort but was not ready until 13 August. On that evening Commodore Sir George Collier

(1738–95), who had left New York ten days before, arrived to confront the American warships which were anchored in a crescent formation across the mouth of the Bay, protecting the transports. Collier, in *Raisonnable* (64 guns), commanded a superior force of three frigates and six sloops and, when, on the following day, the American ships retired up the Bay, he gave chase. This is the moment captured by Serres in his painting of the operation, as the imposing British squadron, with a quartering breeze, sweeps into the Bay after the retreating enemy vessels, shown low down on the horizon, some of them already ablaze (Colour Plate 51). The *Raisonnable*, flying Collier's broad pendant and the signal to chase, is shown on the right firing into *Hunter*, which was captured, while the remainder surge on. Uncertain of the pilotage, the British anchored overnight but discovered the next morning that the American vessels had been beached and burnt, their complements of sailors and soldiers fleeing into the woods. It was a significant victory, if minor incident in the total war scenario, and had been achieved by Collier's alacrity in leaving New York and forthright attack on the numerous American ships. He was therefore justified in his pride in it and his commission, soon after the event, to Serres to commemorate it. A print very closely resembling the painting was published in December 1784 as an illustration to *Rapin's Impartial History of England*.[7] In 1814, when the painting was engraved for the *Naval Chronicle* by James Baily from a drawing by Thomas Whitcombe, the picture was in the possession of Lady Collier, Sir George's second wife. It descended within the family until 1931 when it was purchased and presented to the National Maritime Museum.

Striking up an acquaintance with Claude Joseph Vernet

Serres obviously maintained a high regard for Vernet from his early years as a painter, having exhibited a work in the style of the French artist in 1764 and reflected his influence in various works during the intervening years. Letters which have survived from the period show that, already in 1775, Serres had endeavoured to establish a correspondence and closer acquaintance with his French contemporary, who was his elder by five years and certainly his senior in terms of public esteem in his own country. The extant letters cover a span of twelve years from 1775 to 1788.[8] The gap of six years in the middle, from 1779 to 1785, is probably attributable to the conflict then taking place between England and France which would have made correspondence difficult.

All the letters are from Vernet to Serres except for one which is apparently a rough draft for a reply by Serres, which suggests that his written French may not have been as good as his spoken. Although Serres's manuscripts are not available, Vernet's letters show that Serres was a central figure in Anglo-French artistic and social circles in London and thus familiar with French visitors to England, many of them recommended by Vernet. In December 1789, a year after the last letter, Vernet died peacefully in his official apartment in the Louvre Palace in Paris. Thereafter, letters from other correspondents make it clear that Serres was sought after and involved in the affairs of French citizens who fled to England from the Revolution or who were seeking to salvage something from the disasters which had overtaken them.

Serres followed his 1775 letter to Vernet with others on 24 April and 9 August 1776. Vernet finally sent word on 28 July 1776 by a M. David, who was travelling to London, to acknowledge a drawing or gouache ('la Guazze') which Serres had sent him, together with two drawings by John Thomas. These had been conveyed by hand of M. Belanger, an architect.[9] Vernet says that his son, Carle, would also like to send a couple of his

7. R. Gardiner ed., *Navies and the American Revolution 1775–83*, 1996, p.101.
8. All these letters are located in British Library Add. MSS. Fr.23,201.
9. François-Joseph Belanger (1744–1818) was a fashionable architect who travelled in England studying architecture and gardens. He was noted for producing public spectacles and fêtes for the Court, especially picturesque gardens such as the Bagatelle in the Bois de Boulogne. In 1777 he became first architect to the Comte d'Artois, the younger brother of Louis XVI, and designed 'jardins anglais'.

drawings to John Thomas but that he is at the moment convalescing after an illness. He hopes to be able to send some by Lord Shelbourne, who was shortly to return to London. Vernet promises to write soon, when his present pressure of work has eased. In closing he courteously says that he has high esteem for Mr. Serres.

Vernet was as good as his word and put pen to paper on 19 August 1776. The cover of the letter is addressed to 'Monsieur Serres, Peintre français, Warwick Street, . . .', and Vernet refers to Serres from time to time in the ensuing correspondence as 'Mon cher compatriote'. After about thirty years in England, and apparently complete assimilation into his adopted country, these references may seem surprising, but Serres was clearly a personage of importance in the French community in London, and probably quite happy to be so addressed by a French correspondent of Vernet's standing. Indeed, he may have encouraged it in his letters to the French artist. At the same time, there may have been a touch of chauvinistic pride on Vernet's part.

Vernet opens by apologising for not having answered Serres's three letters. The last, of 9 August, having been brought by M. David, was presumably in reply to Vernet's message of 28 July by that intermediary (whose identity has not been established). Vernet excuses himself by reason not only of his workload but also of the marriage of his daughter, Emilie, with 'M. Chalgrin, first Architect and Intendant des Bâtiments to Monsieur, the King's brother'.[10] Vernet expresses his satisfaction with the match, as well he might. He goes on to discuss and praise the drawing or gouache which Serres had sent him:

> I find the Perspective very good, also the ships very well done, in a marine style, and La Guazze, especially in the sky (which is difficult) done very lightly and with much taste; in total I am satisfied and cannot say more of this drawing, or rather this picture, for that is what it is. You are a clever man if I am not mistaken. I am flattered that you wish to have something of mine and I will do it the first moment of leisure I have.

Vernet then says he is working on four large pictures, for which he is being pressed. He has just sent a fairly large one to Lord Shelbourne, as a pendant to that he had painted for him over a year earlier, and begs Serres to look at it and give him his opinion of it.

Vernet praises the two small drawings of horses by Serres's son, which accompanied his father's, and goes on to say that it is a sign of great talent to be able to produce such work at his age, although he is but following the breed because Serres himself is so gifted. The French artist promises to send in return some of Carle's drawings when he has recovered from his convalescence. John Thomas would have been almost seventeen years of age at the time but was not possessed of the precocious talent of Carle (1758–1836), a year older, who won the Prix de Rome in 1782 at the age of twenty-four.

In closing Vernet expresses his pleasure at having made the acquaintance of Serres, 'which I will cultivate to the best of my ability. We have, in any case, several titles to link us: the same nationality [Patrie], the same Profession, the same genre and, I flatter myself, the same mode of thought'. He finally hopes that it will soon be possible to make their acquaintance in person. In a postscript he sends his greetings to John Thomas, exhorting him to work at and develop his talents.

Three years elapsed before the next extant letter from Vernet, which is dated 9 July 1779 and was again carried by M. David. It acknowledges a letter from Serres of 26 July and a small proof engraving of which he gives a critique, commenting on the heavy shadow on the sails.

He then says that he has recently received a letter from Mr. Gabriel Mathias,[11] sent to him by Mr. [John Christian] Bach, composer of music, in which Mathias speaks warmly of Serres.

10. Jean François Thérèse Chalgrin (1739–1811) won the Prix de Rome in 1758. On his return he joined the Bâtiments de la Ville de Paris and in 1779 was appointed to the position on the staff of the Comte d'Artois which Vernet mentions. He designed several well-known buildings, continued to practice during the revolutionary period and was commissioned by Napoleon in 1806 to design the Arc de Triomphe.

11. Gabriel Mathias (1719–95) was brought up a portrait painter, being a pupil of Allan Ramsay in 1739. In 1745 he went to Rome where he met and became very friendly with Vernet. In that year Vernet married Cecilia Parker, the daughter of an Englishman who was commander of the Pope's navy. Mathias returned to England in 1748 and ultimately became Deputy Paymaster to His Majesty's Privy Purse.

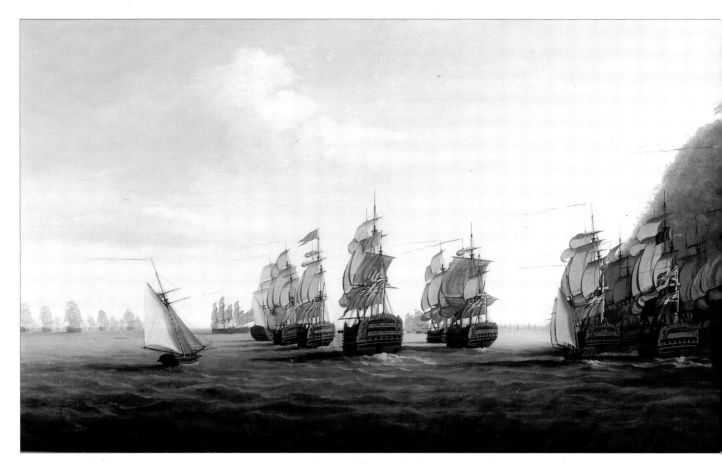

COLOUR PLATE 49. 'The British fleet under the command of Rear-Admiral Sir Hyde Parker, consisting of sixteen sail-of-the-line and a 50-gun ship, going to sea from Gros Islet Bay, St. Lucia, on the 25th. March 1780', oil on canvas, signed and dated 1781, 36 x 62 ins. (91 x 157 cm). This and Colour Plate 50, formed a pair of larger paintings commissioned by the sons to honour their father. Hyde Parker senior was temporarily in command of this powerful squadron in the West Indies and chose to commemorate the moment of leaving his anchorage to protect a large convoy from the approaching French fleet, seen in the right background. The chosen viewpoint adds urgency by showing the high sterns, sails and flags of the warships leaving the shadowed foreground and sailing into the sunshine beyond.

Melford Hall. National Trust Photographic Library/John Hammond

He goes on to mention the Salon du Louvre of the Académie Française, the exhibition of Painting and Sculpture, which lasts six weeks, and in which he has ten pictures, including two ten feet high and length in proportion. Vernet proudly announces that his son, Horace, aged nineteen, has just won the painting prize, after being short-listed from forty-four contestants. He was seven years younger than any other entrant and although it was his first painting, a history painting, sixty-seven out of the seventy academicians voted in favour of it. Several sketches done by his son when fourteen or fifteen years of age were enclosed in the package, which was to be sent by return hand of M. David. A further note, dated 11 July, says that the package missed David, who had already left for Ostend, so it was being sent by post. The public mails between Paris and London must therefore still have been open at this time, over a year after war had been declared.

Although Serres seems to have 'made the running' in this correspondence, Vernet's replies are always effusive and complimentary with regard to both Serres and his son. In spite of the ensuing silence, which lasted six years, Serres achieved at least one of his probable purposes in initiating the exchanges, when, in 1785, he was proposed as a suitable artist, indeed the best Vernet knew, to carry out a commission for the Ministère de la Marine. That episode is described, at the appropriate point in the chronology of Serres's life, in Chapter X.

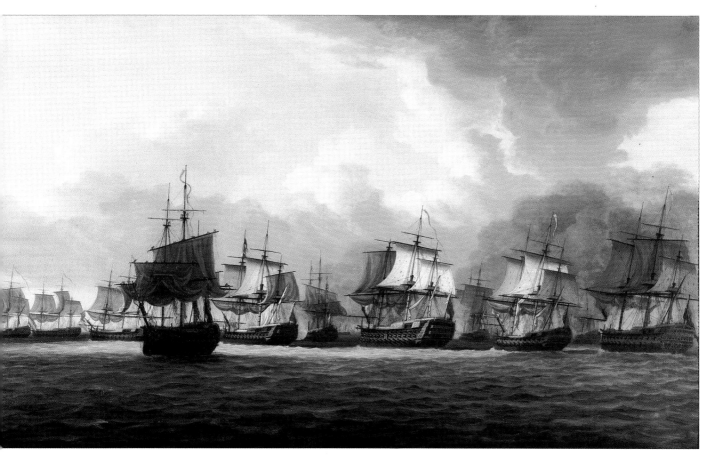

COLOUR PLATE 50. 'Action off the Dogger Bank between a fleet under Vice-Admiral Sir Hyde Parker Bt. and a superior Dutch force under Admiral Zoutman, 5 August 1781', oil on canvas, signed and dated 1782, 36 x 62 ins. (91 x 157 cm). On his return home, Hyde Parker senior was given command of the North Sea squadron and, in protecting a convoy from the Baltic, engaged in an inconclusive engagement with a Dutch force. Complaining about the state of his ships, Hyde Parker, known as 'Vinegar', afterwards said to the King: 'I wish your Majesty better ships and younger officers. For myself, I am now too old for service'. He was then sixty-seven years of age. Melford Hall. National Trust Photographic Library/John Hammond

Naval uniforms illustrated

Before 1748 there was no established uniform to be worn by naval officers, even less so by warrant officers and ordinary seamen. An order dated 14 April 1748 made compulsory the wearing of uniform by admirals, captains, commanders, lieutenants and midshipmen. Ideas for the designs had been initiated by naval officers who wished to introduce the use of uniform, but the colours were chosen by George II. The King was attracted by the habit of blue, faced with white, worn by the handsome Duchess of Bedford, wife of the First Lord of the Admiralty, when riding in Hyde Park, and decreed that these should be the colours of the dress of the officers in his navy. The elegance of the garments and elaboration of decoration increased with the elevation in rank, the admiral's uniform being encrusted with gold trimmings and set off by silk and lace.

After twenty years' experience with these designs, modifications were introduced by an Admiralty order of 18 July 1767. The more elaborate patterns of full dress uniform were discontinued and other alterations incorporated:

> The Admiral's frock to have narrow lappels down to the waist; small boot cuffs; a single lace instead of treble lace down to the skirts – a plain musquetaire lace; but in all other respects the same as now worn. The Captains' and Commanders' frocks

to have narrow lappels down to the waist, and in all other respects as they are now worn. The Lieutenants' frocks to have narrow lappels down to the waist, flash cuffs like the commanders', without lace, instead of roll cuffs, and in all other respects as now worn.

Other changes were made to the Lieutenants' uniform in 1768 when the lapels and cuffs were to be blue instead of white and the waistcoat white with gilt buttons. In 1774 another alteration was made in the uniforms of Captains and Commanders, affecting those which were to be considered full dress and those worn on 'common occasions', spelt out in detail in the Admiralty order.[12]

It was probably to encapsulate these changes and to appeal to public interest in the naval service soon after the outbreak of another war, that Serres decided in 1777 to publish a set of prints, after his own drawings, illustrating the uniforms of the navy (Colour Plate 52). To the five officer ranks for which dress was prescribed in the regulations, he added a seaman, as an example of the hundreds of crewmen who made up the complement of the various ships which the officers commanded. Each figure is shown with an example of the vessel which would typically have been in his charge and appropriate naval trophies or nautical equipment in the foreground. The Admiral with his flagship, usually a first-rate man-of-war, and captured battle ensigns. The Post Captain against a background of frigate and ships-of-the-line, any of which he might have commanded, with guns and shot, to signify his constant concern to ensure that his ship was properly manned, equipped and victualled. The Master and Commander, a transitional rank, with a sloop of war to indicate an intermediate command, often acquired by the fortunes of war, perhaps capture from the enemy or the death of a brother-officer. A Lieutenant and the speedy messenger of the fleet, a cutter, by which messages were exchanged and dispatches sent back to England, with hand arms to show that it was usually this officer who led boarding and landing parties. The Midshipman, with the workhorse long boat as his proud command, and the casks of stores it was frequently his task to ship and load. Finally the Seaman, against the background of a ship's barge. With the boat's anchor on the shore are two oars to exemplify the hard labour which was the poor fellow's lot, while the draconian figure sitting in the stern-sheets makes it clear that authority was never far away. The ordinary sailor's dress would usually have been far from uniform and often rather less tidy than that depicted.

The hand of Dominic Serres, the experienced mariner-artist, is readily apparent in the drawings and prints, which are rather loosely drawn and small in size. Each is a charming nautical vignette seeking to attract attention, rather than a detailed portrayal of the uniform to illustrate the requirements of the Admiralty orders. Inconsistencies with the regulations are evident, even in the few sentences quoted above, such as the lace at the Lieutenant's cuffs, which was specifically excluded.

Serres must have etched the drawings himself, as no other engraver is named, and they were published from his home address in Warwick Street, Golden Square, in November 1777. The lettering on the prints is quite amateur and, as copies are very rare, their printing and publication may never have progressed much beyond a domestic activity of the artist and his family.

Earlier that year the Royal Academy had accepted four paintings from Serres, among them a 'View of Portsmouth from Spithead' (no. 322) and 'A Seaport in the Mediterranean' (no. 323). One commemorative was the up-to-the-minute 1776 'Fireships in the Hudson River' (no. 320), discussed on page 108 (Colour Plate 44), but the other

12. W.L. Clowes, *The Royal Navy, A History*, 7 vols., Vol. III, 1898, reprinted 1996, pp.347–350.

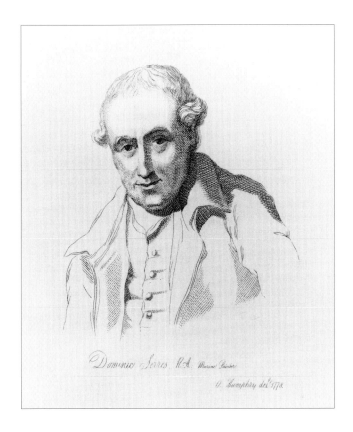

PLATE 59. 'Dominic Serres', etching by Mary Turner after Ozias Humphry. The first recorded individual portrait of Serres, apparently a drawing, was made by his friend Humphry in 1778. It is now only known from this later and rare reproduction.

By courtesy of the National Portrait Gallery, London

still harked back to the previous war: 'The Thésée, a French 74-gun ship, sinking while engaging with the Torbay, commanded by the Hon. Capt. Keppell, in the memorable action of 20 November 1759' (no. 321). Keppel had distinguished himself at the battle of Quiberon Bay nearly twenty years earlier, and this painting was evidently commissioned to add to the gallery of pictures celebrating the victories of Augustus Keppel, who was, by now, Vice-Admiral of the Red and in command of the Channel fleet. He had also recently received a pension of £1,200 and property in Norfolk and Suffolk as a legacy from Admiral Sir Charles Saunders. The critic reporting on the exhibition in the *General Advertiser* for April wrote of these pictures: 'Mr. Serres has been of late unrivalled in the particular department of *painting ships*; here he has brought them to action, in the two former numbers, with equal skill; indeed so much so, as to strike the mind very powerfully at the awfulness of both situations. No. 322 and 323 have likewise considerable merit'.

In passing it may be recalled that 1777 was the year in which Boydell, having acquired the plates after Short's drawings and Serres's paintings, reissued the prints of Keppel's capture of the island of Belleisle which had first appeared in 1763. John Boydell (1719–1804) was the most enterprising and successful engraver and publisher of prints. As early as 1747 he was commissioning drawings from Richard Short and in 1753 paintings from Charles Brooking, and went on to build up a large and prosperous business in Cheapside in the City of London, which ultimately brought him the distinction of being elected Lord Mayor in 1790. His intention, stated in the catalogue of his prints, was 'to commemorate the actions of some of our principal commanders in the late war; and also to do honour to the Artists that executed them. I hope they will be the cause of similar works, which may beautify our public buildings'. By 1807 that catalogue was advertising, for all subjects, forty-eight volumes of prints containing more than 4,400 examples, bound, for £1,000.

During 1778 Serres was already working on some of the commissions for patrons who wished to perpetuate actions in the war, now seriously engaged, over the bid for independence by Britain's American colonies. But he still produced and exhibited the coastal landscapes he evidently enjoyed painting. These show a masterly handling of

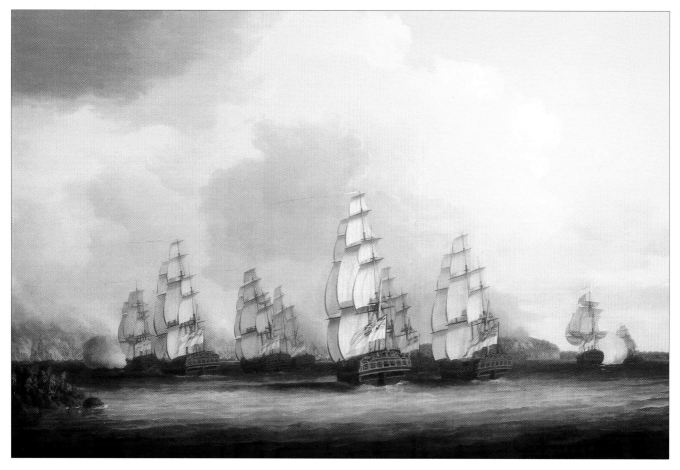

Colour Plate 51. 'Destruction of the American fleet at Penobscot Bay, 14 August 1779', oil on canvas, 40 x 60 ins. (101.5 x 152.5 cm). A significant, if minor, incident in the war, but one which Commodore Sir George Collier, the commander, felt justified in celebrating with a painting by Serres. The movement of the scene, as the squadron sweeps into the Bay, against the background of burning American vessels, is well portrayed.

National Maritime Museum, London

landscape which takes up the stylistic influences of Canaletto and Samuel Scott while also owing something to Paul Sandby. The works of these artists were precursors of the deft portrayal of landscape, particularly in watercolours, which was to evolve in the last decades of the century and become an important British contribution to the history of painting.

Serres's submission to the Academy in 1778 consisted entirely of such views of centres of naval activity: 'The entrance to Portsmouth Harbour' (no. 278), 'A view in the Downs' (no. 279), and 'A view in the Sound at Plymouth' (no. 280).

In this year, also, Ozias Humphry (1743–1810), who had returned to London the previous year, produced the first recorded portrait of Serres. It was apparently a drawing and is now only known from a later and rare etching made by Mary Turner (née Pulgrave, 1774–1850), the wife of the antiquary, Dawson Turner (Plate 59).

The patronage of Edward Hawke (1705–1781)

Edward Hawke was, by virtue of his long career and successes in action, one of the most respected officers in the navy and, after the death of Anson in 1762, the most senior admiral. Tobias Smollett, who had served as a naval surgeon in Central America, called him 'the Father of the English Navy'. Hawke was promoted Admiral of the Fleet in 1768 and Vice-Admiral of England before his death in October 1781. His victory at the battle of

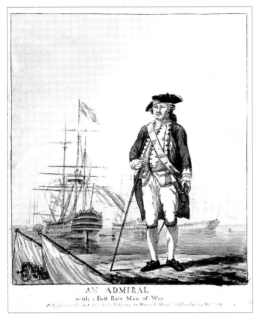

AN ADMIRAL
with a First Rate Man of War

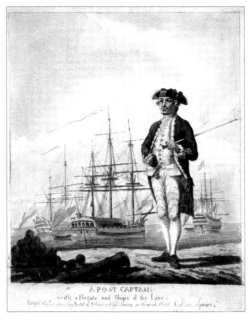

A POST CAPTAIN
with a Frigate and Ships of the Line.

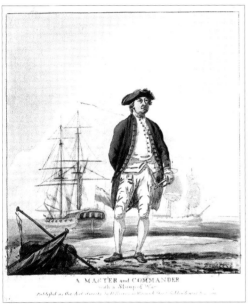

A MASTER and COMMANDER
with a Sloop of War

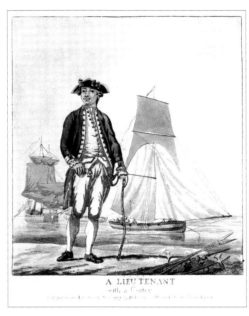

A LIEUTENANT
with a Cutter

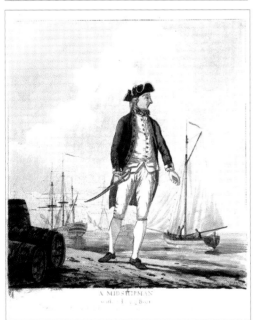

A MIDSHIPMAN
with a

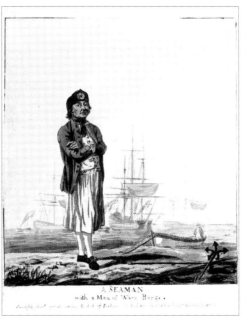

A SEAMAN
with a Man of War's Barge.

COLOUR PLATE 52. Naval Uniforms: An Admiral; A Post Captain; A Master and Commander; A Lieutenant; A Midshipman; A Seaman, set of six hand-coloured etchings by and after Dominic Serres, published by him in Warwick Street, Golden Square, November 1777, each 7¾ x 7 ins. (19.5 x 17.5 cm). Although regulations governing uniforms in the Navy had been introduced during the previous thirty years, Serres's treatment is artistic rather than official. Many of the details in the drawings do not conform to the requirements laid down and each rank is shown with appropriate vessels in the background and trophies or equipment in the foreground.
National Maritime Museum, London

Quiberon Bay on 20 November 1759, which averted the threat of invasion of England, was the pinnacle of his achievement and one of the most audacious and skilful naval successes of all time. The *Royal George* (100 guns) was his flagship at the battle and remained so until the end of the war in 1763. It was then laid up but, recommissioned in 1778, continued to be one of the most powerful and famous units in the navy, finally passing into history by the horror of its tragic demise in Spithead on 29 August 1782, when it capsized and sank with the loss of over 900 lives, including that of Rear-Admiral Richard Kempenfelt. Serres painted her several times, both in the course of the running fight as the fleets surged towards the shoals of Quiberon Bay in 1759 and in more peaceful circumstances, as she returned to her native shores.

The latter, 'The Royal George returning from the Bay', was exhibited at the Royal Academy in 1771 (no. 182), but it is Serres's depiction of the battle itself which is, for him, in a genre of its own and one of his most vital and dynamic representations (Colour Plate 7). The chiaroscuro effect of the light from the clouded sky on the angry water as the warships plough through it, firing random shots at each other, while buoys and wreckage betoken the proximity of the shore, gives a vivid impression of the movement and dangers of the engagement. The *Royal George* is shown coming up with Vice-Admiral de Conflans's flagship, *Soleil Royal* (80 guns), which was ultimately beached and burnt by the French. Two versions of the painting are known, the larger being unsigned and undated. That illustrated on page 33 is signed and dated 1779 and is at Greenwich.

Serres later again painted the flagship in a more peaceful setting, probably as an actual portrait after her recommissioning in 1778. 'The Royal George bringing a French 74-gun ship into St. Helens' was hung at the Academy in 1779 (no. 296) (Colour Plate 53) and was to provide the original for Plate XXVIII in *Liber Nauticus* (Plate 60). The oil painting provides an opportunity to examine Serres's technique in that medium in some detail.

Serres's oil painting technique

Serres used canvases which were normally medium or fine tabby weave and prepared with a beige primer and light, often pink buff-coloured, ground layer applied thinly in predominantly diagonal strokes from top left to lower right. The paint was sometimes applied thickly, particularly in the sky, with crisp, fresh impasto to heighten the cloud and smoke effects which were so characteristic of him, but the ground layer was also occasionally allowed to appear for lighter tones. The paint was laid on progressively from the more thinly painted areas, such as the sea, to the thicker. In the case of Colour Plate 53 the sky itself was thinly and broadly painted with horizontal covering strokes of blue over yellowish green and semi turbid bluish-grey, leaving out the cloud patterns. Thick white highlights were then added and the *Royal George* laid in with transparent dark brown over the light base, the shadows being added after the lights. The ships' rigging is very dark, thick and confidently painted. The whole was finished with the yellow natural resin varnish which the artist customarily used.[13] Serres was a prolific painter, frequently working under pressure to produce large oil paintings to a deadline, and his technique often reflected this with an overall thin and hurried application of paint which has not always withstood the ravages of time. Considerable variations are therefore to be encountered when the brushwork of his paintings is examined in detail.

Hawke at Swaythling

W. Sandby, the great-grandson of Thomas Sandby, wrote in his history of the Royal Academy that Hawke, like other naval commanders, patronised Serres to record his nautical

13. File notes Conservation Department, National Maritime Museum.

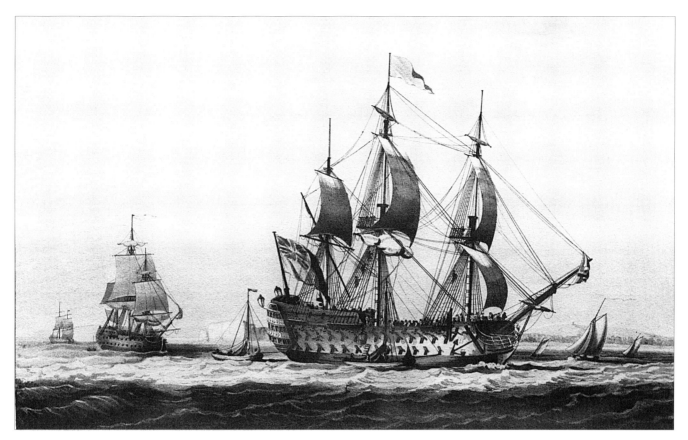

PLATE 60. 'A First Rate: the portrait of the Royal George', *Liber Nauticus,* Plate XXVIII, published by Edward Orme, London, 1806. When Serres was called upon to produce a series of drawings for the instruction of a nobleman and amateur in marine painting (see pages 196–199), he took some of his best paintings as models, in this case that shown in Colour Plate 53. Dominic may have planned a publication with his son, John Thomas, but it was not until long after his death that the drawings were used as illustrations in *Liber Nauticus.*

exploits such as the victory at Quiberon Bay. Precise dates and details are, unfortunately, not available, but the evidence suggests that Hawke extended his patronage and support to the artist over a number of years and that he may have commissioned more than one of the paintings just discussed. Serres was frequently active in the Solent area. 'A View of South Stoneham House on the bank of the River Itchen, near Southampton', signed and dated 1766, was in the collection of Major R.C. Hans Sloane Stanley at Paultons, Ower, Hampshire, and probably commissioned by his forebears, while in 1774 Serres had 'A view of Ealing, near Southampton' hung at the Academy (no. 273). Both locations are near Swaythling, where for many years Hawke rented a country house, which was convenient for Portsmouth, the constituency he represented in Parliament, as well as being the centre for many of his naval duties. Although he owned houses in London and, later, in Sunbury-on-Thames, he always regarded the house at Swaythling as home, for it was there his children were brought up, and where the family spent holidays together and guests were welcomed, Dominic Serres very probably among them. Catherine, Hawke's wife, died in October 1756 at the age of thirty-six and was buried in the local church of St. Nicholas, North Stoneham, alongside those of her children who had died in childhood.

When Hawke was created Baron in 1776, he took the title of Baron Hawke of Towton, after his wife's home in Yorkshire and, on his death at Sunbury, twenty-five years after his wife, his body was taken to North Stoneham for interment with those of his cherished wife and family in St. Nicholas's church. His son, Martin, commissioned an imposing monument for erection on the south wall to honour the admiral and his wife, the

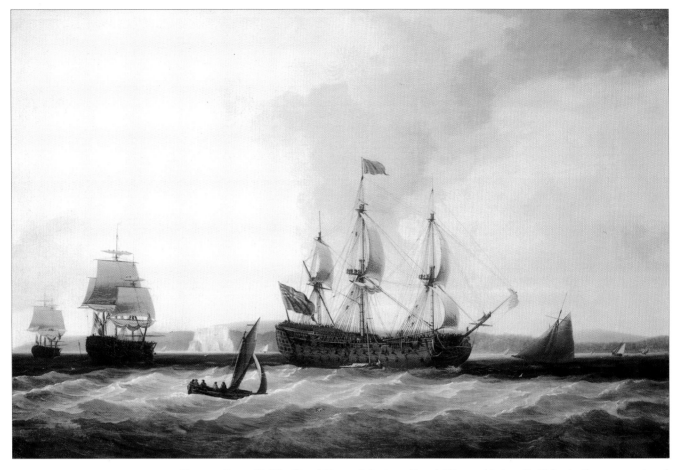

COLOUR PLATE 53. 'The Royal George bringing a French 74-gun ship into St. Helens', oil on canvas, signed and dated 1778, 36 x 53 ins. (90 x 133.5 cm). *The Royal George* was Admiral Edward Hawke's flagship for many years and Serres made several paintings of her, including when in action at Quiberon Bay (Colour Plate 7). The painting provides an opportunity to examine the artist's technique in detail.

National Maritime Museum, London

centrepiece of which is a white marble bas-relief by John Francis Moore (d.1809) after Serres's unforgettable painting of Hawke's greatest victory (Colour Plates 54 and 55). Part of the inscription on the monument reads '…wherever he Sailed Victory attended him. A Prince unsollicited [sic] conferred on him Dignities which he Disdained to ask'. The monument was unveiled on 29 August 1783 and the *Universal Magazine* reported that the relief of 'the last battle he fought in the Royal George against Conflans, is done after the original picture painted by Serres, in white marble, truly delicate and beautiful'

John Thomas as Drawing Master at Chelsea Maritime School

In the closing years of his life Hawke probably gave another helping hand to Serres and his family. In 1777 Jonas Hanway (1712–86), who had founded the Marine Society twenty years earlier to provide nautical training and a career at sea for boys, proposed the establishment of a Maritime School at Chelsea. It was to be a 'Maritime School on the Banks of the Thames, near London, as distinguished from the Royal Naval Academy, at Portsmouth Dock'. Admiral Lord Hawke was the first President-elect and the school motto 'We hope for glory'. Ormond House, opposite the west gate of the Royal Hospital at Chelsea (the military equivalent of that at Greenwich) was purchased and, in March 1779, a retired naval officer installed as Superintendent, with his wife as Matron, and a Master recruited for Mathematics and Navigation. The first ten of the planned twenty-six

COLOUR PLATE 54. John Francis Moore's white marble bas-relief for Hawke's tomb, after Serres's painting of the battle of Quiberon Bay (Colour Plate 7). The *Universal Magazine*, 1783, described the marble as 'truly delicate and beautiful'

COLOUR PLATE 55. The monument to Edward, 1st Baron Hawke, St. Nicholas, North Stoneham, Hampshire. Edward Hawke's son, Martin, commissioned this imposing monument to his father. The centrepiece was a white marble bas-relief by John Francis Moore after Serres's painting of Hawke's greatest victory, the battle of Quiberon Bay in 1759.

eleven-year-old scholars were at the same time admitted for their two to three year course. The staff was later supplemented by the appointment of a French and Writing Master, a Drawing Master, who was John Thomas Serres, a Secretary, a Sergeant, a Surgeon, Mr. (later Sir) William Blizard, and an Apothecary. 'A vessel of competent size for going up the shrouds and formed according to art' was constructed in the playground.

Bringing the staff and pupil numbers up to strength would have taken a few months and, although the records are not precise, John Thomas would therefore probably have started work in the latter part of 1779, when he was just twenty years of age. His salary of £50 per annum would have represented, if not riches, at least a steady means of support for a young and aspiring artist.

The Duke of Cumberland succeeded Hawke on the latter's death, and there was appropriate press comment when the *Britannia* training rig in the grounds was renamed *Cumberland* in honour of the event. The school, however, enjoyed a short life. It ceased operating in 1787, although promptly reincarnated by the Mathematics Master, Mr. Bettesworth, as the Naval Academy, in which guise it continued until 1830. On the closure of the school, the funds were put on deposit and finally transferred to the Marine Society in 1823. How long John Thomas remained a teacher at the school, or the Academy, is not clear, but as he continued to live in London, most of the time with his parents, and collaborate with his father on various works, his tenure may have lasted as long as the school existed. By 1787 he was travelling in Ireland and on the Continent, which suggests that he left when the school closed. If one account, which states that he handed over his post to his younger brother, Dominique Michael, is correct, he may have left earlier.

THE SUMMIT REACHED:
MARINE PAINTER TO THE KING;
THE ARTIST AS COLLECTOR
1780

The opening of the new decade sees Serres, at the age of sixty-one, at the pinnacle of his career. He is appointed Marine Painter to His Majesty the King; he is inundated with commissions from naval commanders for paintings of their victories; he and his family move from Golden Square to a house overlooking Hyde Park, next door to his friend of long standing, Paul Sandby; he is building up an important collection of paintings and drawings and, in artistic terms, the pressure of his patrons obliges him largely to abandon his preferred maritime landscape subject matter in favour of the more purely marine, and more demanding, depictions of naval engagements. As an Academician he has become a respected member of the artistic establishment and his distinguished naval patrons have conferred a certain social standing, while at the same time he has remained an important figure in the Anglo-French community. He is still devoted to his wife and proud of his children, who are becoming proficient artists, his sons exhibiting at the Royal Academy, under their father's aegis, as Honorary Exhibitors. Yet he remains a modest, unassuming person with high professional standards, a warm disposition and a demanding code of personal ethics. He works fast and succeeds in producing a prolific flow of large oil paintings as well as keeping up his sketching of ideas and scenes for use in his set piece pictures. In spite of his age, his self-discipline dictates that he maintain this pace of work throughout the decade and until the last months of his life.

The appointment as Marine Painter to the King was honorary, and carried no remuneration. The procedure for the nomination and appointment was often informal, particularly for designations which were unpaid. The King himself would personally have made the decision, based on the artist's work, such as the series of paintings of the review of the fleet at Spithead in 1773 and, probably, also personal acquaintance through the Royal Academy. Serres would, in any event, undoubtedly have had advocates at Court in the person of senior naval commanders and other patrons. The arrangements were less formalised than they became later in the reign of George III, under his sons and in the time of Queen Victoria, so it is no surprise that details of the appointment have not been traced in the royal archives or in published gazettes. Serres had no immediate predecessor similarly designated and the first occasion on which he was accorded the title was in the Royal Academy catalogue for the spring exhibition in 1780. The appointment must therefore have dated from the second half of 1779 or the early months of 1780. It confirmed the Academician's status as the leading marine painter of the period.

The move to St. George's Row

His enhanced standing and affluence encouraged Serres at this time to make the move, with his family, from the artists' quarter around Golden Square to a more exclusive location at St. George's Row, Oxford Turnpike. This was on the northern edge of Hyde Park, looking out on the rural vistas of the royal parkland with the Surrey hills in the

PLATE 61. 'The Studio of the Artist, 4 St. George's Row, Bayswater', Paul Sandby, watercolour and bodycolour over graphite on blue-green paper, 9 x 12 ins. (24 x 28 cm). Sandby's drawing shows the specially constructed studio at his home overlooking Hyde Park. The neighbouring house, to which the Serres family moved in 1779/80, was probably not as grand but would have enjoyed the same advantages of a rural situation away from the closely-built streets of Soho.
©The British Museum.

background. It seems that some of the Serres children may not have enjoyed robust health and the cleaner air and country environment adjoining the park may have been an added incentive to the artist to move away from the centre. It may also be assumed that he now felt himself sufficiently well established in his profession to attract patronage without being located in the busiest part of town. He had clearly progressed far beyond the necessity to display his work for sale in the window of his house. The location of the house was in what is now Hyde Park Place, beside the Bayswater Road.

But the most likely reason for Serres to choose the Oxford Turnpike, and probably also to decide to move house at all, was that Paul Sandby had, since 1772, lived at 4 St. George's Row (now 23 Hyde Park Place)[1] in a house with a specially constructed studio overlooking the park. The Serres moved next door, but, although several drawings of Hyde Park by Dominic are recorded, the precise location and configuration of their house is not known. Sandby's drawing of his studio shows that it stood apart from other buildings (Plate 61). The arrangements of his neighbours may have been similar, even if not so elegantly designed. The Serres house continued to provide an hospitable family home for the next thirteen years, until Dominic's death in 1793, several of the children staying on as adults with their parents. Here Dominic was drawn more closely into the 'circle of intellectual and attached friends of Paul Sandby, comprising the most distinguished artists and amateurs of the day'.

James Gandon goes on to recall that Sandby's house:

Became quite the centre of attraction, particularly during the spring and summer months, when, on each Sunday, after Divine Service, his friends assembled, and formed a conversazione on the arts, the sciences, and the general literature of the day. I cannot name all the gentlemen who were in the habit of visiting at Sandby's at that period, but I have met the late Lord Maynard, the Earl of Charlemont, Lord Carlow, afterwards Earl of Portarlington, Lord Duncannon, Mr. Charles Greville, Mr. Wyndham, Mr. Sackville Hamilton, and his brother, Captain Hamilton, Sir Richard Musgrave, Mr. Frederick French, Mason, the poet, and very many other admirers of the arts, and almost every artist of eminence of that day.

1. J. Roberts, *Views of Windsor, Watercolours by Thomas and Paul Sandby*, exhibition catalogue, 1995, p.21.

In addition to Dominic Serres, who is named first, Gandon's list of these last includes Richard Wilson, Richard Paton, 'Athenian' Stuart, Wright of Derby, Castells, Verelst, Oram, Mrs. Beale and Flaxman. Serres was evidently well introduced and popular in these circles for Gandon's autobiography goes on to say that 'Serres was a fine, boisterous fellow, and was to be heard in his inquiries from the moment he entered Sandby's hall door until his appearance in the studio'. Indeed, in some quarters he earned the epithet 'Dominic Neverserious'.[2]

However, Gandon concludes with the observation that 'in private life Serres was a very amiable man, very fond of his art, which he cultivated with assiduous industry'.[3]

Ephraim Hardcastle, the pseudonym under which W.H. Pyne (1744–1824+), the artist and engraver, in 1824 wrote *Wine and Walnuts*, a miscellany of biography and anecdotes about artists and their world, recounts the following about Dominic Serres after his move to St. George's Row:

> His Majesty George II allowed him his parole, and patronised his talents. Grateful for this royal munificence, the worthy painter hoisted the English flag when he knew the King was passing the Knightsbridge Road, to or from Windsor. His late Majesty [George III] used to look for the flag, and frequently observed 'There is honest Dominic's signal flying'.

The flag must have been of some size and flown at some height to have been visible from the other side of Hyde Park! No doubt Serres's loyalty to the monarch was strengthened by his appointment as Marine Painter to the King.

The artist as collector

Serres's familiarity with other artists in social circles was reflected in his own collecting of works of art. After his death in 1793, the Christie's sale of his collection and studio contents extended over three days between 13 and 15 March 1794, with a further sale in April 1795. The 1794 sale consisted of a total of 427 lots comprising paintings, drawings, prints and books. This sale took place only four years after another, held in April 1790, in which John Thomas put up for auction a similarly varied collection of works of art which totalled 238 lots. This was on the eve of his departure for France and Italy, presumably to help finance his tour. Dominic had thus evidently been collecting for years and probably throughout his life as long as he could afford it. It is true that a large proportion of both sales consisted of the works of father and son, but the number and range of works by other artists, living and dead, was remarkable. Dominic would clearly have collected some works for their value to him in relation to his own painting, such as landscapes and the van de Velde marine drawings, but other items indicate a broad scope of interest in a wide range of work by English and continental artists.

The number of lots in the posthumous sale of Dominic's collection itself gives a scant idea of the total number of works involved. In Drawings, on the first day, for example, Lot 1, was '[Simon] Devlieger [the Dutch marine painter] Twenty seaskips'; Lot 5 '[Samuel] Scott thirty views, sea fights, &c'.; Lot 12, '[William] Taverner 12 Landscapes'; Lot 17 '[George] Lambert Four landscapes' and, Lot 18, 'Seven of architecture'; Lot 30, '[Agostino] Carlini Twenty historical'; Lot 31 'P.[ietro] da Cortona Seventeen ditto'; Lot 32 '[Francesco] Zuccarelli Six landscapes', and Lot 37 '[?John James] Barolet Eighteen landscapes'. This multiplicity of items in individual lots persisted throughout many of the later lots in the sale and represented a bewildering array of artwork. Artists and engravers in landscape and other genres, apart from marine, represented in the collection included ?Francis Barlow, George Barret, Francesco Bartolozzi, Stefano della Bella, Nicolaes Berchem, Franco Bolognesi,

2. Information provided by John Munday is gratefully acknowledged.
3. J. Gandon and T.J. Mulvany, *The Life of James Gandon*, Dublin, 1869, reprinted 1969, pp.39–40, 190–191.

Canaletto, Cangiaci, Annibale Carraci, Pieter Casteels, Aelbert Cuyp, ?Hugh Primrose Dean, Adriaan van Diest, Raymond La Fage, Franz de Paula Ferg, Charles de la Fosse, Thomas Gainsborough, Gressier-?John Alexander Gresse, Josse or Hendrik (Hond) Hondius, Julius Caesar Ibbetson, Elisha Kirkall, Giovanni Lanfranco, P. Lilly, ?Anton de Lormi, Francesco Londoni, Jean Baptiste van Loo, Claude Lorrain, William Marlow, Gabriel Metsu, Jean-Baptiste Monnoyer, George Morland, one of several named Paracel, Paulus Potter, Raphael, N. Tull, Francesco Solimeni called l'Abate Ciccio, Claude Joseph Vernet, Simon Vouet, Anthonie Waterloo, Wearother, John Webber, Philips Wouvermans and Jan Wyck. It may be noted that several of these, such as van Loo, although not of British origin, spent some time in England and their work may have been known to Serres on a more or less personal basis.

Detailed study of these artists and their techniques could reveal similarities with, and therefore probable influence on, Serres. A substantial proportion of them were either principally engravers and etchers or practised these skills in addition to painting and drawing. This would reflect Serres's early collaboration with engravers and printmakers and his continued association with them throughout his career. Elisha Kirkall (c.1682–1742), for example, was an engraver fascinated by chiaroscuro effects, as was Serres in his turn, and prepared to experiment. Kirkall used mixed techniques to achieve the results he wished, etching outlines, using mezzotint for the dark shadows and woodcuts for the demi-tints. He produced in 1726 a set of ten seapieces after Willem van de Velde the Younger, printed in sea-green mezzotint, which helped to popularise the work of the Dutch master. A connection of a more personal nature might have existed between Serres and Tull, a landscape painter who exhibited at the Society of Artists in 1761. N. Tull was the master of Queen Elizabeth's School, Borough, and one wonders if he was an early acquaintance from the time when the Frenchman was in the Marshalsea prison. John Webber accompanied Captain Cook on his third and final voyage to the Pacific, as official artist, and returned to London in 1780.

The marine discipline was richly represented with works by Charles Brooking, Jan van de Cappelle, Jan van Goyen, Peter Monamy, Abraham Storck and Reinier Nooms called Zeeman. There were apparently about 200 van de Velde drawings and several oil paintings, although the catalogue often does not make clear the precise nature and authorship of each item in each lot. This was an enormous assembly of works by the Dutch artists, father and son, even within a century of their active working lives, and must have represented a considerable investment by Serres over the years. In 1794 the total sale realised £1,083 17s. 6d., a substantial amount when measured against Serres's general level of income and expenditure during his lifetime. He was obviously an avid collector, over and above the requirements he may have perceived for the development of his own painterly techniques.

This brief review of the contents of the sale provides telling evidence that Serres was keenly interested in landscape painting, as well as marine, and was anxious to inform himself of the differing styles and manners of both his contemporaries and older masters. The inclusion of artists such as Paul Sandby and Claude Joseph Vernet was unsurprising, but the presence of Julius Caesar Ibbetson shows that Serres was alive to the newly-emerging English landscape painters, particularly in watercolours, who were to dominate the later decades of the century and the beginning of the next. But Serres remained his own man in landscape painting in spite of his receptive awareness of the work of many other artists. He notably did not follow, for example, the path of Canaletto and Samuel Scott in depicting mainly city and architectural views. His landscapes were typically coastal and pastoral, even though often set in busy naval locations such as Portsmouth and Plymouth. He preferred to choose the less

developed and more peaceful scenes, almost in the spirit later expressed by Herman Melville in *Moby Dick*, that 'meditation and water are wedded for ever'.

In the 1794 sale, 205 lots consisted of works by Dominic, many of them, similarly, containing several individual works. This was only to be expected in a studio sale, but also gives an insight into the artist's wide range of preparatory drawings, sketches and, inevitably, unsold oil paintings. The location of views drawn by Serres among this studio collection shows that he was not only stimulated by the techniques of his contemporaries but, like them, travelled in search of material. Assuming that drawings of places such as Havana and Italian ports were based on his earlier travels, it seems that he spent time in the Low Countries, of which there are many drawings.

The pervading influence of the van de Veldes and other Dutch marine and landscape painters on art in eighteenth century England made this a logical, prime destination for a painter with similar interests. It is perhaps surprising that so few finished oil paintings of Dutch views are known.

Portraits were notable by their absence, the only one immediately memorable being Benjamin West's 'Portrait of a Nobleman'. The evidence of Serres's paintings demonstrates that he was nonetheless deeply concerned to portray figures in a proper and constructive manner. Although his foreground figures are typically staffage, in the traditional sense of filling the foreground and providing personal interest, he achieves his purpose with notable success, bringing life and credibility to his images. The rigging of his ships rarely lacks active figures, however small, climbing the ratlines or carrying out some task aloft. Various works in his collection, such as sculptural drawings, indicate his awareness of these demands and his willingness to learn from the works of others. Further examples may be found among the small number of books included in the sale, fifteen lots in all. Lot 262 was 'A book of anatomy and heads of the cartoons' and Lot 264 'The Farnasean gallery'.

This extensive collection was clearly built up over a period of time and much of it must have been assembled by the early 1780s. Some works would have been purchased, either privately or at auction, others perhaps exchanged with fellow artists or received from them as gifts, Agostino Carlini (d.1790), a sculptor, for example, being also a founder member of the Royal Academy.

The Royal Academy in 1780: Barrington again, Windsor and Rodney

The flow of commemorative commissions from senior naval officers, upon which Serres's success and affluence rested, gathered momentum as the War of American Independence progressed. He naturally responded by working as fast as possible to meet the pressing requests of his anxious patrons. His submissions to the Royal Academy exhibition in 1780 are thus significant in being only of naval engagements which had taken place within the previous two years. The traditional coastal views and retrospectives of earlier conflicts were absent. In depicting contemporary events Serres contributed to the historical record of his times and also, through the medium of prints, helped to meet the public demand for images of the war, which were not readily available by any other means. There was, however, an inevitable impact on Serres's subject matter and style. His timeless coastal landscapes were necessarily abandoned in favour of ship-to-ship actions fought out on the high seas, often with no land in sight, which exemplified the skill and valour of the audacious commander. Serres's aptitude for painting ships and the sea was such that he relished the challenge, especially when a moonlit evening or night scene was required. He

132

nonetheless still liked his coastal landscape with naval vessels in more peaceful surroundings, the more aesthetic landscape view charged with emotion, usually that of victory, the calm after the action. An example is his major painting presented as a 'diploma work' to the Royal Academy (Colour Plate 59 and page 140).

Two of the paintings shown at the Academy in 1780 had been commissioned by a patron who had employed Serres on previous occasions. This was the Hon. Samuel Barrington, who had been promoted Rear-Admiral at the beginning of 1778 and placed in command of the Leeward Islands Station, which comprised the West Indian islands south of Antigua, with his base in Barbados. In September the French sallied from Martinique and captured Dominica, thus securing the chain of four consecutive islands from Guadeloupe in the north to St. Lucia in the south. With the onset of winter in North America and the end of the hurricane season in the West Indies, the theatre of operations moved southwards and reinforcing fleets from both France and England brought fresh troops to the islands. Vice-Admiral Comte d'Estaing took his fleet to Fort Royal, Martinique, while Commodore William Hotham, with 5,000 troops, joined Barrington at Barbados a day later, on 10 December 1778. Barrington wasted no time in turning his force round, sailed for St. Lucia on 12 December, and landed the troops, under the command of Major-General James Grant, who dislodged the French defenders. By the evening of 14 December the British controlled the coastal defences from The Vigie, the bluff commanding the Carenage, to the southern point of the bay known as the Grand Cul de Sac, in which Barrington had anchored his transports (Plate 62). Reference has

PLATE 62. 'Sketch of Part of the Island of Ste. Lucie' (detail), engraving published in 1781 included in *History of the Seven Years' War*, Vol. II, by Colin Lindsay, London, 1793. This contemporary map shows Barrington's squadron anchored across the entrance to the Grand Cul de Sac and d'Estaing's lines of approach. The entrance to the Carenage, now Castries, and The Vigie, which figured in other works by and after Serres, are on the left of the plan.

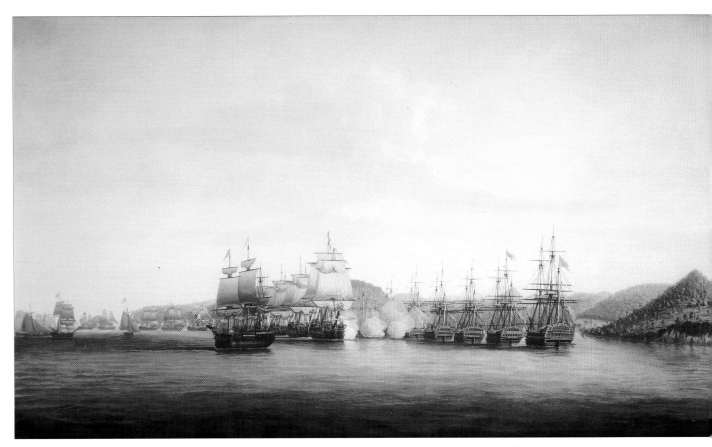

COLOUR PLATE 56. 'The attack by Count d'Estaing on the English squadron, commanded by Admiral Barrington, at St. Lucia, December 15 1778', oil on canvas, signed and dated 1780, 41 x 73 ins. (104 x 184 cm). A further commission for Serres from Barrington, who had anchored his transports in the Cul de Sac and placed his limited force in a protective line across its mouth. The French fleet is shown beginning the attack but was unable to press it home. National Maritime Museum, London

PLATE 63. 'A view of the English squadron, commanded by Admiral Barrington, and transports, in the Cul de Sac, with the French fleet under Count d'Estaing, December 15, 1778', wash and ink on paper, 9 x 12 ins. (23 x 30 cm). The preliminary drawing from which Serres developed his oil painting with the same title which was hung at the Academy exhibition in 1780.

National Maritime Museum, London

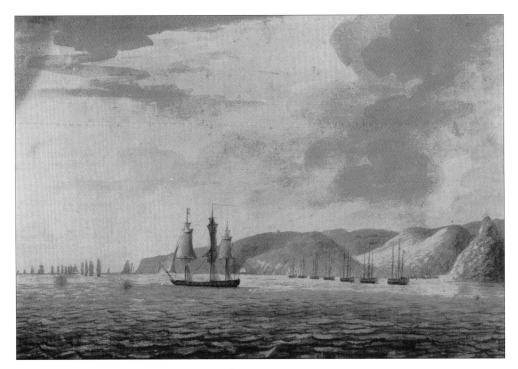

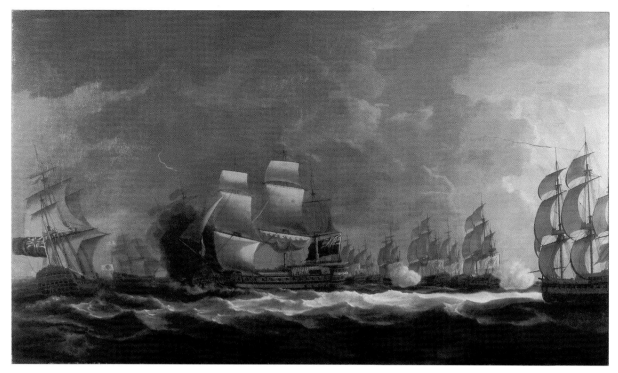

COLOUR PLATE 57. 'The Moonlight Battle: the battle off Cape St. Vincent, 16 January 1780', oil on canvas, signed and dated 1781, 42 x 72 ins. (106.5 x 183 cm). Rodney was ordered to take a convoy to the relief of Gibraltar on his way to the West Indies. He captured an entire Spanish convoy and then fought the enemy fleet in a night action. Serres does not depict the explosion as the San Domingo blows up but, typically, elaborates its effects and the light cast from off the right-hand side of the picture.

National Maritime Museum, London

already been made to the print after Serres's painting of Augustus Hervey's landing at the same location in 1762, which enjoyed a reincarnation as depicting this action by Barrington's force sixteen years later (see page 75 and Colour Plate 25).

D'Estaing, alerted to Barrington's move, quickly mobilised his units and determined to eliminate the English men-of-war before committing his troops to an assault on the shore defences. Barrington had anchored his limited squadron of only two modern ships-of-the-line, two 64-gun ships and three 50-gun ships, in a tight line across the mouth of the Cul de Sac to protect his transports. Although greatly superior in force, having twelve ships-of-the-line, d'Estaing decided, on 15 December, to approach this defensive disposition with his ships in line ahead. Serres's two paintings for Barrington show the opening situation with the French fleet in the left background, and the manoeuvre being carried out: 'A view of the English Squadron, commanded by Admiral Barrington, and transports, in the Cul de Sac, with the French fleet under Count d'Estaing, December 16th. 1778' (no. 45) and 'The attack by Count d'Estaing on the English squadron, commanded by Admiral Barrington at St. Lucia, December 15 1778' (no. 85). The artist laid out the general situation, as the French fleet approached, in his preliminary drawing (Plate 63). Colour Plate 56 reproduces the painting of the attack itself. It shows Barrington's flagship, the *Prince of Wales* (74 guns), at the most exposed southern and seaward end of the line, duly identified with its name on the stern, as are the next visible in line: *Preston* (50 guns), *Centurion* (50 guns), *Nonsuch* (64 guns) and *Boyne* (70 guns). The winds tending to fall light near the high shoreline, d'Estaing was obliged to turn away without inflicting any damage on the anchored English vessels. He tried again in the afternoon with no greater success and, thereafter, on 18 December, landed the 7,000 troops he had brought, to attack The Vigie. They were, however, repulsed, and on 29 December d'Estaing left the island, which formally surrendered the next day. The combined operation between Barrington and Grant,

both in the initial capture and subsequent defence against superior odds, was a singular success and jubilantly acclaimed in England when the news arrived. St. Lucia remained in British hands for the rest of the war and provided the navy's ships with valuable anchorages, particularly Gros Islet Bay on the north-west coast, from which a close watch could be kept on Fort Royal, Martinique, thirty-five miles away. As we have seen, the elder Hyde Parker was to take advantage of it in March 1780, and Serres was to portray his fleet sailing out past Pigeon Island (Colour Plate 49 and pages 112–113).

One reviewer of the Academy exhibition praised the historical accuracy of Serres's paintings:

> The subjects are so well described, that we even fancy ourselves anchored on the spot. The shipping are exceedingly correct, and so far as one can judge from accounts of the engagement, the manoeuvres are strictly represented. This Artist is always fortunate in his subjects, and there never was one which deserved more to be transmitted by his pencil, to prosperity, than the present.[4]

Predictably, however, not all critics were so favourable:

> I would rather be knighted and like Sir John Falstaff, drinking a cup of good sack, than have occasion to give my opinion on this performance, which never from beginning to end transported me in the least by its fire, vivacity or brilliant appearance, it is rather tame in all its parts; but had it been attended by the complete Victory, it would have been admirable, and no true Englishman would bar ringing a ton of bells on the occasion.[5]

These two paintings, like Serres's earlier works for Barrington, were subsequently presented to Greenwich Hospital by the admiral's younger brother. One, that illustrated in Colour Plate 56, was later engraved by P.C. Canot and published by Torre.

Barrington's distinguished service continued throughout this war and into the opening years of the next, during which time he was closely associated with other eminent commanders, notably Sir John Jervis and Lord Howe. He was Howe's second-in-command at the relief of Gibraltar in 1782 and will figure again later in this narrative in that connection. When Barrington died in August 1800, his obituary in the *Naval Chronicle* stated that he had lived 'in habits of the strictest intimacy and friendship' with Jervis, who was by then Earl St. Vincent. Both Howe and Jervis were also to be staunch supporters and patrons of Serres and his family and one may safely assume that this close circle of naval leaders was instrumental in the recommendation and promotion of the artist and his work to each other and to brother officers.

One of these last was responsible for another of Serres's paintings at the Academy in 1780. Number 20 was 'The engagement between the Fox, the Hon. Captain Windsor, and the Junon, a large French frigate'. The *Fox* (28 guns) and the *Junon* (34 guns) were both present, in the auxiliary role accorded frigates, at the inconclusive engagement on 27 July 1778 between the Channel fleet, under Admiral the Hon. Augustus Keppel, and the French commanded by Lieutenant-General Comte d'Orvilliers, which came to be known as the Battle of Ushant. The lack of decisive and victorious outcome for the British led to acrimonious charge and countercharge, heard in Courts Martial, by Vice-Admiral Sir Hugh Palliser, commander of the rear division, and refuted by Keppel. The hearings became, and have remained, a *cause célèbre* of English naval history and aroused violent public emotions at the time, Keppel being a staunch Whig, declining to take up arms against the American colonists, and Palliser a Tory. The London mob wrecked Palliser's house, he himself being fortunate to escape with his life. The

4. *Candid Review*, 1780, quoted by R. Quarm, *Masters of the Sea*, exhibition catalogue, National Maritime Museum, 1987, p.20.
5. *Strictures*, 1780, quoted by Quarm, ibid., p.21.

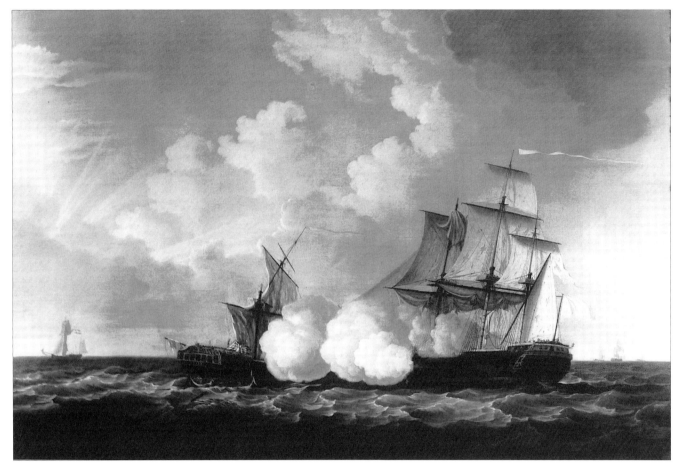

PLATE 64. 'The engagement between the Fox, the Hon. Captain Windsor, and the Junon, a large French frigate, September 1778', oil on canvas, signed and dated (illegible), 40 x 60 ins. (101 x 152.5 cm). Although the *Fox* was captured by its adversary, and wrecked soon afterwards, Windsor was given command of the new *Fox*, commissioned in April 1780. He was therefore clearly judged to have acquitted himself bravely and felt justified in ordering this painting from Serres, which was hung at the Royal Academy exhibition in 1780.

Earl of Plymouth Collection. Photograph: Photographic Survey, Courtauld Institute of Art

controversy represented the effective end of the sea-going careers of both men. The concerns of the Hon. Thomas Windsor, promoted Captain in February 1778 and given command of the *Fox*, were however, immediately after the battle, more modest but nonetheless testing. On 10 September his ship was attacked by the *Junon* and captured, although wrecked shortly afterwards on Belleisle. Nonetheless, Windsor was clearly judged to have acquitted himself bravely in the face of an enemy with superior fire-power, for he was soon appointed to command the new *Fox*, a 32-gun frigate, commissioned in April 1780. He therefore, equally, considered himself justified in ordering a painting from Serres to commemorate the action and in permitting it to be hung promptly at the Academy (Plate 64). The painting is still in the collection of the Earl of Plymouth, the hereditary title of the Windsor family.

The Moonlight Battle and Relief of Gibraltar 1780
Gibraltar had been a key strategic stronghold for Britain since the Mediterranean became one of the principal theatres of naval warfare between England, France and Spain. This had been the reason for its capture in 1704 by Admiral Sir George Rooke and the preservation of the naval base there had remained a basic tenet of British policy ever since, even, and more particularly, at times when the rest of the Mediterranean was denied to British forces. Toulon was the major French naval base in the Mediterranean, and

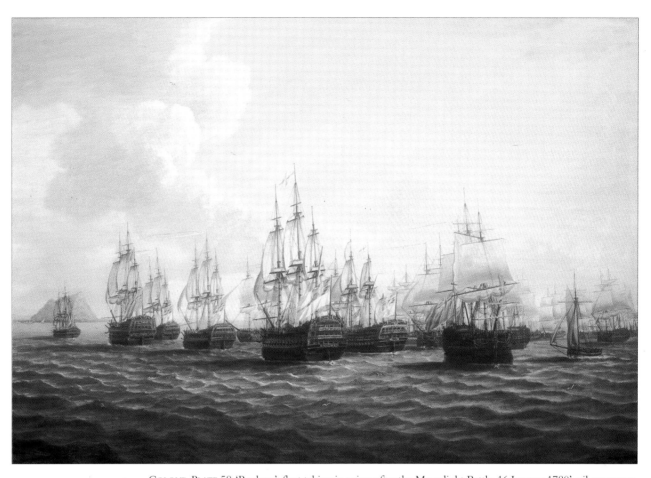

COLOUR PLATE 58. 'Rodney's fleet taking in prizes after the Moonlight Battle, 16 January 1780', oil on canvas, signed and dated 1793, 42 x 60 ins. (106.5 x 152.5 cm). The proud procession into Gibraltar, shown in the left background, after the battle. Painted in the last year of the artist's life, it may then have been commissioned by the Duke of Clarence, later William IV, who was serving in the fleet at the time as a midshipman.

National Maritime Museum, London

Cartagena and Cadiz gave Spain two bases, near at hand, which could potentially strangle Gibraltar at will. The entry of France and Spain into the war on the side of the American colonists therefore rendered Gibraltar once again vulnerable to attack. The Spaniards moved fast after their declaration of war and by July 1779 were blockading the British base with the intention of starving out the defenders. The army commander at the Rock was Lieutenant-General George Augustus Eliott, a veteran of the Havana campaign seventeen years before, who intensified his defensive preparations for the siege. The Spanish assault, when it was finally launched with fireships on the night of 6 June 1780, took the defenders by surprise but was successfully frustrated.

In the meantime, in England, steps were taken to relieve the fortress and Admiral Sir George Rodney, having been appointed to command the Leeward Islands Station, was instructed to escort supplies to Gibraltar and Minorca *en route* to the West Indies. After lengthy delays in assembling the large convoy of transports, he finally sailed from Plymouth on 24 December 1779 with twenty-two ships-of-the-line and fourteen frigates and smaller vessels as protecting force. On 7 January 1780 a complete convoy of twenty-two Spanish vessels was captured to the west of Cape Finisterre, and the twelve supply-carrying merchant ships from it immediately dispatched to the relief of Gibraltar under the escort of the captured *Guipuscoana* (64 guns), with a prize crew on board, later to be taken into the Royal Navy as *Prince William*. Advised that a Spanish squadron was cruising off Cape St. Vincent, Rodney kept his ships on full alert and action was joined by the leading British ships with

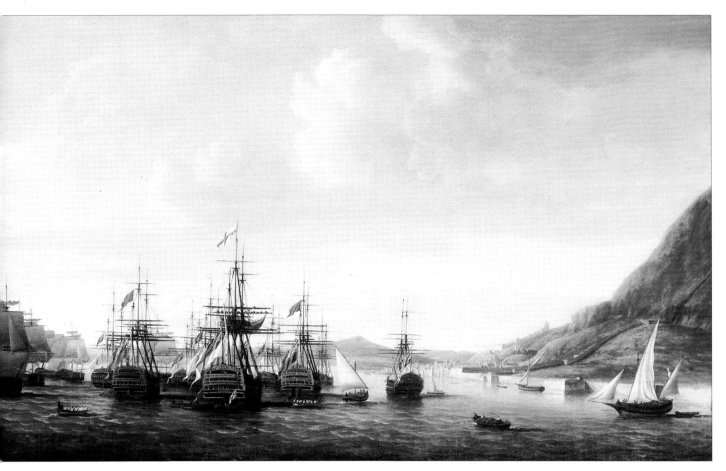

Colour Plate 59. 'Gibraltar relieved by Sir George Rodney, January 1780', oil on canvas, 35 x 57 ins. (89 x 145 cm). Serres seemed to prefer painting the more tranquil scenes when the fighting was over, and this splendid panorama shows victors and vanquished on their arrival at the fortress. He evidently thought it one of his better works as he presented it to the Royal Academy as the equivalent of a diploma work. It was reproduced in 1782 as an engraved print by R. Pollard. ©Royal Academy of Arts, London

those at the rear of the enemy line at four in the afternoon of 16 January. Forty minutes later the *Santo Domingo* (70 guns) blew up with a mighty explosion, the incident preferred by most of the marine painters who afterwards recorded the battle. The faster-sailing English ships overhauled their adversaries and by six o'clock, when the fighting became general, it was already dark. The engagement continued until two o'clock the following morning and thus became known as the Moonlight Battle. Rodney's fleet was totally victorious, capturing six more of the Spaniards' eleven ships-of- the-line, although two were later driven ashore and lost, 'the weather during the night' being, as Rodney reported, 'at times very tempestuous, with a great sea. It continued very bad weather the next day'.[6]

The engagement rapidly achieved great fame because of the completeness of its success, the ensuing relief of Gibraltar and its dramatic setting at night. Dominic Serres painted at least three pictures of the action. That which was probably the first, was produced with all speed and presented at the Academy within a few months of the spectacular victory: 'Part of the engagement between Sir George Rodney and the Spanish squadron' (no. 180). Serres was thus performing the role of war artist, the news being so fresh that further details were unnecessary for the catalogue entry. The painting was probably that illustrated at Colour Plate 57, now at Greenwich, or a version of it. Serres typically savours the effects of cast light and shadow from the explosion of the *San Domingo*, off the right-hand edge of the canvas, rather than the lurid details of the inferno itself. The force of the blast blows black smoke across the middle-distance from the obscured Spaniard, just raked by a

6. W.L. Clowes, *The Royal Navy, A History*, 7 vols., Vol. III, 1898, reprinted 1996, p.449.

broadside from the British two-decker in the centre of the composition.

Many years later, in 1793, the year of his death, Serres painted the scene as Rodney triumphantly brought his fleet and prizes into Gibraltar (Colour Plate 58). Late in his career Serres seems to have executed several commissions for the Duke of Clarence, later to be King William IV, and this may also have been painted for him as a commemorative, for the Prince had at the time been serving as a midshipman on board the *Prince George*.

But it was evidently 'Gibraltar relieved by Sir George Rodney' (Colour Plate 59) which the artist considered the best of this series and one of his most important works to date, for he presented it to the Royal Academy as the equivalent of a diploma work. It is another example of 'action recollected in tranquillity' as the imposing might and splendour of the English flagships, appropriately bedecked, dominate the distant fortifications of the Rock and the Spanish prizes, anchored ahead of them. Stern views of ships of the line were, whenever possible, depicted in order to achieve maximum visual impact from the galleried 'gingerbread' and towering effect of masts, yards and rigging. It was while at anchor here and visiting the *Prince George*, that Admiral Don Juan de Langara, the captured Spanish admiral, came across Prince William Henry acting as duty officer and was amazed to find 'the humblest stations' of the navy 'supported by princes of the blood'. Indeed, this royal presence may have been a further reason prompting Serres to undertake the work, and present it to the Academy, as a means of showing his gratitude for the appointment as Marine Painter to the King.

Approval of the painting was not, however, unstinting. C. Kearsly wrote the satirical and partisan *The Earwig or An Old Woman's Remarks on the present Exhibition of Pictures of the Royal Academy* (no. 231, p.21) in 1781. In addition to a review of the works exhibited, he included a tour of the new premises of the Academy in the rebuilt Somerset House:

> This leads to the *Lecture Room* . . . In the end of the Room fronting the door, we are struck with two noble pictures of their Majesties by Sir Joshua Reynolds . . .
> On the right-hand side, and next the door, is a picture painted by *Dominick Serres*, representing *Gibraltar* relieved by *Sir George Rodney*, in January 1780; this picture has little more than its subject to make it interesting . . . These pictures are to remain in the room; and the frames which are disposed around, are to be filled in the same manner. We are happy to see the first of the collection so perfect in their kind; and we hope that the other artists will be equally emulous in their endeavours, that an out-line may be formed for the *English* School.

This painting is notably smaller than the other two, demonstrating Serres's ability to include nautical detail as well as landscape perspectives within the confines of a relatively small canvas. A preparatory drawing has survived which shows how he developed the composition (Plate 65). The size would also have been selected with a view to engraving, since this image became popular as an important and decorative print. It was engraved by Robert Pollard and published by him and Robert Wilkinson on 1 June 1782. Pollard was born in Newcastle-on-Tyne and came to London in 1774 where he studied painting and drawing under Richard Wilson. In 1781 he set up his own engraving and publishing business in Islington, producing prints with a wide range of subject matter. Although of a later generation than the printmakers who had brought Serres to public attention twenty years earlier, a close collaboration seems to have developed between the artist and the engraver. It is possible that Serres himself commissioned the print of this historic occasion, with its royal association, in the hope of enjoying some additional financial gain from the

PLATE 65. 'Gibraltar relieved by Sir George Rodney, January 1780', pencil, pen and grey ink and watercolour, 9 x 20 ins. (23 x 52 cm). The study for Colour Plate 59 in which the artist evolved the composition and detail of the final image. The Whitworth Art Gallery, The University of Manchester

work of which he was so proud.

The last painting by Serres at the 1780 Academy exhibition was of another thoroughly topical event, 'The engagement between *Serapis*, Captain Pearson, and the *Countess of Scarborough*, with Paul Jones and his squadron' (no. 359), which had taken place on 23 September 1779 off Flamborough Head on the coast of Yorkshire. The American Commodore John Paul Jones had surprised the British public, and severely frightened those inhabitants who had been threatened, by leading his small squadron of French and American vessels in the *Bonhomme Richard* (40 guns) around the northern British isles, attacking coastal towns at random and with impunity. The damage and injury caused in the raids was not important, but the shock to the national sense of security and, above all, pride in its naval strength, was considerable. The culmination of this 'impertinent' intrusion into English home waters came when, having circumnavigated Ireland and Scotland, Jones encountered a British convoy heading north escorted by *Serapis* (50 guns), launched only six months before, and *Countess of Scarborough*, a lightly-armed storeship. The four American ships closed with the British warships and a furious engagement ensued, in which the *Bonhomme Richard* and *Serapis* were the principal protagonists. Aware of his inferior fire-power, Jones endeavoured to lay his ship alongside the enemy and finally succeeded in grappling *Serapis*. They lay locked together for two hours, inflicting heavy damage and casualties on each other, until, at 10.30 pm, *Serapis* struck her colours and was taken over by Jones and his crew. The *Countess of Scarborough* was also captured but *Bonhomme Richard* was so seriously damaged that she sank two days later. Although in strictly naval terms this was a minor skirmish, such a defeat on the shores of England and the prospect of the red ensign being hauled down in the face of the enemy, made a vivid impact on public opinion. In these circumstances, and in view of the timescale, it is unlikely that Serres was commissioned to record the scene, but he would clearly have responded to the public clamour by rapidly producing another of his dramatic night-time images. It has, unfortunately, not been traced.

It was probably because Serres reacted promptly to record these recent wartime events that Press comment on his pictures was generally favourable. On 6 May 1780 the *London Courant* wrote that his exhibits at the Royal Academy 'are very capital paintings; the events represented in them are rendered highly interesting: the shipping very highly finished and the sea expressed with that accuracy of colouring which distinguishes the works of Brooken [sic] and Monamy'.

BATTLE COMMISSIONS IN SPATE 1781

It was the nature of the naval operations during the American war which conditioned the type of commission Serres was receiving at this time. There were few major fleet actions at this stage of the war, and, those that took place, were either indecisive or unflattering to British naval prestige. The Royal Navy was, however, heavily engaged on blockading operations along the length of the north American seaboard, endeavouring to prevent arms and supplies reaching the colonists from their European allies. This warfare extended across the Atlantic and included keeping a close watch on European continental ports and coastal waters, where the entire coastline from Holland to Spain was hostile to the British. The operations were not only against regular units from enemy fleets, and sometimes elements of the embryonic American navy, but also very often against privateers from these nations which were licensed by their governments to engage in belligerent voyages. Many of the actions Serres was called upon to record were therefore single-ship engagements or similar limited operations, such as those of the junior Hyde Parker, already discussed. By way of innovation, Serres evolved a more journalistic method of representing battles which showed two or more stages of the engagement, 'before', 'during' and 'after'. This helped to overcome the difficulties of portraying fighting which had in fact taken place over a period of many hours. At the same time it had the advantage of bringing the viewer of the paintings and, later, the prints, into a greater sense of immediacy and participation. Two examples of this treatment were exhibited at the Academy in 1781.

Before examining them, a retrospective of similar type going back over thirty-five years will be mentioned, if only because it was concerned with one of the more historic and dramatic, even sentimental, episodes of British history. Peircy Brett had been a Lieutenant on Anson's round-the-world voyage from 1740 to 1744 and, as with all his brother-officers who survived that marathon exercise, had received preferment as Anson himself rose to the highest echelons of naval command. In July 1745 Brett was in command of the *Lion* (60 guns) when, off the Lizard, he came upon the French *Elizabeth* (64 guns) escorting the *Du Teillay*, with Prince Charles Edward, the Young Pretender, on board, and engaged the enemy warship. After a running fight of five hours, *Lion* was so damaged in the rigging that she was unable to continue and *Elizabeth* made her escape with her consort. Prince Charles Edward landed in Scotland later in the month and, raising his Stuart supporters, marched on London. He reached Derby, causing a run on the banks in London, before his force melted away and he was obliged to retire northwards, suffering his final defeat at Culloden in April 1746.

Brett made four drawings illustrating successive stages of the engagement, annotated with descriptive details. The drawing of the final phase provided Samuel Scott, the leading marine painter of that period and patronised by Anson, with the model for his painting of the action. Long afterwards, in 1780, Serres produced an oil painting of the third stage of the battle, based on the relevant drawing by Brett, when *Du Teillay* endeavoured ineffectually to join in the exchanges (Colour Plate 60).[1] It is not clear why Serres painted

1. R. Kingzett, *A Catalogue of the Works of Samuel Scott*, Walpole Society, Vol. XLVIII, 1982, p.31.

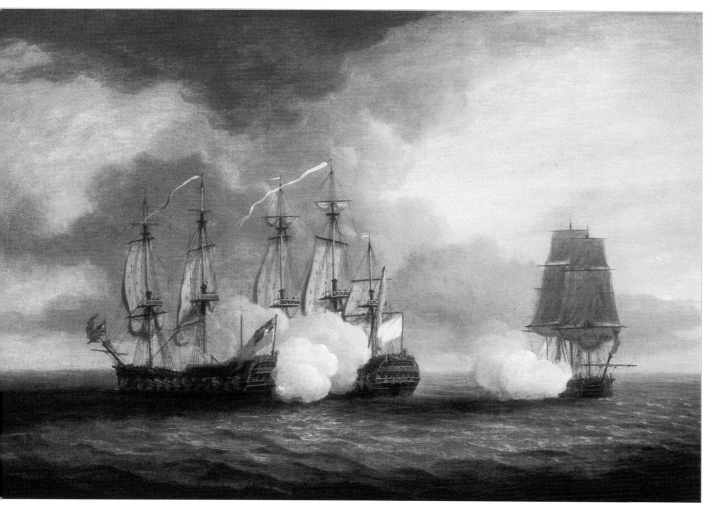

COLOUR PLATE 60. 'The action between H.M.S. Lion, the Elizabeth and the Du Teillay, 9 July 1745', oil on canvas, signed and dated 1780, 25 x 40 ins. (63.5 x 101.5 cm). Prince Charles Edward, the Young Pretender, was on board the *Du Teillay*, but the *Lion* failed to prevent them slipping away and reaching Scotland. The painting was probably commissioned, thirty years after the event, by Admiral Peircy Brett, who had been in command of the *Lion* at the time. National Maritime Museum, London

this picture, signed and dated 1780, at that particular time, but it may have been ordered by Peircy Brett himself, by then Admiral of the Blue, but who was to die in October 1781.

A press report on the Royal Academy exhibition in 1781 was critical of the absence of works by Academicians: 'Not above sixteen Royal Academicians have exhibited this year, which is not one half of that body . . . because they thought their reputation sufficiently established'.[2] Serres did not fall into that category for he had six pictures on display.

Three of those paintings were a time-lapse sequence representing a single engagement, the action between the *Flora* (36 guns) and *La Nymphe* (36 guns) within sight of Ushant on 10 August 1780. *Flora*, newly commissioned and under the command of Captain William Peere Williams, discovered the French frigate escorting a convoy and bore down on *La Nymphe* (R.A. no. 391). A brisk cannonade ensued (no. 396). Finally the two ships became locked together, enabling the British, led by Lieutenant Edward Thornborough, to board and capture *La Nymphe*, upon which she struck her colours (no. 214). The frigate was added to the British navy under her own name. The set of three paintings was in the collection of a renowned twentieth-century admiral and sold a few years ago through a London auction house.

2. Quoted in W. Roberts, *Sir William Beechey R.A.*, 1907, p.28.

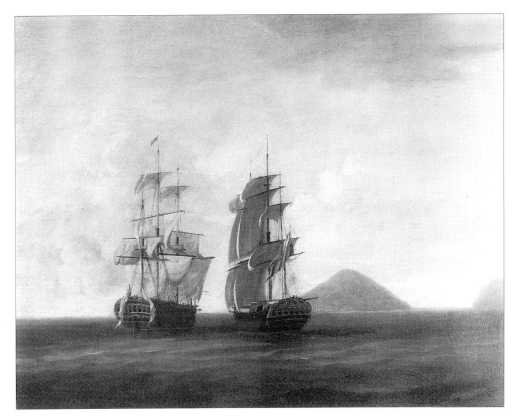

PLATE 66. 'H.M.S. Pearl capturing the Esperance, 30 September 1781', oil on canvas, signed and dated 1781, 24 x 36½ ins. (61 x 92.5 cm). The *Esperance*, shown on the left having just struck her colours, was a privateer carrying private passengers and a valuable cargo. The generous prize money from the capture probably encouraged Captain Montagu of the *Pearl* to commission the painting. The action took place off the islands of Bermuda, shown in the right background.

National Maritime Museum, London

The accompanying pair of paintings at the Academy commemorated in a similar manner an action which took place a year earlier, on 14 September 1779. 'Captain Montagu, of the Pearl, engaging the Sancta Monica, a Spanish frigate, off the Western Isles [the Azores]' (no. 373) and 'The Sancta Monica striking to the Pearl' (no. 375). In September 1780 the *Pearl* (32 guns) enjoyed a further success, recorded by Serres, probably also for Captain George Montagu, but not hung at the Academy, when she captured the 32-gun privateer frigate *Esperance* south-west of Bermuda (Plate 66). The privateer was bound from Santo Domingo to Bordeaux, carrying private passengers and a valuable cargo. The prospect, or receipt, of generous prize money may have encouraged Montagu to commission the pictures of his exploits. The *Esperance* is shown on the left-hand side having just struck her colours, with *Pearl* about to take possession. The Bermuda islands are included in the right background. The painting was bequeathed to the National Maritime Museum by a descendant of Captain Montagu.

Captain John MacBride (1730–1800) was one of those who was always at the centre of the action in support of the admiral commanding. In *Bienfaisant* (64 guns) he was the next in line ahead of Keppel in *Victory* (100 guns) at the battle of Ushant in 1778, defending his admiral at the Courts Martial afterwards, and the following year joined Rodney for the relief of Gibraltar, being accorded the privilege of carrying home Rodney's dispatches. It was MacBride who distinguished himself by discovering, chasing and capturing the convoy on 8 January 1780, a week before the Moonlight Battle, and it was Serres who was called upon to commemorate the action on canvas, probably on the recommendation of Keppel or Rodney. The painting was hung at the Academy in 1781 under the title 'Captain McBride in the Bienfaisant, and Captain Eliot in the Edgar, from Admiral Rodney's fleet, the 8th of January 1780, discovering a Spanish convoy, gave chace, and after several had struck, Captain McBride pursued their Commodore, a 64-gun ship, and took her' (no. 231). This was the *Guipuscoana* previously mentioned. *The Earwig or An Old Woman's Remarks . . .*, in the same review of the exhibition, wrote, caustic as ever: 'The Artist is celebrated for productions in

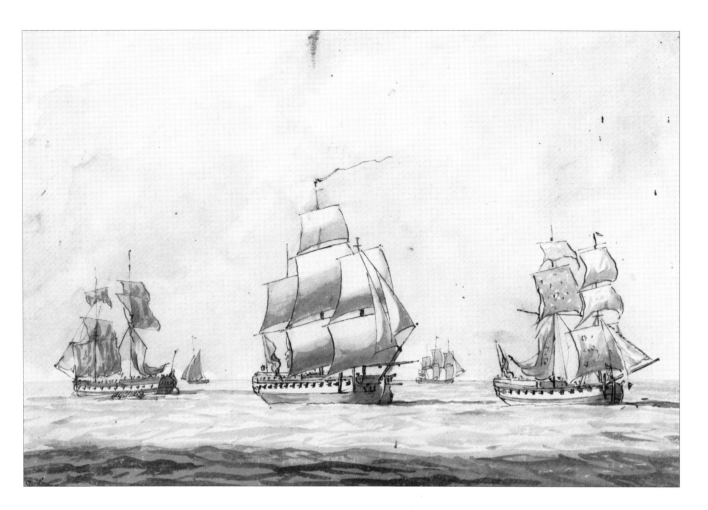

this line; he has succeeded tolerably well in this picture:- the water is transparent, and the smoak of the cannon is well painted. We have no painter at all equal to the Antients, and there is an honourable and beneficial line open to genius'. Another critic was, however, more enthusiastic: 'The clear obscure is well observed, the colouring very harmonious, the water quite in motion; in short, this picture is a "chef d'oeuvre" in that way'.[3]

MacBride went on to greater glory in the battle on 16 January, destroying the *Santo Domingo* and capturing the *Phoenix*, with Admiral de Langara on board. After the return from Gibraltar, he was sent, during the summer of 1780, in search of the *Comte d'Artois* (60 guns), a large privateer which was causing trouble in the Channel, and successfully captured her off the Old Head of Kinsale on 13 August. In the following spring MacBride was appointed to command another French privateer prize taken at about the same time, the new forty-gun frigate named, somewhat confusingly, *Artois*. MacBride was a great proponent of the carronade, a powerful, short-barrelled gun very effective in close-quarter engagements, which was installed selectively in His Majesty's ships from the end of the 1770s and which he had used to good effect in *Bienfaisant*. After taking part in the battle of the Dogger Bank under Hyde Parker senior in August 1781, MacBride had two 68-pounder carronades mounted in *Artois*. These proved decisive when on 3 December 1781 he captured two Dutch privateers from Amsterdam, the *Hercules* and the *Mars* of 24 guns each, which his report described as 'the compleatest privateers I ever saw'. A drawing by Serres inscribed with this title suggests a continuing connection, and probably patronage, between the officer and the artist, although no finished oil of the action is known (Plate 67). The drawing is a good example of Serres's sketching technique, a simple method using inked outlines and light washes. The use of defined outlines is similar to the developed style of Paul Sandby and may indicate that Serres adopted the technique from him.

PLATE 67. 'The Artois taking two Dutch privateers', pen and black ink with grey wash on laid paper, signed, c.1781, 10½ x 14 ins. (27 x 37 cm). Captain John Macbride, in command of *Artois*, was an early proponent of the carronade, having two 68-pounders mounted in his ship. They proved decisive when he met the two privateers from Amsterdam.
National Maritime Museum, London

3. National Art Library Press Cuttings, p.198.

145

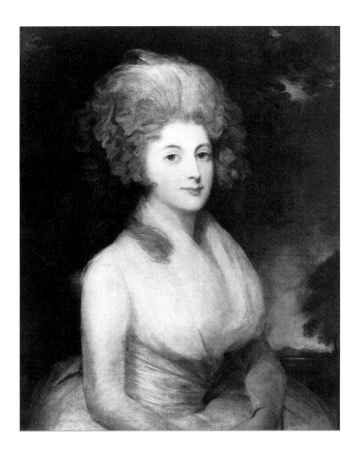

PLATE 68. 'Miss. H. Serres', attributed to Gilbert Stuart, oil on canvas. The sitter was firmly identified in the 1930s as Mary and Dominic's eldest daughter, by a reputable art historian who dated the portrait to 1781/2. 'Miss. H.' would then have been about thirty years of age, but little further is known about her.

By courtesy of the National Portrait Gallery, London

Another successful captain commissioned Serres to paint a pictorial commemoration of a single-ship action which took place on 5 January 1781. Captain the Hon. George Keith Elphinstone was in command of the *Warwick* (60 guns) when he engaged and captured the *Rotterdam* (50 guns) without loss to his crew, the Dutch ship being afterwards added to the British navy. Elphinstone later became Admiral Lord Keith, St. Vincent's successor and Nelson's commander in the Mediterranean after the battle of the Nile, and the painting hung in Tulliallan Castle, his Scottish home. It is now in the collection of The Marquess of Lansdowne at Bowood House, Wiltshire.[4]

Portrait of an artist

Gilbert Stuart (1755–1828), an American who came to England and received the help and encouragement of Benjamin West, his predecessor in such a move, exhibited his 'Portrait of an Artist' at the Royal Academy in 1782 (no. 164). In keeping with the conventions of the time, which were to continue until 1797, the catalogue title was thus anonymous. Equally customary, however, was the practice of the press to publish the identity of the sitters on the day following the opening of the exhibition. Stuart's portrait was of Dominic Serres 'in the act of fresh pointing his pencil' (*London Courant* 2 May 1782). Stuart's biographer, Charles Merrill Mount, notes that John Boydell, the engraver and print publisher, took an interest in Stuart and also that 'a sea battle would be ordered of Dominic Serres almost as soon as its report reached London'. Further that: 'Quick to seize on new talent, Boydell had Stuart paint himself, his nephew and associated engraver Josiah Boydell, and Dominic Serres. These portraits were intended to acquaint visitors to his gallery with those responsible for the production of their engravings'. Stuart's '. . . profile of Alderman Boydell is equally gauche. The dash and exuberance of his informal study of Dominic Serres quickly redeemed him, and his portraits of that winter were a striking revelation of new talent'. Among the group of portraits Stuart submitted to the Academy, that of 'Dominic Serres, whose sea-pictures had such popularity, was a subject certain to

4. Information provided by Dr. K. Fielden, Curator, Bowood House, is gratefully acknowledged

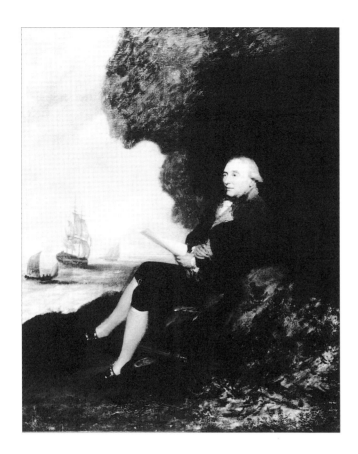

PLATE 69. Portrait of Dominic Serres, by the circle of Thomas Hickey, oil on canvas, 23 x 19 ins. (59 x 49 cm). Thomas Hickey (fl.1760–90) was born in Dublin and studied in Italy before working in Bath and London; he then went to India and, later, to China with Lord Macartney's embassy in 1792. This is the image of the artist as gentleman. Serres is portrayed as self-confident and successful, a person who has achieved the peak of his profession and a place in society. At about this time also he began to be addressed as 'Esquire'.

Photograph courtesy of Sotheby's

attract attention'.[5] Another art historian comments on the portrait: 'Gilbert Stuart portrays precisely a man and his profession. The pomposity of conventional formulas has given way to a concentration on the sitter's personality, and the artist introduces a certain originality to the background as well as to the pose and accessories'.[6] The whereabouts of the painting, believed to be in the United States, are, unfortunately, not known.

The enigmatic figure of Miss H. Serres, Mary and Dominic's eldest daughter, is thrown into sharp relief by the art historian biographer of William Beechey (1753–1839), who confidently asserted that an oil painting by Gilbert Stuart was of this young lady (Plate 68). W. Roberts, in a 1930 file note preserved with the reproduction at the National Portrait Gallery, states:

> Miss H. Serres was the eldest daughter of Dominic Serres, R.A. . . . Among Gilbert Stuart's exhibits at the R.A. of 1782 was a portrait of…Serres, whose portrait was also painted by Ozias Humphry and Sir William Beechey, both fellow academicians. Stuart would have come in contact with Serres at Benjamin West's house in Newman Street, London, which was also Stuart's address from 1779 to 1782. [Ozias Humphry was living at No. 25 Newman Street and Thomas Banks at No. 5.] There can be no doubt that this beautiful portrait of a lovely woman, exceedingly Romney-like in many respects, was painted by Stuart at about the same time as that of her father 1781–2.

If Roberts is correct, the eldest daughter then would have been Catherine, aged thirty, as Jane had died in 1779. None of the daughters had a first name with the initial H, but it is possible that one of them had a second name which did, and that this was in current use. The portrait is of a beautiful lady and it would be rewarding to know more about her. As an Honorary Exhibitor, 'Miss H's' first painting, a landscape, was shown at the Academy in 1783 and another in 1790. Five more, of flowers, were hung in the years up to 1800.

Sir Joshua Reynolds's diary for September 1782 records that a Mr. Serres sat to him that month, one of only two sitters, at a time when he was usually receiving up to eleven a

5. C.M. Mount, *Gilbert Stuart*, New York, 1964, pp.66–72.
6. J. Wilmerding, *A History of American Marine Painting*, Boston and Toronto, 1968, p.23.

month. The portrait has not been identified but is assumed to have been of Dominic, an acquaintance and colleague of Reynolds at the Royal Academy. Nor are further details known, such as who commissioned the work.[7] Nonetheless, the fact that Serres sat to two of the leading contemporary portrait painters in the course of a year is a further indication of his recognition as one of 'the great and the good' of the art world.

This is confirmed by another, admirable portrait of him which was sold recently at auction in London. Attributed to the 'circle of Thomas Hickey' (fl. 1760–90), it is an elegant portrayal of the artist as gentleman (Plate 69). Well-dressed, seated on a rocky ledge with the sea and ships beyond, pencil and paper in his hands, his hat and parasol at his feet, this is the image of a person who has achieved the peak of his profession, self-confident and successful. Although in conventional portrait style of the period, it gives a good likeness and sense of personality. The painting bears a label on the reverse inscribed: 'Dominic Serres R.A. . . . from the collection of Miss. Brock of Meyrick Square SE / direct descendant of the painter'. Miss. Brock was a great-granddaughter of Dominic and Mary (see page 217).

Serres's pictures at the Academy that year, 1782, have been discussed in the review of Hyde Parker's patronage. Peter Pindar, the pseudonym used by John Wolcot (1738–1819), the satirist, wrote one of his Odes on the exhibition and gave mischievous vent to his opinions:

Serres and Zoffany, I ween,
I better works than yours have seen.
You'll say no compliment can well be colder;
Why, as you scarce are in your prime,
And wait the strengthening hand of time,
I hope that you'll improve when you grow older.

In a note Pindar stated that Serres was seventy, but in 1782 he was in fact just over sixty-two years of age. Zoffany was then only forty-nine.

Dominique Michael in *Foudroyant* under Jervis

Captain John Jervis (1735–1823) was appointed in September 1775 to the command of *Foudroyant* (80 guns) captured from the French in 1758, and had played an active role in the actions of the war as a unit of the Channel fleet. At the battle of Ushant in 1778 he was next in line astern of Keppel in *Victory* and, like MacBride, defended his admiral at the Courts Martial. The spring of 1782 was a time of decisive change in the British conduct of the war. Naval victories over the principal enemies were accompanied by the growing acceptance in government that control over the American colonies was unlikely to be regained. A new government under the Marquis of Rockingham took Augustus Keppel, created Viscount Keppel and Baron Eldon, to the Admiralty as First Lord and brought Lord Howe out of retirement to command the Channel Fleet. Samuel Barrington was one of his divisional commanders and on 19 April, cruising with twelve ships-of-the-line to prevent a junction between Spanish, French and Dutch fleets, he discovered a convoy in the Bay of Biscay. Of nineteen transports laden with stores for the French East Indies fleet, thirteen were taken, thus depriving Bailli de Suffren of supplies which could have had a decisive impact on his engagements with Hughes in that theatre of war. Those actions were to be the subject of a major series of paintings by Serres (see Chapter IX).

Jervis in *Foudroyant* was part of Barrington's fleet and, after a night action lasting three hours, captured one of the escorting French warships, *Pégase* (74 guns). It was an action

7. A. Graves and W.V. Cronin, *A History of the Works of Sir Joshua Reynolds*. 4 vols.,1899–1901, Vol. IV, pp.1480, 1581.

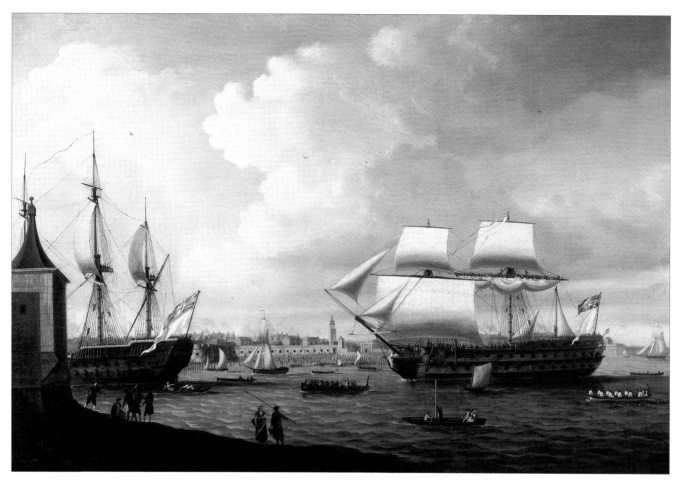

COLOUR PLATE 61. 'The Foudroyant, commanded by Sir John Jervis, bringing the Pégase, a French 74, into
Portsmouth Harbour, 1782', oil on canvas, signed and dated 1782, 30 x 44 ins. (77 x 112 cm). The return to
Portsmouth with a ship-of-the-line as a prize was an occasion for great celebration. Serres does full justice to
the occasion by bringing the subject close to the picture plane, clearly showing the figurehead, and animating
the scene with foreground figures. Serres's second son, Dominique Michael, served briefly as an Able Seaman
on Foudroyant during the summmer of 1782.
 Art Gallery of South Australia. Gift of Mrs. David Evans and Mr. Geoffrey O'Halloran Giles in memory of
 their parents Mr. and Mrs. Hew O'Halloran Giles 1987

of distinction and Jervis was made a Knight Batchelor for his gallant leadership. The return
to Portsmouth was an occasion for great celebration and was marked by an outstanding
painting by Serres, who was probably on the spot to record it (Colour Plate 61).
Immediacy is lent to the scene by bringing the warship close to the picture plane, while
the detailing in the foreground illustrates the liveliness and topicality Serres succeeded in
imparting to it by his keen eye for human and nautical incident and deft brushwork. The
painting was produced soon after the event, being signed and dated 1782, and it is likely
that it was painted for Jervis, either as a speculation in honour of the commander or as a
commission by him. It was exhibited at the Royal Academy ten years later, in 1793, 'The
Foudroyant, commanded by Sir John Jervis, bringing the Pégase, a French 74, into
Portsmouth' (no. 126). This may be explained if Serres, already suffering from the illness
from which he was soon to die and, perhaps, having difficulty in painting, retrieved earlier
successful works for submission to the exhibition. The painting was subsequently also in
the collection of Lord Lansdowne.

 Jervis, who had served under Sir Charles Saunders at Quebec in 1759, and been promoted
Post Captain the following year, was one of that select coterie of naval commanders who

were so important to Serres by virtue of their friendship and patronage. Men of the calibre of Jervis were not only on good terms with their contemporaries and superiors in the service, but also attracted capable subordinates to their employ. Evan Nepean (1751–1822) had been his Purser in *Foudroyant* since April 1780 and was to go on to succeed Sir Philip Stephens as Secretary of the Admiralty, becoming a Baronet in 1802, Chief Secretary for Ireland in 1804, a Lord Commissioner of the Admiralty and, in 1812, Governor of Bombay. He was a friend of Adam Duncan, Jervis's successor in command of *Foudroyant*, and of Horatio Nelson. Also in *Foudroyant* with Jervis was William Gardner as Chaplain. He was evidently close to Jervis, for he accompanied him to his new command in *Salisbury* when the commission in *Foudroyant* came to an end in December 1782. It seems from the letter below, one of the very few surviving, that Gardner was the connection at this stage between Serres and Jervis and probably therefore instrumental in Dominique Michael, Serres's second son, joining *Foudroyant* after its triumphant return.

Dominique Michael was taken on the books on 8 June 1782 as an Able Seaman, having volunteered at Portsmouth and received the Bounty of £5. It was customary for the captain of a man-of-war to accept a number of 'servants', usually sons of friends or relations, who would aspire in due course to be rated as midshipmen. Jervis had twenty-two in *Foudroyant*; Duncan was to increase that number by four. There could have been several reasons why Dominique Michael joined as a volunteer Able Seaman rather than as a Captain's Servant, but the most likely was his age, which was then almost nineteen, whereas servants were more usually in their early teens. But it will become clear that, even if he was obliged to commit himself to the rough and tumble of the lower deck, it was not to be for long and he enjoyed protection from the highest quarters as well as the friendly eye of the ship's Chaplain. Dominic wrote from St. George's Row on 27 June 1782 to his son:

Mr Serres on Board of his Majesty's Ship Foudroyant, Spithead.
Dear Child.
We receiv'd your letter of the 24th Instant last night, but no answer to my last. We are all glad to hear that your Cough is almost gone. I hope the next will tell us that t'is quite gone. I have heard with pleasure about your Mess and accommodations. I dare say that you'll not be mov'd from where you are for I wrote to Mr. Gardiner, but in case of the contrary tell him your case yourself. You must supply your Mess as much as you can with things for puddings and light food for you are certain that salt meat is not good for you. . . I am very glad that you have met with such a good friend as the young gentleman that you speak of. I wish it was in my power to serve him, but t'is entirely out of my way. A word from Capt. Jarvis would do it at once, but I could not take such liberty with Lord Keppel. Give my compts. to the gentleman and tell him that if it was in my power I would do it with the greatest pleasure. If you go to Gibraltar I hope that you'll not be idle, but will bring me some drawings worth seeing. Take care how you behave, be obliging and civil to every body, and you'll be respected and beloved. Your brother has been very poorly but is better. Your mother, brother and sisters join with me their love to you, and be sure that as long as you behave properly I shall always be an indulging father to you.
D. Serres
Webbe Saunders Twiss [?sp] and all friends
Davies and all send their Compliments.
adieu

The letter gives a vivid picture of Serres as a concerned and loving parent, worried about his son's diet and health, which seems never to have been robust, but at the same time pragmatic and correct, declining the friend's request for some help or 'interest'. Also authoritarian, requesting drawings 'worth seeing', the strict advice on behaviour and the conditional nature of the promise of 'indulgence' in the closing sentence. While Serres's connection with Gardner is evident and his familiarity with Keppel inferred, the identity of the various friends who sent greetings is more doubtful. Assuming that the names were surnames, Twiss could be Richard Twiss who, in 1775, published his *Travels through Portugal and Spain* and Davies perhaps Thomas Davies (d.1785), a close friend of James Boswell (1740–95) who first introduced him to Dr. Samuel Johnson (1709–84). Davies had been an actor and became a bookseller, in which role he could have become friendly with Serres in connection with the production or sale of prints.[8] Webbe and Saunders have not, even tentatively, been identified. The reference to John Thomas being 'very poorly' suggests that he was still living at home while employed at the Chelsea Maritime School.

The Muster Roll of *Foudroyant* shows that Dominique Michael was discharged on 10 September 1782 'by Order of Adml. Lord Howe'. Discharge from the ship would have meant, effectively, from the naval service. He does not seem to have transferred to another ship or re-enlisted, so the assumption must be that the brief experiment of shipboard life was not a success and that a discharge was obtained for him, possibly as the result of a direct approach by his father to Lord Howe. This was on the very eve of the ship's departure with Howe's fleet for the relief of Gibraltar, to which Serres had referred in the letter.

The Destruction of the Floating Batteries and the Second Relief of Gibraltar 1782

The dogged defence of Gibraltar under the leadership of General Eliott had continued since Rodney's relief convoy in January 1780. Further supplies had reached the fortress in April 1781 and the time had come for a further major supply and reinforcement. The Spanish had maintained a close blockade and tight grip on the rocky peninsula and in September 1782 launched an attack which they hoped would be decisive. Ten batteries were constructed, built up on ships' hulls, fortified, armed and manned, and then floated across the bay from Algeciras, in front of the Spanish fleet, to positions close to the fortifications of Gibraltar from which they could bombard the defence into submission. By dint of superhuman efforts, the British and Hanoverian defenders were able to destroy or immobilise these floating batteries with a combination of red-hot cannonballs fired from the shore and intrepid commando assaults on the vessels. The threat of imminent defeat was thus averted. Assembling Howe's relief fleet of 183 ships, of which thirty-four were ships-of-the-line and a dozen smaller warships, had taken months, including the tragic loss of the *Royal George* at Spithead. It departed from England before the news of the attack by the floating batteries, and their repulse, was received. Progress was slow with the transports, and a gale on 10 September, but the whole concourse arrived safely off the Straits on 11 October, with the knowledge, however, that forty-eight enemy ships-of-the-line were anchored in Algeciras Bay. After taking several days retrieving transports which had gone past Gibraltar, and avoiding the enemy fleet which had come out to follow them eastwards, Howe finally succeeded in delivering all his charges safely on 18 October. On 14 November the fleet was back in Spithead.

The destruction of the floating batteries was obviously a gallant and colourful event

8. C. Ryskamp and F.A. Pottle ed., *James Boswell, The Ominous Years 1774–76*, Cambridge, 1963.

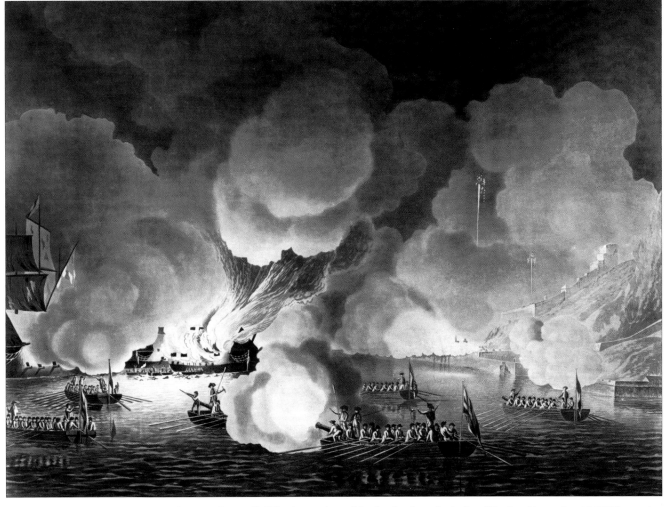

COLOUR PLATE 62. 'The destruction of the floating batteries before Gibraltar, September 14 1782', aquatint engraved by Francis Jukes after Dominic Serres, published by Robert Wilkinson 10 February 1783. The heroism and dramatic pyrotechnics of this action had great popular appeal and attracted many artists. Serres did not have the advantage of his son's on-the-spot drawings as he had hoped, but quickly produced this lurid version for the print market. *National Maritime Museum, London*

which appealed to artists and several quickly produced images, one, George Carter (1737-94), visiting Gibraltar to gain authentic local colour. Dominic Serres was among them, and, although he lacked the on-the-spot drawings he might have expected from his son, was able to rely on the first-hand accounts of Captain Sir Roger Curtis, the leading naval participant, and other principal officers who had returned from Gibraltar. He had soon painted his version of the spectacular scene, depicting the activities of Curtis's gunboats around the exploding batteries, with the Rock shrouded in smoke on the right-hand side. As a dramatic event of immediate public interest, it was equally quickly engraved by Francis Jukes (1745–1812) and published as an aquatint by Robert Wilkinson on 10 February 1783 (Colour Plate 62). The painting, or another version, was not hung at the Royal Academy until 1787 (no. 238). Since Serres had promptly met the public demand for an image and, it is to be hoped, benefited financially from sales of the print, this retrospective presentation of the original oil was probably connected with the choice of John Singleton Copley (1738–1815) to record the action in a major commission for the Corporation of the City of London (see Chapter XIII).

Serres displayed another Gibraltar painting at the 1787 Academy exhibition: 'Fire ships

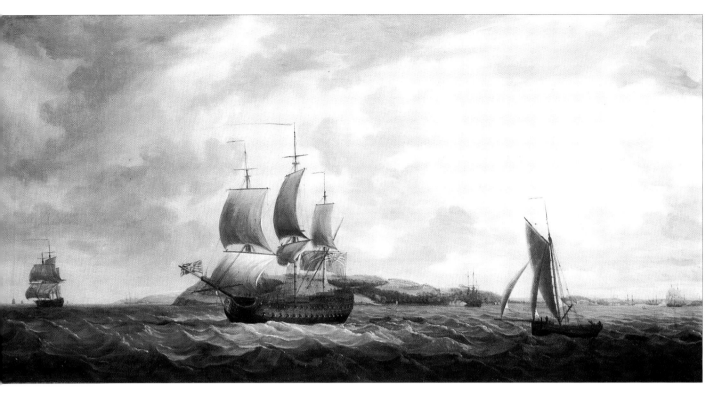

COLOUR PLATE 63. 'The Brunswick, commanded by Captain John Harvey, leaving Plymouth', oil on canvas, signed, 27 x 55 ins. (69 x 140 cm). An outstanding example of Serres's coastal landscape compositions. His preferred pale blend of greens and browns gives the canvas its understated appeal.

Photograph courtesy of Lane Fine Art, London

sent by the Spaniards against the New Mole, etc., the Panther, man-of-war commanded by Captain Harvey, lying off Rosia Bay, Gibraltar' (no. 199). This was a retrospective, portraying an earlier attack with fireships by the Spaniards on 7 June 1780, shortly after Rodney's relief expedition. The *Panther* (60 guns) had been the principal naval unit in the defence force since the beginning of the siege and was at this juncture anchored in Rosia Bay, near the New Mole, at the southern end of the fortifications, guarding a group of transports, storeships and prizes. All the anchored vessels were in great peril from the attack, four fireships coming very close, one near enough to melt the pitch caulking of *Panther*'s topsides. Fortunately, the wind dropped and the burning hulks drifted away.[9] Captain Harvey (1740–94) stayed in command of *Panther* when she sailed the following year to join Rodney in the West Indies, and it seems very likely that he commissioned this painting from Serres in order to commemorate his service in the ship and, particularly, the testing and triumphant years at Gibraltar. A later painting, one of Serres's most successful of its type, may also have been produced for Harvey, in this case to reflect his pride in a new command. The caption reads: 'The *Brunswick*, commanded by Captain John Harvey, leaving Plymouth' (Colour Plate 63). The painting, which was in the collection of 2nd Earl Beatty, shows the 74-gun ship in a typical Serres coastal landscape composition, bathed in its own patch of sunlight and framed by towering heaps of cloud. The palette is the artist's preferred pale blend of predominant browns and greens which gives his canvases their characteristic, understated appeal. The painting is fully signed but not dated. If the caption is justified, this must have been one of the artist's last works, for Harvey only took command of *Brunswick*, which was launched in 1790, during 1793. The captain went on to distinguish himself, and meet a gallant death, when his ship sank the *Vengeur* at the battle of the First of June 1794.

9. T.H. McGuffie, *The Siege of Gibraltar*, 1965, pp.71–72.

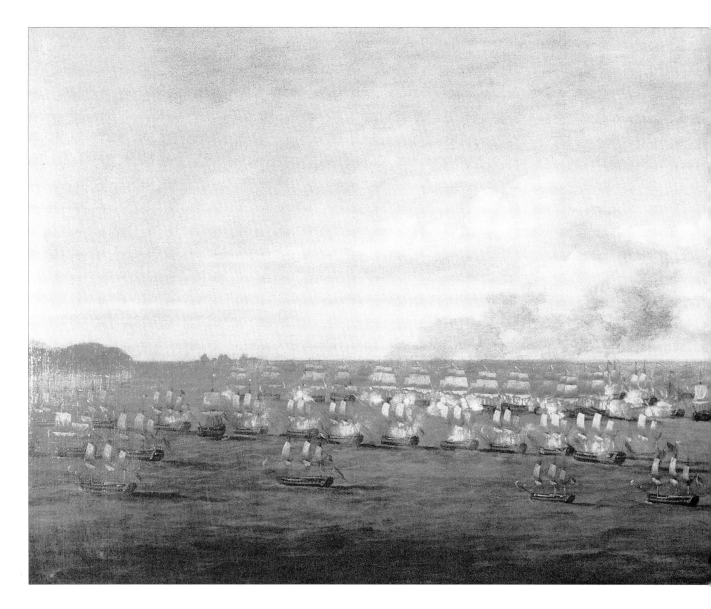

CHAPTER IX

RODNEY IN THE WEST INDIES; A LEGACY; HUGHES IN THE EAST INDIES 1782-1784

On the other side of the Atlantic, the decisive naval battle of the War of American Independence had been lost by the British navy when it failed on 5 September 1781 to defeat de Grasse and his fleet off Chesapeake Bay. Blockaded by the French and deprived of hope of relief, General Charles Cornwallis was obliged to surrender to General George Washington at Yorktown on 19 October. Although the war continued for more than a year longer, the British never regained a position from which they could expect to impose their will on the American colonists. Rodney had not been on station at the time of the inconclusive battle off Chesapeake Bay, but returned from England to the West Indies in February 1782, bringing twelve ships-of-the-line, and took command of the formidable fleet arrayed against de Grasse, who had come south from North America. After days of manoeuvring, battle was joined on 12 April near the islands known as Les Saintes, between Dominica and Guadeloupe, from which the major fleet action took its name. Thirty-six British ships-of-the-line were

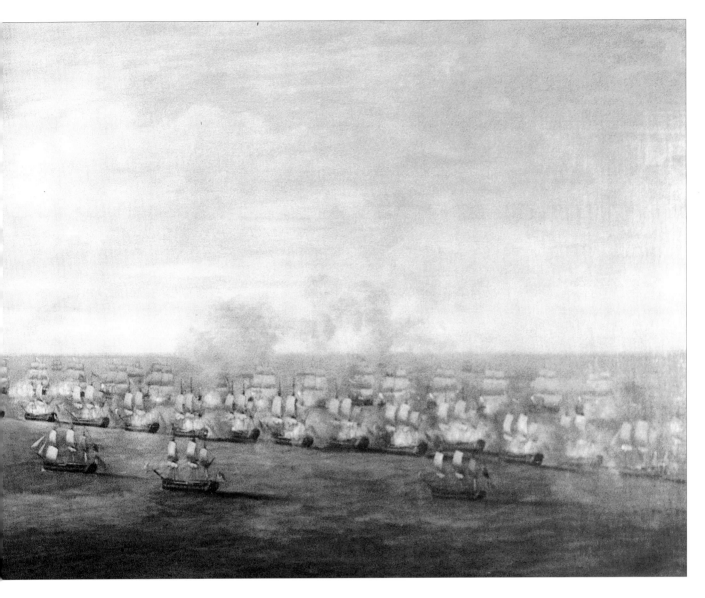

engaged with thirty-five French and the outcome was a celebrated victory for the former, capturing five French capital ships, including the flagship *Ville de Paris* (110 guns) with Admiral de Grasse on board. Although the British had lost the struggle with the American colonies, the victory was strategically important for the defence and consolidation of British possessions in the West Indies, principally Jamaica, which was Rodney's primary task and which had always been a principal aim of wartime policy. And, as a resounding victory after the setbacks in North America, it was immediately hailed in England with the greatest enthusiasm, prompting the production of many pictures, drawings, prints, charts and plans. It has remained one of the most discussed battles in English naval history owing both to Rodney's innovatory tactic of 'breaking the line' and the controversy engendered by Rear-Admiral Sir Samuel Hood's criticism of Rodney's failure to follow through his advantage.

'Serres is fitting out a great fleet'

Paul Sandby wrote to James Gandon in Dublin on 3 February 1783: 'My friend Serres is fitting out a great fleet, and has taken many prizes from Luttrell, Rodney & Co., and is at present at the head of naval affairs'.[1] Serres painted at least four pictures of the battle of Les Saintes and its aftermath, and some of them at least were therefore clearly for Rodney. The most remarkable was a panoramic view of the two fleets engaged, with a key at the foot listing

Plate 70. 'The Battle of the Saints. A bird's-eye view of the action on 12 April 1782 between the English and French fleets off Les Saintes', oil on canvas, signed and dated 1784, 42 x 114 ins. (105 x 285 cm). Unique as a panoramic view of one of the largest major fleet engagements of the period, this was probably painted for the victorious Admiral George Rodney to illustrate his innovatory tactic of 'breaking the line'. A key at the foot of the canvas indicates the principal ships of each fleet, while tablets on the frame list the vessels taking part: thirty-six British and thirty-five French ships-of-the-line and nine frigates each.

The Crown Estate. Photograph: Photographic Survey, Courtauld Institute of Art

1. Quoted in W. Sandby, *Thomas and Paul Sandby*, 1892, p.163.

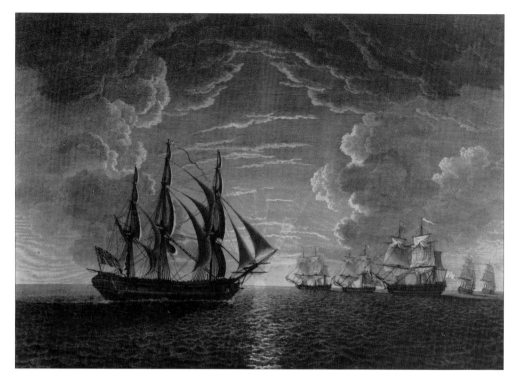

PLATE 71. 'H.M.S. Mediator, of 44 guns, commanded by the Hon. Capt. Luttrell, bearing down at sunrise to attack five sail of the enemy's . . .', engraving by R. Pollard after D. Serres, published by R. Pollard and R. Wilkinson, 1784. Serres's three original paintings, commissioned by Luttrell, for this set of prints were hung at the Royal Academy exhibition in 1783. An example of his time-lapse sequence to illustrate successive phases of the engagement, Plates 71, 72 and 73 are also known as 'Morning', 'Noon' and 'Night'.

National Maritime Museum, London

all the vessels depicted (Plate 70). It is large, 42 x 114 ins. (105 x 285 cm), signed and dated 1784. Although its artistic merit is not great, it was evidently painted as an accurate record of the action at a crucial point, from which the admiral could recall, and perhaps describe to companions, the tactics employed and the manoeuvres carried out. In this sense it is one of very few paintings of any era which endeavours to give an overall bird's-eye view of an engagement between two major battle fleets. It was hung at the Royal Academy exhibition in 1784 as 'A bird's-eye view of the action on 12th. April 1782 between the English and French fleets' (no. 436), and is now at the Institute of Directors in Piccadilly, London.

The other paintings were more conventional scenes of the action. 'La Ville de Paris striking to the British fleet, April 12, 1782' was shown at the same exhibition (no. 89). The image has not been traced, but the critic in the *The Painter's Mirror* (No. VI May 1784), presumably the same as the previous year, expressed his customarily decided views on it:

> The brave <u>Cornwallis</u> of the *Canada* might have been mentioned. But <u>Lord Hood's</u> name is placed under an engraving of this subject and the honor given to his Ldship.! 'So much easier, as Lord Chesterfield observes, is it to *deceive* than to *undeceive* mankind!'. . . Mr. Paton has painted this event much better than his maritime *rival*.

The dedication to Hood was not so grossly out of place as it was to him in *Barfleur* that the *Ville de Paris* surrendered. The reference to Paton illustrates the keen competition that existed between marine painters to produce promptly for an avid public popular paintings, and their derived prints, of topical events. No print of Serres's painting has been discovered and the reviewer must have been referring to another, perhaps after Paton's picture. Another pair of paintings by Serres depicts 'An incident from the battle of the Saintes' and 'Lord Rodney bringing the Ville de Paris and French prizes into Port Royal, Jamaica, after the battle of the Saintes' and is signed and dated 1788, like the version at Ickworth (see page 76 and Colour Plate 26). The latter may have been the painting with the same title exhibited at the Academy that year (no. 136), which would suggest that it, and its companion, were produced in response to a later commemorative commission, perhaps again from Rodney.

The commission from Captain the Hon. James Luttrell (1751–88), mentioned by Sandby,

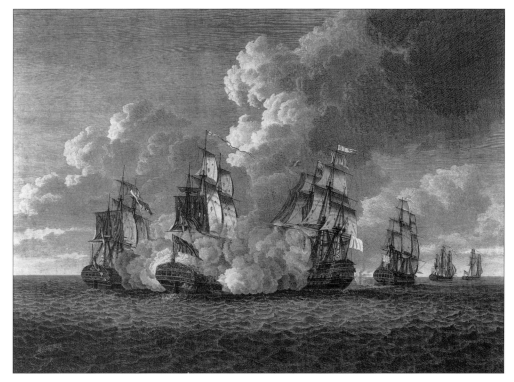

PLATE 72. 'H.M.S. Mediator . . . having put to flight three of the enemy's ships, attacks two and takes one', engraving by R. Pollard after D. Serres, published by R. Pollard and R. Wilkinson, 1784. Luttrell was the brother-in-law of Henry Frederick, Duke of Cumberland, to whom the prints are all dedicated 'by Permission'. Serres's daughter-in-law, Olivia Wilmot, was later to claim to be the legitimate daughter of the Duke.

National Maritime Museum, London

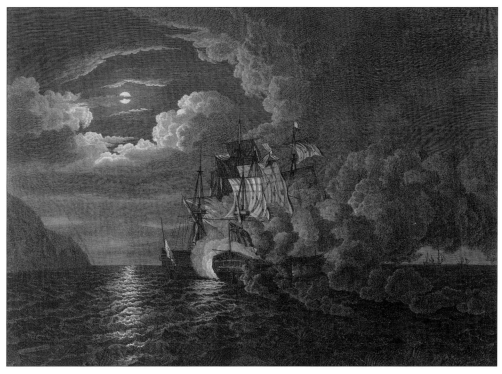

PLATE 73. 'H.M.S. Mediator . . . pursues and comes up with the flute La Ménagère, about ten at night, which, after some conflict, strikes', engraving by R. Pollard after D. Serres, published by R. Pollard and R. Wilkinson, 1784. The moonlight, like the scene at sunrise, gave Serres the opportunity to paint the chiaroscuro effects he enjoyed so much. The three original paintings, each 4 x 6 feet in size, must have made an imposing display.

National Maritime Museum, London

was for three paintings which dominated Serres's submission to the Academy in 1783, there being only one other. James Luttrell was the son of Baron Irnham, created Viscount in 1780 and 1st Earl of Carhampton in 1785, and the younger brother of the 2nd and 3rd Earls. His eldest sister, Anne, married, first, Christopher Horton and then, on 2 October 1771, Henry Frederick, Duke of Cumberland, the brother of George III, a connection which might not have been without relevance to the Serres family (see page 28). Luttrell's naval career brought him to the command of *Mediator* (44 guns) in March 1782 and on 12

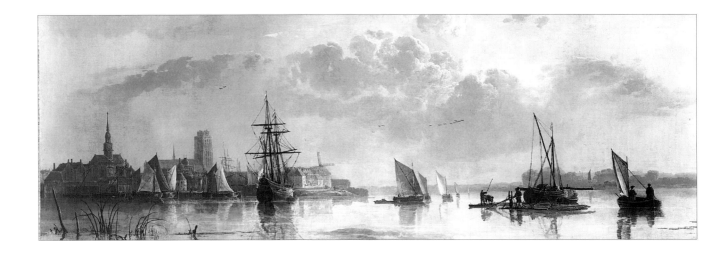

PLATE 74. 'A view of Dordrecht on the river Maas by Aelbert Cuyp', oil on canvas, 48 x 72 ins. (122 x 182 cm). This well-known painting was previously in two halves and reassembled as one in the middle of the nineteenth century. Serres made a copy of each half, signed with initials and dated 1783. He was therefore not the contemporary copyist of Cuyp about whom he joked to a disillusioned collector.

Photograph: Photographic Survey, Courtauld Institute of Art

December he discovered five armed enemy vessels off El Ferrol. He cut off one of them and obliged her to surrender while the others scattered. Five hours later he came up with *Ménagère* and captured her after an engagement lasting a further five hours into the darkness of night-time. Serres again employed his time-lapse method to meet Luttrell's requirement for a commemoration of his success. The three paintings at the Academy were entitled: 'His Majesty's Ship Mediator, of 44 guns, commanded by the Hon. Capt. Luttrell, bearing down at sunrise to attack five sail of the enemy's, mounting in all 130 guns, forming in a line of battle, to prepare for action' (no. 67) (Plate 71); 'His Majesty's Ship Mediator, commanded by the Hon. Capt. Luttrell, having put to flight three out of five of the enemy's ships, attacks two and takes one' (no. 79) (Plate 72); 'His Majesty's Ship Mediator, the Hon. Capt. Luttrell, having secured his prize, pursues and comes up with the Flute La Ménagère, about ten at night, which, after some conflict, strikes' (no. 194) (Plate 73).

The critic in *The Painter's Mirror* wrote:

That able painter of naval subjects, Mr. Paton, having declined exhibiting for these last two seasons, from motives which are, no doubt, well grounded, Mr. Serres remains without any formidable rival to oppose his pencil. His subjects are as follow: [listed as above]. Mr. Serres's ability in *marine* painting was never better displayed than in the two first mentioned performances. No. 79 does him particular honor; but it is fair to remark, that as the Mediator is *English* built, it is not quite so *national* to give her a *Dutch* stern, and a heavy hull. In the representation of the action with La Menagere, the land should be kept more distant; and though Mr. Serres has succeeded very well in preserving the *two* different lights produced by the *morn*, and the *fire* of the ships which are engaging; yet a scene of *night* is no excuse for leaving the other parts of the picture in so unfinished a state. 'The ship of the line carrying her prize into Portsmouth harbour' (no. 238) is an admirable performance, but defective on account of its *consistency*; it is not in the memory of the *Father* of Greenwich hospital to name the time when a ship of the line and her prize came into *harbour together*; the artist should have confined his scene to Spithead.

The initial criticisms concerning the build of the ship and the lack of finish in some parts of the painting may be attributable to Serres's frequent haste in completing his canvases. In the last comments, however, the reviewer reveals the frailty of his knowledge of naval affairs, or else is being deliberately provocative. If Serres had, indeed, been an eye-witness the previous year of *Foudroyant* entering the harbour with her prize, his painting showed that it was entirely possible for both to enter together (Colour Plate 61). One is left to speculate whether this was the same painting or another version.

The paintings of the *Mediator* action were engraved by Robert Pollard and published by him and Robert Wilkinson on 3 January 1784. The set comprised four prints, three of

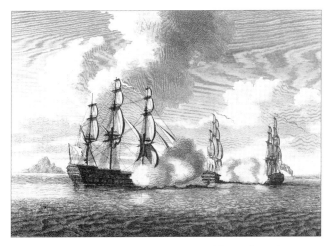

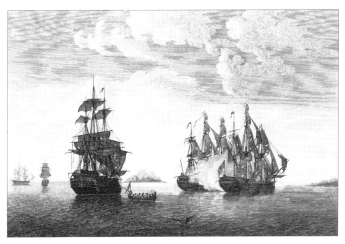

Plate 75. 'The Valiant, 74 guns, Captain Goodall, attacking the Caton and the Jason, French men-of-war, of 64 guns each, 19 April 1782', engraving by W. Skelton after D. Serres, published by James Fittler, Marine Engraver to His Majesty the King, 1787. Sent after the French to follow up the victory of The Saintes on 12 April 1782, *Valiant*, the leading ship of the squadron, came up with the enemy vessels near Isla Mona, at the west end of Puerto Rico. The sharp cone of the island appears in the background of each of Serres's pair of paintings and, with the silhouetting light, gave the engraver plenty of scope for dramatic representation. National Maritime Museum, London

Plate 76. 'The taking of the Caton and the Jason, French men-of-war, of 64 guns each, by the Valiant, Captain Goodall, of 74', engraving by W. Skelton after D. Serres, published by James Fittler, 1787. The original painting with this title was exhibited at the Academy in 1784. Goodall, who had already had a distinguished career, was clearly proud of the successful outcome of his daring exploit and pleased to see it commemorated. National Maritime Museum, London

which have been used here as illustrations. They were dedicated to the Duke of Cumberland, Admiral of the White, which was not unusual, but in this case, Cumberland was, of course, also Luttrell's brother-in-law.

Serres's final works, signed, with initials, and dated 1783, are something of a curiosity. They are two views of Dordrecht, in the Netherlands, each 24 by 36 ins. (60 x 91 cm), copied from the famous painting by Aelbert Cuyp (1620–91), which was then in two parts, but has since been reunited and now hangs at Ascott (Plate 74). Dordrecht had always been popular with marine and landscape painters and Cuyp an admired Old Master, so Serres may have painted the copy either as an exercise for himself or to meet an order from a patron.

Julius Caesar Ibbetson (1759–1817), a contemporary landscape and genre painter, published his *An Accidence, or Gamut, of Painting in Oil* in 1803. In it he wrote 'There is a painter who imitates Cuyp in a surprising manner at present; (I believe on the Continent). Mr. Bryant has, or had some of them. I saw one or two in collections in Lancashire, but I do not know for certain whether they are always sold for originals'.[2] In spite of the discrepancy in time and suggested location, this reference could have some relevance to the following story about Serres recorded by an historian of English landscape painting:

> Perhaps the most amusing [anecdote] is his descent from his studio over Bryan's (the famous dealer and art-biographer) into Colnaghi's shop, what time Baron Bolland was cross-questioning the wariest old dealer in the trade as to the existence of a being who was alleged to make his living by copying Cuyp. Serres soon set the collector's doubts, but not his spirit, at rest (for the Baron possessed a number of these very 'Cuyps'), by blurting out that he not only knew the forger, but had seen in his room no fewer than 'five such 'Cuyps' on as many easels'!'[3]

The anecdote is otherwise unauthenticated and it is difficult to reconcile some of the quoted details with known facts and locations of Serres's life. Since he signed and dated his paintings of Dordrecht it is unlikely that he could be accused of any similar sharp practice himself, nor would it have been worth the risk to his reputation.

2. Quoted in J. Mitchell, *Julius Caesar Ibbetson*, 1999, p.47.
3. M.H. Grant, *The Old English Landscape Painters*, 2 vols., 1974, Vol. II, p.153.

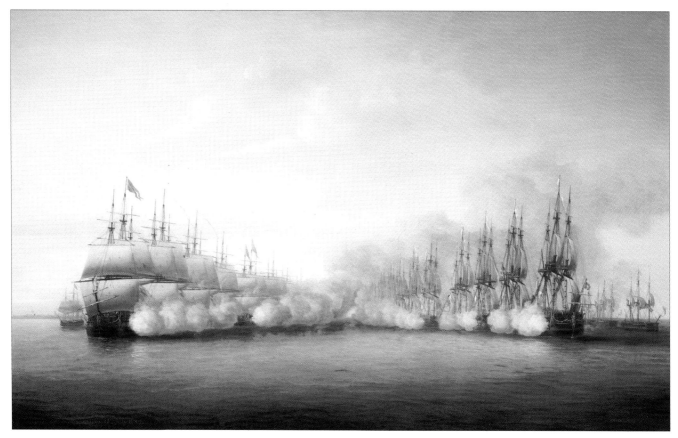

COLOUR PLATE 64. 'The action off Negapatam, July 6 1782', oil on canvas, signed and dated 1786, 44 x 72 ins. (112 x 183 cm). Following the chase, battle was joined in the customary lines ahead, with the English line shown on the left, led by Commodore Richard King. Serres was reputedly paid £1,000 for the seven paintings. This one remained at Greenwich. National Maritime Museum, London

'Monuments to perpetuate his talents'

Rodney was undoubtedly dilatory in his pursuit of the enemy after his victory on 12 April 1782 and stayed off Guadeloupe refitting his fleet until 17 April, when he finally despatched Hood, his main critic, to follow ten ships-of-the-line reported heading westwards. Hood's squadron pushed for the Mona Passage, between Puerto Rico and Santo Domingo, and on 19 April came up with two enemy ships separated from their compatriots. Captain Samuel Granston Goodall in *Valiant* (74 guns), Keppel's flagship at Havana twenty years before, led the chase and was successful in capturing both the ships. One of Serres's pair of paintings of the engagement was hung at the Academy in 1784: 'The taking of the Caton and the Jason, French men-of-war, of 64 guns each, by the Valiant, Captain Goodall, of 74' (no. 56). The paintings, showing the sharp cone of Isla Mona in the background, were clearly in the best Serres tradition of indirect light and strong chiaroscuro and made fine prints when engraved by W. Skelton (1763–1848) and published by James Fittler three years later (Plates 75 and 76). The popular appeal of such prints to a public much more knowledgeable in nautical realities and niceties than today's, lay not only in the dynamic artistic representation but also in the detailed description of skilful seamanship and gallant risk-taking contained in the lettering. Part of the caption to Plate 76 reads:

> In chace the VALIANT cross'd the shoals of Cape Rojo with great risque of the Ship striking for several Miles, as she was often so near the Ground as to drag the Sand up after her, and coming up with them about three o'Clock in the Afternoon, while the rest of the Squadron was becalm'd or Chasing different ways, Attacked and took them both as describ'd in these Plates.

Small wonder, too, that Goodall, who had had a successful career, including the capture of Havana and the battle of Ushant, was proud of the victorious outcome!

The critic in *The Painter's Mirror* reflected the keen topical interest in all the circumstances of the action, even if comment on the artistic aspects remained more muted:

> Let it be remembered that the two French ships had been very severely treated in the action of the 12th. of April, and that they were making for the Cape at the time they struck to the Valiant. Three more English ships of the line were in sight when they became prizes. The picture is nonetheless a good one.

In January 1782, before Rodney's arrival, Hood had out-foxed de Grasse in a series of manoeuvres in Frigate Bay, Basse Terre Roads, on the shore of St. Kitts, opposite Nevis, and achieved great acclaim for his endeavours, being created Baron later in the year. Serres's record of the scene was displayed at the Academy in 1784, 'Lord Hood's action with the French fleet before the island of St. Kitts' (no. 53). Unfortunately no image of it has been traced, but the critic's review gives an idea of what we may be missing:

> Here is confusion and smoke! and to strengthen the *immortality* which two *Extraordinary Gazettes* have given to Lord Hood, let the aid of pallet be contributed! The story, in brief, is: Lord Hood contended for the French anchorage and obtained it... (Vide Gazette the 1st. on this subject)... He afterwards cut his cable, and left the island, with the French colours flying on its citadel... (Vide Gazette the 2nd.)... As a further comment,
> The king of France, and forty thousand men,
> Went up a hill ——,
> But, as Hamlet says,
> 'Something too much of this!'

It must be remembered that the *Official Gazette* usually published the commander's report to the Admiralty in full, so there was always room for a fine gloss to be placed on the events. The reviewer was not alone in his adulation of Lord Hood, who was considered a hero almost on a level with Rodney, and the admiral, not surprisingly, commissioned paintings of his successful actions in the West Indies. Five large pictures were ordered from Nicholas Pocock and painted between 1784 and 1786, one of the Frigate Bay action being exhibited at the Royal Academy in 1788.[4] Serres's painting, finished in time for the 1784 show, may also have been commissioned by Hood, but it seems more likely that, in his self-appointed role as 'war artist', he took the initiative to paint it as a topical subject with ready popular appeal.

Another pair of similar battle pictures was also hung at the Academy exhibition, again, sadly untraced. The first of the pair, 'The action between La Magicienne of 32 guns, Captain Greaves, and La Sybile of 36 guns' (no. 210) prompted the critic to write:

> A very masterly representation of one of the best actions that has been fought during the late war, The Magicienne arrived at Jamaica a wreck being incapable of taking charge of the enemy when she struck. ... The Sybile was afterwards, in a defenceless state, carried into New York by an English frigate she fell in with. It is remarkable that Admiral Rowley, at Jamaica, and Admiral Digby, in North America, both sent home accounts of this event, without doing Capt. *Greaves* the justice of mentioning him by *name*!'

On the other, 'La Sybile, dismasted by La Magicienne' (no. 168), the comment is 'A continuation of the foregoing subject, equally to the honor of the artist'.

Occasionally paintings were ordered for a specific location in a house, sometimes to be framed by the plasterwork, and the artist was obliged to tailor size, subject matter and treatment to the precise situation. Serres received several such commissions at this time, one being hung

4. D. Cordingly, *Nicholas Pocock 1740–1821*, 1986, pp.63–65.

at the Academy in 1784 and another in 1785. The first was 'A view of Gibraltar, for the frieze of a chimney' (no. 127), of which the same critic says: 'A performance that does Mr. Serres great honor. The water is bright. The Ships distinct, the works in excellent perspective, and the sky glowing'. The other, possibly for the same building, was 'A view of Dover, with the fleet of men-of-war going to the northward, for a frieze of a chimney piece' (no. 38). A chimney piece would not necessarily entail a canvas, or, more likely, a panel, of long horizontal format, but the mention of 'frieze' suggests that they had this shape. Further cases are mentioned later but few visual examples have been found which can safely be attributed to this use. Gibraltar was obviously a topical subject at this time and the view reproduced in Colour Plate 70 may refer to this version, although it has a later date and is discussed at that point (see page 208).

A legacy

Sir John Barnard (1685–1764) was a London merchant, Lord Mayor in 1737 and Member of Parliament for almost forty years, who achieved particular distinction, and his knighthood, by averting a run on the banks as panic set in when the Young Pretender and his invading force reached Derby in 1745. As a further mark of esteem a statue was erected in his honour in the Royal Exchange to accompany that of its founder Sir Thomas Gresham. Sir John's son, also John but known as 'Jacky', seems to have been able to enjoy a leisured existence and became known as an art collector. He had two sisters, Sarah, who married Alderman Thomas Hankey, and Jane, who married the Hon. Henry Temple and was the mother of Henry Temple, second Viscount Palmerston. 'Jacky's' daughter had in 1770 eloped with and married Jan Chalon (1738–95), a Dutch musician and engraver. Barnard was so incensed that he renounced her and she died five years later. Henry-Bernard Chalon (1770–1849), the son born to the couple, became Animal painter to the Prince Regent and the Duke of York.

Joseph Farington noted in his diary on 22 August 1809 that, when 'Jacky' Barnard died in 1784, he 'also left to Mr. Hankey his large collection of prints and drawings which were sold at auction. He left to Paul Sandby – Nollekens – Serres and Captain Baillie £300 each'. Captain William Baillie (1723–1810), a friend of the Grevilles and the Earl of Bute, George III's early favourite and Prime Minister, was a trustee of Barnard's will. He was himself an avid collector and dealer, having sold, by auction at Langford's, part of his collection in 1771 and the 'remaining copies of his prints' in 1774. In February 1787 Greenwood sold at auction the 'Cabinet of Drawings of John Barnard, late of Berkeley Square, deceased'. A press report on a dinner at Mr. Bertels's after the auction, stated that Barnard had collected for fifty years, helped by his friend Captain Baillie and Mr. Bertels. Mr. Greenwood, the auctioneer, also bought for John Barnard on his travels on the Continent and 'remembered him at his death'. When, in due course, Barnard's pictures which had been bequeathed to Thomas Hankey, were put up for auction in June 1799 on Hankey's death, Christie's catalogue announced that these were '. . . collected during the course of a number of years by John Barnard Esq. Universally esteemed for his correct knowledge of the Fine Arts, and superior Taste in the line of Virtu – Selected from the finest collections, both Foreign and Domestic, at a most liberal Expense'.

It has not been possible to establish how the association between John Barnard and Dominic Serres came about, nor more details of the friendship, but the relationship must have been close to have prompted such a generous legacy. A key may have been, as in other connections, Serres's friendship with Paul Sandby, but he is not known to have been close to the sculptor Joseph Nollekens, R.A. (1727–1823). Indeed, J.T. Smith, an often

biased witness, states in his *Nollekens and his Times* (1829, Vol. I, p.329), that:

> Barnard, who was very fond of showing his collection of Italian drawings, expressed
> surprise that Mr. Nollekens did not pay a sufficient attention to them. 'Yes, I do', replied
> he; 'but I saw many of them at Jenkins's at Rome, while the man was making them for
> my friend Crone, the Artist, one of your agents'. This so offended Mr. Barnard, who
> piqued himself upon his judgement, that he scratched Nollekens out of his will.

Whatever the case concerning the legacy to Nollekens, it is at least evident that this circle
of wealthy connoisseurs and collectors was another in which Serres moved with ease and
a degree of intimacy.

The last series of great battle paintings

The conflict in Europe, America and the West Indies had, as during the Seven Years' War, been
accompanied by fighting in the East Indies where the French, British and Dutch struggled to
preserve and extend their networks of valuable trading and defensive outposts. These were in
coastal locations and therefore heavily dependent on naval support for succour and
protection. It was inevitable, however, that the principal theatres of war nearer home claimed
the lion's share of large and modern men-of-war. Although maritime industries were available
and developing in India, bases with adequate repair facilities were few and far between, most
stores and supplies being sent out from Europe. The British relied mainly on Bombay, but the
French, for want of a secure anchorage and established base on the mainland, operated from
Ile de France, now Mauritius, *en route* from Europe but some 1,800 miles from the scene of
naval action. The Dutch, who entered the war in 1780, were established at Trincomalee on
the north-east coast of Ceylon, the only safe year-round anchorage for a fleet in the Bay of
Bengal. The weather, with the alternating north-east and south-west monsoons and
intervening calms, was another determining factor in naval deployment and manoeuvres.

Edward Hughes (1720–94) had been at the capture of Louisburg in 1758 and Quebec in
1759 as captain of the *Somerset* (64 guns) and was bringing Vice-Admiral Charles Saunders
home when they diverted to join Hawke at Quiberon Bay, but arrived too late to take part in
the battle. His first spell of duty in the East Indies was from 1773 to 1777 as commander-in-
chief with the rank of commodore. In 1778, with the entry of the French into the war on the
side of the Americans, it became necessary to strengthen the naval presence in support of the
army in India, which was in constant conflict with Hyder Ali, supported by the French, in
Mysore, and the Mahrattas. Promoted Rear-Admiral, Hughes returned to command the East
Indies squadron in the spring of 1779, flying his flag in *Superb* (74 guns) and taking with him
five 64-gun men-of-war. He was to remain on that station until 1785 since, as we have seen,
his replacement, Vice-Admiral Sir Hyde Parker, was lost at sea in 1783 on his way to relieve
him. Hughes at least enjoyed the local cuisine for he came to be known by the nick-name of
'old hot-and-hot'. Moreover, his service in the East was also most lucrative, as the Admiral's
share of prize money from every capture made under his command was very generous. As a
result, when Hughes retired on his return from India, he was able to command the princely
income of £40,000 per year. It was only natural, therefore, that he should wish to commission
pictures of his fleet actions in Indian waters, and that he should turn to Dominic Serres to paint
them, seven in all, just as he ordered portraits of himself from Sir Joshua Reynolds.

The British squadron remained unopposed until January 1781 when French
reinforcements arrived in Mauritius. Further ships arrived for both sides a year later. They
had already joined battle on the way out at Porto Praya in the Cape Verde Islands in April

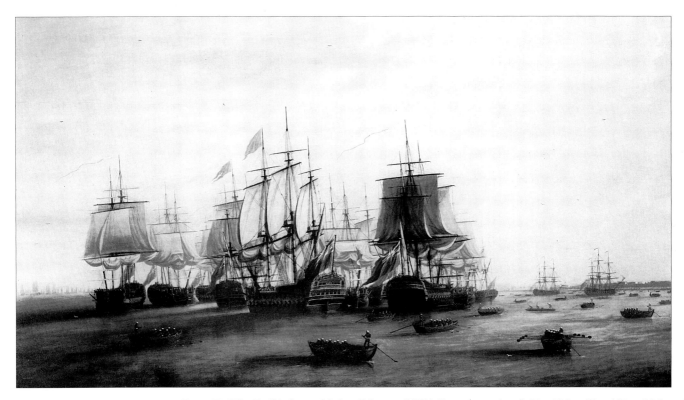

PLATE 77. 'The English fleet at Madras, February 1782', oil on canvas, signed, 36 x 60 ins. (91 x 152 cm). The first of the series of seven paintings commissioned by Admiral Sir Edward Hughes of his actions against the French under Admiral Bailli de Suffren off the coast of India. It shows the hasty scramble as the fleet prepares to get under way in pursuit of the French, who are seen in the left background.

Ipswich Borough Council Museums and Galleries

1781, when the British failed to prevent Vice-Admiral Pierre-André Bailli de Suffren from reaching the Dutch base at Cape Town before them and securing it against capture. When the French arrived off the Coromandel coast in February 1782, their commander, Comte d'Orves, died and Suffren took over. His force then consisted of three 74-gun ships, including his flag-ship *Héros*, seven 64-gun and two 50-gun ships. Hughes, who had captured Trincomalee in January, commanded nine ships-of-the-line: two 74-gun, one 68-gun, five 64-gun and one 50-gun ships. Although these numbers and vessels were to vary in the succeeding engagements during 1782, as battle damage and other vagaries affected the fleets, the respective strengths of the opponents remained roughly equal at between ten and fourteen varied ships-of-the-line, even though often severely deficient in crew numbers.

The French found the English fleet at anchor in the open roadstead off Madras on 15 February 1782 but did not close to engage them. The anchored ships immediately cleared for action and prepared to get under way to give chase to the French. This is the moment depicted in Serres's first painting of the series, which captures all the bustle of men returning to their ships from the shore, sails being hoisted and hurried preparations made to follow the enemy ships, seen in the left background. The admiral's flag, now that of Vice-Admiral of the Blue, is flying at the fore top-mast head of *Superb*, shown port quarter view, at the left centre of the composition (Plate 77). The British alacrity was rewarded by the capture of six of Suffren's transports which had become separated from his warships. It was the afternoon of 17 February when action was joined between the fleets, with Suffren in the advantageous windward position. Although his astute tactics enabled him to establish a superiority, fickle winds, stout British defence and the advent of darkness deprived him of success. Like all the following engagements, this ended without loss of a vessel by either side, although there were always losses of men by death and wounding.

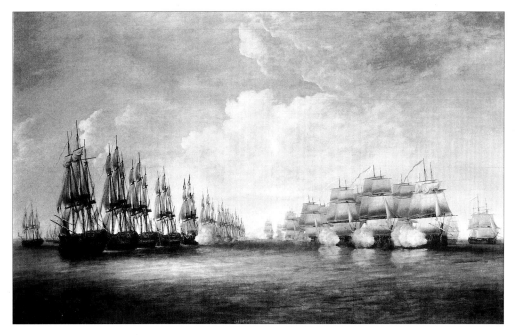

PLATE 78. 'The action off Sadras, February 17, 1782', oil on canvas, signed and dated 1786, 42 x 85 ins. (107 x 216 cm). Light and uncertain winds made manoeuvring difficult and the outcome was usually inconclusive. This painting of the action near Madras demonstrates the in-line-ahead formation which was still the normal convention as the two squadrons first engaged. The frigates, shown behind the lines at the edges of the picture, repeated signals which would otherwise be obscured by sails, rigging and smoke.

Ipswich Borough Council Museums and Galleries.

This first action off Sadras, near Madras, was the subject of the second painting (Plate 78). It shows, probably by design, an early stage of the battle, before the French were able to isolate the last five of the ships in Hughes's line and come within an ace of taking *Exeter*, the flagship of Commodore Richard King, the second-in-command. Hughes's *Superb* is at the centre of the left-hand, English, line, the nearest ship shown firing her guns. The dullness of the composition bears out the Reverend William Gilpin's further observation:

> The line of battle is a miserable arrangement on canvas, and it is an act of inhumanity in an admiral to enjoin it. If the line of battle must be introduced, it should be formed at a distance; and the stress laid on some of the ships, at one end of the line, brought into action, near the eye'.[5]

Serres, for his part, as we have seen, was usually able to impose a more painterly handling of the subject matter and achieve a result meeting Gilpin's criteria.

Hughes was joined by two more ships at the end of March and on 12 April, the date of the decisive battle of the Saintes on the other side of the world, met the French again off Providien,

5. Reverend W. Gilpin, *Observations relative chiefly to Picturesque Beauty*, 2 vols., 1772, Vol. I, p.72.

PLATE 79. 'The Monmouth, disabled, and in danger of being taken by the French, Providien near Trincomalee, April 1782', oil, wash and pencil. One of the preliminary drawings Serres made for his painting of this engagement. *Superb*, the flagship of Hughes, who commissioned the paintings, is lost in the mêlée, but in the final oil painting it is placed firmly and distinctly in the centre of the canvas (Plate 80).

National Maritime Museum, London

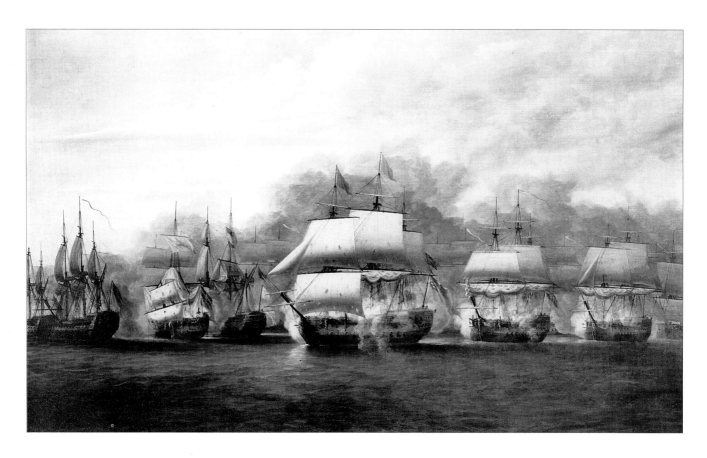

PLATE 80. 'The action off Providien, April 12, 1782', oil on canvas, 42 x 85 ins. (107 x 216 cm). Although in other versions Hughes's flagship, *Superb*, is concealed at the heart of the battle, in the large formal oil painted for the admiral, it is placed prominently in the centre, firing a broadside, in deference to the patron's commanding position. The *Héros* and *Monmouth* are shown closely engaged to the left of the *Superb*.

Ipswich Borough Council Museums and Galleries

near Trincomalee. Suffren again concentrated on the English centre, aiming to lay his flagship, *Héros*, alongside *Superb*. She and the ship next ahead, *Monmouth* (64 guns), bore the brunt of the attack, the latter losing her main and mizzen masts. The fighting continued until the evening, when the exhausted fleets separated, anchoring five miles apart, where they remained for six days repairing damage and burying their numerous dead. The three surviving images by Serres of this bloody, but again inconclusive, encounter demonstrate, on the one hand, the difficulty of depicting the changing situations during a day-long engagement, and, on the other, the recurring importance of the patron's directions. With his customary care, and no doubt basing the dispositions upon eye-witness accounts, Serres produced a preliminary drawing (Plate 79). But this shows the situation at about three o'clock in the afternoon, before the fleets turned back to head away from the shore, when the disabled *Monmouth* (right middle distance) was left behind by the action and in danger of being taken by the French. From this fate she was saved by the gallant action of her captain and the prompt move of the British *Hero* (second from right foreground line) which succeeded in towing her out of danger. *Superb* is at the centre of the composition but lost in the mêlée of a group of vessels. In the large oil painting, however, the patron's flagship is placed firmly and distinctly in the centre of the canvas, in an almost broadside view (Plate 80). This is an earlier phase of the battle, when *Monmouth* and *Héros* are shown in the left middle distance closely engaged and inflicting heavy damage on each other. A print after a Serres painting was engraved by John Peltro and published by Robert Wilkinson on 20 October 1786 (Plate 81). This is quite different and shows the desperate plight of the *Monmouth* as she battles with three French ships. The lettering reads, in part: 'The Monmouth, Captain Alms, at the close of the action . . . between that ship and the French Admiral in the Héros of 74 guns and two other French Ships . . . when the French Admiral, having the weather gage, Sets all his sails and Hauls out of the Line'. Although the print, understandably, carries the dedication, 'by permission', to Sir Edward Hughes, the hero of the hour was clearly Captain Alms. Alms was a veteran captain, whose part in the approach to Havana, twenty years before, when in acting command of the *Alarm*, had been

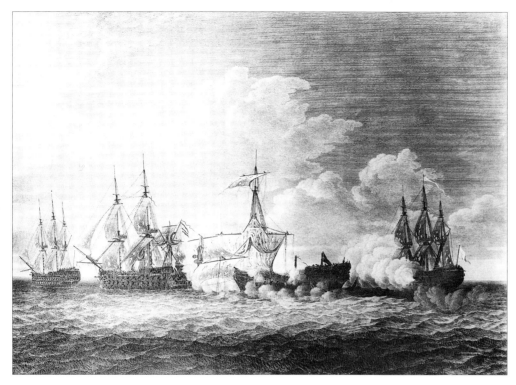

PLATE 81. 'The Monmouth, Captain Alms, at the close of the action . . . between that ship and the French Admiral in the Héros of 74 guns and two other French ships . . . when the French Admiral, having the weather gage, Sets all his sails and Hauls out of the Line', engraving by John Peltro after D. Serres, published by R. Wilkinson, 1786. The original oil painting for this print, untraced, was probably that hung at the Royal Academy in 1785 with a similar title. It may have been produced for Alms, in celebration of his courage and seamanship in escaping from his dire situation during the battle, and could have prompted Hughes to place his large commission with Serres.

National Maritime Museum, London

recorded by Orsbridge and Serres (see pages 50-51) and the original oil painting for the print may have been produced for him or with him in mind.

Hughes feared that Suffren would attack Trincomalee, but that did not materialise and the British were able to return there and refit. The next engagement took place on 6 July 1782 off Negapatam, on the mainland coast, which the British had previously captured from the Dutch. Serres commemorated it with two paintings. The first, Plate 82, shows the commencement of the fighting, with the English fleet running down on the French line, Hughes's ship again prominent in the right foreground, flying the signal for the chase from her mizzen shrouds. The second, Colour Plate 64 (page 160), reverts to the more formal representation of the two strict

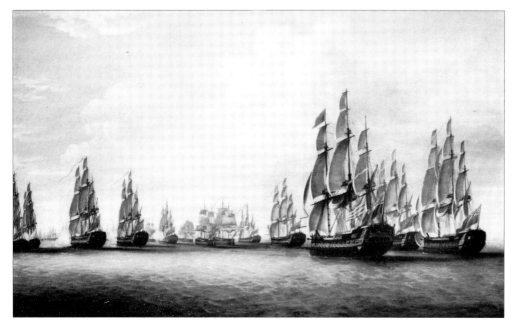

PLATE 82. 'The action off Negapatam, July 6, 1782', oil on canvas, 36 x 60 ins. (91 x 152 cm). The English fleet is shown running down on the French line, the signal for the chase flying from *Superb*'s mizzen shrouds. Lady Hughes presented all seven of Serres's paintings to Greenwich Hospital on the death of her husband. Admiral Benjamin Page, who had been with Hughes as a midshipman in India, was so incensed at finding them hanging in the passages at Greenwich that he bought six of them back and later presented them to the Borough of Ipswich.

Ipswich Borough Council Museums and Gallerie

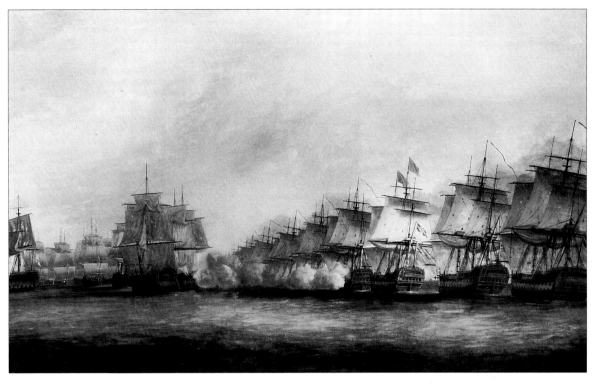

PLATE 83. 'The action off Trincomalee, Ceylon, 3 September 1782', oil on canvas, 42 x 85 ins. (107 x 216 cm). The last action of the year, before the north-east monsoon made the waters untenable. The port quarter view of the British line ranging up to the French, with Hughes's flagship, *Superb*, again prominent, provides a more dynamic handling of the scene but remains within the artistic, as well as naval, conventions of the time.

Ipswich Borough Council Museums and Galleries

lines of warships firing at each other during an early stage of the battle. The admirals' flagships are fifth in each line, Commodore Richard King in the *Hero* leading the English line on the left. The position of the frigates of each fleet behind the line, ready to transmit the admiral's signals or carry out any other support task, is clearly shown. The action was very intense and one French ship, the *Sévère*, had actually hauled down its colours to surrender, but the first lieutenant locked the captain in his cabin and fought on successfully. Suffren reacted strongly to the inadequacy of this captain, and two others, and sent them back to France charged with misconduct.

Hughes returned to Madras for stores and to refit while Suffren went to Ceylon and, having received reinforcements, was able to capture the anchorage of Trincomalee at the end of August. Hughes arrived too late to prevent the surrender but caught the enemy, and the last action, before the north-east monsoon made these waters untenable, took place off Trincomalee on 3 September. Serres's painting is another imposing, if conventional, representation of the scene as the English line, on the port tack, approaches the French, who are dispersed in loose order (Plate 83). The port quarter view permits the *Superb* to be clearly shown, third from the right, flying the admiral's blue flag from the fore top-mast head, the red signal at the main to engage the enemy and the union flag, as the signal to form line of battle, from the mizzen peak. Meanwhile, Suffren's flagship, *Héros*, leads the French line on the left but has already suffered the loss of her main top-mast.

Both fleets retired for the change of monsoon, Hughes to Bombay and Suffren, finding insufficient resources at Trincomalee, to Achen in Dutch Sumatra, and both received reinforcements from Europe. The naval forces were back on the east coast in 1783 to support the military activities, which were centred on Cuddalore, and it was near there, off Porto Novo, that the final action took place on 20 June, after the peace had been signed in Europe but before the news reached India. Hughes now had eighteen ships-of-the-line under his command to

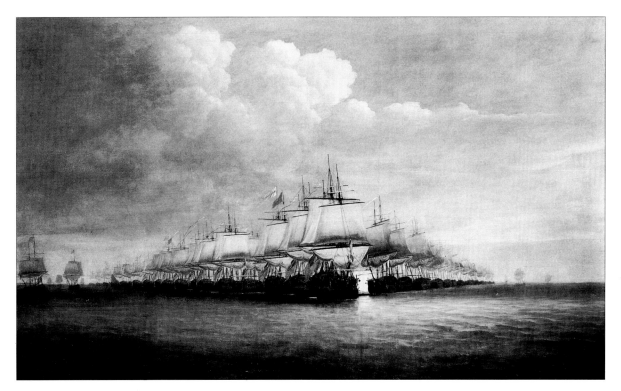

Plate 84. 'The action off Portonovo, Cuddalore, June 20, 1783', oil on canvas, 42 x 85 ins. (107 x 216 cm). The Reverend William Gilpin observed: 'The line of battle is a miserable arrangement on canvas, and it is an act of inhumanity in an admiral to enjoin it'. Serres here attempted to overcome the problem by again varying the composition, while adhering to the factual requirements of the situation. The engagement was fought after the peace treaty, but before the news reached India, and was the last of the long campaign between Hughes and Suffren.

Ipswich Borough Council Museums and Galleries

Suffren's fifteen but the battle was not fought with the same ferocity as the earlier ones as both sides were seriously undermanned. The action was the most orderly of the five as Serres demonstrated in his painting, where the two lines are shown stretching regularly away, the English on the left, as they engage each other (Plate 84). Suffren flew his flag in the frigate *Cléopatra*, the better to observe the action and control his fleet. The result was again inconclusive and the forces separated, Hughes going to Madras where he learnt of the end of hostilities. Suffren returned immediately to France, praised by his opponents and feted by his compatriots for his gallant conduct, but was killed in a duel five years later. Hughes received the thanks of both Houses of Parliament but was obliged to remain on station until 1785. After his return he was not again in active command and retired to his country seat at Luxborough in Essex.[6]

Serres's painting of these actions hung at the Royal Academy exhibition in 1785 was entitled 'The distressed situation of the *Monmouth*, Captain Alms, in the last engagement in the East Indies, between Sir Edward Hughes and Monsieur de Suffrein, out of which he extricated himself by wearing his ship under the spritsail and the spritsail top-sail' (no. 203). The title suggests that this was probably produced soon after the heroic event to commemorate it publicly and to provide the original for the print, which was published just over a year later (Plate 81). Captain Alms may, as mentioned above, have played a part in its commissioning. Admiral Hughes may not have seen that oil painting, but would have known about it, and the engraving in preparation, and, if he had no other recommendation, would have been persuaded to order his pictures from the same artist. Two of the seven paintings are of a similar, smaller size, while the other five are on larger canvases, 1786 being the date on all those that are signed and dated. Serres obviously received a large and well-rewarded commission, apparently to the tune of £1,000, and made all speed to complete most of it within the year.

6. E.H.H. Archibald, *The Maritime Struggle for India 1781–83*, Ipswich Town Hall, 1972.

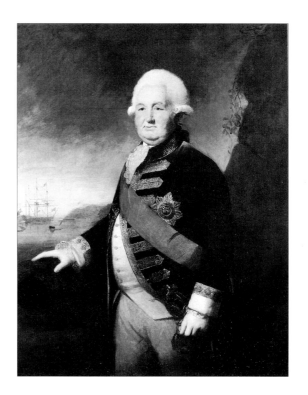

PLATE 85. 'Admiral Sir Edward Hughes K.B.', Joshua Reynolds, oil on canvas, 1785, 55 x 40 ins. (140 x 102 cm). A portrait of the patron of both Admiral Page and Dominic Serres, purchased by the Admiral from Greenwich Hospital and presented to the Borough of Ipswich. The background shows his flag, as Vice-Admiral of the Blue, flying in *Superb* and his barge coming ashore.

Ipswich Borough Council Museums and Galleries

'The famous Serres, the Van de Velde of his day'

Edward Hughes, who came from Ipswich, had taken with him in *Superb* on his posting to the East Indies in 1779, four local boys as midshipmen, among them Benjamin William Page (1765–1845), then aged fourteen. Page stayed with Hughes during the first four actions, was promoted acting lieutenant before the final engagement in 1783 and returned with his admiral and patron in 1785. He thereafter had a successful career in the navy, finishing as Admiral of the Blue in 1841. Throughout his long naval service he remained loyal to his roots in Ipswich. Admiral Page's Journal may appropriately take up the story of the paintings Hughes had commissioned:

> By the aid of Mr. E.H. Locker, 1836, I got the fine portrait of my first patron, Admiral Sir Edward Hughes K.B. by Sir Joshua Reynolds, 1785 [Plate 85] and six fine and large paintings of the squadron, battles etc. with Suffren in India, . . . by the famous Serres, the Van de Velde of his day, and is said to have cost the admiral £1,000, and on his demise given by Lady Hughes to Greenwich Hospital, and put into passages there – disrespectfully, I often said; and obtained and gave the portrait and four of the battle-pieces to the town hall of my native town Ipswich, where the good admiral resided in my youth and whence he took me, . . . as mids. to his flagship Superbe, 74, soon after Keppel's battle with the French fleet, 27 July 1778, and made us all lieuts. in the East Indies, whence I came home, 1785, with the admiral, being put on the list of Lieutenants, 20 Nov 1784, as Lieut. of the Eurydice, and paid off with her, July 1785. I gave money for the above paintings, and for the life size marble bust of Duke of Wellington and a model of HM Ship Caroline fully rigged and placed in a glazed case, and a genuine sabre of Sultan Tippoo Sahib, all of which I gave to the corpn. of Ipswich, who had voted and given me the honorary freedom of the borough, on my accompanying the Duke of Wellington to take up his freedom of Ipswich and as I had brought Sir Arthur Wellesley from his victories in India to England, as Captain of Adm. Rainier's flagship, the Trident, 64.[7]

Page subsequently also presented the other two Serres paintings to Ipswich, where the six hang, together with the portrait of Hughes and one of Page himself, in the Town Hall. The seventh is in the Greenwich Hospital collection at the National Maritime Museum.

7. Navy Records Society: Naval Miscellany No. 2, 1912.

SERRES IN PARIS WITH VERNET
1785-1786

Paul Sandby writing in late 1785 to his friend James Gandon, the architect, then in Dublin, takes up the story of Serres's acquaintance with Claude Joseph Vernet (Plate 86):

> My chief wants are what the worldlings call 'the needful'. My sons, aye, and my daughter, too, are grown to such a height that I find the increase of expense in proportion to their size. Happy my neighbour, in having a race of pigmies that might almost be hidden in a pair of my son's pantaloons. But Dom is grown a very great man, he has been to Paris, seen the grand exhibition, dined with the King's architect, and is going to paint for the Grand Monarque. Alas! poor Paton, hide your diminished head, your topsails are lowered.[1]

Edward Edwards continued his brief biography of the artist with:

> In the year 1785, Mr. Serres painted a large picture of an engagement between a French and English frigate by moonlight, in which the former claimed some sort of merit in not being captured, as the English was obliged to retreat, in consequence of another French vessel interfering. This picture the artist carried to Paris, where it was left, but upon what speculation the author never could learn. This was the only time in which the painter ever saw Paris, although a native of France.

'Voici une affaire'

What actually happened was a 'speculation' in a rather more complicated sense than that immediately suggested by the word, as Vernet's letters to Serres now make clear. The unsatisfactory progress and final outcome of the business probably explain why the artist was apparently reluctant to discuss the matter further, even with his friend Edwards. .

It was 6 July 1785 when Vernet again took up the correspondence, writing in haste. He apologises for not writing for so long but his son has been sick, there was fear for his life, and Vernet himself also ill in the winter, but both are now better. He continues: 'Voici une affaire'.

Five or six weeks previously the Marquis de Castries[2] asked Vernet to arrange for a pupil

PLATE 86. Portrait bust of Claude Joseph Vernet by Louis Simon Boizot (1743–1809), bronze, height with socle 27 ins. (69cm). This bust was exhibited at the Paris Salon in 1783.

Victoria & Albert Museum Picture Library

1. Quoted in W. Sandby, *Thomas and Paul Sandby*, 1892, pp.166–167.
2. Charles-Eugène-Gabriel de la Croix, Maréchal, marquis de Castries (1727–1801) was a professional soldier who rose to become Commander-in-Chief of the Gendarmerie and, from 1780 to 1787, Ministre de la Marine, being appointed Maréschal de France in 1783. He fled France at the beginning of the Revolution. His son raised a corps of *émigrés* in the service of England during the war and returned to France with Louis XVIII.

under his direction to paint pictures of France's glorious deeds performed by the navy in this last war to decorate the walls of the naval training establishments at Brest, Rochefort and Toulon. Vernet replied that he had no pupil but that Serres was the person he knew who painted ships best. Castries had seen some of Serres's drawings brought from London by his [Castries's] son, but wanted oils, to be engraved afterwards. He wanted Vernet to direct the entire operation.

Castries then suggested that Vernet should do them himself, but Vernet said that he did not want to have the servitude and constraint of the commission, setting out in fluent phrases his reasons for this refusal.

In his letter to Serres, Vernet expects that someone will write to Serres about this, making a proposal and that the latter will go to Paris to paint them. He hopes that it will be arranged to Serres's satisfaction but goes on to give him some advice about the terms and conditions of such commissions in France:

> Make your bargain well, make sure that you are well paid and above all that you
> are paid precisely for each picture, because it often takes the Court years to get the
> money together, and it must be cursed, as I know something about it. I warn you
> that everything is expensive here and that it costs a great deal to keep oneself.

Vernet's letter of 4 August acknowledges Serres's reply, brought by a M. Desforges,[3] together with a small picture which Serres had given him. Desforges was, according to Vernet, well informed about the exchanges between Castries and Serres and could fill in the details which Serres had not had time to write in his letter. The manuscript is not clear, but it appears that Desforges was not himself Castries's official intermediary.

Vernet expresses dissatisfaction with the way things have gone between Castries and Serres. The proposal now being put forward is that Vernet's son should do the pictures with Vernet finishing the colour and other touches. The commission would be for about twenty pictures, each of five or six feet, and the charge should be five or six thousand livres each, without which, says Vernet, he would not take the trouble to undertake the work. He says that Serres has asked too little and that he is very much mistaken in his agreements, in which he has been taken in. Serres does not know Paris, how expensive it is to live there, on top of 6,000 livres for the Pension, so that you have to do four pictures per year of average size or six smaller. Vernet apologises for giving advice but hopes that all will be arranged and that he will see Serres in Paris.

Repeating the warning about payment by the Court, he reaffirms that all the troubles he has with his debts have forced him to refuse to continue the series of the ports of France which he has been much requested to continue. He has also declined all other work for the King. Court officials try to impose rules but Vernet cherishes his liberty. It is fifteen days since Vernet gave his reply to the proposition and, as he has received no answer, he does not know how things will work out. Finally, he states that the small picture Serres gave to M. Desforges is too small for Vernet to be able to use it to demonstrate and extol his capabilities.

Serres decided to go to Paris and left London shortly after receiving this letter. He went either because he felt that he was on the point of receiving the commission or, more probably, because he believed that his presence on the spot, where he could deal directly with the people concerned, would improve his chances of finalising an arrangement. He took with him his son, presumably John Thomas, who had exchanged drawings with Carle Vernet nine years earlier. They were in Paris by 25 August 1785, or soon afterwards, because Vernet's next missive, an undated note addressed to Serres at the Hotel de l'Empereur, Rue de Grenoble,

3. Pierre-Jean-Baptiste Chaudard Desforges (1746–c.1810) experimented with several callings, including that of painting, and finally became a dramatist, some of his plays being based on Fielding's *Tom Jones*.

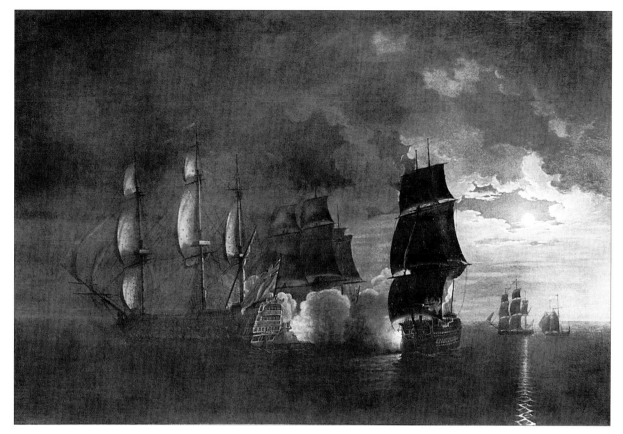

PLATE 87. 'Combat de nuit du Scipion et H.M.S. London et Torbay, Mer des Antilles, 17 Octobre 1782', attributed to Capitaine Auguste Louis, le Marquis de Rossel de Cercy, oil on canvas, 45 x 65 ins. (112.5 x 162 cm). Serres's painting of this action, arranged by Vernet, was not successful in obtaining the award of the commission from the Marquis de Castries, French Minister of Marine, for an extensive series planned to decorate naval training schools. Although it has not been traced, it seems that Serres's work may have had some influence on Rossel, who finally received the commission for most of the paintings.

©Musée de la Marine, Paris

St. Honoré, describes his unsuccessful hour-long search for Serres at the Salon de l'Exposition des Tableaux, which opened traditionally on St. Louis's day and lasted for about one month. Vernet proposed to call on Serres at his hotel at nine o'clock the following morning.

On 5 September the French artist invites the Serres to join him the following day at half-past twelve in a visit to the Salon and after that to dine with him at home. His daughter will be there, wishing to make the acquaintance of the Messrs. Serres, but he regrets that his dinner will be simple, as it is every day for the Vernets, father and son. Better that than loving extravagance. Emilie, the daughter, had married the elder son of Jean François Thérèse Chalgrin, the architect, as Vernet had recorded in his letter of August 1776 to Serres. Vernet's wife had been confined in an asylum outside Paris since 1774 and this would have been the reason for father and son dining simply at home most days.

The effort Serres had expended in going to Paris was rewarded with the grant of a commission for at least one painting. Whether he was to be paid for it or whether it was to be submitted as a trial is not clear, but it was of the monumental size planned for the commemorative series and was therefore presumably envisaged, if successful, as the precursor of others to follow.

Louis-René Levassor, comte de Latouche-Treville (1745–1804), had been an active and distinguished French naval commander during the war, having also been captured and spending some months as a prisoner of war in England. In 1785 he was at Versailles as assistant director of ports and arsenals, and on 20 October wrote to Serres giving the necessary

directions for the picture of 'The engagement between the French vessel Scipion and the English vessels London and Torbay', which the artist was to paint, of ten feet in width by four or five in height. Latouche-Treville specified that the 'first position' required fine moonlight. Naval battles were quite frequently fought in moonlight at this time and made impressive subjects for paintings. As we have seen, Serres had, over the years, made something of a speciality of them. Latouche-Treville's reference to the 'first position' may imply that Serres was to include several phases of the engagement across the width of the single canvas.[4]

The painting has not been traced but a French version may refer to it (Plate 87). The painter is stated to be Rossel, but, in view of the evolution of the commission, discussed below, and similarities to Serres's night scenes, it seems that the image could well owe much to his work. While this scene clearly depicts the moonlit phase of the action, a print after an original painting by Causse, is of a daylight engagement and therefore, presumably, a later stage of the battle (Plate 88). If the assumption regarding Serres's original painting is correct, the latter print may be derived from another part of the canvas.

An English account written within twenty years of the engagement, describes the *London* (98 guns), *Torbay* (74 guns), and *Badger*, sloop, cruising off Hispaniola when they fell in with *Le Scipion* (74 guns) and a large frigate. They chased the enemy all day until the evening of 18 October 1782, when:

> After a most resolute and spirited resistance, in which the French commander, M. de Grimouard, displayed great bravery and nautical skill, he ran his ship on shore in Samana Bay on Santo Domingo, where she was lost, but all hands saved. In the engagement, which was principally with the London, they fell on board of each other, and by a masterly manoeuvre the Frenchman disentangled himself, and so much disabled the London, as to render her incapable of pursuing him. The Torbay continued the pursuit, but M. Grimouard had run his ship on shore before she reached within shot.[5]

Although hardly a resounding victory, the action sounds from this account, by a British naval captain, as if it was indeed one of which to be proud, in view of the superiority in numbers and armament of the British ships over *Le Scipion*. It was probably patriotic fervour which prompted Edwards's disparaging comment when he came to write his *Anecdotes of Painters*. The wreck of *Le Scipion* has been relocated in recent years by American archaeologists, found to be in good condition and efforts made to raise it for preservation.

It seems that Serres returned to London to paint the picture, and despatched it at the beginning of 1786 to Paris in the hands of one of his sons. It would therefore have been this son who was the recipient of a note written on Friday 27 January 1786, addressed to the Café de Quatre Nations in the Rue de Grenoble. In it Vernet says that he is unable to go to see the picture in question at M. le Maréschal de Castries's either that day or the following. If, however, Serres would call on Vernet the next Sunday at half past twelve, then they could go together to the house of M. le Maréschal de Castries. In the context of the letters and a later reference, it may safely be assumed that 'the picture in question' was that which Serres had painted and sent to Paris in the care of his son. It appears that Vernet failed to keep the appointment to go to Castries's home on Sunday 29 January and a further visit was apparently planned a week later.

On Tuesday 7 February Vernet sent another note to the same address, saying that he was very angry because extremely important matters prevented him from going that morning to the home of Castries, which would have been agreeable for Serres. The French artist said that he would be very busy the whole of that day, but that he would always be willing to do everything that rested with him which could be advantageous to Serres and to his

4. *A la Gloire de la Marine*, exhibition catalogue, Musée de l'Orangerie, Paris, 1935, no. 179.
5. Captain I. Schomberg R.N., *Naval Chronology*, Vol. 11, 1802, p.106.

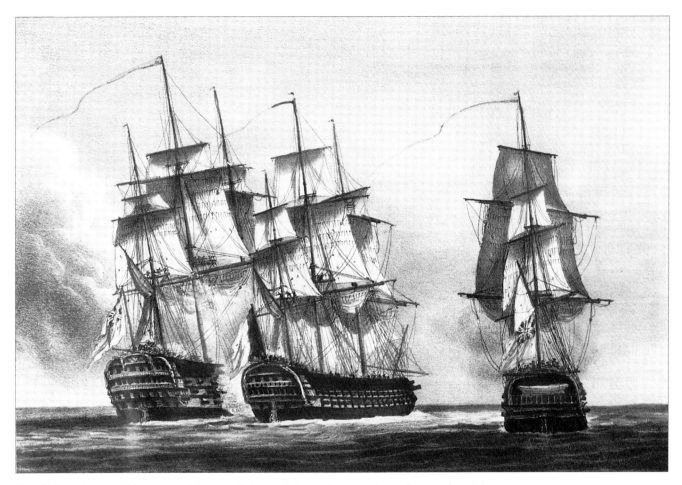

Plate 88. 'Le vaisseau de 74 canons, le Scipion, capitaine de Grimouard, soutient le combat entre les vaisseaux anglais le London de 98 et le Torbay de 74 dans la mer des Antilles, le 17 Octobre 1782', engraving after Causse. It appears from a contemporary letter that the painting Serres sent to Paris may have had two parts, by moonlight and daylight, representing separate phases of the long engagement. If so, this painting may bear some resemblance to the latter part. It clearly shows the disparate size of the London (98 guns) and the Scipion (74 guns), with the Torbay (74 guns) approaching, from which the French vessel took such honour.

©Musée de la Marine, Paris

family, of whom he was very fond.

This sounds very much like a 'sign-off' by Vernet and is perhaps more readily explained as the recipient of the notes was a young Serres, perhaps on this occasion Dominique Michael, the second son, who would have been twenty-two years of age at the time. One feels that Vernet would have paid more courteous attention had Dominic senior, or John Thomas, whom he had met the previous year, been the visitor, even though he may no longer have wished to be involved in the affair. Subsequent correspondence suggests that this was probably the case and Vernet's promotion of Serres may never have been as enthusiastic as he professed.

Nearly three months later, on 28 April 1786, Vernet wrote to Serres in London, saying that it was a long time since he had news of him and that he would probably be astonished at the outcome of the story regarding the pictures of the war. 'You were given a trial but you were not persevered with'. Vernet had proposed that his son should do twenty-five to thirty pictures for about 100,000 livres. He had received no reply but heard that the commission was to be given to an amateur painter, an inexperienced retired naval officer. Everyone was surprised. The officer did one picture and asked Vernet to look at it, also seeking his written approval. Vernet declined to do this as it was against his conscience. He had not seen the officer since, but does not think that the project will continue.

The officer was Capitaine Auguste Louis, le marquis de Rossel de Cercy (1736–1804).

The Musée de la Marine in Paris has ten paintings by him of actions during the war, so the project clearly did go ahead, even though the artist was an amateur and not of the calibre of either Serres or Vernet. In addition to the subject Serres had been called upon to record, other paintings were of the capture of the frigate *Fox* by the *Junon* in 1778 (see pages 136–137) and the repeated engagements between Bailli de Suffren and Sir Edward Hughes in Indian waters in 1782/3. There is evidence, in the form of copies and prints, of further paintings by Rossel commemorating the wartime actions, and it is possible that the series finally totalled eighteen, as Castries had originally intended. With regard to Serres's painting, it seems to have disappeared after its arrival in Paris and display at the home of Castries.

What appears to be a rough draft in French of a letter from Serres to Vernet is the last extant item in the manuscript exchanges on this subject. It is dated 25 December 1786 and opens 'Monsieur et cher Compatriote'.

Serres starts by acknowledging Vernet's letter of the previous month, sending greetings and compliments. With regard to the pictures of the last war he writes:

> You can rest assured that I have forgotten nothing of this subject and that I am very calm about it. You tell me that you have proposed that your son should execute them, without doubt nothing to be done but under your inspection, and with honour, but I imagine that he will encounter plenty of difficulties as you have described in one of your letters.

The manuscript is involved and the French not always easy to follow, but Serres retraces the steps in the whole sad story. He continues that, when his son carried the picture to Paris, he also took a letter to Vernet in which Serres asked him to go and look at it, saying that he would submit to the French artist's judgement and rely on his candour:

> I hoped that you would give me the pleasure of saying something about it. Since you have not said a word of your opinion, I am really afraid that I am in the same situation as that officer.
>
> Some years ago you did me the honour of inviting me to go and see the Pictures that you had painted for Lord Shelbourne. I had great pleasure in viewing them and gave you my opinion, thus I expected that you would have done the same with regard to mine. As I am not vain enough to consider myself infallible, I should have been very flattered to receive any remarks from you. But I will not say any more.
> I wish you a Happy Christmas and New Year, together with M. Carlo and M. and Mme. Chalgrin.

The tone of the draft is polite but clearly aggrieved and reproachful. It suggests that Vernet may not, in the event, have been as helpful to Serres as he pretended. The draft may, of course, have remained just that, and the letter itself never been sent, but Serres's hurt feelings about the entire episode are evident.

Whatever the case, Vernet was not bashful about writing to Serres again eighteen months later to introduce yet another friend who was visiting London. He wrote on 14 April 1788 regretting that he had not had news for a long time, except via friends, including M. Desforges who had recently received a letter from Serres. 'The warm welcome you have given to everyone that I have recommended to you, makes me hope that you will do the same for M. Rouille, Sous-intendant de Champagne, bearer of this letter'. He sent affectionate greetings to the dear family and in a postscript says that his son was married six or seven months previously and sends good wishes to Serres's sons.[6]

6. All these letters are in British Library Add. MSS. Fr.23,201.

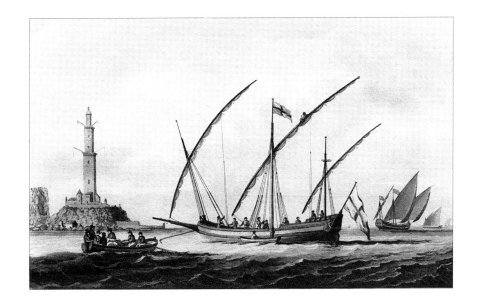

PLATE 89. 'A settee with a view of the lighthouse at Genoa', *Liber Nauticus,* Plate XXXVI, published by Edward Orme, London, 1806. The painting with a similar title submitted to the Academy in 1786 may have been the basis for this illustration. With other drawings and prints, it reinforces the view that Serres made a tour in the western Mediterranean at about this time.

CHAPTER XI

TRAVELS; A MARRIAGE AND BATH SPA FOR THE CURE 1785-1788

Serres had from the earliest days painted pictures of Mediterranean shipping and ports. This has been attributed to his voyages as a seaman before sailing the Atlantic and residing in Cuba and, in the case of Gibraltar, to the further availability of first-hand drawings and copies illustrating topical events. But in 1786, Serres submitted two paintings to the Royal Academy which suggest that he may have made another tour in the western Mediterranean at about this time for his own enjoyment and benefit. No. 158 was entitled 'View of the lighthouse, Genoa', and No. 161 'View of Europa Point, Gibraltar'. Although neither has been traced, the subjects appear in *Liber Nauticus*, respectively Plate XXXVI 'A settee with a view of the lighthouse at Genoa' (Plate 89), and Plate XXXVII 'A tartan with a view of Europa Point Gibraltar' (Plate 90), and may have been based on those oils.

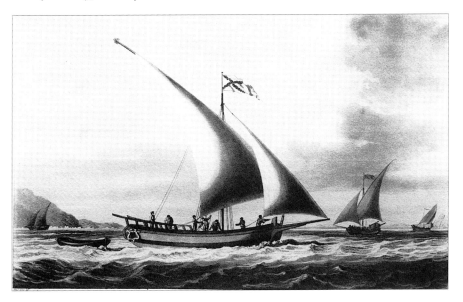

PLATE 90. 'A tartan with a view of Europa Point Gibraltar', *Liber Nauticus,* Plate XXXVII, published by Edward Orme, London, 1806. The Pillars of Hercules, the view every mariner has when approaching Gibraltar on his way into the Mediterranean. Serres's simple wash drawings of local craft were originally to show his aristocratic pupil the many types of vessel which could be incorporated in marine paintings.

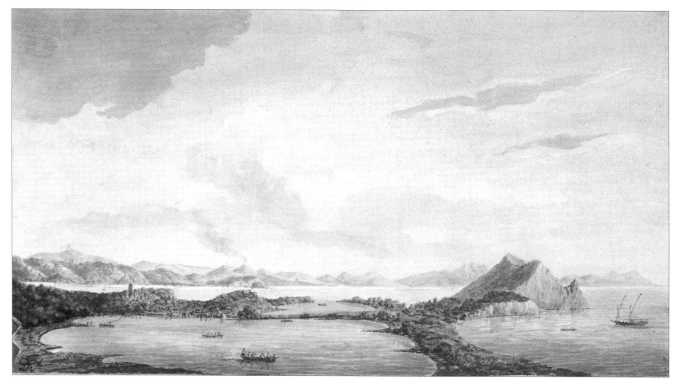

COLOUR PLATE 65. 'General View of the Environs of Naples', watercolour over pencil with pen and black ink on laid paper, signed with initials and inscribed on reverse 'D. Serres 1787 No. 51' with a numbered key to sixteen points of interest, 10 x 17 ins. (26 x 43.5 cm). The drawings and other images created by Serres indicate that he made a tour in Italy at some time between 1785 and 1788. The number inscribed on this drawing and the key to principal features may imply that he was planning publication of a record of his travels.

©Tate, London 2000

A well-executed drawing, signed with the characteristic, cursive initials 'D.S.' and inscribed on the reverse: 'General View of the Environs of Naples', accompanied by a key detailing sixteen features numbered on the face of the drawing, and 'D. Serres. 1787. No. 51', seems to confirm his presence on the spot (Colour Plate 65). As does another drawing, inscribed 'Agropoli, Coast Tower & Temples of Paestum, Coast of Salerno' and similarly bearing on the reverse, a shorter key to landmarks (Colour Plate 66). The noting of important features with a key was common on topographical prints of the time and had been previously used in those after Serres of Halifax and Belleisle. This, and the number 51 on the back of the Naples drawing, may suggest a serial reference and perhaps that Serres planned a series of prints on his return from his travels.[1] Other plates in *Liber Nauticus*, which include background views of Naples and the volcanic island of Stromboli, could also have been derived from drawings Serres made at this time.

Naples, the capital of the Kingdom of the Two Sicilies, was at this period a place of lively cultural and artistic activity. As an ancient centre of civilisation it had long been an essential part of the Grand Tour, but its appeal was greatly enhanced by the excavation of Pompeii, started in 1763, and the hedonistic rule of the Bourbon king, Ferdinand IV, and his volatile wife Maria Carolina, daughter of Maria Theresa and sister of Marie Antoinette of France. Stimulated by a visit to Naples early in 1784 from the Queen's brother, Emperor Joseph II, to view the ravages of the Calabrian earthquake, and wishing to emulate the elegance of another brother, Leopold, Grand Duke of Tuscany, Maria Carolina persuaded her husband to make a tour of northern Italy. The party left Naples on 30 April 1785 in a richly-appointed vessel followed by twelve men-of-war, and, travelling with all pomp and splendour, visited Leghorn, Pisa, Florence, Milan, Turin and Genoa.

[At Genoa] they embarked upon the same fleet, increased by English, Dutch and Maltese vessels, which, together with the ships of the king (twenty-three men-of-war of all sizes),

1. *British Watercolours from the Oppé Collection*, exhibition catalogue, Tate Gallery, 1997, no.21.

COLOUR PLATE 66. 'Situation of the Temples of Paestum', inscribed 'Agropoli, Coast Tower & Temples of Paestum, Coast of Salerno', wash and pen and ink over graphite on paper. A further drawing which endorses the likelihood that Serres made a tour of southern Italy. .

Yale Centre for British Art, Paul Mellon Collection/Bridgeman Art Library

conveyed them as far as the port of Naples. They had travelled four months with so much splendour and profusion . . . that Ferdinand acquired the name of the Golden King. The city of Naples held great rejoicings on the return of the sovereigns, which was celebrated as if they achieved a national victory. The journey cost the treasury more than a million ducats, enough to have healed the recent wounds inflicted by the earthquake.[2]

A painting by Dominic Serres is recorded of the arrival of the Neapolitan fleet at Leghorn, and he was at Naples, too, to join in the celebration of the return by painting a large and colourful picture of the scene (Colour Plate 67). Travelling in the Mediterranean at this time and visiting Naples, it would be have been most natural for him to record such magnificent occasions. Historical annotations state that the painting was the property of the King and Queen of Naples in Leghorn in 1786, but the Greenwich canvas illustrated is signed and dated 'London 1787'. This anomaly has not been resolved, but Serres may have painted more than one version, perhaps one in Naples for the royal family and another after his return to London. It was presumably the latter which was exhibited at the Academy in 1788: 'Their Sicilian Majesties' return to Naples from Leghorn' (no. 32). It is of interest to note that Lord Keppel, one of Serres's earliest patrons, was in Naples during the winter, having left England in the autumn of 1785 for the sake of his health, and staying in Rome and Naples before returning in the spring of 1786. His tour may have had some connection with Serres's visit to Naples and the commission for the painting from the royal couple. Under the rule of Ferdinand and Maria Carolina, the Kingdom was friendly towards the British and provided a valuable foothold for British Mediterranean operations, not least those of Nelson, until annexed by Napoleon in 1806.

In the course of the royal progress, on 15 May 1785, Sir William Hamilton, the British ambassador, reported a diverting incident:

Monsieur de Las Casas, the new Spanish minister, having been on board the ship

2. P. Colletta, trans. Horner, *History of Naples*, Edinburgh, 1858, pp.158–159.

179

PLATE 91. 'Charles II's Visit to the Combined French and English Fleets in the Thames, probably 5 June 1672', Dominic Serres and ?van de Velde the Younger, pen and ink with grey wash on laid paper, 14 x 24 ins. (35.5 x 61.5 cm). An inscription on the reverse by John Thomas Serres states that his father drew this in 1785. Probably an example of Serres's working up of drawings from his large collection of works by the Dutch masters. The paper upon which the sky is drawn has been pieced in.

National Maritime Museum, London

in which the King and Queen went to Leghorn . . . was very much offended at seeing the state room furnished with English prints representing the defeat of Langara and Monsieur de Gras by Sir George Rodney, and the destruction of the floating batteries before Gibraltar; he was weak enough to reproach His Sicilian Majesty with the impropriety of such furniture and to threaten to complain to His Catholic Majesty [Charles III]. The Queen sent for him, and, in a very spirited manner, warned him to be on his guard and rather to endeavour at diminishing than increasing the coolness which unfortunately subsisted between the father and the son, owing to the cabals of ill-designing persons.[3]

The wide dissemination of nautical prints could, on occasion, have unexpected ramifications!

Pictures in 1786 and 1787

Two of Serres's works exhibited at the Academy in 1786 were entitled 'Sea piece, in the style of Vanderveld, by the particular desire of a gentleman' (nos. 197 and 213). The pervasive influence of the van de Veldes on eighteenth century marine painting has been recognised and Serres's large collection of drawings by the father and son, some of which he worked up into a more finished state (see page 131). It is not, therefore, surprising to find Serres producing two works in the style of the van de Veldes for a discriminating patron. It has been suggested that the originator of the commission was Edward Knight of Wolverley but that he did not in the event purchase Serres's work (see page 69). The artist, apparently left with the pictures, clearly felt that they were good enough to be hung at the Royal Academy where they could still appeal to current taste.

A surviving example of Serres's working-up of van de Velde drawings is 'Charles II's Visit to the Combined French and English Fleets in the Thames, probably 5 June 1672' (Plate 91). John Thomas inscribed the reverse to the effect that his father drew this in 1785. The original drawing, perhaps by van de Velde, has been considerably developed by Serres, who presumably also drew the sky on separate paper which was then pieced in.[4] This itself would clearly not have been a submission to the Academy exhibition, but it may give an idea of how the artist developed a composition, perhaps as a preliminary sketch for discussion with the patron, before turning to his easel, canvas and brushes for the final work.

It is noteworthy that during these later years of his life, Serres produced a number of portraits of merchant ships, although some of them, being East Indiamen, were of a

3. Quoted in H.M.M. Acton, *The Bourbons of Naples 1734–1825*, 1956, p.193.
4. R. Quarm, *Masters of the Sea*, exhibition catalogue, National Maritime Museum, 1987, p.16.

PLATE 92. 'The East Indiaman Pitt and other vessels off Dover', oil on canvas, signed and dated 1786, 46 x 71 (117 x 180.5). In the years of peace towards the end of his life Serres painted several pictures of merchant vessels. This one may have been commissioned by George Mackenzie Macaulay, who commanded the ship on its rapid sixteen-month voyage to China and back, for the print after it was dedicated to him.

National Maritime Museum, London

singularly warlike aspect. 'A homeward bound Indiaman in three positions, passing by Dover' was exhibited in 1785 (no. 237), and others followed in 1789, 1790 and 1793, while 'Portraits of four Greenland ships outward bound' appeared in 1787 (no. 433). Showing the subject vessel in three positions was the convention in ship portraits, not only to display the fine points of the vessel from different angles but also to provide balance in the middle distance of the composition. 'The East Indiaman Pitt and other vessels off Dover' (Plate 92) could well be a version of the 1785 Royal Academy picture. It is signed and dated 1786 and is an excellent example of Serres's mature style in the genre. The ship left the Downs under the command of George Mackenzie Macaulay on 28 March 1786, and, after a fast round trip, returned there on 6 August 1787. Before leaving Macaulay had presumably instructed Serres to paint the portrait commemorating his departure on the voyage. When an aquatint and etching by John William Edy (1760–1817) after the painting was published by John Harris on 20 July 1789, it was dedicated to Macaulay and lettered: 'The Ship Pitt in the East India Company on her return from China off Dover 1787'. Perhaps Macaulay had, from the beginning, been confident of a successful return, for the image served equally well to commemorate that event.

John Thomas on tour

John Thomas had been travelling consistently in southern England and submitting works to the Royal Academy, mainly identified landscape views, as an Honorary Exhibitor, in the years since his first appearance there in 1776. In 1786 and 1787 his travels took him further afield, on a visit to Germany. The early part of his tour coincided with the visit of the royal yacht *Princess Augusta*, which his father had painted at Spithead thirteen years earlier, carrying some of the royal princes. Also on board, as an able seaman, was Robert Clevely, the marine painter. Although it therefore seems unlikely that John Thomas would have accompanied the party in a similar capacity, he was nonetheless nearby, for he submitted to the Royal Academy in 1787 'Portrait of the Augusta Yacht, with a view of Gluckstadt, on the Elbe' (no. 37), 'View of Cuxhaven on the Elbe, with a portrait of his Majesty's yacht Augusta' (no. 144), as well as three paintings or drawings of Hamburg. If he was not actually of the royal party, he may have felt it appropriate, in view of his father's appointment with the King, and his presence on the spot, to record the scenes.

Later in 1787 John Thomas was in Ireland, having his 'View of the lighthouse in the Bay of

COLOUR PLATE 67. 'Arrival of their Sicilian Majesties at Naples, 1785', oil on canvas, signed and dated London 1787, 45 x 72½ ins. (114.5 x 184 cm). Serres was very probably at Naples to witness the return of King Ferdinand and Queen Maria Carolina from their tour of northern Italy. Their court was characterised by display and extravagance and the scene of welcome, which Serres ably depicts, seems to be in keeping.

National Maritime Museum, London

PLATE 93. 'View of the lighthouse in the Bay of Dublin, with his Majesty's yacht Dorset', John Thomas Serres, oil on canvas, signed and dated 1788, 40 x 60 ins. (102 x 152 cm). After leaving Chelsea Maritime School, John Thomas travelled continuously in Britain and on the Continent. The royal yacht Dorset was placed at the disposal of the Viceroy of Ireland, but was also used to transport important visitors. In painting this scene, and having it hung at the Royal Academy exhibition, John Thomas may have had his eye on royal patronage. He was rewarded a year later with the appointment of Marine Painter to H.R.H. the Duke of Clarence.

Victoria & Albert Museum
Picture Library

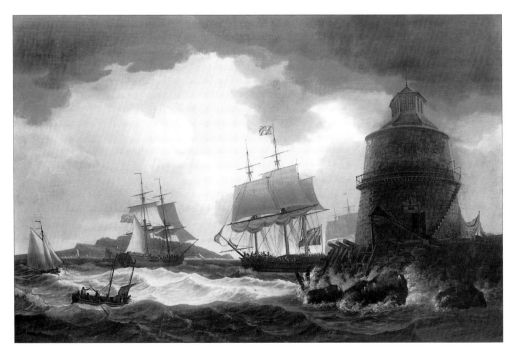

COLOUR PLATE 68. Study of Dominic Serres asleep by Paul Sandby, watercolour over pencil on laid paper, 5¾ x 3¼ ins. (15 x 8 cm). Sandby could not resist the opportunity to make a quick drawing of his friend dozing off, perhaps after a good lunch.
Photograph courtesy of a Private Collection

Dublin, with his Majesty's yacht Dorset' hung at the Academy the following year (no. 47) (Plate 93), and 'The Exchange at Waterford' in 1789 (no. 89) (Plate 94). The *Dorset* was in fact the yacht placed at the disposal of the Viceroy of Ireland, but frequently used for transporting important guests and visitors to and from Dublin. The recording of these voyages of royal yachts and personages suggests that, even if John Thomas had no formal role, he was taking care to keep himself in the eye of the royal family. This, no doubt also influenced by his father's position, was rewarded when, at the turn of 1789/90, he was appointed Marine Painter to the Duke of Clarence, the most nautical of the King's sons. Prince William Henry had been created Duke of Clarence in March 1789 and promoted Rear-Admiral in December, the end of his service afloat, and he would have wished to mark his elevation and long naval service by adding the attribute of a personally nominated marine painter. It was to prove a valuable asset to John Thomas in his dealings with the Navy in the years to come. Although never elected an Associate of the Royal Academy, he continued to have generous numbers of his works accepted for display at many of the annual shows until 1820.

A marriage

Since 1778, Dominique Michael Serres, the second son, had also been exhibiting landscapes at the Royal Academy as an Honorary Exhibitor, a privilege accorded, among others, to children of Academicians. He would in that year have been fourteen years of age and was described as 'Master Serres' in the catalogue. He became 'Dominic Serres Junior' in the 1781 list and 'D.M. Serres' in 1782, all the while having St. George's Row, Oxford Turnpike, as his address. His identified landscape views indicate that he travelled in the south of England, probably with his father or, in the case of Gloucestershire in 1781/2, with his brother. After his brief naval interlude in the summer of 1782, he was joined, as an Honorary Exhibitor at

PLATE 94. 'The Exchange at Waterford', John Thomas Serres, watercolour and ink on paper, signed and dated 'Waterford 1787', 13 x 19½ ins. (32.5 x 49 cm). A further, topographical, work from John Thomas's tour in Ireland, which was also exhibited at the Academy. Victoria & Albert Museum Picture Library

the Academy in 1783, by his sister, 'Miss. H. Serres', who submitted a landscape. Dominique Michael then made a visit across the Channel, for his 1785 submission to the Academy, from Welbeck Street, where he was presumably living with John Thomas, was a 'View of Boulogne-sur-Mer' (no. 453). His absence from the 1786 exhibition may suggest that he was again on the Continent, for both drawings sent in from St. George's Row to the 1787 show were of scenes in Boulogne and on the road to Paris. It has been stated that in the following year he made another tour in France and went as far as Italy,[5] but his work was not again hung at the Academy until 1804 and no other documentary evidence has been found. It is possible that, at about this time, he took over from John Thomas as Drawing Master at Chelsea Maritime School. In any event, he was certainly back home by the summer of 1788.

According to the Marriage Register of St. Marylebone Church, Marylebone Road, Dominique Michael married Lucretia Maddan on 4 August 1788. The witnesses were Sarah and Charlotte Serres, which prompts one to wonder why none of the parents was a witness and to speculate that Dominique may have emulated his father in the manner of his marriage. The Serres home in St. George's Row was not in the parish of St. Marylebone and the church was some distance away, but the family clearly preferred it and seems to have regarded it as their local church. Three of John Thomas's children were to be baptised there. Any parental disapproval of the marriage was soon forgotten, however, for after the wedding the newly-married couple returned to live with Mary and Dominic in their house overlooking Hyde Park.

5. S. Redgrave, *Dictionary of Artists of the English School*, 2 vols., 1874.

To the spa at Bath for the cure

Three months later it was considered desirable for Dominic, now nearing seventy years of age, to go to Bath to take the waters. The nature of the ailment is not clear but it seems from his comments in the following letter to his wife, written on 18 November 1788, that it may have been gout or a similar affliction.

My Dear Soul,

I have begun this day to drink the waters, but must not jump on my leg yet. It was not proper to drink before for I have got a cold after my arrival here without knowing how but every body has it as in London, but as it is most gone, the doctor told me I may begin. I am thank God very well otherwise. My friend the Col. is going home next Friday for this season, but is going to introduce me to a Gentleman of fortune who is a great lover of the Arts and paints himself. He tells me that he is a most agreeable worthy man, and therefore hope that he may be of some service to me. He is acquainted with my painting. I have now bespoke a Set of Colours of a man that keeps a shop for every thing fit for painters. He is a very ingenious man, has found out a varnish that he says is equal to Lucas. He is here in great vogue, and he paints and varnishes tables, boxes and all other works the same as Lucas. He seems to be a very worthy good man. He is very impatient to see my work, so that I shall begin something tomorrow, I let you know further as I go – give my love to the children Dom and Lucy and let me know how you go on with Devaiynes. Compts. to them, my friend Paul, ?Lucas Maderna ?Hira friend Edwards, Banks and all enquiring friends. Take care of your health and be sure that I shall be till death your loving and faithfull husband

D.Serres

I forgot to give you my address in my last. I lodge at Mrs. Omory, Chapel Court. I am very near the Pump Room, and quite handy to walk on the Parades. I am very sorry to hear such bad tidings from Windsor, tell John to let me know about the election of Secretary yesterday. Adieu my dear love; have a good heart till our next meeting – adieu, adieu – [6] (Plate 95).

The letter, again, gives a warm insight into Serres's honest and affectionate nature, unassuming, and loving towards his wife after nearly forty years of married life. His assertion that he is 'very well otherwise', the mention of walking on the parades and his excitement at buying colours, eager anticipation of painting and hoping for commissions, all suggest that he was in generally good health, his ailment being limited to his leg. He was evidently able to fulfil his expectations of working, for several examples painted in Bath have already been noted. Taking lodgings in Chapel Court, conveniently close to the Pump Room, was in sharp contrast to his more supercilious friend, Horace Walpole, who was in Bath twenty years earlier and wrote to G. Montagu on 5 October 1766: 'I lodge close to the Cross Bath, by which means I avoid the Pump Room and all its works', and, the next day, to the Countess of Suffolk: 'I steal my glass at the Cross Bath'. [7]

Plate 95. A reproduction of the second page of Serres's letter to his wife from Bath, 18 November 1788, giving an example of his handwriting and autograph. ©Royal Academy of Arts, London

6. Royal Academy Archives, JV/1/95.
7. Quoted in A. Barbeau, *Life and Letters at Bath in the 18th Century*, trans. 1904.

The colourman Serres was so enthusiastic about could well have been 'J. Crease, 10 Bridge Street, Painter, Colourman and Varnish-Maker' who so advertised himself in the *Bath Chronicle* at the time of the artist's arrival. His advertisement continued:

> Papering and varnishing on tables and boxes. The real Balsamic white varnish – 16s per quart. . . . Colours of every description, dry or ground, in cake or powder. Tables, boxes or caddees sold either papered or unpapered. Drawings varnished in the most brilliant manner. Transparent and Whatman's Drawing paper. Floor cloths . . . and old cloths new painted. Linseed, Spermaceti and Florentine oils. De Lamantin's Liquid for cleaning boot-tops.

Evidently a comprehensive stock and one can imagine the artist enjoying himself, perhaps unexpectedly, with this expert tradesman. Several of his drawings are on Whatman's recently-introduced English paper.

'HIS MAJESTY IS BETTER' proclaimed the despatch from Windsor, reproduced in the *Bath Chronicle*, but it went on to say that the King was 'still unwell'. This was the first bout of the 'madness' the King suffered and Serres's anxiety about his health reflected the public mood, but in his case the more concerned because of his personal acquaintance and favours received. The enquiry regarding the election of the Secretary of the Royal Academy shows his keen interest in the internal workings of the Academy, also illustrated by Edward Edwards's letter the previous year canvassing support for his nomination as Teacher of Perspective (see page 12). John Inigo Richards (d.1810) was elected Secretary to replace Francis Milner Newton, R.A. (1720–94). Newton, a portrait painter, had retired after filling the post since the establishment of the Academy twenty years earlier, having previously performed the same role in the Incorporated Society of Artists. Richards had been for many years a scenery painter at the Covent Garden Theatre and later specialised in landscape paintings of ancient buildings. He, in turn, was Secretary for twenty-two years until his death in 1810.

A circle of friends

The names mentioned in the letter from Bath are of obvious interest in helping to establish further the identity of Serres's friends and acquaintances. Punctuation was not one of his strengths when writing, with what is otherwise admirable fluency in a language which was not originally his own, and the liberty has been taken to add full stops and capital letters to the transcriptions of his letters in order to aid comprehension. '. . . love to the children Dom and Lucy' presumably includes all the children at home as well as the newly-weds. Some of the other names are readily legible and permit safe, or fairly safe, attributions to be made. '. . . my friend Paul' and 'friend Edwards' are clearly Sandby and Edward respectively, two of his closest friends. The reference to 'Devaiynes' could be either to William Devaynes, a director of the East India Company from 1770 to 1805 and its Chairman or Deputy Chairman at about the time of this letter, or to John, his brother, the King's apothecary, or general medical practitioner, who was a friend of James Boswell and attended him in his last illness.[8] The manner in which Dominic refers to Mary being in contact with Devaynes suggests that it could be the latter, perhaps on a medical matter, rather than the former, which would more probably have been regarding a commission. 'Banks' was almost certainly Thomas Banks, R.A. (1735/8–1805), the sculptor, who, although younger than Serres, was elected to the Academy in 1785, and moved in similar circles, obtaining commissions for military memorials for St. Paul's Cathedral and Westminster Abbey. The other names present greater difficulty, partly because, not being separated by commas, it is not clear how many friends are implied, and some of the calligraphy

8. C. Ryskamp and F.A. Pottle, ed., *James Boswell, The Ominous Years 1774–76*, Cambridge, 1963, p.286.

is doubtful. 'Lucas', which could be a first or a surname, would appear, from the earlier context, to be Serres's colourman in London but has not been further identified. 'Hira' is also doubtful.

Six months after this letter, on 4 April 1789, a M. L.Sicardi[9] wrote to Serres (spelt 'Ceres') from Paris saying that he expected to arrive on 1 May and, among other messages, asked Serres to go and see Mr. Burke[10] to discover if the plate he was engraving for him was progressing, because he needed it back in May. In closing, he says that he is looking forward to seeing in London two superb pictures by Vernet, done in 1747, and 'votre belle vue de Naples'. Finally, that his wife had smallpox at the beginning of the year but 'is now better and not marked'. The Sicardis may have stayed with the Serres during their visit for, at the end of May, Mme. Sicardi wrote an effusive letter of thanks for their hospitality, in which she also sent her greetings to the family of 'Mr. Maderna'. Maderna himself wrote to Serres from Amsterdam on 4 March 1791, in Italian, telling of their travels and return to Holland. His greetings to the family are joined by 'daughter Sara and Dominiko', which seems to imply that the Serres children of these names had travelled with Maderna. He was apparently an artist as John Thomas's sale of paintings in April 1790 included one by 'Maderna'. The identity of the Madernas has not otherwise been clarified, but it seems that they were probably visitors to London from the Continent, and became friendly with the Serres. The Sicardis wrote in French, so both friendships could have been based on the polyglot hospitality of the Serres household.[11]

Dominic wrote to Mary again from Bath on 16 December 1788, giving news of his progress and saying, in the same terms of endearment, that she 'must make herself easy' at his absence, 'for in a few days we shall have the great pleasure of embracing each other...' In the course of the letter he wrote that 'Bamfylde has bespoke another picture' and, elsewhere, that 'My old friend Mr. Bowles . . . wants me to stop at his house . . . he will have another picture of me, companion to one that he has already. . . .'[12]

Coplestone Warre Bampfylde, who has already been mentioned in connection with Edward Knight (pages 68–69), came from an old West Country family, the Bampfyldes of Poltimore in Devon, and in 1750 inherited the estate of Hestercombe, near Taunton, from his mother. He landscaped the gardens in the Picturesque and Sublime manner, to such effect that it was considered one of the best in the country, Arthur Young mentioning it in his 1771 'Tour'. A restoration project is now under way to bring the landscaped grounds back to their eighteenth century splendour. Bampfylde was a versatile and capable artist, painting landscapes, some of which were engraved by P.C. Canot, and caricatures, as well as engraving other artists' landscape paintings. He was also a soldier, becoming a Colonel in the Somerset militia. He, therefore, may be the Colonel to whom Serres referred in his earlier letter as a friend and patron.

Bampfylde was related by marriage to Oldfield Bowles (1739–1810), another wealthy member of the West Country gentry, owning an estate in Jamaica, who was also an amateur painter of landscapes, marines and portraits. His collection included two paintings by Brooking in addition to those ordered from Serres in Bath. Bowles took instruction from the landscape painter Thomas Jones (1743–1803) in the early 1770s and often invited him to his country seat at North Aston in Oxfordshire, until Jones, receiving a bursary from the Dilettanti Society in 1776, left to study in Italy, where he stayed for the next seven years.[13] It was probably to North Aston that Bowles invited Serres, perhaps on his way back to London from Bath, in order to paint the companion to the picture he already owned. Unfortunately nothing is known of these paintings, nor of those commissioned by Bampfylde.

The Duchess of Cumberland arrived in Bath on 29 October 1788, attended by her sister, Lady Elizabeth Luttrell, and took a house in Royal Crescent, where she was joined

9. Louis Sicard (or Sicardy) (1746–1825) was a miniature and enamel painter who worked in Paris and exhibited miniatures, portraits in oils and 'Pierrot' scenes at the Salon between 1791 and 1819.
10. Thomas Burke (1749–1815) was an engraver who adopted the style of Bartolozzi and, occasionally, Earlom, and produced works after contemporary artists, particularly Cipriani and Angelica Kauffmann. His engravings, dated from 1772 to 1791, were typically printed in red or brown colours.
11. British Library Add. MSS Fr.23,201.
12. M.H. Grant, *The Old English Landscape Painters*, 2 Vols., 1974, Vol. II, p.154.
13. *Memoirs of Thomas Jones 1743–1803*, Walpole Society, 1946–48, Vol. 33; J. Lane, 'The Dark Knight: Edward Knight of Wolverley and his collections', *Apollo*, June 1999, pp.25–30.

a few days later by the Duke. The newspaper was at pains to point out that the Duchess's visit, her first for eleven years, was not on account of her health, for she intended to attend all the functions and entertainments.

'. . . the very first hand in sea painting'

Other acquaintances of Serres who were visiting Bath at the same time included Lord Howe, Admiral Gambier and Captain Baillie, but it is from the letters of a lady living in the city that a brief insight emerges of how quickly and successfully Serres was introduced to the best society among the residents of the spa.

Mary Hartley, an accomplished amateur artist and daughter of the philosopher David Hartley, was 'cultured, pious and possessed of a philosophical turn of mind'. In 1781 she had met, if only briefly, the Reverend William Gilpin, the enthusiastic proponent of Picturesque beauty in the depiction of landscape, and for over twenty years thereafter maintained a regular and copious correspondence with him. For reasons of health, Mary Hartley moved to Bath, living at 37 Belvedere, and there made the friendship of artists as well as enjoying the highest social connections. She patronised the young Thomas Lawrence (1769–1830), born in Bristol, whose precocious talent rapidly propelled him to fame in London.[14] On 4 January 1789, she wrote to Gilpin:

> I have had several visits lately from Mr. Serres (Dominick Serres) the sea painter whom an acquaintance of mine introduced to me. He had none of his works here, but he painted two little pictures while he was here, & they were very masterly indeed! I fancy he is the very first hand in sea painting. I have always heard so from sea officers. My poor friend Captain John Bentinck[15] held him in the highest estimation. He has done two charming little drawings too, that he has made me a present of. One is a view of St. Helen's & the other Calshot Castle, with the most excellent ships, boats, sloops etc. Do you know his works?[16]

The following month, on 14 February 1789, Mary Hartley's letter opens with news and views about the work of John 'Warwick' Smith, recently returned from Italy, who had been the pupil of Gilpin's younger brother, Sawrey, and whose five-year stay in Italy had been financed by Lord Warwick, also in Bath at this time. She continues:

> I do not believe that with your ideas of Vanderveld about you, you wou'd be satisfied entirely with Serres sea-views, or with the effect of light and shade in them. Yet they are very good too, & I believe the correctness of the ships and boats is unequalled in any other master. The sailors admire him very much. Pocock's ships are very correct too, for he has been a sailor all his life; but his chief attention is to produce a fine effect of light and shade; & the motion of the waves in his drawings is so inimitable, that you would be astonished to see it. Mr. Bampfylde has great Genius; & his drawings, both by sea and land, are charming, & full of spirit. Pocock says that he rec'd his first instructions in landscape from Mr. Bampfylde; however, the scholar now excells the master; as may well be supposed, from his constant practice, in having made it his profession.

Mary Hartley appears to have met Nicholas Pocock at about the same time as Serres, for her letters refer to him at length on several occasions. Pocock had left the sea and taken up painting in Bristol, his native city, a few years earlier and been introduced to Bath society by a gentleman who had met him at the Hotwells spa in Bristol. As the brief reference quoted above suggests, Pocock's artistic approach and technique was closer to that propounded by Gilpin, and adhered to by Mary Hartley, than was that of Serres. Gilpin's theory of the

14. C.P. Barbier, *William Gilpin. His Drawings, Teaching and Theory of the Picturesque*, Oxford, 1963, pp.149–150.
15. Captain John Bentinck (1737–75) was a grandson of the first Duke of Portland. He entered the navy early and rose to the rank of captain, taking over command of *Centaur* (74 guns) in 1770. His ingenuity with mechanical devices resulted in his being credited with the invention of improvements to the chain pumps used on ships. He was elected M.P. for Rye in 1761. His son William, Count Bentinck rose to the rank of Vice-Admiral in the navy. From the date of his death it is clear that he knew Mary Hartley and Serres many years before the time of her writing. (Dictionary of National Biography.)
16. The correspondence is in the Bodleian Library, Oxford. MS. English Misc. D 572.

Picturesque called for the portrayal of the beauties of landscape according to certain idealised precepts, one being that the 'roughness' of nature should be captured by the artist. Much discussion centred, for example, upon whether or not cottages should be allowed to appear in the composition. Trees, however, were always an essential element of the landscape and Mary Hartley's letter to Gilpin of 28 July 1789 consists of a long dissertation on the longevity of different types of tree, oak, yew and lime, in which she mentions:

> I have lately conversed with old Dom. Serres, the sea painter, who is a Gascon; and he tells me that there are many very large old hollow chestnuts near Ausch; within which he has often seen 7 or 8 shepherd boys and girls, sitting together round a fire, which they had made in the middle.

This engaging picture of Serres enjoying the social pleasures of Bath implies that he stayed there for the early months of 1789, but it seems likely that it was not long before he returned to London.

Portraits of the artist

During 1788 the miniaturist Philip Jean (1755–1802) painted a portrait of Dominic Serres which, in spite of its size, seems to give the most complete picture of the artist and his character (Frontispiece). Jean was a Jerseyman, born in St. Ouen, who served in the Navy under Rodney and came to live in London, practising for several years in George Street, Hanover Square. This miniature was one of seven, within a frame, hung at the Royal Academy in 1788 (no. 315). It is one of Jean's earliest recorded works, most being dated in the 1790s. He also painted a full-length portrait of George III, now in the Royal Court, Jersey. His other sitters do not provide clues to any special relationship with Serres, apart from Paul Sandby, whom he painted a year earlier, in 1787, and who later engraved one of Jean's miniatures, and Admiral Lord de Saumarez (1757–1836), also from the Channel Islands, who owned work by Serres. Like Stuart's portrait six years before, Jean's shows the artist typically at work in his studio, confirming, again, that he was right-handed. While obviously, at this date, of advancing years, one can still perceive some of Serres's evident characteristics, the dedicated and determined look of the professional who has struggled but has now achieved his goals, and, at the same time, something of a whimsical sense of humour which appealed to his friends and patrons. The eyes and sharp features indicate a finer sensibility than some of the accounts of his more boisterous behaviour might suggest.

Also exhibited at the Academy in 1788 was a 'Portrait of an Artist' by William Beechey (1753-1839) (no. 429), which the press reported as being of 'Dominic Serres, Marine Painter'. Beechey, described as jovial and convivial, had been a neighbour of Serres at Golden Square and remained a friend of the family for many years. They would also have been linked by Sandby, whom Beechey always referred to as 'father Paul', and whose portrait Beechey displayed at the Academy the following year.[17] The whereabouts of the portrait of Serres are unknown.

As engaging as the Jean miniature, but less formal, are sketches made by Paul Sandby of Serres asleep in an upright chair (Colour Plate 68). One can imagine Serres more than once, perhaps after a good lunch and in a warm room, dozing off during a long conversation and Sandby, the irrepressible artist, making a quick drawing with which to tease his friend afterwards. The sketch illustrated seems to show Serres in his own studio or parlour with a marine painting on the wall behind, but others, where he wears his hat and holds a kerchief, as if just finished mopping his brow, were taken elsewhere, perhaps in Sandby's studio, having recently arrived, hot from the walk.

17. W. Roberts, *Sir William Beechey, R.A.*, 1907, p.29.

CHAPTER XII

SENIOR ACADEMICIAN;
DRAWINGS AND PRINTS;
JOHN THOMAS'S TOUR AND MARRIAGE
1789-1791

The events in France of 1789, which saw the beginning of the French Revolution, were watched anxiously by the Government and ruling classes in England. On a more personal level, Serres and his family found themselves, as time passed, increasingly involved with friends from the Continent and others who deemed it safer, or more discreet, to leave France for London. But they were still years of peace, for Britain did not feel obliged to intervene or take action against France until the situation there deteriorated and war was declared in February 1793. It was to be a long war, lasting, with a short interlude, for more than twenty years. The declining years of Dominic Serres were therefore marked by the gathering clouds of war, though open hostilities did not break out until the very last months of his life. Apart from a few retrospective naval paintings and copies, or versions, of some of his important marine works, his commissions and output were increasingly of more peaceful subjects, East Indiamen and other merchant vessels. He also returned to his early love of landscape, and examples of coastal views with shipping again figure in his production, as they had done before the demands of wartime naval actions came to preclude them.

Many drawings are dated to these last years of Serres's life. This could suggest an inclination towards a less demanding work schedule or, perhaps, the beginnings of a publishing venture with members of his family.

This was an age of experimentation and development. Since 1785 the Polygraphic Society had been holding exhibitions to promote a method of reproduction of paintings by a form of colour printing. The technique of etching and printing by Acqua Tinta, or aquatint, was also being introduced from the Continent, for which the original credit is usually given to the Hon. Charles Greville and Paul Sandby. Philipp de Loutherbourg R.A. (1740–1812) had invented the Eidophusikon in 1781, a type of model theatre with moving scenes, which intrigued other artists, notably Thomas Gainsborough, as well as the public. Dominic Serres and his family evidently also joined in this drive for inventiveness. A press cutting in 1789 announced 'Mr. Serres's Transparencies on Friday – His Majesty – St. Paul's – a Fleet saluting and the Sun darting from a dark passing cloud with 'Clarior Emicat'!'[1] Transparencies were not unknown, the face of the Royal Academy building, Somerset House, had been so decorated, with lamps behind for illumination, and it would be rewarding to know more of the attraction here advertised. The strong chiaroscuro effects mentioned in the advertisement would point to Dominic's hand but it seems probable that John Thomas, later to be a theatre designer, and, indeed proprietor, also had a major hand in the enterprise.

Commissions for paintings and the prints to follow them were not always executed with the dispatch which characterised Serres's approach. Two notorious sagas of delay were

1. National Art Library Press
Cuttings, p.517.

190

PLATE 96. 'Shipping', ink and grey wash on paper, signed with initials and dated 1766, 4 x 9 ins. (10 x 23 cm).
Probably a quick sketch made as an aid to memory for future use.

Victoria & Albert Museum Picture Library

running through the later years of the 1780s, and one, for twenty years longer. The latter, and longer, John Singleton Copley's commission in 1783 from the Corporation of the City of London for a painting of the destruction of the floating batteries at Gibraltar in 1782, in which Serres played a minor part, will be discussed in the next chapter. The other also began in 1783 when Benjamin West exhibited at the Royal Academy two 'modern history' paintings: 'Oliver Cromwell ordering the mace to be taken away, when he expelled the Long Parliament' (no. 62) and 'General Monck receiving King Charles II, on the Beach at Dover' (no. 91). Although Boydell had published prints after two of West's earlier and very successful modern history paintings, 'The Death of General Wolfe' and 'William Penn's Treaty with the Indians', West decided to publish the prints after his two latest paintings himself, and commissioned William Woollett to etch them. Woollett unfortunately died in 1785 and there was a delay while his widow reorganised the venture, bringing in John Hall (1737–97), who also succeeded Woollett as Engraver to his Majesty, and William Sharp (1749–1824) to finish the assignment. After repeated announcements in the press, assuring those subscribers who had already paid for them that work on the prints was 'very forward', they were finally published on 5 April 1789.

Seven months later, on 6 November, Rear-Admiral Sir John Jervis wrote to Dominic Serres: 'As I came through the City yesterday in my chaise, I thought I saw the landing of Charles II at Dover, and Oliver Cromwell removing the mace from the table of the House of Commons, hanging in Boydell's window; if so, I hope Mr. West has taken care of me...'[2] The remainder of the letter has not been traced, which adds to the mysterious and tantalising nature of the fragment preserved. Jervis had plainly missed the publication date of the prints, and was therefore apparently not a subscriber, but Boydell, although losing the initial right to publish them, was keen to sell copies through his shop in Cheapside. The final words are the most intriguing, as they clearly imply that Jervis felt that West owed him something, perhaps as an 'angel', dating back to the time that the venture was begun six years before. Jervis obviously wrote to Serres urgently as soon as he had discovered the prints, which further suggests that

2. Royal Naval Exhibition Chelsea Catalogue, 1891, no. 2142.

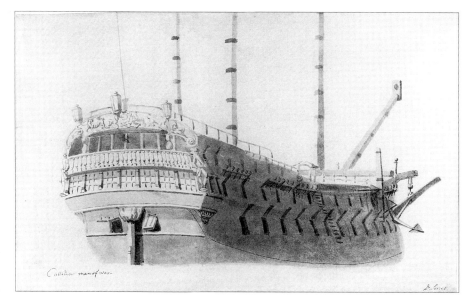

PLATE 97. 'Culloden, man-of-war', ink and grey wash on paper, signed, 12 x 17 ins. (29 x 43 cm).
National Maritime Museum, London

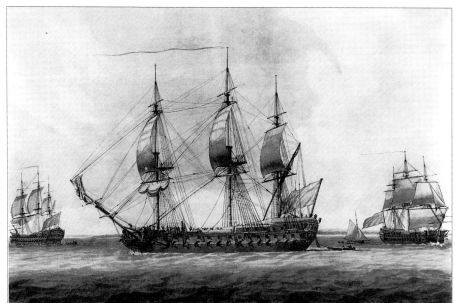

PLATE 98. 'A 74-gun ship in the Solent', watercolour with pen and ink on wove paper, c.1788, 12 x 17 ins. (29 x 43 cm).
National Maritime Museum, London

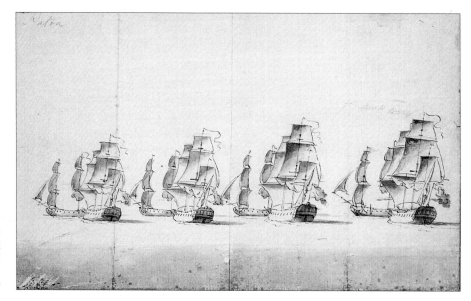

PLATE 99. 'Warships sailing to break the line', ink and grey wash on paper, signed with initials and dated 1788, 6 x 12 ins. (15 x 30 cm).
Victoria & Albert Museum Picture Library

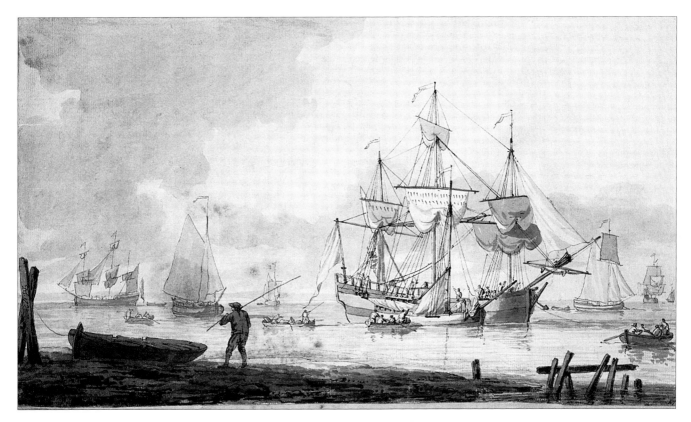

PLATE 100. Inshore shipping scene, ink and grey wash on paper, signed with initials and dated 1783, 12 x 20 ins. (30 x 51 cm). The profusion of drawings from the last years of Serres's life may suggest that he was already, at this date, planning to publish a guide to marine painting. Victoria & Albert Museum Picture Library

Serres was somehow involved as an intermediary with West. As an artist with long experience of working with engravers and print publishers, Serres may possibly have acted on behalf of Jervis in a transaction related to the publication. Although the whole episode caused West some embarrassment, the definitive biography of the artist and *catalogue raisonné* of his works throws no more light on this detail,[3] nor have Jervis's papers yet yielded further clues.

Drawings and prints

As one would expect from an artist working with such subject matter, Dominic Serres had always been a keen and competent taker of topographical views and details of shipping. Examples have previously been mentioned as well as his working-up of van de Velde drawings. One further example has survived, signed, as usual, with initials, and dated 1766 (Plate 96). It is a typical ink and grey wash sketch, probably made quickly as an aid to memory. Many drawings are undated, but those that are date to years throughout Serres's working life, with a significant number made in the last five years. A representative selection of coastal and shipping sketches is illustrated at Plates 97–101. Foreign views, many of them undated, again support the assumption that Serres actually saw and drew these in the course of his travels, among them 'The castle of Belem, Lisbon' (Plate 102) and 'Staten Island from Fort Hamilton, New York' (Plate 103). Finally, a stormy wreck scene in the style of Salvator Rosa and Backhuizen, which remained a popular

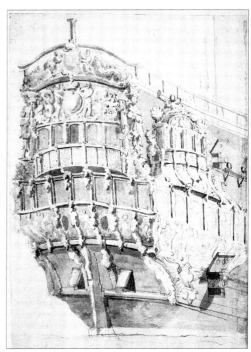

Plate 101. 'Stern galleries of a 3-deck warship', grey wash on paper, signed with initials and dated 1790, 12 x 9 ins. (30 x 23 cm). Victoria & Albert Museum Picture Library

3. H. von Erffa and W. Staley, *The Paintings of Benjamin West,* New Haven and London, 1986, nos. 83 and 84.

193

PLATE 102. 'The castle of Belem, Lisbon', pen, ink wash and bodycolour on paper, 12½ x 22 ins. (32 x 56 cm). Lively and truthful foreign views like this indicate that Serres made a practice, throughout his life, of recording his travels in on-the-spot drawings. ©Crown Copyright. U.K. Government Art Collection

theme, and was taken up again later by the Romantic painters, is dated 1793, the year in which Serres died (Plate 104). His drawings were evidently highly considered in themselves, for a press announcement in 1783 advertised an 'Exhibition of Drawings at the Great Rooms, 28 Haymarket', with D. Serres among the English and Continental artists mentioned.[4]

The Serres effort at producing prints of the series of naval uniforms in 1777 has been noted. Plate 105 reproduces another experiment, a small etching lettered on the plate 'D. Serres invt. & Sculp'. A further exercise some years later reproduced a line drawing of the broadside view of a fully-rigged 100-gun ship, with his Majesty on board, inscribed with letters and numbers 1–148, apparently for an explanatory key (Plate 106). It is

4. National Art Library Press Cuttings, p.231.

PLATE 103. 'Staten Island from Fort Hamilton, New York, 1791', ink and watercolour on paper, signed with initials, 9 x 23 ins. (22.5 x 57.5 cm). National Maritime Museum, London

PLATE 104. 'Rocky shore, with a fortress, a ship driving in, and some men at a wreck', water-colour, signed with initials and dated 1793, 10½ x 13 ins. (27 x 33 cm). Subjects on this theme, in the style of Salvator Rosa and Backhuizen, remained popular with painters until the nineteenth century. No oil painting derived from this drawing has been located.

Victoria & Albert Museum
Picture Library

lettered: 'D. Serres R.A. del'. and 'Etch'd by J.T. Serres 1783'. It bears similarities to the illustrations later to appear in *Liber Nauticus*, and, together with other extant drawings which may have been intended for the same purpose, suggests that Dominic and John Thomas were from that time contemplating an illustrative and didactic publication.

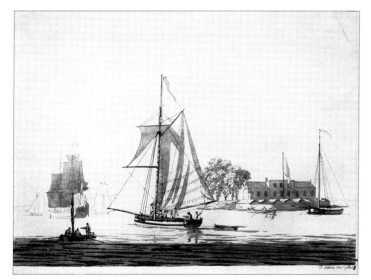

PLATE 105. 'A cutter and other small vessels close to the shore, etching with brown wash, inscribed 'D. Serres invt. & Sculpt', 9 x 12 ins. (23 x 30 cm). One of the very few examples of Serres undertaking etching himself. Others, of similar size, may indicate that he was considering publishing a series of prints, perhaps in co-operation with members of his family.

©The British Museum

PLATE 106. 'A First Rate man-of-war' with His Majesty on board', line engraving, inscribed 'D. Serres R.A. del.; Etch'd by J.T. Serres 1783', 16 x 19 ins. (41 x 48 cm). The print is also inscribed with the numbers 1–148, and letters, apparently intended for a key to the illustration. There are evident similarities to *Liber Nauticus* (Plate XVII) and Serres may have been planning such a publication more than twenty years before it finally appeared.

©The British Museum

PLATE 107. Title page and Address, *Liber Nauticus,* Part Second, Edward Orme, London, 1806. The text suggests that Dominic had not intended these particular drawings for publication but that John Thomas obtained permission to do so when he decided on the publishing enterprise.

PLATE 108. Opening Address, *Liber Nauticus,* Part First, Edward Orme, London, 1805. John Thomas's Part First of the instructional manual included diagrammatic illustrations of the hulls, rigging, sails and equipment of ships as well as points of sailing and sea state. These were preliminary basics to consideration of his father's drawings in Part Second.

Liber Nauticus 1805–6

The Address at the beginning of Part Second of *Liber Nauticus* states that the 'Twenty-four Subjects, by Dominick Serres, . . . were made expressly for the instruction of a Nobleman, who, in testimony of the esteem which he had for Artist, and the love which he entertaines for the Arts . . . has . . . liberally condescended to permit them to be engraved for Publication' (Plate 107). References and derivations have been established, and previously discussed, between oil paintings by Serres and some of these drawings. He therefore clearly drew on the body of his finished and studio works for the purposes of these instructional drawings. 'Instruction' could here mean active teaching, which Serres is not otherwise known to have undertaken, but more probably implies a guide for better appreciation of marine painting, and, perhaps, some help with amateur drawing. From a biographical point of view, it would be most interesting to know for whom they were originally produced. The wording implies, further, that Dominic did not have publication of these drawings in mind, but that it was John Thomas who took the initiative to obtain them from the Nobleman when he decided on the publishing venture.

John Thomas, in the years following his father's death, evolved the concept of an instructional manual and determined the final shape of *Liber Nauticus*. The title was a deliberate echo of Claude Lorrain's *Liber Veritatis*, begun in 1635, but its purpose was

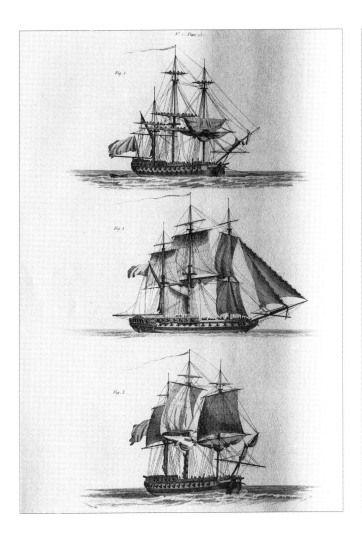

LIBER NAUTICUS. 11

PLATE XIII.

FIG. 1. Represents a ship of the line preparing to sail, with the men on the yards unfurling the sails.

Fig. 2. Is a frigate going *about*. About means the situation of a ship immediately after she has tacked, or changed her course by going about, and standing on the other tack. Tacking is also used, in a more enlarged sense, to imply that manœuvre in navigation by which a ship makes an oblique progression to windward, in a zigzag direction. This, however, is more frequently called beating, or turning to windward.

Fig. 3. Is a frigate lying-to, or *lying-by*, which means the situation of a ship when she is retarded in her course, by arranging the sails in such a manner as to counteract each other with nearly an equal effort, and render the ship almost immoveable with respect to her progressive motion or *headway*. A ship is usually *brought-to* by the main or fore top-sails, one of which is laid *aback*, whilst the other is full; so that the latter pushes the ship forward, and the former resists this impulse by forcing her astern. This is particularly practised in general engagements, when the hostile fleets are drawn up in two lines of battle opposite each other. It is also used to wait for some other ship, either approaching or expected; or to avoid pursuing a dangerous course, especially in dark or foggy weather.

PLATE XIV.

FIG. 1. A ship *casting*.

Casting, in navigation, is the motion of falling off, so as to bring the direction of the wind on either side of the ship, after it has blown for some time right a-head.

This term is particularly applied to a ship when her anchor first loosens from the ground, at the time she is about to depart from any place where she had anchored; and as she had probably rested at anchor with her head to windward, it is plain she must turn it off, so as to fill the sails before she can advance in her course; which operation is called casting. Hence she is said to cast the right or the wrong way.

Fig. 2. Represents a ship veering.

Veering is the operation by which a ship, in changing her course from one board to the other, turns her stern to windward:—Hence it is used in opposition to *tacking*, wherein the head is turned to the wind and the stern to *leeward*.

The ship having made the necessary dispositions to veer, *bears away* gradually before
E the

different. It aimed to set out the elements of marine painting by way of illustrated examples accompanied by a minimum of text. It was intended more as a handbook for artists and connoisseurs (or 'amateurs' in contemporary parlance) than a basic primer for those wishing to learn to paint marine pictures. Dominic's drawings were added to illustrate how the elements could be combined into a series of finished compositions, showing every type of vessel, portrayed, for topographical interest, against a well-known background. Analytical and instructive books had been published previously, but this was the first dedicated to marine art and its appearance demonstrated the prevalence and popularity the genre had achieved by the turn of the century. J.M.W. Turner was to take up the idea soon afterwards, with somewhat different objectives, when he published *Liber Studiorum* between 1806 and 1819.

John Thomas created the Part First of the *Liber Nauticus, and Instructor in the Art of Marine Drawing*, writing the text and making seventeen drawings for the plates. His opening 'Address To The Amateurs of Marine Drawing' is reproduced at Plate 108. The device at the foot spells the title on the spine of the book *Liber Nauticum*. The designers, but not, one would hope, the linguist John Thomas, had some difficulty with the gender and patches bearing 'S' had to be stuck over the offending 'M' on some of the page headings of the first copies printed. The contents of Part First cover masts, rigging, sails, tackle and deck equipment, with a key to the explanatory text where necessary; parts of ships, including bows, sterns and stowage arrangements; illustrations of various sea states; shipyard activities such as setting up a new mast; a sailing vessel's manoeuvres and sail trim appropriate to wind strength and sea state; and two portraits of naval frigates. The more diagrammatic illustrations were line drawings, engraved by John Swaine (1775–1860), of which Plate 109 is an example. Another, Plate XI, with its key

PLATE 109. *Liber Nauticus*, pages 10 and 11, drawn by J.T. Serres, engraved by J. Swaine, Edward Orme, London, 1805. The layout generally placed the text opposite the relevant illustrations.

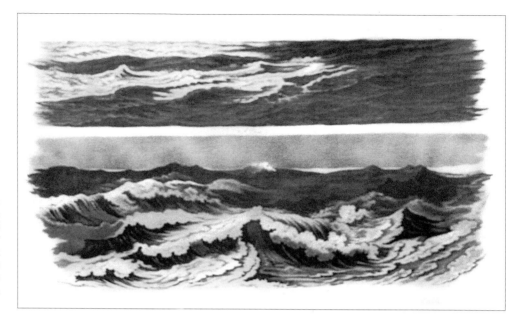

PLATE 110. *Liber Nauticus,* No.1, Plate III, drawn by J.T. Serres, aquatint by J.C. Stadler, Edward Orme, London, 1805. Studies for Water: 1. A Breeze. 2. A Brisk Gale. Aquatint, rather than line engraving, was employed to render the more amorphous sea surface.

identifying all the sails of a frigate, is currently receiving wide circulation in amended reproduction as an explanatory frontispiece to the paperback editions of Patrick O'Brian's popular Aubrey-Maturin novels. The wash drawings of the sea were reproduced in aquatint by Joseph Constantine Stadler (dates uncertain) (Plate 110), and some others by John Clark (dates uncertain) and Richard Harraden (1756–1838) (Plate 111). All the plates were inscribed 'Published and sold by Edw. Orme, His Majesty's Printseller, 59 New Bond Street, London' with dates spread through 1805. The title page bears the same date so the collated prints and text of Part First were probably put on sale before the end of the year.

Part Second consisted of the twenty four-plates after Dominic's drawings with skeletal explanatory text of a few lines for each. Various examples have already been quoted and used as illustrations in this text. The quality of Dominic's original drawing was largely preserved, thanks to the skills of the engravers, John Clark and Joseph R. Hamble (c.1784–c.1814), who produced all the aquatints, with the result that there is a better and more consistent level of visual presentation than in Part First. The prints were dated in batches, as the engravers were able to produce them, from January 1806 until January 1807, the last probably being an over-run, as the date on the title page of Part Second is 1806. The opening Address of the second part is reproduced at Plate 107, cheerfully and informatively framed by the flags of the nations. The last paragraph advises that 'Mr. Serres has rendered the subjects more interesting and amusing, by introducing the views of real scenes in the back ground, of which the vessels are characteristic', with the result that 'there is scarcely any kind of bark, which floats on the water, that is not delineated'. An idea of the range of vessels and variety of scenes depicted has been given by those previously illustrated. Others included: 'A sloop of war, with a view of Old Harry, in Studland Bay', 'A Bermudian sloop, with a view upon the Spanish main', 'A schooner, with a view of New York' (Plate 112) and 'A Dutch galliot, with a view of Amsterdam'.

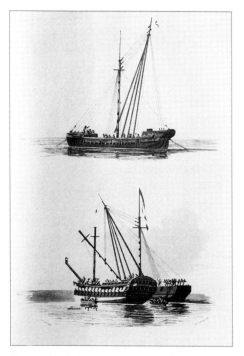

PLATE 111. *Liber Nauticus,* No. 2, Plate IX, drawn by J.T. Serres, aquatint by J. Clark and R. Harraden, Edward Orme, London, 1805. 1. A Sheer-hulk . . . used to hoist in or displace the lower masts of ships. 2. A ship of the line taking in her masts.

The number of copies of the *Liber Nauticus* printed or sold is not known and it is not easy to assess the extent of its influence, particularly as it was intended to aid the appreciation of marine painting by amateurs as much as to aid its execution. With one or two notable exceptions, such as de Loutherbourg and Turner, the early decades of the nineteenth century

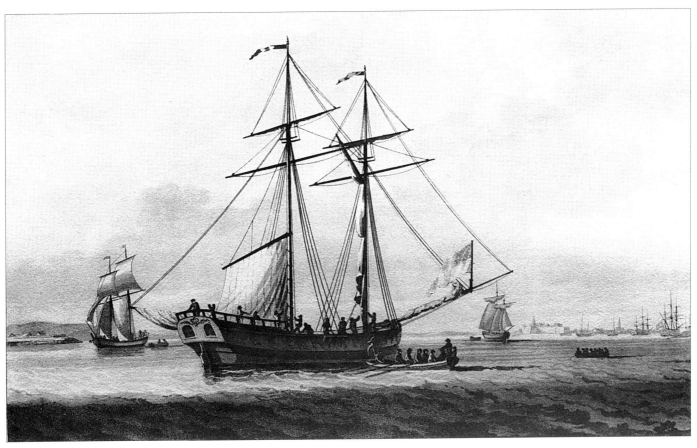

PLATE 112. 'A schooner, with a view of New York', *Liber Nauticus,* Plate XXXI, Edward Orme, London, 1806. Serres's drawings covered a wide geographical spread.

revealed a certain stereotyping in marine painting, particularly ship portraits, and *Liber Nauticus* may have contributed to this. Few professional artists can be seen to have drawn directly on the ideas and formulae put forward in the plates.

John Thomas's sale, tour to Italy and marriage 1790–91

Mr. Greenwood held an auction sale at his Rooms in Leicester Square on 22 and 23 April 1790, of 'a Collection of Modern Pictures and Drawings, chiefly consisting of the works and Property of Mr. Serres, Junior, Marine Painter to His Royal Highness the Duke of Clarence; Going to Italy, To which are added Some by the most admired and esteemed Masters. . . .' It was a substantial sale consisting of 123 lots on the first day and 115 on the second. The 'esteemed Masters' included names such as Atkins, Rowlandson, Chalon, Metz, Boucher, Sandby, Farrington, Cipriani, Cozens, Angelica Kauffmann, Bartolozzi, Zuccarelli, Pether, Hackaert, van Olst, Reinagle, Morland, Bourgeois and Monamy. Many of the works were by John Thomas himself, several by his father and two by brother Dominique Michael. Many of the works may have been on paper, but the collection, nonetheless, demonstrates a catholicity of taste and degree of affluence which is notable in a thirty-one-year-old artist. Taken together with the collection his father had been building up over the years, discussed on pages 130–131, it betokens an artistic family enthusiastically given to collecting and one which also had the means to indulge its passion.

The scope of John Thomas's travels before this date, already revealed in his submissions to Academy exhibitions, is further confirmed by the subject matter of pictures included in the sale. Views included Dover; Leybourn Castle, Kent; Canterbury; Holland; Dargle and Rings End, Dublin; 'Camp in Hyde Park', a subject favoured by Paul Sandby when

the army was camped in front of his house during the Gordon riots in 1780; Bath; Purfleet; Limehouse; Tilbury Fort; Hambourg and Cox Haven; Broad Stairs; the Rhine; Edditson, Plymouth; Battersea Church; Naples and Belem Castle, Lisbon. Many of those unidentified were of shoreside scenes, fishermen and their boats.

How much the sale made has not been recorded, but it seems clear that Dominic senior was either unable or unwilling entirely to finance his son's Continental tour and no other wealthy sponsor or companion was forthcoming. The slender evidence available indicates that John Thomas's travels were not, in the event, seriously curtailed by lack of funds. The date of his departure from England is not known, but, travelling by way of Paris, Lyon, Marseille and Nice, he was in Genoa by 27 September 1790. From Genoa he wrote to his parents, his previous letter having been from Marseille.

The letter is headed 'Genoa la Superba' and decorated with a drawing of the coastline and felucca-rigged boats. The city has, he writes:

> ... afforded me much pleasure and exercise for my pencil, the English Consul having procured permission of the Senate for that purpose, altho' they do not like it much, I therefore hired a felucca and have made the best of my harvest, so intend pursuing my journey to Leghorn, on thursday next & I hope to arrive there in two or three days at the most. From Nice to this, the coast is bold & Picturesque, but am told from here to Livourne, it is more noble than can be imagined, particularly the Gulph of Specia. I shall hire a felucca, to myself here, that I may have an opportunity of Drawing whenever I find anything worthy my attention. The Consul invited me to Dinner twice, and introduced me to Lady Knight, who has a Daughter very accomplish'd, and draws *very well*. They have been abroad 14 years, at Rome, Naples & knew Mr. Gore & others of our acquaintance. I made my first visit at her Palazzo, in the country one morning, about 10 oclock; they received me remarkably civilly and would not let me return home till 9 in the evening. She had a conversazzioni after dinner of fashionable people among them was a princess & her daughter; she introduced me to them all, saying, they were determin'd to love this Gentm. for the sake of his father, whom they knew in London, not but his own abilities & amiable qualifycations would secure him the esteem of everyone. So much for that, I should not repeat this noncence but to you, thinking it would give you pleasure. This Lady is the widow of Adml. Knight, & an acquaintance of my good friend Capt. Vandeput; they desired their Compts. to him and to you when I wrote.

John Thomas went on to write at length and in flamboyant language about the rigours and pleasures of his journey by land from Marseille to Nice. He spent five hours passing through the forested Esterel mountains, describing the surroundings and cloud effects in terms of the Sublime and the Picturesque, and was charmed to arrive in the evening at La Napoule as a wedding dance was in progress. In closing he offers his father and mother 'my Duty for your acceptance, & desire you to present my sincere love to my sisters likewise to my Brother & Lucy . . .'[5]

Rear-Admiral Sir Joseph Knight had died in 1775 and the following year his widow, having failed to obtain a pension and needing to economise, went abroad with her daughter. Lady Knight was a friend of Sir Joshua Reynolds's sister and, as John Thomas related, mingled with the best society in Italy, becoming particularly intimate with Sir William and Lady Hamilton in Naples. On her mother's death in 1799, the daughter, Ellis Cornelia Knight (1757–1837), placed herself under the protection of Lady Hamilton and returned to England

5. National Maritime Museum Phillips MSS 26/x ref. R.C.L./14.

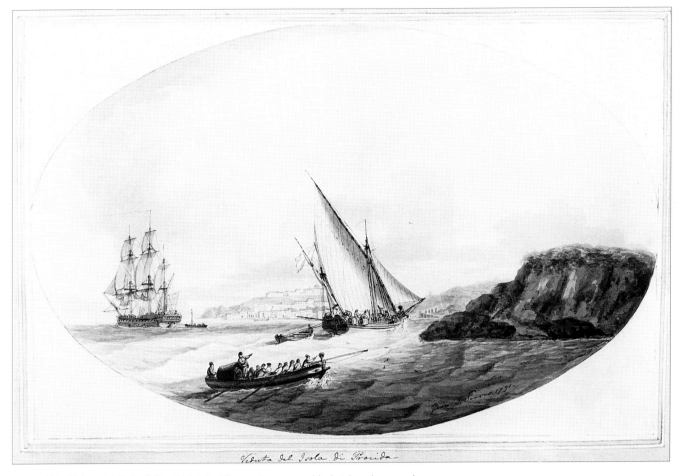

Veduta del Isola di Procida

PLATE 113. 'Veduta del Isola di Procida', John Thomas Serres, pen, black ink and watercolour on wove paper, signed and dated 1791, 11 x 17 ins. (27.5 x 43 cm). One of a number of surviving drawings made by John Thomas during his Italian tour. National Maritime Museum, London

with the ménage-a-trois which included Nelson, only there to become embarrassed by it. In 1805 she became a companion to Queen Charlotte and remained at Court until 1814, when its vagaries obliged her to leave and live again on the Continent. She was an erudite scholar and wrote several academic volumes as well as keeping an informative diary.

Charles Gore (1729–1807) was sufficiently affluent to be able to paint as an amateur and did not exhibit. For the sake of his wife's health, he spent the years 1773 to 1781 with her in Italy, Corsica and France and, after a period in England, visited Florence again before settling finally at the court of the Duke of Weimar. George Vandeput had been promoted Post Captain in 1765 and was the friend of the marine painter Robert Clevely, making him his clerk.[6] He was to be promoted Rear-Admiral in 1791, the year after John Thomas's letter. No other references have been found to these friendships with Dominic Serres and his family, but they would have been acquaintances from the artistic and naval circles in which the painter moved.

On arrival at Leghorn, John Thomas presented the letter of introduction he had been given by Sir Joshua Reynolds to John Udny, the British Consul there. John Udny (1727–1800) was Consul in Venice from 1761 until 1776 when he moved to Leghorn and remained there for twenty years. In Venice he had been the junior partner of Consul Joseph Smith (1682–1770), the renowned agent for British royalty and aristocracy in the acquisition of works of art, living in his house and sharing his interests and activities as a collector of and dealer in art. Smith nominated him as his successor as Consul in 1761. Robert Udny, his brother, assembled a collection of old master works in London. John

6. Farington's diary, quoted in D. Joel, *Charles Brooking*, Woodbridge, 2000, p.79.

travelled with George Romney (1734–1802) in Italy in 1775 and with Allan Ramsay (1713–84) in 1783. Appointed acting Chargé d'Affaires in Florence in 1787, Udny took over from Horatio, the nephew of Horace Mann, Horace Walpole's frequent correspondent, and handed over a year later to Lord Hervey. This introduction to Udny was obviously of the greatest value to John Thomas in enabling him to meet influential people and enjoy a tour which was beneficial artistically as well as agreeable socially.

From Leghorn he went on to Pisa, Florence and Rome, where he spent the winter months. It was from here that he sent his submissions to the 1791 Royal Academy exhibition: 'Moonlight' (no. 10) and 'Sun rising with a fog on the water' (no. 110). In February 1791 he dined with John Flaxman (1755–1826), the sculptor, and his wife, who were resident in Rome from 1787 until 1794. Flaxman had, in 1790, received the commission for 'The Fury of Athamas', now at Ickworth, and wrote to Sir William Hamilton: 'I shall be detained here three years longer by the noble patronage of Lord Bristol, who . . . has reanimated the fainting body of Art in Rome'.[7]

During March and April 1791 John Thomas was based in Naples, surviving drawings of Vesuvius, Capri, Ischia and Procida being dated in those months, of which Plate 113 is an example. He returned to Rome in May and took his final leave of the Flaxmans on 15 May, drawing Civitta Castellana and Terni on the following days.[8] It was probably on his way home that he drew the ferry crossing on the Arno, dated 1791 without month, signing it with the Italianate form of his name, Giovanni Serres, which he adopted, or affected, during his tour, and used from time to time afterwards (Plate 114). Ten of the twelve works accepted by the Royal Academy from John Thomas, as an Honorary Exhibitor, for the two exhibitions after his return, 1792 and 1793, were of Italian subjects, derived from his travels. The other two were retrospectives of the battle of The Saintes in 1782.

John Thomas's tour had been planned to last three years, but in spite of the fine opportunities which it had already opened for him, he cut it short and returned hurriedly to England. The reason was that in the weeks immediately before his departure he had fallen desperately in love and the lady was importuning him to return. Her name was Olivia Wilmot, the daughter of Robert Wilmot, a decorative and mural painter employed by the Earl of Warwick, whom Dominic Serres had probably met in the course of his visits to Warwick at the Earl's invitation. The Wilmots were distant relatives of the Earl, while Robert's brother, Dr. James Wilmot, Fellow of Trinity College, Oxford, and Rector of Barton-on-the-Heath, Warwickshire, was reputed to enjoy the close friendship of senior members of government. As a result of a falling-out between the brothers, apparently connected with an election, Robert moved to London, 'applied to the elder Serres for assistance and ultimately, by his endeavours, was established in trade at Paddington'.[9] Once settled, he brought his daughter to live with him. Welcomed by the Serres family, where she started taking painting lessons, it was not long before she met John Thomas. It is said that this was only three weeks before he was due to leave on his continental tour. They fell helplessly in love and, in spite of parental disapproval on the part of Dominic and Mary, a secret engagement to marriage was probably agreed between them. The love-lorn John Thomas left as planned, while Olivia eagerly urged him to return as soon as possible. She was equally quickly making her mark in London after his departure, for a small drawing of her by Sir Joshua Reynolds, signed and dated October 1790, was preserved by her family.

John Thomas did not delay his journey from Rome and was back in England in time for his marriage to Olivia, conducted by her uncle, at Barton-on-the-Heath on 1 September 1791. Olivia had been born in 1772 and, as she was therefore under age on the date of her

7. National Trust Ickworth Catalogue, 1988.
8. Brinsley Ford, J. Ingamells, ed., *A Dictionary of British and Irish Travellers in Italy 1701–1800*, New Haven, 1997.
9. *Memoir of John Thomas Serres by a Friend*, 1826, p.11.

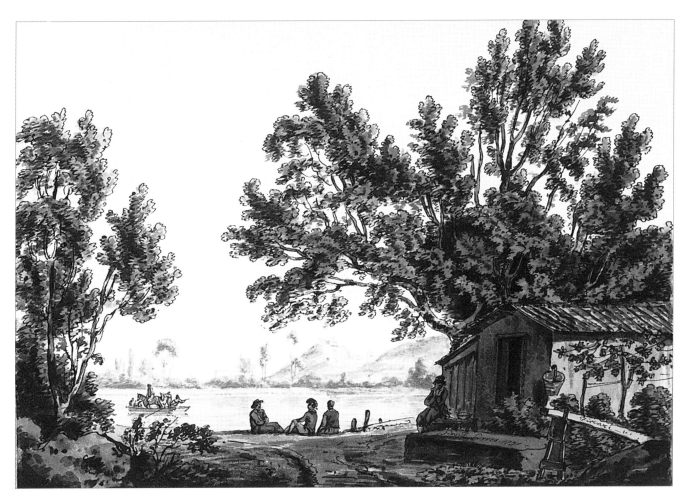

PLATE 114. 'The ferry over the Arno above Florence', John Thomas Serres, ink and watercolour on paper, signed and dated 1791, 10 x 13 ins. (25 x 33 cm). Probably painted on John Thomas's way home, after he had decided to cut short his tour and return to marry Olivia Wilmot. ©The British Museum

wedding, a special licence was necessary, which, in turn, required an affidavit signed by Robert that he was her true and lawful father. On returning from the church, the Reverend Wilmot, who had been Olivia's guardian, warned the bridegroom: 'Serres, she is now your wife; but mind me – keep her employed, or she will be plotting mischief'.[10] Her mischief was to be the downfall of John Thomas and, in later years, to bring her a life of obloquy and ridicule when she made the pretentious claim to royal blood as the legitimate daughter of the Duke of Cumberland. After the wedding they moved to 32 Upper Seymour Street, Portman Square, in London, and for the first year all was happiness. The first child, John Dominick South, was baptised at the family church, St. Marylebone, on 22 December 1792, to be followed, a year later, by the second, Mary Estr.(?ella) Olivia, at the same church on 13 December 1793. But acrimony came between the parents as Olivia became jealous and possessive, accusing John Thomas of infidelity, while she ran up debts in his name. They were to produce, apparently, six more children, but, of the eight, only two survived infancy. Lavinia was baptised on 31 August 1797 in the parochial chapel of St. Nicholas, Liverpool, where her parents were then living, and Britannia, born on 2 December 1802, whose baptism at 2 Berners Street, London, on the evening of 20 January 1803 was entered in the registers of St. Marylebone church. In the latter year John Thomas succeeded in obtaining a separation from Olivia, but she continued to aggravate him, endanger his finances and blight his chances of royal preferment for the rest of his life.

10. Ibid., p.12.

CHAPTER XIII

A PAINTING EXHIBITED;
LIBRARIAN OF THE ROYAL ACADEMY;
LAST MONTHS 1791-1793

The excitement generated in London by the destruction of the floating batteries at Gibraltar in September 1782 (see page 151) extended to the City of London and, in February 1783, the Court of Common Council decided to honour the heroes of the four-year siege and the last relief expedition. It was resolved that 'an historical Painting will be the most suitable mode for the Council to express its respect to the Gallant conduct of General Elliot, Governor of Gibraltar, Lord Viscount Howe, Commander of the Fleet, and the rest of his Majesty's Officers, Soldiers and Sailors employed in its defence and relief'.[1] The Council sought proposals from the two leading 'modern history' painters of the day, Benjamin West R.A., court favourite and later the Academy's second President, who had originated the genre with his 'The Death of General Wolfe' in 1771, and John Singleton Copley R.A. (1738–1815), who had already established himself as a painter of large pictures of dramatic events with his 'Death of Chatham' (National Portrait Gallery, London). Copley secured the commission by saying that he had already started work on the subject and that both land defence and naval relief could be combined in one canvas, whereas West said it would take two. Copley, further, offered to paint it for the low price of one thousand guineas, in consideration of the honour of the commission and 'hoping the advantage of an Exhibition of the Picture and publication of a Print from it will compensate him for the time and study requisite for completing so large a work'. He also promised to have it ready in two years.

Copley was now at the pinnacle of his career. The exhibition of 'The Death of Major Pierson' (1783, Tate Britain, London) followed soon after the commission and he shortly received Royal patronage for his portraits 'The Daughters of George III'. His efforts were thus dissipated and the difficulties of his mammoth undertaking with 'The Siege and Relief of Gibraltar' soon began to manifest themselves. The problems presented by the composition on one canvas were numerous. The Rock and its defenders had to be shown, with exact portraits of the leaders, including the Hanoverians (for which purpose Copley was to visit Hanover), together with the brave attack on and burning of the floating batteries and the arrival of Lord Howe's relieving fleet. All the components were, naturally, expected to meet the requirements of eye-witnesses for historical truth as well as histrionic effect. The composition which Copley finally evolved bore considerable similarities to that adopted by George Carter, who had visited Gibraltar for the purpose, in a painting completed in 1785 (National Army Museum, London). The demands of a dramatic representation of a climactic moment of the siege, the destruction of the floating batteries, made it increasingly difficult to incorporate the arrival of Howe's fleet, a month later, congruously into the composition. It was not until July 1787 that Copley admitted the impracticality of covering both events in the one canvas and went for a compromise. The relief by the fleet would be painted as a long, low panorama and placed as a predella, or pendant, below the main painting, with portrait medallions, by Copley, of Admiral

1. The sources for this episode are: J.D. Prown, *John Singleton Copley*, 2 vols, Vol. 2 *In England 1774–1815*, Cambridge, 1966; E.D. Neff, *John Singleton Copley in England*, 1995; V. Knight, Curator, Guildhall Art Gallery in litt.

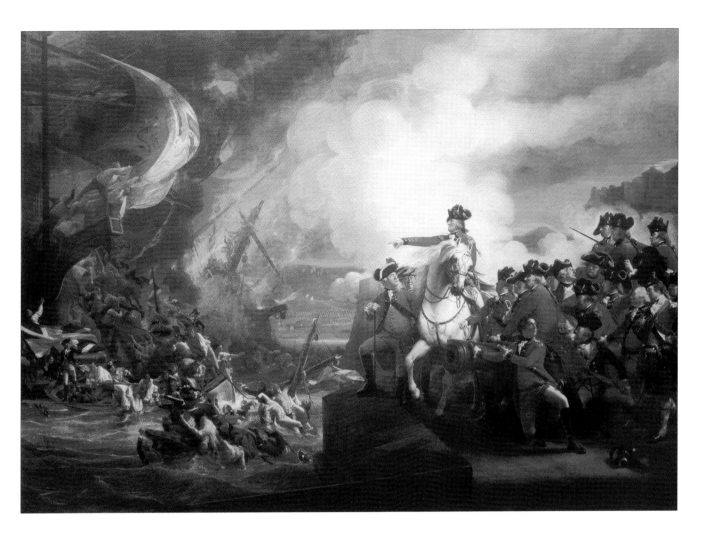

Howe and Admiral Samuel Barrington, his second-in-command, flanking it at each end.

It must be admitted that there was a certain logic in portraying Howe's fleet, which totalled 180 vessels, strung out across the water, in a long, low format. Copley was essentially a portrait painter and his commission was primarily to honour the leaders, so the introduction of the medallions was an understandable, if cumbersome, solution. It could also be argued that the separation of the naval relief was historically justified since, although the supplies brought by the fleet were vitally necessary, the military threat to the garrison had been effectively defeated by the heroic resistance of the defenders, who destroyed the floating batteries with red-hot shot and dashing commando attacks.

Dominic Serres had, as previously discussed (page 152), produced his own version immediately after the events of September 1782. As a fellow-Academician and the leading marine painter of the time, he was therefore Copley's logical choice to paint the predella. A press report in March 1788 refers to it as if it was by then already completed. It was not, however, a subject or format which offered Serres much scope for inventiveness. The space available was probably about 20 inches (50 centimetres) in height and 16½ feet (5 metres) in width. The unchallenged procession of men-of-war and transports with Gibraltar in the distance was probably the best which could be achieved: a massive demonstration of naval might but not visually as exciting as the explosive action taking place in the canvas above it.

As time passed, the paintings were not delivered and Copley's shortage of funds became more acute, his relations with the Court of Common Council became increasingly acrimonious. But finally, by the spring of 1791, the paintings were ready, eight years after Copley had received the commission (Colour Plate 69). Ten years earlier Copley had

COLOUR PLATE 69. 'The destruction of the floating batteries at Gibraltar, September 1782', John Singleton Copley, oil on canvas 216 x 300 ins. (545 x 763 cm). Copley obtained the commission for this work from the Corporation of the City of London by promising to incorporate this action with the arrival of Lord Howe's relieving fleet in one canvas. Finding this impracticable, he employed Serres to paint the naval episode as a long, low predella to fit beneath his enormous canvas (Plate 116).

Guildhall Art Gallery,
Corporation of London

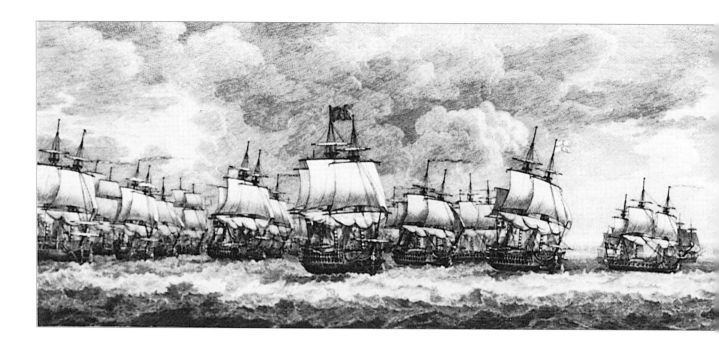

exploited the commercial possibilities of exhibiting his great paintings individually and charging the public for admission, as a means of promoting the picture and sales of the print made after it and, more immediately, of raising funds. In 1781 he had rented a room in the old Royal Academy building in Pall Mall, the Academy having moved the previous year to its new premises in the rebuilt Somerset House, in order to display his 'Death of Lord Chatham'. Exhibiting paintings in this way was not new. Hogarth had displayed his 'Rake's Progress' and 'Marriage à la Mode' in his studio, but had not charged for entry. Entrance to the Royal Academy exhibitions at this time cost one shilling. For 'The Destruction of the Floating Batteries' Copley procured a 'magnificent Oriental tent', 84 feet long, large enough to accommodate the painting, which was set up in Green Park, near Arlington Street. But the Duke of Bolton and other residents objected and it was moved several times. Finally, the King, who had seen the picture, told Copley to 'push it up nearer my wife's house [Buckingham House, now Palace] – she won't complain' and the problem was solved.

PLATE 115. Admission ticket to the exhibition of Copley's 'Siege and Relief of Gibraltar' in a tent in Green Park, June 1791, engraved by Francesco Bartolozzi. Serres's predella to the great scene is scarcely visible.

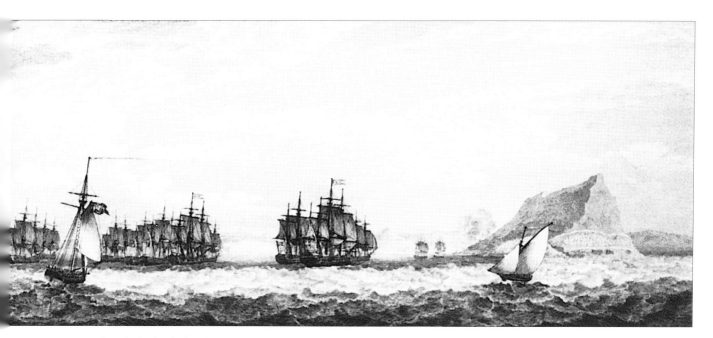

PLATE 116. 'The relief of Gibraltar by Lord Howe's fleet, October 1782', engraving by R. Pollard after D. Serres, published in 1810, 7 x 35 ins. (18 x 88 cm). Serres's painting did not survive and this engraving, published long after the events depicted and the original paintings, is the only record of his work. The format clearly gave Serres little scope for an imaginative handling of the subject matter.

National Maritime Museum, London

Copley later told a friend that sixty thousand people visited the tent, each paying one shilling entry fee. The £3,000 income must have come as a welcome relief for the painter.

The exhibition opened on 8 June 1791. For admission, the engraver Francesco Bartolozzi, R.A. (1727–1815) produced a ticket which depicted the scene inside the tent (Plate 115). The predella painted by Serres is scarcely visible and received little recognition. Critical comment on Copley's great painting was mildly enthusiastic, and the reviewer in the *Morning Chronicle* of 23 June noted, without mentioning Serres by name, that the predella 'is equal to Brooking, and much in his manner'.

As the visitors entered the tent they were given a copy of the *Proposals for Publishing by Subscription, an Engraving, from the Historical Picture, of the Siege and Relief of Gibraltar . . .*, which also served as a catalogue, describing the action and identifying the participants portrayed. Those who subscribed at that time were to need even more patience than the Court of Common Council, for the engravings, published by Copley himself, did not appear until 1810. Serres's painting of the Relief, which, after the closure of the tent, had been further exhibited at the Royal Academy in 1792 (no. 126), was engraved by Robert Pollard (Plate 116). William Sharp engraved Copley's main picture of the Siege and the portrait medallions. After so many years and intervening historic events, public interest in the subject had virtually evaporated, and the engravings were a financial failure, many of the original subscribers not paying the remaining balance to obtain them. One can only hope that Serres was paid promptly for his work in 1788. The engraved print is now the only record of the painting of the Relief. When the paintings came to be hung in the Council offices, the wall was not large enough to accommodate both paintings and the custom-made frame had to be cut down, to the exclusion of Serres's predella. It appears never to have been hung, even alone, and was recorded in 1829 as 'Spoilt', after which it is assumed to have been thrown out. Copley's 'Siege' is now given a place of honour in the new Guildhall Art Gallery, opened in 1999. The flanking portrait medallions also had chequered histories. That of Lord Howe is in the National Maritime Museum, London, but the location of the Samuel Barrington is unknown.

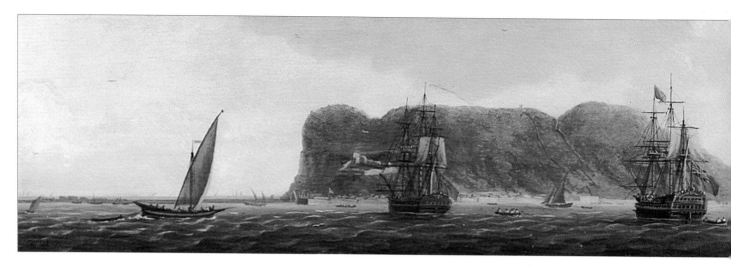

Librarian of the Royal Academy

Knowledge of Olivia Serres's unstable nature and the growing discord between her and John Thomas must have darkened the closing months of Dominic's life, but otherwise life went on largely unchanged for the elderly artist, one of the senior Academicians. On 1 November 1785 he and his fellow-Academicians had been entertained at the Mansion House by the Lord Mayor of London. John Boydell was present as an Alderman and, although it was not his term as Lord Mayor, he probably had a hand in organising the event. Serres was again on the Council of the Royal Academy in 1790 and on the Hanging Committee, in which role he was among the recipients of the following advice from a press commentator on 8 April 1790:

> Among the hangmen for this year are Mr. P. Sandby, Mr. Serres, Mr. Hamilton and Mr. Russel; – and this advice we will be so free to give – Not to hang the walls with *too many* works from the pencil of ONE artist, to the exclusion of the pictures of ANOTHER who has more moderation![2]

The constantly-recurring argument about the number of pictures hung and competition for the best location on the heavily cluttered walls, was exemplified in a contemporary print of the 1787 exhibition at Somerset House. Only one marine painting is visible, high on the right-hand wall (Plate 117).

The painting in Colour Plate 70, signed and dated 1791, has traditionally been regarded as a commission to Serres by the Duke of Clarence. Painted on panel, it appears to be another example of a frieze for a chimney piece. The Duke, whose romance with Mrs. Jordan began at this time, had just bought Clarence Lodge at Petersham and was also having his apartments at St. James's Palace redesigned and decorated by John Soane, so it is entirely possible that he ordered from Serres a marine decoration which reminded him of his naval service.[3]

Serres's only exhibit at the Royal Academy in 1791 was a painting entitled 'Hebe frigate, belonging to Mr. Fitzgerald, with a view of Spithead' (no. 34). It appears that Mr. Fitzgerald owned the *Hebe* and had equipped her as a privateer frigate for his own account, perhaps later commissioning a picture of her from the marine painter.

Edwards's biographical account of Dominic Serres in his *Anecdotes of Painters* notes:

> In January 1792, he was appointed librarian to the Royal Academy in the place of Mr. Wilton, who resigned that post upon being appointed keeper. In this situation, it must be allowed, he was better qualified than some others who have enjoyed it, for he was a tolerable Latin scholar, spoke the Italian language perfectly, understood the Spanish, and possessed something of the Portuguese; add to this, that few foreigners were better masters of the English language; but, what is still more to his praise, he was a very honest and inoffensive man, though in his manners, 'un peu Gascon'.

2. National Art Library Press Cuttings, p.554.
3. C. Tomalin, *Mrs. Jordan's Profession*, 1994, p.114.

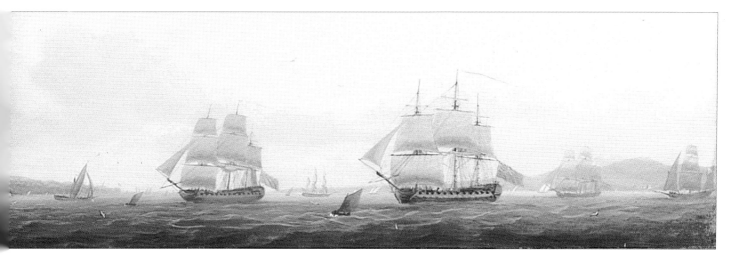

COLOUR PLATE 70. 'The Leander, 52-gun 2-decker, with other shipping off Gibraltar', oil on panel, signed and dated 1791, 9 x 57 ins. (22 x 144 cm). In 1790 Serres exhibited two works at the Royal Academy described as 'a frieze for a chimney'. The dimensions and material of this picture suggest that it was for a similar purpose. Traditionally regarded as a commission by the Duke of Clarence, it may have been used by John Soane in the redecoration of the Prince's apartments he was undertaking at this time. Galerie Lingenauber, Düsseldorf

This catalogue of Serres's linguistic talents, if taken literally, seems to confirm that he spent considerable time in Italy or on Italian ships, probably at an early stage of his maritime career, but, as he only 'understood the Spanish', perhaps less time in Havana and Spanish ships. Portuguese has some similarities with Spanish, but may also indicate some time spent in Portugal, its colonies or aboard its vessels. Some accounts of Serres's life in London state that he was employed as an interpreter by certain foreign embassies. If this was so, it is likely to have been on an informal, *ad hoc* basis by embassies where he was known and with whose language he was familiar.

Edwards's disparaging reference to the qualifications of previous Librarians of the Academy probably reflected the custom of using the appointment to assist older and impecunious Academicians. Francis Hayman (1708–76) was the first Librarian, appointed by the King, in

PLATE 117. 'The Exhibition of the Royal Academy, 1787', engraving by P.A. Martini after J.H. Ramberg. Serres was on the Hanging Committee of the Academy in 1790. The illustration makes clear why there was so much argument about the number of pictures by each artist to be hung and the competition for the best locations. One marine painting is visible, high on the right-hand wall!

©Royal Academy of Arts, London

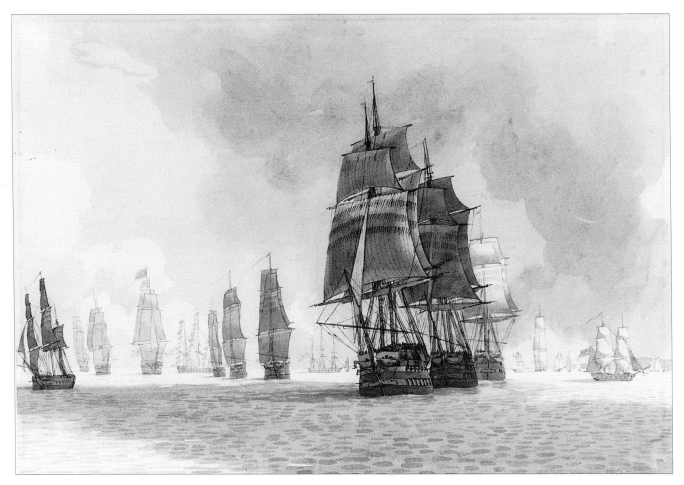

PLATE 118. 'The Royal review of the Fleet, Spithead, May 1778', ink and watercolour. This may have been a preliminary drawing for an oil painting of similar title hung at the Academy in 1793. It has the Serres hallmarks of a retiring sightline to the centre of interest, the royal yacht, in the left background, caught in the streaming sunlight. National Maritime Museum, London.

1770. The salary of £50 per annum provided relief to the artist in the poverty of his final years. Richard Wilson, who succeeded Hayman, was similarly supported by the salary until his death in 1782, for '. . . the appointment happily rescued him from utter starvation'.[4] Samuel Wale filled the post until his death in 1786. Wale, an engraver and architectural draughtsman, was also Professor of Perspective, and in this role he was succeeded on his death, as previously noted, by Edward Edwards. Joseph Wilton (1722–1803), the sculptor, was Librarian until 1790, when a short interregnum ensued before Serres's nomination early in 1792. After his death, Edward Burch (d.c.1840), miniaturist and sculptor, occupied the position until 1814. It is difficult to believe that Serres was short of funds at this time, even though he may not have been in the best of health. After the early years, the Academy seems to have adopted the practice of appointing Librarians from among senior Academicians with suitable qualifications, rather than, or perhaps in the absence of, deserving cases of penury. For Serres it was an honour he would undoubtedly have appreciated as a recognition of his talents, artistic as well as linguistic, and of his long years of membership.

1793: Last Academy exhibition

Seven works were exhibited by Serres at the annual Royal Academy exhibition in 1793. Several have already been mentioned as possible versions of earlier successful paintings, such as 'Foudroyant, commanded by Sir John Jervis, bringing the Pégase, a French 74, into Portsmouth'

4. W. Sandby, *A History of the Royal Academy*, 2 vols., 1862, Vol. I, p.108.

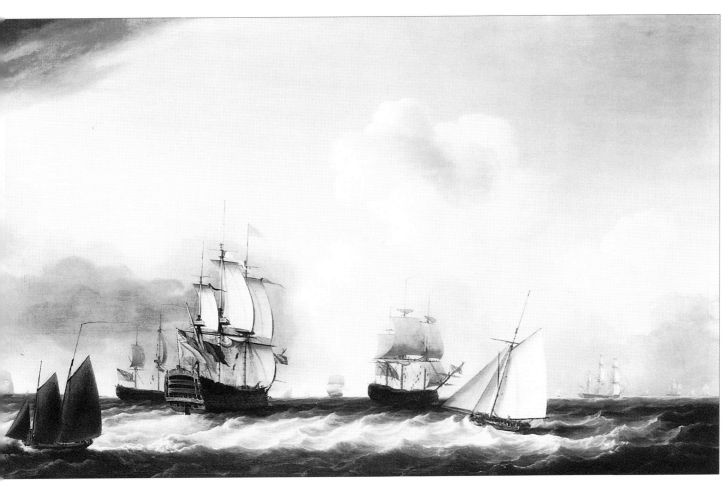

PLATE 119. 'H.M.S. St. George with other vessels', oil on canvas, signed and dated 1787, 53 x 85 ins. (134.5 x 216). King George III had visited the *St. George* at Portsmouth while under construction and this may have been why Serres painted her when in service. It is a finely executed marine painting in classic style, even to the detail of the men on the top-mastheads and yardarms. National Maritime Museum, London.

(no. 126) (Colour Plate 61). Two others were of merchant ships, two were seascapes: 'A lively breeze' (no. 50) and 'A pleasing gale' (no. 132) and one a coastal view at Plymouth.

The seventh was 'Their Majesties in the Augusta yacht, sailing through the fleet at Spithead in May 1778' (no. 147). This has not been traced, but Plate 118 may have been a preliminary sketch for it. It is a carefully structured composition with three powerful men-of-war in the foreground, sailing sedately towards the viewer, while others frame the retiring sightline to the centre of interest, the royal yacht in the left background. The cloud effects and the sunlight streaming across the background to illuminate *Augusta* are characteristic Serres hallmarks and sustain a vivid portrayal of the scene. The week-long Royal visit to the fleet followed a similar pattern to that five years earlier, and the incident depicted is probably when, on 8 May, the King and Queen sailed in the royal yacht through the fleet to St. Helen's and then anchored. The Commander-in-Chief, Admiral Keppel, was soon afterwards to lead his fleet into the Channel and the inconclusive Battle of Ushant. As the date of the original painting is unknown, the picture exhibited could either have been an earlier work, submitted this year in the absence of other fresh works, or another version newly produced. In either case, its display could well have been an acknowledgement and celebration by the ailing artist of the royal patronage he had received.

While he was with the fleet, the King on 5 May 1778 visited Portsmouth Dockyard and 'went into the St. George, of 90 guns, whose frame is nearly completed . . .'[5] The *Saint*

5. Annual Register 1778, Appendix to Chronicle, p.234.

George was launched seven years later, in 1785, and, perhaps because of the interest sustained by the royal visit during her construction, Serres in 1787 produced a major painting of her in classic style (Plate 119).

In a similarly commemorative, possibly even valedictory, sense were two important works, signed and dated 1793. 'Rodney's fleet taking in prizes after the Moonlight Battle, 16 January 1780' (Colour Plate 58) illustrates the phase between Serres's two other paintings of this operation, the battle itself (Colour Plate 57) and the victorious fleet anchored at Gibraltar (Colour Plate 59), as the procession makes its way towards the Rock. Rodney had died in May 1792 and this may have been intended as a posthumous tribute to the memory of a great naval commander who had entrusted the artist with major commissions. The second painting was immediately topical being entitled 'Vice-Admiral Sir Samuel Hood (Admiral of the Red) in his flagship Victory, with the British fleet at Gibraltar, early summer of 1793' (Colour Plate 71). It hung for many years in the Dolphin Hotel, Southampton, until sold at auction by the proprietors in 1968, and again passed through the London art market in 2000. At the outset of the war with revolutionary France in 1793, the French had a powerful fleet of thirty-one ships-of-the-line and twenty-seven frigates and corvettes in Toulon. The British navy's first task was therefore to contain the enemy in its harbour or at least prevent its escape from the Mediterranean. Various squadrons were dispatched to Gibraltar and, finally, a force under Lord Hood which arrived in July 1793, bringing the total strength to twenty-two ships-of-the-line and seventeen frigates. The fleet left shortly afterwards and succeeded in occupying Toulon, where the defenders were divided between royalist and revolutionary loyalties. The painting of the fleet approaching Gibraltar, reminiscent of other depictions of similar scenes by Serres, must have been produced promptly after the event. Painted to honour the achievement of Admiral Hood, probably another earlier patron, it is unlikely to have been commissioned by him, as he was fully occupied in the Mediterranean until after the death of Dominic Serres in November.

A final portrait

On 11 March 1793 George Dance, R.A. (1741–1825) made a portrait drawing of Dominic Serres, one of a series of Royal Academicians he completed over several years (Plate 120). They were subsequently engraved by William Daniell, R.A. (1769–1837) who published them between 1809 and 1814. Although a full profile, the portrait again shows Serres as a sensitive and distinguished personality not, apparently, greatly worn by the ravages of time, except for the mole or growth on his left temple. This had not been evident in earlier portraits, but the sitter's position may have then obscured it. The assumption from the March date of the portrait, as well as the dated paintings by Serres already discussed, must be that he was in reasonably good health until the summer, when the terminal cancer set in.

Dominic will have been encouraged in October 1793 when John Thomas was among the candidates for the election of two Associates at the Royal Academy. Twenty-four names were on the list, nineteen painters, including Thomas Whitcombe (c.1752–1824), a marine painter, one sculptor and four architects, but by that stage Dominic was probably not well enough to canvass on behalf of his son. He did not live long enough to learn the result, declared on 4 November, that William Beechey and John Hoppner (1758–1810) were elected to the vacant places.

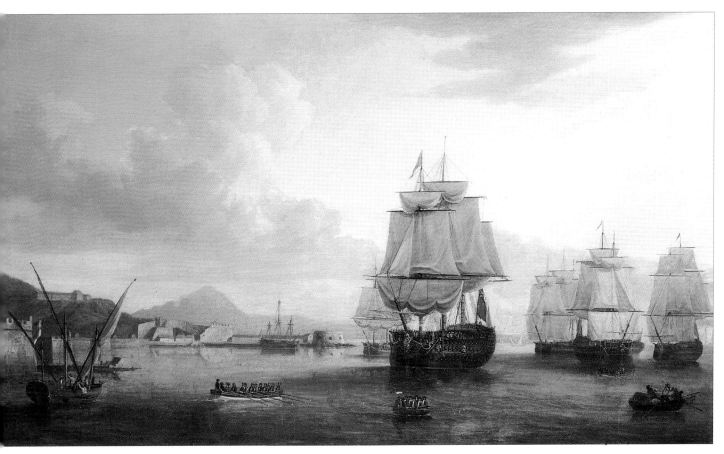

COLOUR PLATE 71. 'Vice-Admiral Sir Samuel Hood (Admiral of the Red) in his flagship Victory, with the British fleet at Gibraltar, early summer of 1793', oil on canvas, signed and dated 1793, 35½ x 57½ ins. (90 x 146 cm). Hood was sent with reinforcements to contain the French fleet in the Mediterranean at the outset of the war with France, after the Revolution had begun in 1789. It was one of the last paintings by the artist.

Photograph courtesy of Daniel Hunt Fine Art, London

The final paragraph of Edwards's 'Anecdote' on Dominic Serres reads:

> He died at his house in St. George's Row, near Oxford Turnpike, where he had resided several years, November the 3rd., 1793, and was buried at [St. Mary's Church] Paddington. He left a widow, two sons, and four daughters; the eldest, who pursues the profession of his father, visited Italy in 1790, and is now settled in London; the youngest teaches drawing.

Joseph Farington noted in his diary on 4 November 1793 that, at the Royal Academy, 'The death of Mr. Serres was declared by the President. He died this morning, after a very painful illness occasioned by a cancerous complaint in his neck . . .' A press report on 6 November stated:

> The late Mr. Serres had been long ill, of a complaint in the throat, which it was known must be fatal to him, his difficulty of receiving sustenance having slowly, but irresistably increased, for several months. He had, besides his appointment of Marine Painter to the King, a place in the Lord Chamberlain's Office. . . .[6]

No other reference to the latter appointment has been found. The obituary in the November number of the *Gentleman's Magazine* was convoluted and scarcely generous:

> He was one of the forty artists who first established the academy; a man, in private life, benevolent and inoffensive; and, as a painter, if not one of the most eminent abilities, superior to what could have been well expected in the weakness of that neglected art he contributed in a great measure to revive.[7]

6. National Art Library Press Cuttings, p.645.
7. ibid., p.1058.

The sentiment expressed in this last sentence seems to epitomise the attitude of contemporaries towards marine painting, that it was an underprivileged sector of the visual arts. The great hierarchy of painting, established by Sir Joshua Reynolds in his 'Discourses' to the Academy, placed history painting, and, by extension, modern history painting, at the head of the list. Portrait painting, in which this period produced some of the greatest exponents and works in the whole of English art, ranked very highly in public taste and demand among the eminent and affluent. Landscape, in which Serres had begun his professional career, was the least regarded of Reynolds's eclectic categories, although clearly popular with some sections of the public. Marine painting, broadly grouped with landscape, received scarcely a mention by Reynolds. Yet, it too, had a popular following, through the medium of prints, in addition to the limited number of senior naval patrons. Marine painting was also clearly set in a largely conventional and stylistic mould, inherited from the van de Veldes, whether the subject matter was coastal, 'pure' sea or naval engagements. It was during the decade after Serres's death that Turner and de Loutherbourg were to revolutionise the genre by introducing a Romantic vision and interpretation of the forces of the sea, the drama of naval warfare and the part the individual played in them.

Although Dominic Serres did not succeed in breaking out of the mould of his century, his paintings display a feeling for sea, coast and sky, with their inevitable content of shipping, interpreted with a unifying sense of light and space. The shipping had, by definition of the demand, to be accurately delineated, but it was never over-detailed, to the detriment of a balanced composition and the total artistic impact. His evident preference for the peaceful, almost pastoral scene, even when treating a belligerent theme, was similarly demonstrated by the restrained palette he employed. This brought to his depictions a painterly sensibility which avoided dullness on one hand, and the more strident visual effects on the other. The thinness of the paint layer on some of his paintings, which betrays a speed, sometimes haste, in working, is a reminder that he was, like most artists, driven by the economic necessities of earning enough, week by week, to support his family and give them the best opportunities in life. His character was customarily described as 'inoffensive', but elsewhere as 'boisterous', so the balanced judgement must be that, even though perhaps not a great 'mover and shaker', he was a worthy and warm-hearted personality who got on well with his fellows and earned their respect. The evidence suggests that he was, by virtue of these solid qualities, as well as his own experiences and linguistic ability, a leader in the expatriate community in London.

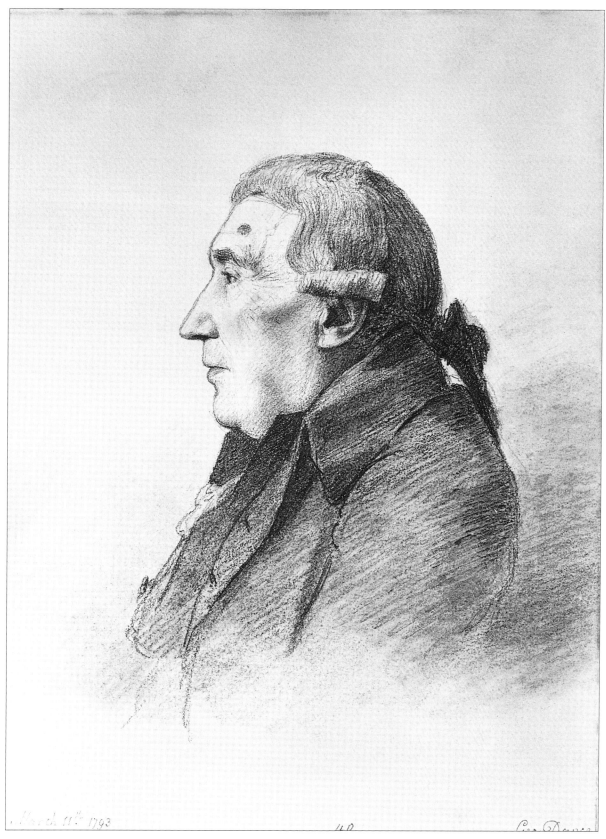

March 11th 1793 Geo Dance

PLATE 120. 'Dominic Serres, R.A.', George Dance, R.A., red chalk on paper, signed 'Geo. Dance' and inscribed 'March 11th. 1793'. In this final portrait, Dance shows the artist as still a sensitive and distinguished personality, little worn, apparently, by the ravages of time. The terminal cancer was to set in during the summer and Serres died in November.

©Royal Academy of Arts, London.

CHAPTER XIV

EPILOGUE

COLOUR PLATE 72. A view of the
Tamar near Plymouth by
Dominique Michael Serres,
pencil and watercolour on paper,
signed and dated 1796, 14½ x
21⅛ins. (37 x 55cm). Dominique
Michael lived in Bath and many
of his pleasant watercolours were
of rural scenes in the West
Country.

The first sale of the contents of Serres's studio was held in March 1794 at Christie's and has
been discussed as a review of the artist's tastes as a collector (see pages 130–131). Inevitably,
many of the works were studio material and unsold finished paintings, some with familiar titles.
The names of purchasers, preserved in an annotated copy of the sale catalogue in the possession
of the auctioneers, throw some light on continuing interest by friends and patrons and on the
part of dealers and print publishers, but are not particularly revealing. Names from naval and
social circles occur, such as Capt. Maude, Capt. Ommaney, Admiral Cornish, Sir H. Inglefield,
Reverend M. Keppel, Capt. Thompson, Mrs. Townley and Lord St. Helens. Surnames only are
usually noted, some perhaps indicating people who had figured in Serres's life and work or
who were to become familiar later: Clarke, Colnaghi, Wilmot, Knight, Anderson, Turner,
Boileau, Fouquiere, Heath, and Banks. Others, who bought a large number of lots, were
probably dealers or private collectors. The total value realised by the three days of the sale was
just over £1,000, before auctioneer's commission. A second sale a year later, on 18 April 1795,
of sixty lots, part of the 'Reserved Collection', brought in only about £94.[1]

John Thomas was appointed Marine Painter to the King very soon after his father's death,
being noted as such in the catalogue of the Royal Academy exhibition in the spring of 1794.
This nomination he added to the similar appointment bestowed on him by the Duke of Clarence
four years earlier. He was subsequently to be appointed Marine Draught-Man to the Honour-
able the Board of Admiralty, when he undertook an assignment to draw the coasts of France and
Spain, publishing afterwards *The Little Sea Torch*, an illustrated pilotage guide. John Thomas went
on to pursue a varied career as an artist, living at times in Liverpool and Edinburgh, publisher,
and, for a while, as a shareholder in the Royal Coburg Theatre, London (now the Old Vic) and
director of its scenic department when it opened in 1818. But he was dogged by misfortune,
much of it attributable to his wife, Olivia, and was bankrupt at least twice, dying within the rules
of the King's Bench debtors' prison on 28 December 1825. In the absence of other funds, the
Society of Arts, through the good offices of Sir William Beechey, gave £20 to cover the cost of
his funeral. He was buried with his parents at St. Mary's Church, Paddington.

1. Christie's Archives.

Olivia lived until 1834. Two, of the eight children Olivia reportedly bore to John Thomas, survived. The elder, Lavinia, stayed with her mother and supported her in her pretensions to royal birth. She married Anthony Thomas Ryves and continued to pursue her mother's claims throughout the rest of her life. Britannia, the younger daughter, aged one year when her parents separated in1803, was placed with one of her aunts, probably Sarah Serres. A pair of portrait miniatures by Sarah of Britannia and herself has recently passed through a London auction house. Britannia afterwards stayed with her father and later married a Mr. Thomas Brock.

Dominic's wife, Mary, found life difficult after his death, having still the care of her daughters. As early as 9 July 1796 the Minute book of the Royal Academy records: 'Proceeded to reading the several Recommendations, of Petitions for the Annual Donations which were resolved as follows: viz. Mrs. Serres. Widow of Dom. Serres RA . . . £26.5s.0d'.[2] Mary Serres, as the widow of an Academician, became eligible for an Academy pension in April 1801, on reaching the age of seventy: '8 April 1801 . . . Mesdames . . . Serres coming on the Pension Fund . . .'[3] A month later in the same year: 'The Two Misses Serres' applied for assistance and, on the Motion of Mr. Banks, were granted twenty pounds .[4] In June1813, '. . . the situation of Mrs.Serres and her daughters to be deserving the consideration and assistance of the Academy . . . in addition to her Pension a Donation of £24 to be paid . . .'[5] Further applications by the daughters and other descendants were met with charitable grants by the Academy from time to time in the ensuing decades.

Dominique Michael and Lucy, probably already with their infant son, had moved to Bath before his father's death. One may surmise that this was on the recommendation of Dominic senior, who may have seen, on his visit in 1788/9, an opportunity for a drawing master, for this was the occupation Dominique Michael took up there. An advertisement by Razzini, 20 Belvedere, appeared in the *Bath Chronicle* of 9 October 1793 proposing the publication of an aquatint print of 'A south-west view of Bath from Perrymead' by D.M. Serres at a price of one guinea. When the same journal on 13 November announced the death of Dominic, he was referred to as the father of D.M. Serres 'of this city'. Further evidence of Dominique Michael's stay in Bath is fragmentary. On 6 September 1798 a Sarah Palmer, writing to Ozias Humphry to seek advice on tuition for her daughter, says that 'Mr.Palmer, delighted with the landscapes of a Mr. Serres then at Bath, approved a wish that their daughter should learn and she attended for eight months . . .'[6] Joanna Serres's submission to the Royal Academy exhibition in 1798 was 'A view near Bath' (no. 533), which could suggest that she had been staying there with her brother. Dominique Michael appears to have suffered a mental breakdown and is stated to have turned to his brother for shelter and support. He was evidently still alive in 1816, but as yet no further details of the remainder of his life have been uncovered. He produced pleasing landscapes in watercolours, of which Colour Plate 72 is an example.

Information about the lives of the Serres daughters is at present equally scarce. It seems that they probably went on living at St. George's Row with their mother and all submitted pictures to the Royal Academy intermittently until about 1800, as Honorary Exhibitors. The eldest, 'Miss. H.', perhaps Catherine, reputedly painted by Gilbert Stuart in 1782, disappears from view in the early years of the new century. Two of the other three sisters, Augusta Charlotte and Sarah were, as previously noted, appointed Stationers to the Royal Academy in 1800, but little seems to have come of that commercial enterprise. Augusta Charlotte appealed again to the Academy in 1805 'imploring assistance in her present illness and Distress' and receiving twenty pounds.[7] She is believed to have died in about 1820. In November 1814 Johanna submitted to the Academy, in manuscript, *A Plan for Forming an Institution for the Instruction of Females in the Fine Arts* which went

2. Royal Academy Minute Books, c II 273.
3. ibid., c III 105.
4. ibid., c III 98.
5. ibid., c V 51.
6. Royal Academy Archives, HU 5/60.
7. Royal Academy Minute Books, c III 364.

on to set out a lengthy prospectus. The only subscriber listed at that stage was 'Admiral Savage, author of The Royal Naval Seminary'. Her purpose was evidently achieved by the endorsement: 'We hereby certify that Miss Johanna Serres is fully capable of instructing young ladies in the various branches of Art mentioned in the Paper. [signed] Benjn. West P.R.A., W. Beechey R.A., James Ward R.A., John Flaxman R.A., R.R. Reinagle R.A. Nov 23rd. 1814'.[8] If Joanna was able to assemble a more numerous list of subscribers, one may assume that the initiative went ahead and she became, like her brother, an art teacher. She died at the age of seventy-five in March 1833, when the Academy granted Sarah ten pounds towards the expenses of her sister's funeral.[9] Sarah herself died four years later, on 26 March 1837, aged eighty-one, and the Academy again gave ten pounds to her niece, Mrs. Brock, to defray her funeral expenses.[10]

In spite of adversity and the vagaries of the passing years, a happy family celebration took place in April 1816 when Mary reached her eighty-fifth birthday. John Thomas wrote an ode in honour of the occasion and very probably read it to the assembled party. The quality of the verse may leave something to be desired, but its very existence, and the sentiments it expresses, manifest an affectionate gratitude on the part of the children towards their mother and a close family relationship enduring since their father's lifetime.

> To Mrs. Serres on her Birthday. 8th April 1816:
> Awake my Muse, sleep not thy time away
> Thy aid I need, some grateful thoughts to say,
> In numbers pure, pray assist me to sing
> The blessings which, this Natal day does bring.
>
> A Parent I have, who still is alive
> Whose years! when number'd make Fourscore and five.
> Each Virtue attended, this Female thro' life
> A loving mother, and a faithful wife.
>
> Receive oh God! my heartfelt thanks sincere
> And grant her to live still many a year.
> And when extinguish'd, the vital spark shall be
> Then take her, I beseech thee! God to thee.
>
> Till that time arrives, we'll yearly rejoice
> When Relations!, shall all rally round
> Then merryment make, with music and voice,
> And there nought, but affection be found.
>
> That happy may pass, her remnant of life
> Dear Brother and Sisters, I prithee be kind
> Let's united be, and banish foul strife,
> With contention alike, to the wind.
>
> Here's love! health and life, to our Mother most dear,
> And also the same, to us every one
> Let Mirth! and good humour, now pass without fear,
> And finish this day, with pleasure and fun.[11]

But Mary was sadly only to join in one of the promised annual celebrations, that in April 1817. Her pension was renewed, at £50, by the Academy in July, but she did not live to enjoy it longer, dying in the following month, August 1817. She was buried at St. Mary's Church, Paddington, beside her husband.

8. Royal Academy Archives, Mis/SE1.
9. Royal Academy Minute Books, c VIII 25.
10. ibid., c VIII 37.
11. Royal Academy Archives.

Monument for Dominic Serres Esq.
late Painter to his Majesty.

A drawing and proposal made in a letter to the Editor of the *Town and Country Magazine* in August 1794, for a monument to Dominic Serres:

The late Dominic Serres, esquire, (late engraver to his majesty) both as a man and an artist, was entitled to the admiration of the public while living; and I think his virtues and talents deserve emblazoning, by erecting a monument to his memory, with an inscription that should enumerate his good works, to induce posterity to pursue those steps, which led him so gloriously to fame and honour: I have therefore transmitted to you, for your consideration, a sketch of a design which I think properly calculated for the purpose. Should you concur with me in opinion, you will cause an engraving to be executed from it, and with it decorate the next number of your Town and Country Magazine. In this you will at least oblige,

Your most obedient servant
A.B.

The monument was never realised.

INDEX

Page numbers of illustrations are shown in bold

Académie Française, 17, 118; Salon du Louvre, 118, 173
Achilles, 37, 85, **34**, **87**
Admiralty, 23, 70, 114, 119–120, 161; Arch, 68; Board of, 97, 216; Lord of, 45, 108, 119, 148, 150; Secretary, 97, 108, 150
Agropoli, 178,**179**
Alarm, 49–51, **50**
Albemarle, General George, 3rd. Earl of, 46, 49, 53, 62–63
Albion, 97, 99, **97, 99**
Alcide, 54, **54**
Alms, Captain James, 49–51, 166–167, 169, **50, 169**
Ambuscade,72, **73**
America, 27
Amsterdam, 145,187,198
Analysis of Beauty, 19
Analysis of Deformity, 19
Anecdotes of Painters, 12–14, 21
Anecdotes of Painting, 12–13
Angria,Tulagee, 88, 90, **89, 91**
Anson, Admiral George, Lord, 33, 64, 67, 97, 108, 122, 142
Antigua, 13, 133
Arbuthnot, Captain Marriot, 46, 52
Argenteira, 71, **72**
Arno, river, 202, **203**
Artists, in Dominic Serres's collection, 130–131; in John Thomas Serres's collection, 199–200
Artois, 145, **145**
Artois, Comte d', 116 and note, 117 and note
Atlantic Neptune, 108
Auch, 13–14, 189
Augusta, 29, 99–102, 211, **100–101, 210**
Aveline, François Antoine, 41–42

Bach, John Christian, 117
Backhuysen, Ludolf, 88, 93, 95, 105, 193, **90, 195**
Bahamas, 46, 50,
Baillie, Captain, 162, 187
Bampfylde, Coplestone Warre, 69, 185, 187–188
Banks,Thomas, 147, 185–186, 217
Barbados, 74, 133
Barfleur, 97, 99, 156, **98**
Barnard, Sir John, 162; John (Jacky), 162–163
Barrington, Admiral Hon. Samuel, 75, 77, 84–85, 97, 102, 133–136, 148, 205, 207, **75, 85–87, 97, 133–134**
Barrington, Hon. Shute, Lord Bishop of Durham, 85, 136
Bartolozzi, Francesco, 102, 130, 207, **206**
Barton-on-the Heath,Warks., 28, 202
Bath, 19, 76, 79, 96, 185–189, 217
Bath Chronicle, 186
Battery, New York, **107**
Battles: Copenhagen, 114; Dogger Bank, 113, 145, **119**; First of June, 153; Les Saintes, 76, 154–156, 165, 202, **154–155**; Moonlight, 139, 144, 212, **135**; Plassey, 89; Quiberon Bay, 34, 84–85, 92, 121, 124–125, 163, **33**; Ushant, 136, 144, 148, 161, 211

Beaumont, Sir George, 69
Beechey, Sir William, 147, 189, 212, 216, 218
Belanger, François-Joseph, 116 and note
Belleisle, 23, 34–35, 37–40, 42, 46, 74, 85, 121, 137, **35–38**
Bellisle, 52, **52**
Bellona (ex-*Bellone*), 84, **85**
Bellotto, Bernardo, 57
Benazech, Peter Paul, 26
Benoist, Antoine, 26, 38, **36**
Bentinck, Captain John, 188 and note
Bermuda, 144, **144**
Bienfaisant, 144–145
Black Bear, the, 19
Black-eyed Susan, 92, **93**
Bombay, 88, 150, 163, 168
Bonetta, 51, **50, 55**
Bonhomme Richard, 141
Boscawen, Admiral Hon. Edward, 23, 26–27, 34, 64, 71
Boscawen, Fanny, 71
Boswell, James, 151, 186
Bowles, Oldfield, 185, 187
Bowles,Thomas, 92
Bowood House,Wilts., 146
Boydell, John, 23, 35, 38, 44, 121, 146, 191, 208, **34–36**
Boydell, Josiah, 146
Boyne, 135, **134**
Brest, 26, 74, 172, **73**
Brett, Admiral Sir Peircy, 142–143
British Museum, London, 20, 110
Bristol, 106, 188
Bristol Channel, **103, 106**
Bristol, Earl of, 64, 70–76, 202
Britannia, 127
Brock, Mrs. (granddaughter), 148, 217–218
Brooke, Lord, 18, 28, 64
Brooking, Charles, 16–17, 20–21, 26, 121, 131, 141, 187, 207
Brooklyn Heights, N.Y., 108
Brownsea Island, Dorset, 104
Browne, Mary, see Caldecott, Mrs.
Brunswick, 153, **153**
Bryan, Bryant, art dealer, 159
Buckingham House, 103, 206
Burke,Thomas, 187 and note
Burnett, Captain Thomas, 52, **53**
Bury,Viscount, see Keppel, George
Byng, Admiral Hon. John, 26, 70–71
Byron, Admiral Hon. John, 112

Cadiz, 27, 138
Caldecott, Mary, see Serres, Mary
Caldecott, Mrs. (mother-in-law), 15
Calshot Castle, 78, 188, **79**
Cambridge, 52–53, **53**
Campbell, Captain James, 52–53, **53**
Canada, 156
Canada, National Archives of, 23
Canaletto, Antonio, 18–19, 28, 57, 122, 131
Candid Review, 136
Canot, Pierre Charles, 26, 35, 38, 47, 60–61, 75, 136, 187, **34–35, 37, 48–56, 74–75**
Cape of Good Hope, 33, 88

Cape Town, 95, 164
Cape Verde Islands, 163
Cardiff, 105
Carenage (Castries), St. Lucia, 75, 133, **75, 77, 133**
Carhampton, Earls of, 157
Caribbean, 46, 74,
Caroline, 170
Carter, George, 154, 204
Castle Ashby, Northants., 102
Castries, see Carenage
Castries, Mareschal, Marquis de, 171, note 177
Cato, 114
Caton, 160–161, **159**
Causse, 174, **175**
Centurion, 32–33, 97, 135, **134**
Ceylon, 163, 168
Chalgrin, Jean François Thérèse, 117 and note, 173
Chalon, Henry Bernard, 162
Chambers, Sir William, 20, 79, 96, 102, **94**
Chandernagore, 88–89, 96, **91**
Charles II, 180, 191, **180**
Charles Edward, Prince, 18, 142, 162, **143**
Charlotte, 107
Charlotte, Princess, later Queen, 20, 29–30, 201, **28–30**
Chelsea Maritime School, 126–127, 184
Chesapeake Bay, Del., 112, 154
Chesterfield, Lord, 156
Chimney friezes, 76, 162, 208, **209**
Christie, auctioneer, 47, 162
Clarence, Duke of, see William IV
Clark, John, 198, **198**
Cleopatra, 169
Clevely, John, senior, 64
Clevely, John, junior, 64
Clevely, Robert, 64, 181, 201
Clive, Robert, Lord, 88–89, **91**
Clue, Admiral de la, 27
Colldycutt, see Caldecott
Collier, Admiral Sir George, 115–116, **122**
Collier, Lady, 116, **122**
Collingwood, Captain Thomas, 52, **52**
Comte d'Artois, 145
Comte de St. Florentine, 85, **87**
Conflans, Admiral le Marquis de, 34, 124, 126, **33, 127**
Cook, Captain James, 23, 26, 131
Copley, John Singleton, 152, 191, 204–207, **205–207**
Coram, Captain Thomas, 17
Cornwallis, General Charles, 154
Cornwallis, Admiral Hon. William, 156
Cotes, Francis, 17
Countess of Scarborough, 141
Crawford, Colonel John, 38, **36**
Crease, J., 185–186
Criterion Theatre, 19
Cuba, 14, 46, 49, 115, 176
Culloden, 49, 83
Culloden, 142
Cumberland, 89, 127
Cumberland, Duchess of, 187–188
Cumberland, Henry Frederick, Duke of (after 1765), 18, 64, 81, 84, 95, 127, 157, 159, 188, 203

Cumberland, Princess Olive of, see Serres, Olivia
Cumberland, William Augustus, Duke of (until 1765), 18, 46, 64
Curtis, Admiral Sir Roger, Bart., 152
Cuyp, Aelbert, 159, **158**
Cygnet, 55, **55**

Danae, 104, **105**
Dance, George, 212, **215**
Dartmouth, N.S., 41, **40, 42–43**
David M., 116–118
Davies,Thomas, 150–151
Denmark, King of, 63, 79
Derby, 142, 162
Desforges, Pierre, 172 and note, 176
Devaynes, John, 185–186
Devaynes, William, 185–1866
Digby, Admiral Hon. Robert, 161
Dodd, Robert, 65
Dogger Bank, 113, **119**
Dordrecht, 159,**158**
Dorset, 183, **182**
Douai, Jesuit College, 13
Dover, 162, 181, 191, **181**
Downs, the, 92, 122, 181, **93**
Dragon, 37, 51–53, 74, **34, 51, 53, 74, 76**
Drake's Island, Plymouth, 79–80
Dublin, 99, **98, 100**
Duc de Chartres, 85, **85**
Duke of Cumberland, 96
Duncan, Admiral Adam,Viscount, 150
Dunk, Edward, Earl of Halifax, 90
Dunk, George Montague, 2nd Earl of Halifax, 44–45
Durnford, Elias, 60, **60, 62**
Du Teillay, 142, **143**
Dysart, Earl of, 104, **104, 105**

Earlom, Richard, 93
Earwig,The, 140, 144
East India Company, Honourable, 88, 90, 186
East Indies, 88, 163, 170; station, 88, 114, 163–170
Echo, 52, **52–53**
Edgar, 144
Edgcumbe, Admiral George, Lord Mount, 33.99, **98, 100**
Edwards, Edward, 186, 210; *Anecdotes of Painters*, 12–14, 21; entry on Dominic Serres, 13, 16, 19, 65, 68, 171, 174, 208–209, 213
Edy, John William, 181
Eidophusikon, 190
Eliott, General George Augustus, Lord Heathfield, 138, 151–153, 204–207, **205**
Elizabeth, 142, **143**
Elliott,William, 26, 38, 61, **36**
Elphinstone, Admiral Hon. George, Viscount Keith, 49, 146
Engravers, 21, 26, 34, 38, 40, 61, 64, 121, 131, 140, 160, 187, 193, 198
Engravings, 21, 86, 140, 146, 207
Esperance, 144, **144**
Essex, 37, **35**
Estaing, Admiral Comte de, 112, 133, 135, **133–134**

Exeter, 165
Exhibitions, see Royal Academy and
 Societies
Experiment, 82, **83**

Falstaff, Sir John, 136
Farington, Joseph, Diary entries, 13, 64,
 162, 213
Ferdinand IV, King of the Two Sicilies,
 178–179, **182**
Finisterre, Cape, 85, 138
Fittler, James, 160–161, **159**
Flaxman, John, 202, 218
Fleet Prison, 14
Fleet, Royal Review of, in 1773, 96–102,
 128, **97–101**, in 1778, 211–212, **210**
Flora, 143
Florence, 178, 201–202
Foote, Samuel, 19
Fortitude, 113
Forts: d'Arfic, Belleisle, 35, 37, **35**;
 Baccurnao, Cuba, 51; Choera, Cuba,
 52, **52**; Cojimer, Cuba, 51, **51**; Lee,
 New York, 108–109, **111**; Royal,
 Martinique, 74, 84, 133, 136, **78**; St.
 David, Madras, 88; St. Michael, Goree,
 33; Victoria, Bencote, 90; Washington,
 New York, 108–109, **111**
Foudroyant, 148–151, 158, 210, **149**
Fougeron, John, 26, 41–42, **43**
Foundling Hospital, 17, 20
Fourdrinier, P., **93**
Fox, 136–137, 176, **137**
France, 17, 21, 34, 46, 71, 112, 130, 138,
 161, 171, 184, 190; Ports of, 67, 84,
 172, **87**
Francis I, **86**
Free Society of Artists, see Societies
French Revolution, 116, 190, 212
Frigate Bay, St. Kitts, 161
Frigates, 110, 112, 168, **165**

Gainsborough, Thomas, 20, 104, 190
Gambier, Admiral James, 187
Gandon, James, 14, 129, 155, 171
Gardner, William, 150
Garrick, David, 19
Gascony, 13
Geary, Admiral Sir Francis Bart., 115
General Advertiser, 121
Genoa, 177–178, 200, **177**
Gentleman's Magazine, 65, 213
George II, 12, 14, 119, 130
George III, 20, 35, 46, 63, 79, 81, 86, 95,
 114, 128, 130, 157, 162, 186, 189, 194,
 204, 206, 211–212, **97–101, 195, 211**
George Island, Halifax, 42, **41**
George Washington Bridge, 108
Geriah, 88, **91**
Germany, 103, 181
Gibraltar, 27, 84, 88, 96–97, 162, 177,
 212, **99, 177, 213**; Floating Batteries,
 destruction of, 180, 191, 204–207,
 205–207; Relief of, in 1780, 137–140,
 144, 151, 212, **135, 139, 141**, in 1782,
 136, 150–153, 204–207, **205–207**;
 Siege of, 204, 207, **205**
Gilpin, Sawrey, 16, 188
Gilpin, Reverend William, 67, 165,
 188–189
Goldsmith, Oliver, 19
Goodall, Admiral Samuel Granston, 49,
 52, 160–161, **52, 159**
Goostrey, Captain Wiliam, 52, **53**
Gordon Riots, 14
Gore, Charles, 200–201
Goree, capture of, 33, 70, 79, **68–70**
Gosport, 84, **87**
Granado, 51, **50–51**

Granby Square, Havana, 61, **60, 62**
Grand Cul de Sac, St. Lucia, 133, 135,
 133
Grant, General James, 133, 135–136
Grasse, Admiral Comte de, 76, 108,
 154–156, 161, 180
Greenwich Hospital, 126, 158;
 Collection, 26, 84–85, 136, 167, 170;
 Governor, 26, 84, 86; Painted Hall, 84
Greenwood, auctioneer, 162, 199
Grenoble, rue de, Paris, 172
Gresham, Sir Thomas, 162
Greville family 28
Greville, Hon. Charles, 18, 190
Greville, Hon. Francis, 64
Grignion, Charles, 26
Grimouard, Capitaine de, 174, **173, 175**
Gros Islet Bay, St. Lucia, 113, 136, **118**
Guadeloupe, 74, 88, 133, 154, 160
Guichen, Admiral Comte de, 112–113
Guildhall Art Gallery, London, 207
Guipuscoana, 138, 144

Haarlem, 107
Halifax, Earl of, see Dunk
Halifax, Nova Scotia, 23, 40–42, 44,
 39–44
Hall, John, 191
Hamble, Joseph R., 198
Hamilton, Lady (Emma, née Hart), 18,
 200–201
Hamilton, Sir William, 18, 179, 200–202
Hamlet, 161
Hamond, Captain Sir Andrew Snape,
 109, 111
Hampton Court, 37, 71, **35**
Hankerson, Captain Thomas, 54, **54**
Hankey, Alderman Thomas, 162
Hanway, Jonas, 126
Hardcastle, Ephraim, 130
Harraden, Richard, 198, **198**
Harris, John, 181
Harry-Grace-a-Dieu, 85, **86**
Hart, Emma, see Hamilton, Lady,
Hartley, Mary, 79, 188–189
Harvey, Captain John, 153, **153**
Harwich, 19, 29–30, **28–30**
Havana, Cuba, 14, 16, 46–63, 75, 132,
 207
Havanna, The, capture of, 44, 46–63, 79,
 89, 106, 138, 160–161, 166, **46–63**
Hawke, Catherine, 125, 127
Hawke, Admiral Edward, Lord, 26, 34,
 73–74, 82, 84–85, 92, 122–127, 163,
 33, 125–127
Hawke, Martin, 125–127, **127**
Hayman, Francis, 20, 92, 209, 94
Hebe, 208
Henry VIII, 85, **86**
Hercules, 145, **145**
Hero, 166, 168, **160, 165**
Héros, 164–169, **166–167**
Hervey, Captain Hon. Augustus John,
 Lord Bristol, 37, 46, 51–52, 64, 70–76,
 34, 51, 53, 72–77
Hestercombe, 69, 187
Hickey, Thomas, 148, **147**
History painting, 81, 214
Hogarth, William, 17–20, 64, 92, 206
Holburne Museum, Bath, 115
Holman, Francis, 64
Hood, Admiral Samuel, Viscount,
 155–156, 160–161, 212, **213**
Hoppner, John, 212
Horton, Anne, 64, 95, 157
Hotham, Admiral William, Lord, 104, 133
Howe, Admiral Richard, Earl, 106–107,
 136, 148, 151, 187, 204–207, **206–207**
Howe, General Hon. William, 52, 106, **52**

Hudson, river, 107–109, 120, **107–111**
Hughes, Admiral Sir Edward, 148,
 163–170, 176, **164–170**
Hughes, Lady, 170, **167**
Humphry, Ozias, 122, 147, 217, **121**
Hunter, 116, **122**
Hurst Castle, Hants., 88
Hyde Parker, see Parker
Hyde Park, 96, 119, 128, 130, 184; Place,
 see London: Streets

Ibbetson, Julius Caesar, 131, 159
Ickworth, 71–72, 75–76, 202, **72–73, 77**
Incorporated Society of Artists, see
 Societies
India, 88, 90, 163, 168, 170
Indiaman/men, 85, 88, 96, 180–181, **85,
 181**
Institute of Directors, London, 156
Invincible, 106
Ipswich, 170
Ireland, 127, 141, 181
Isle of Wight, 78, 97, 106, **79, 105**
Italy, 14, 17, 19, 33, 130, 184, 187,
 199–202

Jamaica, 155, 161, 187
James, Lady, 90
James, Commodore Sir William, 88, 90,
 89
Jason, 160–161, **159**
Jean, Philip, 189, **Frontispiece**
Jeffereys Hook, New York, 109
Jersey, 65, 189, **65**
Jervis, Sir John, see St. Vincent, Earl,
Johnson, Dr. Samuel, 151
Jones, John, 104
Jones, Commodore John Paul, 141
Jones, Thomas, 187
Jordan, Mrs., 208
Joy, William, 110
Jukes, Francis, 152, **152**
Juno(n), 136–137, 176, **137**

Kearsly, C., 140
Kent, 89, **91**
Keppel, Admiral Augustus, Viscount,
 33–35, 37–38, 45–46, 49, 56, 58, 63,
 70, 74, 81, 85, 121, 136, 144, 148, 150,
 160, 170, 179, 211, **32, 34–37, 56, 59,
 68–70**
Keppel, George, Viscount Bury, 64
Keppel, Colonel Hon. William, 46, 63–64
King, Admiral Sir Richard Bart., 165,
 168, **160**
King's Bench Prison, 216
Knight, Edward, 68–69, 180, 187
Knight, Lady, 200
Knight, Ellis Cornelia 200–201
Knight, Admiral Sir Joseph, 52, 200, **52**
Knight, Richard Payne, 69
Knowles, Admiral Sir Charles, 64

Lagos, 27, 34
Lambert, General, 37, **35**
Lambert, George, 17, 130
Landguard Fort, Harwich, 30, **30**
Langara, Admiral Don Juan de, 140, 180
Langford, auctioneer, 162
Latona, 113
Latouche-Treville, Louis-René Levassor,
 Comte de, 173–174
La Trinité, 74, **74, 76**
Lawrence, Thomas, 188
Leander, 208, **208–209**
Leeward Islands station, 46, 74, 133, 138
Leghorn (Livorno), 31, 178–179,
 200–201
Lendrick, Captain John, 52, **52**

Lennox, 99, **98**
Leopard, 23
Leopold, Grand Duke of Tuscany, 178
Le Palais, Belleisle, 37, 40, **36–38**
Liber Nauticus, 29–31, 40, 78, 106, 124,
 177, 195–199, **30, 38, 79, 105, 125,
 177, 195–198**
Liber Studiorum, 197
Liber Veritatis, 196
Lime, 72, **73**
Lindsay, Admiral Sir John, 52, **53**
Lion, 142, **143**
Lisbon, 193, **194**
Little Sea Torch, 216
Locker, Edward Hawke, 84, 170
Locker, Captain William, 82–84, **82–83,
 86**
Locmaria Point, Belleisle, 37, **35**
London, 174, 173, 175
London: Bridge, 14–16, 19–21, 64, 15;
 Corporation of, 15, 152, 191,
 204–207, **205–207**; Lord Mayor of,
 121, 162, 208
 Streets, etc.: Arlington 206,
 Bayswater Road 129, Beak 18,
 Berners 96, 203, Bond 16, Broad 68,
 Carnaby 68, Castle 16, Charing Cross
 20, Cheapside 121, 171, Covent
 Garden 47, 68, Gerrard 20, Golden
 Square 18–19, 68, 120, 128, 189,
 Haymarket 194, Hyde Park Place 129,
 Knightsbridge 130, Leicester Square
 16, 199, Maiden Lane 47, 68, New
 Bond 198, Newman 147, Oxford
 Turnpike (see St. George's Row),
 Piccadilly Circus 18–19, 21, 68, Poland
 96, Poultney 19, St. George's Row 96,
 128–130, 150, 183, 213, 217, St.
 Martin's Lane 17, Silver 18, Spring
 Gardens 20, 31, 68, Strand 20, Token
 House Yard, Lothbury 16, Trafalgar
 Square 68, Upper Seymour 203,
 Warwick, 19, 68, 117, 120
Long Island, New York, 108
Long Melford, Suffolk, 112
Long Parliament, 191
Lorrain, Claude, 196
Louisbourg, 23, 26, 45, 163
Loutherbourg, Philipp de, 190, 198, 214
Louvre Palace, Paris, 116
Lowestoffe, 84
Lundy Island, 104–106, **103, 106**
Lurcher, 52, **52**
Luttrell, Captain Hon. James, 155–159,
 156–157
Luttrell, Lady Elizabeth, 187

Macaulay, George Mackenzie, 181, **181**
MacBride, Admiral John, 144–145, 148,
 145
Macklin, Charles, 19,
Maddan, Lucretia, 184
Madras, 88, 164, 168, **164**
Magicienne, 161
Malabar, 88, 114, **91**
Malta, 72; Knights of, 72–73
Manhattan Island, 107–108, **107**
Mann, Horace, 202
Marchant, Nathaniel, 69
Maria Carolina, Queen of the Two
 Sicilies, 170–180, **182**
Marlborough, 52, **53**
Marlow, 104
Mars, 145, **145**
Marshalsea prison, 14–15
Martinique, 46, 73–74, 84, 112, 133, 136,
 74, 76, 78
Mason, James, 26, 38, 41–42, 44, 47, **36,
 39, 42–43, 48, 51**

Massachusetts, Commonwealth of, 115
Mathias, Gabriel, 117 and note,
Mediator, 156–157, **156–157**
Mediterranean, 14, 32–33, 70, 74, 84, 97, 120, 137, 146, 177–179, 212
Melampe, 103–104, **104–105**
Melford Hall, Suffolk, 112
Melville, Herman, 132
Members of Parliament, 66, 90, 104, 108, 162
Ménagère, 158, **157**
Mercury, 49, 51–52, **50, 52–53**
Milos, 71
Ministère de la Marine, 118
Minorca, 26, 33, 70–71, 138
Mitchell, Thomas, 64, 110
Mona Passage, 160–161
Monamy, Peter, 16–17, 92, 131, 141, **93**
Monck, General George, 191
Monckton, General Sir Robert, 74, 76, 78, **78**
Monmouth, 166, **165–167**
Montagu, Admiral Sir George, 144, **144**
Moore, John Francis, 126, **127**
Morning Chronicle, 207
Morro, El, Castle, Havana, 51–58, 63, **53–59**
Mortimer, Thomas, 19
Moser, G.R., 79
Mount, C.M., 146–147
Musée de la Marine, Paris, 176
Mystic Seaport Museum, Conn., 108

Namur, 49–51, 56, **50, 56**
Naples, 18, 178–179, 187, 200, 202, **178, 182**
Napoleon Bonaparte, 117, 179
National Army Museum, London, 204
National Gallery, London, 88
National Gallery of South Africa, Cape Town, 95
National Maritime Museum, London, 26, 57, 62, 72, 83–84, 110, 115–116, 144, 150, 179, 207
National Portrait Gallery, London, 147, 204
Naval Academy, 127
Naval Chronicle, 116, 136
Needles, The, Isle of Wight, 97, 106, **105**
Negapatam, 167–168, **160, 167**
Nelson, Admiral Horatio, Lord, 18, 84, 114, 146, 150, 179, 201
Nepean, Evan, 150
Netherlands, The, 103, 132, 142
New York, 106–110, 116, 161, 193, 198, **194, 199**
Newcastle-upon-Tyne, 12, 140
Newton, Francis Milner, 79, 186, **94**
Nollekens, Joseph, 162–163
Nonsuch, 135, **134**
Nore, 114
North Aston, Oxon., 187
North river, see Hudson river,
North Sea, 29, 104, 113
North Stoneham, Hants., 125–126, **127**
Northampton, Earl of, 102
Notre Dame, Church of, Auch, 13
Nottingham, 52, **52**
Nova Scotia, 23, 40–41, 44–45, **40, 41, 44**
Nymph, 71, 143

O'Brian, Patrick, 198
Ocean, 26–27
Official Gazette, 161
Old Bahama Channel, 46
Ommaney, Captain, 109, **111**
Orford, 46, 52, **53**
Orford, Earl of, see Walpole, Horace

Orme, Edward, 30, 177, 196–199, **30, 38, 79, 105, 177, 196–198**
Ormond House, Chelsea, 126
Orsbridge, Lieutenant Philip, 46–56, 62, 167, **46–57**
Orvilliers, General Comte d', 136

Paddington, 202, 213
Paestum, 178, **179**
Page, Admiral Benjamin, 167, 170
Paine, James, 20
Painter's Mirror, 156, 158, 161
Palliser, Admiral Sir Hugh Bart., 26, 136
Panther, 153
Paris, 116–117, 171, 184, 200; Treaty of, 61, 68
Parker, Sir Harry, 106–107, 112
Parker, Admiral Sir Hyde, Bart., senior, 106, 112–115, 136, 145, 148, 163, **118–119**
Parker, Hyde, junior, 106–114, 142, **107–115**
Paton, Richard, 64–65, 156, 158, 171
Pearl, 144, **144**
Pearson, Captain Richard, 141
Pégase, 148–149, 210, **149**
Peltro, John, 166, **167**
Pembroke, 96, **99**
Penn, William, 191
Penny, Edward, 79
Penobscot Bay, Maine, 115–116, **122**
Petit, le, W.A., 86, **86**
Phoenix, 50, 70–71, 106–108, 114, 145, **50, 72, 114–115**
Pigeon Island, St. Lucia, 113, **118**
Pindar, Peter, 148
Pitt, 181, **181**
Pitt, William the Elder, Earl of Chatham, 46, 204, 206
Plan of an Academy, The, 19
Plymouth, 23, 33, 78, 84, 131, 138, 153, 211, **79–80, 153, 216**
Plymouth, Earl of, 137
Pocock, Admiral Sir George, 46, 49, 51, 56, 75, 89, **50, 56, 59**
Pocock, Nicholas, 65, 161, 188
Pollard, Robert, 90, 113, 140, 158–159, 207, **156–157, 206–207**
Port Andro, Belleisle, 34, 37, **34**
Port Louis (Lorient), 34
Port Royal, Jamaica, 156, **77**
Portsmouth, 84, 97, 102, 120, 122, 125, 131, 149–150, 158, 210–211, **87, 149**
Preston, 135, **134**
Prince George, 140
Prince of Orange, 23, 35, 37, **34**
Prince Regent, 162
Prince of Wales, 135, **134**
Prince William, 138
Princess Augusta, 181
Prints, market for, 21–22, 45, 104, 113, 121, 132, 160, 180, 191–192, 204, 206–207; production of, 21–22, 38–39, 47, 56, 61, 113, 121, 140, 160, 191–192
Prix de Rome, 117
Proby, Commodore Charles, 97, **99**
Procida, Isola, Naples, 202, **201**
Providien, 165–166, **166**
Public Advertiser, 47
Puerto Rico, 160
Punta Brava, 53, **53**
Punto Castle, Havana, 52, 54–55, **53, 55**
Pye, Admiral Sir Thomas, 99, **98**
Pyne, W.H., 130

Quebec, capture of, 22–23, 26–27, 45, 74, 106, 149, 163; paintings of, 23–24, 26, **24–25, 27**; prints of, 23–24, 26, 40, **24–25**
Queen's House, see Buckingham House

Rainier, Admiral Peter, 170
Raisonnable, 116, **122**
Raminet battery, Belleisle, 37, **37**
Ramsay, Allan, 71, 117 and note, 202
Randall, William, 79
Reinagle, R.R., 218
Revenge, 71
Reynolds, Sir Joshua, 17, 20, 33, 81, 93, 104, 140, 147–148, 163, 170, 200–202, 214, **32, 94, 170**
Rheims, Archbishop of, 13
Richards, John Inigo, 186, **94**
Richmond, 49
Roberts, W., 147, **146**
Roch, le, W., 86, **86**
Rockingham, Marquis of, 148
Rodney, Admiral George Brydges, Lord, 46, 74, 76, 85, 102, 112–113, 138–140, 144, 151, 153, 154–156, 160–161, 180, 189, 212, **77–78, 135, 139, 141, 154–155**
Roebuck, 109, **111**
Rome, 117 note, 163, 179, 200, 202
Romney, George, 115, 147, 202
Rooke, Admiral Sir George, 137
Rooker, Edward, 61, **62**
Rosa, Salvator, 193, **195**
Rose, 72, 107–108, **73, 107, 109**
Rossel de Cercy, Capitaine Auguste, Marquis de, 175–176, **173**
Rotterdam, 146
Roubiliac, Louis François, 20
Rowley, Admiral Sir Joshua Bart., 112, 161
Royal Academy of Arts, London, 17, 19, 66, 103, 124, 128, 132, 148; Academicians, 20, 92–93, 143, 208, 212, 94; Arranging/Hanging Committee, 96, 208, 209; Council, 78, 81, 96, 102, 208; Council Minutes, 79, 217; Dinner, 1774, 102; Exhibitions, 69, 76, 84, 88.89, 92, 96, 99, 101, 104, 106, 108–109, 112–113, 120–122, 124–125, 133–134, 136, 140–144, 146, 148–149, 152, 156–158, 160–162, 177, 179–181, 183, 189, 191, 202, 206–208, 210, 209; Foundation, 79, 81, 213; Laws and Regulations, 96; Librarian, 79, 96, 208–210; President, 81, 109, 213; Professor of Architecture, 12; Secretary, election of, 186; Stationers to, 79–80, 217; Teacher of Perspective, 12, 186
Royal Charlotte, 29
Royal Coburg Theatre, 216
Royal Collection, 86, 97, **86**
Royal Exchange, 162
Royal George, 34, 84, 92, 124, 126, 151, **33, 125–127**
Royal Hospital, Chelsea, 126
Royal Hospital, Greenwich, see Greenwich Hospital
Royal Marriage Act, 95
Royal Military Academy, Woolwich, 18
Royal Naval Academy, 126
Royal Oak, 99, 112, **98**
Royal Society of Arts, see Societies (Society for the Encouragement: of Arts)
Royal Yacht, 30
Ryves, Anthony Thomas, 217

Sadras, 165, **165**
St. Bride's, 14
St. Foy, Belleisle, 37–38, **35**
St. George, 211–212, **211**
St. Helens, 100, 124, 188, 211, **125**
St. Helier, 65, **65**
St. James's, Piccadilly, 19

St. Lawrence river, 23, 26, 45
St. Lucia, 75, 85, 113, 133–136, **75, 77, 118, 133–134**
St. Martin's Lane Academy, 17–19
St. Mary's, Paddington, 213, 216, 218
St. Mary's, Marylebone, 184, 203
St. Mather's Meeting House, 45
St. Nicholas, North Stoneham, 125–126, **127**
St. Paul's Cathedral, 186, 190
St.Vincent, Cape, 83, 138
St.Vincent, John Jervis, Earl, 83, 136, 146, 148–151, 191–192, 210, **149**
St.Vincents, Kent, 84, **86**
Salerno, 178, **179**
Salisbury, 89, 150, **91**
Saltonstall, Commodore Dudley, 115
Sancta Monica, 144
Sandby, Paul, 12–14, 18–20, 28, 61, 64, 66, 68, 79, 81, 93, 96, 122, 128–131, 145, 155–156, 162, 171, 186, 189–190, 208, **94, 129, 183**
Sandby, Reverend George, 64
Sandby, Thomas, 12–13, 18–19, 26, 64, 66, 93, 124, **94**
Sandby, W., 124
Sandy Hook, New York, 110
Santo Domingo, 139, 145
Santo Domingo, 144, 160, 174
Sapphire, 84
Saumarez, Admiral James, Lord de, 113, 189
Saunders, Admiral Sir Charles, 23, 26, 121, 149, 163
Sauzon, Belleisle, 37–38, **36**
Savannah, Georgia, 110, **114**
Sayer and Bennett, 47
Scipion, 174, **173, 175**
Scott, Samuel, 16, 18, 64–65, 67, 96, 114, 122, 130–131, 142
Serapis, 141
Serres, Antoine (of Auch), 13
Serres, Augusta Charlotte (daughter), 19–20, 79, 81, 184, 217
Serres, Britannia (granddaughter), 203, 217
Serres, Catherine (daughter), 16, 147, 217
Serres, Count Dominic de, 13
Serres, Dominic,
 Life: Antecedents, 13–14; Birth, 13; Collection, 93, 128, 130–132 (artists in collection not indexed); Death, 13, 213; Expatriate circles, 66, 116–117, 128, 214; Family, 14–16, 19–20, 68, 95, 147, 150–151, 183–184, 200, 202, 208, 213, 216–218; Friends, 16, 20, 129–130, 151, 186–189, 200; Health, 185–186; Letters, 116–118, 150–1, 171–176, 185–187; Linguist, 14, 187, 208–209; Marine Painter to George III, 128, 130, 140, 211, 213; Marriage, 14; Portraits of, 66, 92–93, 122, 146–148, 189, **Frontispiece, 94, 121, 147, 183**; Residences, 14–16, 19, 120, 128–130; Studio sales, 130–132, 216; Travel, 65, 172, 177–180, 185–186, 193
 Work (see also Commissions, Exhibitions, Paintings, Prints, Royal Academy, below): Assessment and reputation, 17, 21, 213–214; Calm, preference for, 132–133, 214, **69, 139**; Chiaroscuro, 29, 113, 117, 124, 145, 160, 190; Chimney friezes, 76, 162, 208, **209**; Clouds and gunsmoke, 29, 39, 58, 80, 100, 108–110, 153, **101, 107, 111**; Coastal views, 39; Drawings and watercolours, 29, 97, 110, 116, 132, 141, 145, 178–179, 190–199, **28,**

222

111, 145, 178–179, 191–195; Figures, 42, 57, 79, 84, 132, **44, 87, 98, 211**; Fleet actions, 82, 112, 142, 154–156, 163–170, **154–155, 164–169**; Landscape, 19, 22, 31, 39, 57, 65, 79, 84, 105, 122, 131, 190, **31, 86**; Landscape premiums, 27–28; Line of battle, 165; Marine subjects, 19, 22, 84, 190; Naval uniforms, 84, 119–120, **123**; Night scenes, moonlight, 26, 31, 84, 88, 92, 108, 132, 158, 174, **110, 135, 156–157**; Output and speed, 21; Patrons, links between (see also Commissions below), 64, 66, 84, 97, 121, 136, 150; Perspective, 80 99, 100, 117, **98**; Prices, 114–115, 169, **114, 160**; Portrait by, 83–84, **82**; Press comment, 65, 102, 121, 126, 136, 141, 143, 145–146, 156, 158, 161–162, 194, 205, 207–208, 213; Single-ship actions, 82, 84, 137, 142, 144, 146, **85, 87, 137, 144**; Style and technique, 16, 39, 58, 60, 65, 67, 70, 101, 108, 124, 132–133, 140, 153, 165, 214, **65, 101, 107, 210**; Time-lapse depiction, 80, 142–144, 156–158, **156–157**; Transparencies, 190; Vernet, correspondence with, 116–118, 171–176; Vernet, influence of, 67, 84, 88, **67**; Vessels, types of, 106, 177, 198, **199**; War artist, 139 141, 152, 161

Commissions: Albemarle, 56–63, **56–63**; Alms, 166–167, **167**; Barrington, 84–86, 133–136, **85–87, 97, 133–134**; Castries, 171–177; Clarence, Duke of, 140, 208, **138, 208–209**; Collier, 115–116, **112**; Copley, 204–207, **205–207**; George III, 97–102, **97–102**; Goodall, 160–161, **159**; Harvey, 154, **153**; Hawke, 122–127, **33, 125–127**; Hervey, 70–76, **72–77**; Howe, 136, **206–207**; Hughes, 163–170, **164–170**; James, 90, **89**; Jervis (St. Vincent), 83, 136, **149**; Keith, 146, ; Keppel, 33, 56–63, **56–63, 68–70**; Knight, 68–69; Locker, 82–84, **82–83, 86**; Luttrell, 155–159, **156–157**; MacBride, 144–145, **145**; Monckton, **78**; Montagu, 144, **144**; Palliser, 26, **27**; Parker, Harry, Hyde, senior and junior, 106–115, 136, 142, 145, 148, **107–115, 118–119**; Proby, 97, **99**; Rodney, 76, 137–140, 154–156, 212, **77–78, 135, 138, 141, 154–155**; Tollemache, 103–104, **104–105**; Warren, 104–105, **103, 106**; Windsor, 136–137, **137**

Exhibitions: Incorporated Society of Artists, 31, 63, 68, 78, **59, 69, 79**; Royal Academy, 66, 69, 76, 84, 88, 89, 92, 96, 99, 101, 104, 106,108–109, 112–113, 120–125, 133–134, 136, 140–142, 144, 148–149, 152, 156–158, 160–162, 177, 179–180, 207, 208, 210; Society of Arts (Free Society), 20, 27–28, 30–31, 39, 42, 44, 67–68, **29, 41, 44–45**

Paintings, major: Goree, 33, 70, **68–70**; Havana, 51–63, **56–63**; India, East Indies, 88–90, 148, **89–91**; Martinique, 46, 77, **74, 76, 78**; St. Lucia, 75, 133–136, **75**

Prints: own, 120, 194–195, **123, 195**; Belleisle, 34–35, 38–40, 178, **34–37**; Halifax, 40, 178, **39–42**; Havana, 46–56, **46–56**; Quebec, 23–24, 26, **24–25**

Royal Academy: Council member,

96; founder member, 66, 81, 213; Dinner 1774, 102; Diploma work, 133, **139**; Librarian, 79, 96, 208–210

Serres, Dominique Michael (son), 20, 127, 148–151, 175, 183–187, 213, 217, **216**

Serres, H., Miss. (daughter), 147, 184, 217, **146**

Serres, Jane (daughter), 15, 147

Serres, Jean (of Auch), 13

Serres, Joanna (Johanna) (daughter), 16, 217–218

Serres, John Dominic South (grandson), 203

Serres, John Thomas (son): Birth, 16; Chelsea Maritime School, 126–127, 151; Collection and sale 1790, 130, 187, 199–200; Death, 216; Divorce, 203; Drawings, 116–117, 180, 183, 195, 202, **184, 195, 201, 203**; Family, 184, 203, 208, 218; Letter from Genoa, 200–201; *Liber Nauticus*, 29–30, 106, 196–199, **30, 125, 196–198**; Marriage, 28, 95, 202–203; Marine Painter to Duke of Clarence, 183, 199, 216, **182**; to George III 216; Paintings, 103, 183, **182**; Royal Academy exhibitions, 103, 181–183, 202, 212; Theatre designer and shareholder, 190; Travels, 130, 172, 175, 181–183, 199–202, 213

Serres, Lavinia (granddaughter), 203, 217

Serres, Lucretia (née Maddan) (daughter-in-law), 184–186

Serres, Mary (née Caldecott) (wife), 14, 16, 19–20, 202, 217–218

Serres, Mary (daughter), 16

Serres, Mary Estr. Olivia (granddaughter) 203

Serres, Olivia (née Wilmot) (daughter-in-law), 28, 69, 95, 202–3, 208, 217

Serres, Sarah (daughter), 16, 79, 81, 184, 187, 217–218

Severe, 168

Severndroog, 90, **89**; Tower, 90

Shackleton, John, 17

Sharp, William, 191, 207

Shelbourne, Lord, 117, 176

Shenstone, William, 69

Shooters Hill, Kent, 90

Short, Richard, 22–24, 26, 35, 38, 40–42, 44–45, 47, 56, 121, **24–25, 34–40, 42–43**

Shrewsbury, 26

Shugborough, 67

Sicardi, Louis, 187

Single-ship actions, 82, 84, 137, 142, 146, **85, 87, 137**

Skelton, W., 160–161, **159**

Smith, J.T., 20, 163–164

Smith, John 'Warwick', 188

Smith, Consul Joseph, 18, 201

Smollett, Tobias, 122

Soane, Sir John, 208

Societies: Free Society of Artists, 31, 39, 42, 44, 47, 67–68, 81, **41, 44–45, 51**; Marine Society, 126–127; Polygraphic Society, 190; Society of Artists of Great Britain, 20, 31, 131, (after 1765) Incorporated Society of Artists, 63, 68, 78–79, 81, 186, **59, 69, 79**, special exhibition 1768, 63, 70, 79, **54, 69**; Society of Dilettanti, 187; Society for the encouragement of Arts (now Royal Society of Arts), 20, 26–28, 30–31, 68, 216, **29**, premiums at, 20, 26–28, 64

Soleil Royal, 124, **33**

Solent, 97, 125

Somerset, 163

Somerset House, 102–103, 190, 206, 208

Southampton, 104, **105**

Southampton, 125, 212

Southwark, 14–15

Spain, 13, 46, 138, 142

Spithead, 23–24, 84, 92, 97, 99, 109, 120, 124, 158, 181, 208, 211, **97**; Review, 97–102, 211–212, **97–98, 210**

Stadler, Joseph Constantine, 198, **198**

Stanhope, Commodore Sir Thomas, 37–38, **35**

Staten Island, New York, 193, **194**

Stephens, Sir Philip, 97, 106, 108, 150, **149**

Stirling Castle, 52–53, **53**

Stonehenge, 97, **96**

Strachan, Captain Sir John Bart., 82–83

Straits of Bahama, 50

Strawberry Hill Villa, Twickenham, 12

Stuart, Prince Charles Edward, 18, 142, 162, **148**

Stuart, Gilbert, 146–147, 189, 217, **146**

Stubbs, George, 114–115

Suffren, Admiral Pierre-Andre Bailli de, 148, 164–170, 176, **164–169**

Superb, 163–170, **164–169**

Suraj-ud-Dowlah, 88–89

Swaine, Francis, 26, 64

Swaine, John, 197

Swaythling, Hants., 125–126

Sweet William, 92, **93**

Swiftsure, 37, **35**

Sybile, 161

Tappan Zee, 107, **109**

Tarrant, Reverend John, 14

Tarrytown, 107, 109, **109**

Tartar, 109, **111**

Tate (Gallery), Britain, 88, 204

Télémaque, 83–84, **83**

Temple, Hon. Henry, 162

Thames, 14–15, 18, 92

Thelwell, Reverend Robert Carter, 115

Thésée, 34, 121

Thetis, 50

Thornborough, Lieutenant Edward, 143

Thornhill, Sir James, 17

Tiger, 89, **91**

Tippoo Sahib, 170

Tollemache, Wilbraham, 103–104, **104–105**

Torbay, 33, 99, 121, 174, **98, 173, 175**

Torre, 75, 136, **75**

Toulon, 26–27, 137, 172, 212

Town and Country Magazine, 219

Transparencies, 190

Trent, 53, **53**

Trident, 170

Trincomalee, 163–164, 168

Tryal, 107–108, **107, 110**

Turk's Head Tavern, 20

Turner, Dawson, 122

Turner, J.M.W., 197–198, 214

Turner, Mary (née Pulgrave), 122, **121**

Twickenham, 12, 64

Twiss, Richard, 150–151

Udny, John, 201–202

Udny, Robert, 201

Uniforms, 84, 119–120, **123**

Universal Magazine, 126, **127**

Ushant, 73–74, 84, 143

Valiant, 49, 56, 63, 160–161, **56, 159**

Vandeput, Admiral George, 200–201

Velde, Willem van de, the Elder, 19, 68–69, 93, 99–100, 130, 214

Velde, Willem van de, the Younger, 19, 68–69, 93–95, 130, 170, 180, 188, 193, 214, **180**

Vengeur, 153

Venice, 18, 201

Venus, 84, 104

Vernet, Carle, 116–117, 172, 176

Vernet, Claude Joseph, 67, 84, 88, 116–118, 131, 171–176, 187, **67, 87, 171**

Vernet, Emilie, 117, 173, 176

Vernet, Horace, 118

Vertue, George, 12

Victoria, Queen, 128

Victoria & Albert Museum, London, 88

Victory, 144, 148, **213**

Ville de Paris, 76, 155–156, **77**

Waddesdon Manor, Herts., 106, **105**

Walker, Anthony, 26, **15**

Wallace, Admiral Sir James, 106, 108

Walpole, Horace, 64, 92, 185, 202, **94**; *Anecdotes of Painting in England*, 12–13, 64

Ward, James, 218

Warren, Admiral Sir John Borlase, Bart., 104–105, **103, 106**

Wars: of American Independence, 76–77, 81, 84, 106–116, 132–170, **77**; of Austrian Succession, 15; Seven Years', 21, 26, 70, 81, 88, 103, 163, **74**

Warwick, 146

Warwick Castle, 18, 26–28, 69

Warwick, Earl of, 18, 28, 188, 202

Washington Bridge, 108

Washington, General George, 107–108, 154

Waterford, 183, **184**

Watson, Admiral Charles, 88–90, **91**

Wellington, Duke of, 170

West, Benjamin, 23, 79, 109, 132, 146–147, 191–192, 204, 218, **94**

West Indies, 13.15, 46, 70, 74, 76, 112–113, 133, 153–156, 161

West Malling, Kent, 84, **86**

Westminster, 47; Abbey, 90, 186

Whatman paper, 186

Whitcombe, Thomas, 116, 212

White Bear, the, 19

White, Taylor, 17

Wilkinson, Robert, 113, 140, 152, 158–159, 166, **15, 152, 156–157, 167**

William IV, as Prince William Henry, 140, 183; as Duke of Clarence, 140, 183, 208, **138, 208–209**

Wilmot, Reverend Dr. James, 28, 202–203

Wilmot, Olivia, see Serres, Olivia

Wilmot, Robert, 28, 202–203

Wilson, Richard, 19–20, 26, 79, 104, 140, 210

Wilton, Joseph, 20, 79, 208, 210, **94**

Winchester, Cathedral, 13; College, 64

Windsor Castle, 85, **86**

Windsor Great Park, Deputy Ranger of, 18, 64

Windsor, Captain Hon. Thomas, 136–137, **137**

Wolcot, John, 148

Wolfe, General James, 23, 53, 191, 204

Wolverley, Worcs., 68

Woollett, William, 191

Worcester, 99, **98**

Wright, Richard, of Liverpool, 64–65

Wright, Thomas, of Durham, 102

York, Edward Augustus, Duke of, 84

Yorktown, 112, 154

Young Pretender, see Stuart, Charles Edward

Zoffany, Johann, 92, 148, **94**

Zoutman, Admiral Johan Arnold, 113, **119**